A.Y. JACKSON

The Life of a Landscape Painter

A.Y. JACKSON

The Life of a Landscape Painter

Wayne Larsen

Dundurn Press
Toronto

Project Editors: Michael Carroll and Jennifer McKnight
Copy Editor: Andrea Waters
Design: Heidy Lawrance, WeMakeBooks.ca
Printer: Friesens

Library and Archives Canada Cataloguing in Publication

Larsen, Wayne, 1961-
A.Y. Jackson : the life of a landscape painter / by Wayne Larsen.

ISBN 978-1-55488-392-9

1. Jackson, A. Y. (Alexander Young), 1882-1974. 2. Group of Seven (Group of artists). 3. Painters—Canada—Biography. I. Title.

ND249.J3L372 2009 759.11 C2009-900296-5

1 2 3 4 5 13 12 11 10 09

 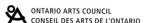

Canada Council Conseil des Arts Canada ONTARIO ARTS COUNCIL
for the Arts du Canada CONSEIL DES ARTS DE L'ONTARIO

We acknowledge the support of the **Canada Council for the Arts** and the **Ontario Arts Council** for our publishing program. We also acknowledge the financial support of the **Government of Canada** through the **Book Publishing Industry Development Program** and **The Association for the Export of Canadian Books**, and the **Government of Ontario** through the **Ontario Book Publishers Tax Credit program**, and the **Ontario Media Development Corporation**.

J. Kirk Howard, President

Printed and bound in Canada.
www.dundurn.com

Dundurn Press Dundurn Press Gazelle Book Services Limited
3 Church Street, Suite 500 2250 Military Road White Cross Mills
Toronto, Ontario, Canada Tonawanda, NY High Town, Lancaster, England
M5E 1M2 USA 14150 LA1 4XS

To Darlene,
as always, for making all things possible

and

To Nikolas and Bryn-Vienna
for all their help and patience

CONTENTS

A.Y. Jackson for instance

83 years old

halfway up a mountain

standing in a patch of snow

to paint a picture that says

"Look here

You've never seen this country

it's not the way you thought it was

Look again"

— *Al Purdy, "The Country of the Young"*

ACKNOWLEDGEMENTS

FIRST AND FOREMOST, I WOULD LIKE TO acknowledge a great debt to the late Dr. Naomi Jackson Groves, whose documentation of her uncle's life was very helpful. I would also like to acknowledge the work of Dennis Reid, Charles C. Hill, and Joan Murray, whose books and articles also facilitated the research process.

Many thanks to David Silcox of Sotheby's for his invaluable help in procuring some of the colour images, to Alex Hamilton for providing family photos, and to Gabor Szilasi for the use of his own photos.

I would also like to thank Anna Brennan, literary trustee for the estate of the late Dr. Naomi Jackson Groves, Michael Millman of the West End Gallery, Alan Klinkhoff of the Klinkhoff Gallery, Nora Hague at the McCord Museum of Canadian History, and Nathalie Hodgeson at the Concordia University Archives.

For help with the colour images, thanks to Greg Spurgeon, Andrea Dixon, and France Beauregard of the National Gallery of Canada; Alexa Parousis and Sean Weaver of the Art Gallery of Ontario; Janine Butler of the McMichael Canadian Collection; Susan Ross and Maggie Arbour-Doucette of the Canadian War Museum; and special thanks to Leah Berkhoff and Rhys Stevens of Lethbridge College.

At Dundurn Press, thanks to Kirk Howard, Michael Carroll, Shannon Whibbs, Jennifer McKnight, and Andrea Waters for all their work in bringing this project together.

For contributing in one way or another, I wish to thank Rhonda Bailey, Roch Carrier, Karen Forbes Cutler, May Cutler, John B. Claxton, Peter Downie, Jeremy Eberts, the Hon. Heward Grafftey, Michael Judson, Doreen Lindsay, Karin Marks, Ann Moffat, Florence Millman, Emanuela Nicolescu, Brian Puddington, Eduardo Ralickas, Enn Raudsepp, Terry Rigelhof, Beverley Slopen, Tom Smart, Bill Thornley, Marilynn Vanderstaay, Magda Weintraub, and Robert N. Wilkins.

Special thanks to William Weintraub, whose unwavering belief in the importance of this project was a constant inspiration.

And, of course, thanks to my children, Nikolas and Bryn-Vienna, for helping in countless ways, and to my wife, art historian Darlene Cousins, whose research skills helped to unearth so many new facts. This book is affectionately dedicated to them.

PREFACE

"I FIRST MET A.Y. JACKSON IN THE SPRING of 1978 …" I frequently begin a lecture on Jackson or the Group of Seven with that statement, and more often than not an uneasy stir ripples through the audience until I hastily add, "Unfortunately, he had been dead for four years by that time."

No, my initial encounter with Canada's most dedicated landscape painter did not take place among the white rocks of Georgian Bay, nor on the rugged tundra of the Northwest Territories. Instead, I had to settle for meeting him in the pages of the April 1978 issue of *Reader's Digest* (Canada), which featured a six-page profile so well written that Jackson's no-nonsense, hearty personality shone through in every sentence.

The timing could not have been better. As a teenager just learning the rudiments of oil painting and already a keen outdoorsman, I was fascinated by this bigger-than-life character who scoffed in the face of harsh weather and other natural hazards as he painted Canada's diverse landscape. I clipped out the article, and the next day I checked a few Group of Seven books out of my high school library. Before long, I was on a bus to Ottawa to inspect the canvases up close in the National Gallery. There, standing alone in front of the imposing *Terre Sauvage*, with no guard in sight — I confess — I gently ran my finger across its rough, heavily painted surface.

That's when I knew I was hooked.

Over the next few years, I had a chance to paint in some of the regions where Jackson had worked several decades earlier — the Banff Rockies, southern Alberta, northern Ontario, the Ottawa Valley, and Quebec's Laurentians and Eastern Townships. I never emulated his distinct style, but I certainly developed a profound respect for his talent, fortitude, and keen eye for colour and composition.

Fast-forward to 2003: When my first book on Jackson was published (*A Love for the Land*, an introduction to his life and work for the Quest Library series), I happened to be working as a contracted copy editor at the very same magazine that first introduced me to my subject. As I was handing out my book launch invitations, someone went off to the *Reader's Digest* archives and returned with a pristine copy of the April 1978 issue, allowing me to make a few new photocopies of the article to replace the yellowed, dog-eared, and coffee-stained clipping I had been carrying around in my ever-growing collection for the past twenty-five years.

Throughout my research on the life of A.Y. Jackson, one thing that has constantly amazed me has been the lack of a definitive biography. Of the surprisingly few books previously published on this giant of Canadian art, each focused only on a narrow aspect of his life or work (his old age, his pencil sketches, etc.). This full-length biography is intended to finally fill that hole.

One of the first questions biographers have to ask themselves is, "How deep do I want to go?" In Jackson's case, his extraordinarily long and busy life means the depths are very deep indeed. The chronology at the end of this book illustrates just how busy he was, criss-crossing the country year after year. I originally toyed with the idea of producing an exhaustive biography that chronicled all of his sketching trips, incorporated his vast body of correspondence, and included a catalogue raisonné of seventy years' worth of painting — but that would certainly have resulted in a very long, dull book. The prospect of reading such a tome would have been almost as daunting as writing it.

This book aims to portray the public and private Jackson in a relatively concise way. I hope it will serve two main functions: to further inform and entertain those Canadians already familiar with Jackson and the Group of Seven, and to provide a new generation of younger and recently arrived Canadians with an interesting introduction to one of their country's key cultural heroes, much the same way I discovered him thirty years ago.

Finally, a brief word about the title. The words *Landscape* and *Painter* had to be included, for they not only describe Jackson's main vocation but also allude directly to the two major works about his career in which he actively participated — Canadian Landscape, the 1941 National Film Board documentary about him, and A Painter's Country, his 1958 autobiography. For both of those projects, he modestly refused to allow his name to appear in the main title. That could not be done for this book, of course, but I think this title would have met with his gruff, grudging approval.

I hope so, anyway.

Wayne Larsen
Val David, Quebec
March 2008

PART I

1846–1920

1

THE BREATH OF CANADA

ON A BITTERLY COLD AND RAINY OCTOBER evening in 1953, Alexander Young Jackson left his cluttered third-floor studio on Severn Street and trudged the long, familiar route down Yonge Street toward the Art Gallery of Toronto, muttering softly to himself as he pondered ideas for the speech he would be expected to make later that night. As he approached the art gallery on Dundas Street, his train of thought was suddenly interrupted by the laughter of a young woman in a plastic raincoat just ahead of him on the slushy sidewalk.

"A.Y. Jackson?" she said to her companion. "Hasn't he been dead for years?"[1]

Jackson nearly burst out laughing, but somehow managed to stay quiet and anonymous beneath his bulky overcoat and wide-brimmed fedora. Yes, he was still very much alive and tonight was to be his night — perhaps the highest point of his long career.

Dressed in his best suit and favourite tie, the seventy-one-year-old painter would be spending the next few hours holding court in the gallery, surrounded by old friends, relatives, fellow artists, and even quite a few strangers, some of whom had travelled from different parts of the country to pay tribute to him and view a selection of his work from the past half-century.

The opening reception for the exhibition *A.Y. Jackson: Paintings 1902–1953* was being hailed in the press as an event of historic importance in the Canadian art community.[2] As a founding member of the Group of Seven in 1920 — still the best-known and most influential art movement in the nation's history — and a tireless champion of modern art throughout his professional life, Jackson was by 1953 much more than a landscape artist whose images were familiar to thousands of his fellow Canadians from coast to coast. He had also made his mark as a writer, teacher, debater, curator, naturalist, outdoorsman, explorer, and tireless traveller who had carried his camping gear and sketch box to every region of the country, from Newfoundland to British Columbia, from the American border to Ellesmere Island.

The artist himself would probably have passed unnoticed in the crowd if not for the group of well-wishers who surrounded him throughout the evening. Slightly below average height, he stood five feet five inches tall, with broad shoulders and a rotund figure that seemed to strain at the front of his suit jacket. A lifetime of working outdoors had left his face permanently tanned and weather-beaten, and what little hair remained was snowy white. Advancing age had left him with heavy jowls and drooping eyelids, giving him the appearance of a friendly old bulldog. He smiled graciously and joked with each guest who lined up to shake his hand, speaking to them in his slow, deliberate baritone. He accepted their compliments with a polite modesty that sometimes bordered on the uncomfortable.

Jackson may have been uneasy with all the attention, but he was highly gratified whenever someone asked him to comment on his earlier canvases — especially the ones that had collected dust in his studio for so many years because no one wanted to buy them. Some had been condemned in the press as ugly and incompetent, but now many of these same paintings were cherished pieces of Canadian culture — colourful artifacts of the country's first and most enduring art movement.[3]

Among the special guests that night was Governor General Vincent Massey, making his first official visit to the Art Gallery of Toronto since his appointment as the Queen's representative in Canada.[4] As long-time friends and admirers of the artist, Vincent and Alice Massey owned several of Jackson's sketches and canvases; once they had even visited Jackson's studio separately and sworn him to secrecy as each bought the other an original work for their upcoming wedding anniversary.[5]

"What am I to say about my old friend Alex Jackson himself?" the governor general asked in his opening address. "Few Canadians are less in need of an introduction to any group of fellow Canadians. As you know, for well over forty years Mr. Jackson has painted all over Canada. This is no idle phrase, for his painting embodies his interpretation of the landscape of this vast country from one coast to the other and well into the Arctic North … Alex Jackson is not only a great Canadian painter, he is a great Canadian, and a legendary figure on the Canadian scene."[6]

A total of 125 works were on display — 86 canvases, 35 small oil sketches on wood panels, and 4 watercolours. The earliest dated all the way back to 1902 and the most recent was barely dry, having been completed that spring. As visitors slowly made their way around the brightly lit rooms of the gallery, pausing here and there in front of particularly striking canvases, they were getting a virtual tour of Canada in all of its moods and seasons. Here were quaint, colourful Quebec villages under a late winter snow; a springtime wind bending big pine trees on Georgian Bay; summer sunlight playing on icy peaks in the High Arctic; the blaze of autumn colours in the thick northern woods of Algoma and Algonquin Park. There were also scenes of Native settlements in northern British Columbia, warped old fishing shacks in Nova Scotia, the stark north shore of Lake Superior, and the rugged Barren Lands of the Northwest Territories. Taken together, they stood as silent testimony to A.Y. Jackson's lifelong quest to portray his beloved country on canvas. These paintings, as the governor general pointed out in his speech, "have the breath of Canada in them and are treasured wherever they are owned."[7]

It was an impressive tribute to one man's accomplishments. Jackson had had many solo exhibitions before, but never one of such magnitude. He had already been given honorary doctoral degrees from Queen's and McMaster universities and was hailed by critics and fellow artists alike as the dean of Canadian landscape painting. But this gala opening of *A.Y. Jackson: Paintings 1902–1953,* co-organized by the Art Gallery of Toronto and the National Gallery of Canada, was the highest profile event to date. After Toronto, the show would be moving on to Ottawa, Montreal, and Winnipeg.

Organizers could not have chosen a more fitting venue to open Jackson's retrospective. The Art Gallery of Toronto — now the Art Gallery of Ontario — had been the setting for the first Group of Seven exhibition thirty-three years earlier, as well as many other shows that figure prominently in the Group's story. The evolution of Jackson and his colleagues

through the 1920s, from self-proclaimed radicals to the established voices of modern art in Canada, was fraught with public controversy, much of which had resulted from exhibitions held in this very gallery. Years ago, while hanging on these same walls, dozens of brightly coloured, thickly painted canvases attracted the ire of art critics — some of whom honestly disliked the new style, while others were merely playing along with the politics of the day and supporting the conservative art establishment. What most people didn't know was that some of the negative opinions published in the Toronto newspapers and magazines had actually come from within the Group of Seven itself; they knew that the battle for public acceptance had less to do with art than it did with propaganda, and Jackson was keenly aware that any publicity for an artist is good publicity.

Canada's Most Important Canvas

Governor General Massey neglected to comment on a particularly important painting in his opening address, listed as No. 2 in the exhibition catalogue: a small, quiet canvas of a Quebec farmyard in early spring, painted by Jackson when he was just twenty-seven — but its historical significance cannot be overstated. By no means a bold or radical painting — in fact it appeared downright tame compared to Jackson's later work — it was easily overlooked by most visitors. Even those who did pause to admire *The Edge of the Maple Wood* were probably not fully aware of its role in Canadian art history. But those who had read the exhibition catalogue were informed of its importance by Jackson's old friend and fellow Group of Seven member Arthur Lismer, who recalled in the main essay how, many years earlier, that particular painting brought the Montreal-based Jackson to the attention of a group of like-minded Toronto artists who were just then beginning to discuss the idea of a uniquely Canadian style of landscape painting:

> One of his paintings called *The Edge of the Maple Wood* was exhibited in the annual exhibition of the Ontario Society of Artists at the public library on College Street, Toronto. He had found a group of admirers. I can remember this one canvas. It stood out among the usual pictorial array of collie dogs, peonies, and official portraits, like a glowing flame packed with potential energy, and loveliness. I can remember looking at it with MacDonald, Thomson, and Harris, and talking enthusiastically about its quality … Jackson's contribution was the beginning of a kinship and a movement in Canada.[8]

Jackson painted *The Edge of the Maple Wood* outdoors one late March afternoon in 1910 while staying at Sweetsburg, in Quebec's Eastern Townships. He had retreated there to paint in the "crisp clear air and sharp shadows of my native country"[9] while contemplating an uncertain future. He had just returned to Canada after two years in Europe, and the bright, Impressionistic paintings he brought home were generating only scorn and indifference among the Montreal art dealers. *The Edge of the Maple Wood* was one of the first canvases he painted in Canada, and the first in which he attempted to apply his European art training to the Canadian landscape.[10]

The Edge of the Maple Wood, 1910. Painted outdoors on a bright spring day in rural Quebec, this quiet, unassuming canvas sparked a revolution in Canadian art.

Oil on canvas, 54.6 x 65.4 cm. © National Gallery of Canada, Ottawa. Courtesy of the estate of the late Dr. Naomi Jackson Groves.

Had Jackson not painted *The Edge of the Maple Wood*, or destroyed it before it could be exhibited (a habit the highly self-critical artist retained throughout his life), he most likely would have moved to the United States and never have come into contact with the future members of the Group of Seven at that crucial point in their history. He would not have discovered those kindred spirits in Toronto who were also struggling to promote their own modern work against the overwhelming opposition posed by old-fashioned tastes and conservative art critics. There may very well have been a Group of Seven without Jackson, but it certainly would not have been the outspoken, aggressive Group that blazed its way into the Canadian consciousness throughout the inter-war period and well beyond. And given Jackson's eventual role of leader and promoter within this country's art circles — built largely upon the reputation he established with the Group — the aura surrounding this one simple canvas outshines all others in public galleries across the country. Many myths and legends about the Group of Seven have sprung up through the years, some of which were even deliberately perpetuated by Jackson himself, but the importance of *The Edge of the Maple Wood* in our nation's history is no exaggeration. Without it, the course of Canadian art would have been quite different.

Of the eleven artists associated with the Group of Seven, it was Jackson alone who remained closely devoted to the Group's original doctrine of painting this country in a bold, inventive way that was uniquely Canadian. Through the fortunate circumstances of good health and a self-imposed frugal lifestyle, he was able to devote his entire life to painting and promoting Canadian art. In doing so, as Lismer wrote in the exhibition catalogue, "A.Y. Jackson, by his personality and achievements, has brought new and lasting experiences to others, prestige and honour to his country."

After the exhibition's opening reception, Jackson's closest friends and fellow members of the Canadian Group of Painters accompanied him back to his home in the Studio Building on Severn Street, where they entertained the governor general at a party that continued long into the night.

"To be the centre of such a demonstration seemed the happy culmination of my life's work," Jackson later wrote of that monumental evening in 1953.[11] He might now be in his seventies, but he showed no signs of slowing down.

The young woman in the raincoat outside the Art Gallery of Toronto earlier that evening could not have been more wrong. A.Y. Jackson was far from dead — in fact, he still had twenty years and many painting adventures ahead of him.

2

ROOTS IN UPPER AND LOWER CANADA

FOR YOUNG ALEX JACKSON, NINE YEARS of genteel comfort came to an abrupt end one terrible day in 1891. It began much like any other day, with a full regimen of grammar, spelling, and arithmetic at school, then a leisurely walk home along Montreal's Sainte-Catherine Street. Horse-drawn wagons rushed by as he made his way past the storefronts, offices, and the occasional cottage set back from the road behind a white picket fence.

But as he approached the corner of Fort Street, he realized there was a crowd of neighbours gathered in front of his house. Alarmed, he quickened his pace. He pushed his way through the people on the sidewalk and rushed inside to find that all the lights had been turned on — a rarity in the afternoon. A solemn-faced man stood in the foyer, holding a clipboard. Another was in the dining room, counting out pieces of silverware.

Alex found his mother in the kitchen, surrounded by his younger brother and two sisters. A couple of sympathetic neighbours were comforting her, but she was in tears. Had somebody died? What was going on? Someone explained to him that the men in the house were bailiffs. They had come to collect the family's possessions because Alex's father owed a lot of money to the bank and could not pay it back. To make matters worse, his father was gone. The story spreading through the neighbourhood was that Henry Jackson had abandoned his wife and children and had fled to Chicago. Now, at age forty-one, Georgina Jackson was left with no income and six children to raise on her own.

The young family was humiliated. Their financial collapse and public shame on Fort Street marked the crashing end of a success story that had begun half a century earlier.

A Gentleman of the Railway

Until the Victoria Bridge was completed in 1859, there was no way for trains to reach the island of Montreal. Passengers, freight, and livestock all had to be ferried back and forth across the St. Lawrence River from the busy railway terminus at Longueuil. As a result, the south-shore towns of Longueuil and Boucherville grew and prospered throughout the first half of the nineteenth century.

Living alongside third- and fourth-generation French Canadians in these communities were many new arrivals from Europe, all eager to prosper in Lower Canada's bustling commercial centre just across the river. It is commonly believed that the European artist Cornelius Krieghoff settled in the area in the 1840s.[1] During this period he established himself as a painter of exceptional ability, producing cheerful images of French-Canadian

families, Natives, and lively outdoor activities that have survived as a valuable, if sometimes overly idealized, visual account of rural life in nineteenth-century Quebec.

One of Krieghoff's best-known canvases, *The Ice Bridge at Longueuil*, is a winter landscape that depicts the meeting of two horse-drawn vehicles on the shore of a frozen St. Lawrence River. Soon after it was painted in 1848, it found its way into the possession of a local resident, a young English railway employee named Henry Fletcher Joseph Jackson. Exactly how well H.F.J. Jackson and Krieghoff knew each other has never been determined, but it is certain that they were acquainted. *The Ice Bridge at Longueuil* — now hanging in the National Gallery of Canada under the title *The Ice Bridge at Longue-Pointe*[2] — is one of several Krieghoff paintings H.F.J. Jackson is known to have obtained from the artist.[3]

H.F.J. Jackson, whose interest in art would be passed on to his grandson, was born in London, England, in 1820. After receiving a considerable portion of his education in Switzerland, he moved to Canada in 1846 and settled at Longueuil. There he found work as an agent with the St. Lawrence and Atlantic Railroad, an early line running between Montreal and Maine. He spoke French fluently, thanks to his Swiss education, which enabled him to rise quickly to the position of traffic superintendent. In 1849 he married Isabella Murphy, whose father had come over from Ireland thirty years earlier. The Murphys owned one of Montreal's most prominent dry goods and linen retail businesses.[4] The large store on McGill Street advertised "ready made clothing, cloths, cassimeres, dry goods &c., for sale very low for cash."[5] The Jacksons' first son, Henry Allen, was born a year later, in 1850, followed by a daughter, Fanny Elizabeth, in 1851. Another son, christened Samuel, died in infancy.

H.F.J. Jackson was certainly comfortable, though by no means wealthy compared to the fur trade barons, bankers, and transportation tycoons who were by then building grand, imposing mansions in what would eventually become known as Montreal's Square Mile neighbourhood. He owned property on Saint Paul Street in Montreal,[6] but from all accounts remained living in Longueuil until he was offered a contract to build a section of the Grand Trunk Railway through Waterloo County in western Ontario. He moved his young family out to Berlin (now Kitchener) in 1854, where he not only built a railway line from Breslau to Berlin but also got into the insurance business as a co-founder and first president of the Economical Fire Insurance Company. Within a short period he became one of Berlin's most prominent and respected citizens.[7]

Prosperity brought more children to the Jackson fold. Between 1858 and 1864 came a second Samuel, then Alexander, Isabella, and Geneva.[8]

The Youngs of Galt

But while H.F.J. Jackson had built a lucrative career for himself in Canada, the same could not be said for fellow immigrant Alexander Young, a schoolmaster living several kilometres down the road in the town of Galt. Young was born in 1821 in the town of Kelso in Roxborough, Scotland, and had arrived in Dumfries Township, Upper Canada, at the age of thirteen. He taught school in Galt, St. Thomas, and Berlin, eventually becoming

principal of the Berlin Central School. His wife, Anne Keachie, was from a family whose roots in the New World dated back to before the American Revolution, when her ancestors arrived from Scotland. She was born near Paris, Upper Canada, in 1829. The couple's daughter, Eliza Georgina Young, was born in Galt in 1850.[9]

Alexander Young's life seems to have been one of constant financial struggle. The monthly salary of a schoolmaster was approximately forty dollars — barely adequate to support a family, even in the 1850s. According to family legend, he tried his hand at business just once — by putting his hard-earned savings into a St. Thomas flax mill. The local farmers did not grow flax, so the mill soon failed and he lost his investment.[10] But despite his lack of talent for earning money, Alexander Young was remembered most for his intellect — a quality on which very little value was placed in a farming community. He had a great love of the outdoors, particularly of hunting and fishing, for which he made his own rods and flies.[11] As an amateur entomologist, he gathered a formidable collection of insect specimens, acknowledged by some as the most complete in Canada.[12]

A.Y. Jackson's interest in art may have come from his grandfather Jackson, but his lifelong passion for the outdoors was most likely inherited from his grandfather Young.

When Henry Jackson, son of the successful H.F.J. Jackson, courted and married Georgina Young, daughter of a local school principal, the groom's family believed the bride was very fortunate to be taking this considerable step up in Berlin society.[13] After all, Henry was not only a bright, cultured young gentleman who played the violin and cello, he was also a hard-working, devout Anglican who aspired to a career in the clergy. The wedding took place in 1871 in Berlin, but it soon became evident that Georgina, a Presbyterian by birth,[14] was not to be the wife of an Anglican minister. Instead, H.F.J. Jackson was pushing his son toward a much more lucrative career in business.

Back to Montreal

Although it is not known precisely why after twenty years H.F.J. Jackson decided to leave Berlin, it seems likely that he was lured back to Montreal in 1876 by the many more business opportunities to be found in Canada's largest city and booming commercial centre. Montreal at this time was growing at a rapid pace, especially now that it had the Victoria Bridge to connect it with the mainland and, from there, the entire continent. Now the railways ran right into the heart of the city, criss-crossing their way through an ever expanding port area and stretching out in all directions as more and more people from Europe and the outlaying rural areas flocked to the big city to seek their fortunes. With more people came opportunities for more business, and the wheels of the city's economy were spinning rapidly.

But culturally, Montreal lagged far behind the great cities of Europe. Despite the intellectual progressiveness of such venerable institutions as McGill University, where eighteen-year-old Samuel Jackson enrolled as a law student, tastes in literature and the visual arts among Montrealers were decidedly conservative. Collecting art was an activity restricted to the rich, and their preferences remained rooted in the traditional schools of European painting. The works of seventeenth- and eighteenth-century Dutch artists were

prized above all, and their distinctively quiet, dun-coloured landscapes depicting grazing cattle, windmills, and canals could be found hanging in the salons of Montreal's wealthiest families. A close second in popularity was the work of contemporary Dutch painters who mimicked the dark style of their predecessors. The groundbreaking work of the Impressionists was being exhibited — and hotly debated — in France during the mid-1870s, but none of that enthusiasm seemed to have reached Montreal collectors. They continued buying large, dark Dutch landscapes, which were invariably placed under glass in heavy frames and displayed beneath a small spotlight.

One man, however, was just beginning to cultivate a reputation as Montreal's most progressive and radical art collector. William Cornelius Van Horne, the wealthy railway tycoon and amateur painter whose mansion on Sherbrooke Street would eventually be home to dozens of nineteenth-century French paintings, acquired his first canvas in 1871.[15] This led to the acquisition of works by Eugène Delacroix, Honoré Daumier, and Théodore Rousseau — and before the turn of the century the Van Horne Collection would contain works by Paul Cézanne and Henri de Toulouse-Lautrec.[16] Van Horne's pioneering interest in art was not only infectious, it would also change the course of painting in Canada. Among the friends and neighbours who admired his collection was textile merchant David Morrice, who had built a mansion on nearby Redpath Street and whose son James would take up brush and palette in the 1880s and later become a major inspiration to A.Y. Jackson and many other young Montreal painters.

A Square Peg in a Round Hole

No doubt encouraged by the prevailing climate of economic prosperity, Henry and Georgina Jackson followed the rest of the family back to Montreal and settled into a house at 51 City Councillors Street. Henry and his father set up the accounting firm of Jackson and Jackson, which seems to have been contracted exclusively to the City and District Savings Bank and which had an office in the bank's building on Saint James Street. That venture eventually led to the establishment of the curiously titled firm of Jackson Brothers, leather merchants, which stayed open on Saint-Paul Street for several years, even after H.F.J. Jackson retired to Brockville, Ontario, in 1880.

But despite all appearances, Henry Jackson was no businessman. He somehow lacked that inherent business savvy essential for any successful entrepreneur. Undaunted, he continued to engage in a wide variety of short-lived ventures as children began to arrive. Georgina gave birth to their first son, Henry Alexander Carmichael (immediately dubbed Harry), in 1877. He was followed by Ernest Samuel in 1880.[17]

In early 1882, the growing Jackson family moved into a spacious, three-storey townhouse at 43 Mackay Street. The big house, since demolished to make way for a parking lot, stood on the east side of the street, between Sainte-Catherine Street to the north and Dorchester Street to the south. Mackay is now a busy urban thoroughfare, part of bustling downtown Montreal, but in the 1870s and '80s it was almost entirely residential — a quiet avenue with white picket fences and neat rows of grand, greystone buildings with stained glass windows and outdoor staircases that descended to wooden sidewalks. There

were also plenty of large old shade trees along the street, some of which A.Y. Jackson would remember throughout his life and point out to friends whenever he happened to pass through the old neighbourhood.[18]

Mackay Street was part of a respectable, middle-class enclave, populated by the families of bank clerks, bookkeepers, merchants, and commercial travellers.[19] The family of Henry Jackson, the up-and-coming young businessman, appeared to fit right into this genteel social environment. But even a more affluent address could not help Henry's faltering businesses. Aside from his brief careers as leather merchant and accountant, he was, in the space of about a decade, the publisher of a small newspaper called the *Dominion Grocer*, the proprietor of a factory that manufactured shoemaking equipment, and a real estate, financial, and insurance agent working out of an expensive office in the Temple Building on Saint James Street, in the city's financial district. [20]

Into this cycle of optimism and failure, the Jacksons' third son, christened Alexander Young, was born at the family home on Mackay Street on October 3, 1882. He would always claim to be named after his maternal grandfather, the educator and naturalist. Georgina's father had died a year earlier, virtually penniless, after holding a brief, undistinguished post with the Ontario government as an inspector of weights and measures.[21] But Henry's younger brother Alexander had also died in 1881, so the name was perhaps doubly significant.[22]

An ancient family photograph of young Alex, as described eight decades later by his niece, suggests that his personality was already very much in evidence: "Even at the advanced age of three, photographed in an immaculate white linen dress with scalloped embroidered edges and a wide tartan sash, shod in high button boots, and with silky fair hair curling down to his shoulders, A.Y. wears a really tough expression on his square chubby face. He has probably just finished telling the photographer what he thinks of his old-fashioned ways."[23]

Alex and his two older brothers had to be tough, for there was real trouble ahead.

All of Henry's enterprises were financed by his successful father — but even H.F.J. Jackson's patience and goodwill had their limits. A discouraged Henry began spending more and more time away from home, but not in the office. Instead of meeting with potential clients, he could usually be found at a church function or lodge meeting. In the evenings, when it was too late to go back to the office, Henry came alive — he eagerly produced his violin and cello and joined a few of his friends in a small amateur ensemble that played light classical pieces and lively versions of contemporary standards. Sometimes, much to Georgina's dismay, Henry's musician friends turned up at the door and set up in the large front room for musical evenings that attracted an audience of neighbours and delighted the children, whose bedtime would be postponed thanks to all the excitement.[24]

As Henry's string of businesses continued to falter, he was forced to reduce expenses. In 1887, when Alex was four, the family moved to a much smaller, two-storey house at 75 Fort Street, on the corner of busy Sainte-Catherine Street. Though just a few blocks west of Mackay Street, it was a noticeable comedown from the big townhouse.

Despite the reduced living space, the Jackson family continued to grow. A daughter, Isobel (known as Belle), had been born in 1885, and after the move came the arrival of William Hespeler (Bill) in 1888 and Catherine (later known as Katie or Kay) in 1890.[25] Bill

and Alex took to spending their Saturdays on long hikes through forests and fields, or along the dirt roads that led west across the island, past the town of Lachine.[44] In pleasant weather, they could pack a lunch and hike as far as Sainte-Anne-de-Bellevue, the distant town Alex had reached the day he borrowed Ernest's bike for that memorable "one ride." Along the way were plenty of old barns, snake fences, grand old trees, and rushing streams — a seemingly endless array of subjects waiting to be drawn. These marathon hikes not only instilled in the Jackson brothers an appreciation for the natural landscape but also built up Alex's endurance for covering long distances on sketching expeditions. Throughout his life — even in his seventies — he would think nothing of walking forty kilometres at a time, often weighed down by camping equipment and his painting materials.

Montreal's waterfront, a few kilometres east of Saint-Henri, was also a favourite haunt. The bustling harbour of Canada's main seaport offered the brothers an opportunity to sit and sketch the crowded docks and the wide variety of vessels that converged on the port from around the world. The tall masts, riggings, and sails that dominated the harbour when their grandfather H.F.J. Jackson arrived fifty years earlier had now been replaced by towering smokestacks. As viewed through a thick screen of smoke and steam, the many cranes, railway boxcars, and mountains of cargo provided an ever changing series of compositions for the amateur artists, and inspired them to develop their skills even further.

3

AN APPRENTICESHIP IN THE ARTS

IN 1895 IT WAS NOT UNCOMMON TO SEE children working full-time in a wide variety of unskilled occupations, from stable hands to delivery boys. Even large companies took on pre-teenagers to clean offices, keep the coal- or woodstoves full, or run errands. The economy of the day favoured practical apprenticeship over good grades, so a high school education was nowhere near as essential as it is today. For the youth of Saint-Henri, learning a practical trade was considered the safest route to a secure future.

In the Jackson household, bringing in money was still a high priority four years after they were abandoned by their father. Harry, now eighteen, was employed full-time as a commercial artist, and Ernest, seventeen, was working in the office of an insurance firm. At twelve, Alex was also yearning to be free of school; he wanted to get out in the world and contribute to the family coffers. A bright student, he seemed well qualified to succeed in the business world, despite a confessed weakness in mathematics. To be certain, Georgina took him to a phrenologist, who, after carefully examining the contours of the boy's skull, pronounced him best suited for a career in law.[1] A spot in an insurance firm — likely arranged through Ernest — was promised him for when he was a bit older, but Alex was too restless to wait. He bade farewell to Prince Albert Public School and found himself regular employment as an office boy at the Bishop Engraving and Printing Company, a lithography firm that designed labels and logos for a wide variety of commercial products, from beer bottles and canned goods to cigar bands.[2] The offices at 169 Saint James Street were a considerable distance from Saint-Henri for a twelve-year-old to travel each day, but he was punctual and diligent, which no doubt caught the attention of his employer, George Trenholme Bishop.

At first, the job was far from glamorous. Alex's main occupation seems to have been delivery boy — running errands through the streets of what is now known as Old Montreal. He was conscious that this menial position was not likely to lead anywhere, and the salary of less than two dollars per week was not making a significant impact on the family's financial situation.[3] In his idle moments between deliveries, he often lingered in the art department, watching the designers and lithographers conceive and produce commercial images for the company's clients. Other times he sat in a corner with pen and paper, practising his drawing. "I used to make copies of Henri Julien's drawings in the *Montreal Star*," he recalled. "I used to copy these things when I wasn't running messages, and one day the boss saw me and liked my drawings, so I moved to the art department."[4]

That promotion proved to be the first step in his career, for it placed him under the supervision of his earliest mentor, lithographer Arthur Nantel.[5] He was now working as a professional artist, albeit in a strictly supportive capacity, but the work was anything but artistic. Producing labels for cornmeal and barrels did little to stir the creative imagina-

tion, but the friendship he developed with Nantel would lead him further toward discovering the more advanced theories of the fine arts.[6] The self-educated Nantel was a member of the free library at the Fraser Institute, where he read everything he could — philosophy, biography, history, and fiction — and encouraged his young assistant to do the same. He recommended books, which the two could discuss while working on their designs.

Throughout his teenage years, as soon as he finished work, Alex would often head straight for the Fraser Institute on Dorchester Street, where he spent hours immersed in the pages of books recommended by Nantel.[7] The Fraser Institute also had several art books — a rare commodity in those days — so he was able to acquaint himself with traditional European art, from classical Greek sculpture through the Renaissance to the theories of Victorian critic John Ruskin, whose book *Modern Painters* had provided many a student with an excellent introduction to the world of paint, brush, and canvas.[8] Ruskin's words, along with the reproduced images, were so inspiring, he later recalled, that they stirred within him "the first beginning of when I ever thought of being an artist."[9]

Learning the Landscape

The Jacksons remained devout Anglicans, which meant Sundays were strictly reserved for church services and observing the Sabbath.[10] But, weather permitting, Alex still spent most Saturdays on long, cross-country hikes with Harry.[11] Both were now working in the arts, as Harry was firmly established as a commercial artist/designer, a vocation he would continue to pursue until his retirement in the mid-1940s.[12] The hikes were now full-fledged sketching trips, with the brothers working in watercolour as they transposed nature onto paper, always striving to improve their technique. The aim was to render their subjects as realistically as possible.

"Lacking money even to hire a bicycle or a broken-down cart horse, we tramped all over the countryside around Montreal sketching everything that took our fancy," Jackson recalled. "We slept in barns and haymows, even under bushes. We were great walkers … Fifty miles a day was common for us. My best effort was the day I covered 62 miles alone, from dawn to dusk. That took me from Montreal out to beyond Saint Eustache and around in a great circle. It was hard on boots but great for the health."[13]

Over the next few years they would hike out across the Victoria Bridge, becoming familiar with the farmland and rustic villages on the other side of the St. Lawrence River. During the week, exhibitions at local art galleries and the front windows of dealers gave them an opportunity to inspect canvases by professional artists. Among the paintings they especially admired was *The Stream in Autumn* by American watercolourist George Howell Gay, "so wonderful you could count the dead leaves."[14]

As a painter, Alex Jackson chose his professional identity at an early age. Watercolours produced when he was just nineteen were signed "A.Y. Jackson," and for the rest of his life he would be known publicly by his initials. To family and friends he answered to both Alex and Alec; to his male chums he was commonly known as Jackie (a familiar contraction of Jackson); but as an artist he would always be A.Y.

Few Jackson watercolours from this early period have survived. Those that have, such

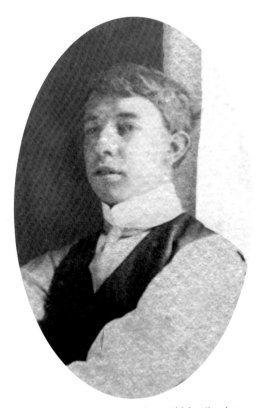

Alex Jackson as a teenager, in an old family photo from the late 1890s.

Early Spring, Hemmingford, 1905. Jackson had friends in Hemmingford, Quebec, near the American border. He thought nothing of walking an entire day to visit them.
Watercolour on paper, 28.3 x 39.1 cm. Art Gallery of Ontario, Toronto, gift of A.Y. Jackson, 1941. Courtesy of the estate of the late Dr. Naomi Jackson Groves.

as *River St. Pierre, Montreal* from October 1902 — the earliest work included in his 1953 retrospective exhibition — show a complete adherence to realism and a well-developed technique. This is hardly surprising, for during his late teenage years he had taken the first bold steps in becoming a legitimate artist, supplementing his daily commercial work with night courses under instructor Edmond Dyonnet at Montreal's Monument National.[15] Four nights a week, he dutifully took his place at an easel in Dyonnet's classroom to learn the rudiments of painting from the conservative teacher who for many years would serve as secretary of the Royal Canadian Academy. Here he learned the proper way to mix colours, how to stretch and prime a canvas, and the basic rules of composition.

There is no question that Jackson was in the right place for anyone who aspired to a career in the arts. Dyonnet was certainly a valuable connection, one who could open doors for anyone he deemed worthy, and Jackson's success at the Monument National led to his enrolling in a painting class held under the auspices of the Royal Canadian Academy at the Art Association of Montreal's headquarters on Phillips Square, where his teacher was the Scottish-born William Brymner.[16]

While Brymner is now remembered more as an influential art teacher and an early mentor to dozens of Montreal painters who would rise to prominence in the post–First World War period, he was also a painter of great skill and grace. Much of his work from the 1880s and '90s clearly demonstrates a mastery of Impressionist techniques, but he never ventured too far from the conventional standards. His subject matter and overall style were deeply rooted in the Barbizon tradition, as seen in his canvases *A Wreath of Flowers* from 1884, now in the National Gallery of Canada, and **Le Champ-de-Mars en hiver** from 1892, now in the Montreal Museum of Fine Arts. But his early support for new ideas coming from Europe was most valuable: "While his students plunged into impressionism, he neither lost interest nor sympathy, and had it not been for his fearless attitude, it would hardly have been possible to have exhibited modern work in Montreal."[17]

Jackson was never impressed with Brymner's talents, but the man himself left a great impression on the young artist. Brymner was a gruff, no-nonsense teacher who did not believe in freely lavishing praise on students' work. As a result, a few complimentary words from Brymner were considered a major triumph for many young painters. "Of all the artists I knew as a student, there was no one I admired more," Jackson wrote of Brymner. "He was not a very good painter, but he was a great individual, much respected by James Morrice and Maurice Cullen, and the young artists in Montreal."[18]

It was probably through Brymner that Jackson and his fellow students became aware of the exciting work being produced by Morrice and Cullen — the two Montrealers whose Post-Impressionist landscapes stood out from the dull Dutch or Barbizon canvases found throughout the city. If Brymner was not considered a trailblazer, his friends Morrice and Cullen were hailed as radical heroes by the young painters of Montreal. They had had the courage to break with tradition and paint bold, colourful canvases that caught the eye and engaged the imagination while students were still being taught the formal, old-fashioned theories promoted by the Royal Canadian Academy. "Morrice and Cullen opened our eyes to things no one ever thought of painting," Jackson wrote. "They delivered us young artists in Montreal from the stodgy Dutch painting that dominated the market, and made us aware of the great development going on in Europe."[19]

But the plight faced by both Cullen and Morrice served as a warning to Jackson. They were producing wonderful, inspiring paintings, but they still had difficulty finding a market for them. Morrice, born to a wealthy Montreal family in 1865, had been living as an expatriate in Paris since 1892, where his wide circle of friends included not only artists such as James McNeill Whistler, Robert Henri, and Henri Matisse, but also the writers Somerset Maugham and Arnold Bennett, both of whom used Morrice as a model for characters in their novels — Warren and Cronshaw, respectively, in Maugham's *The Magician* and *Of Human Bondage*, and Priam Farll in Bennett's *Buried Alive*.[20] Morrice frequently returned to Canada, sketching with Brymner and Cullen in rural Quebec, but the lack of widespread acceptance of modern art in his native land prevented him from moving back permanently.

The Newfoundland-born Cullen, a year younger than Morrice, had also lived and studied in Europe, but he painted extensively in Quebec throughout his life and, like Brymner, was a respected teacher in Montreal. His sales were also few and far between; in fact, Jackson would later recall an exhibition of Cullen's European canvases at the Fraser Institute, which yielded no sales at all. Determined to sell them, Cullen put one hundred of his works up for auction and sold them all for a lump sum of eight hundred dollars — a lot of money at the time, but still a mere eight dollars per canvas.[21]

Back Up the Hill

It was more than a decade before Georgina Jackson and her family had fully recovered from their devastating financial setback of 1891. By the turn of the century, most of her children were young adults and had been working for several years. Poverty had gradually been replaced by comfortable circumstances, which by 1904 allowed a move from working-class Saint-Henri to a spacious, two-storey duplex at 69 Hallowell Avenue — shouting distance from their Park Avenue flat, but symbolically a few rungs higher on the social ladder. They moved up the hill, over the railway tracks, and into the affluent suburb of Westmount. The new house was just a five-minute walk along the tracks from the Canadian Pacific Railway station, convenient for the twenty-one-year-old artist, who was now venturing further and further away from home on his sketching trips.

Jackson had spent most of the summer of 1902 in Nova Scotia with a fellow lithographer named Billy Ives, whose father worked for a coal company on Cape Breton Island. They travelled by boat to Pictou, and roamed the region on their bicycles, making watercolour sketches of the hilly, rugged landscape and seacoast. Establishing a habit he would retain for many years, Jackson often gave away one of his sketches to a farmer in exchange for a night's lodgings.[22] The Cape Breton adventure was memorable for Jackson not only as the first time he had travelled so far from home but also as the first of many times throughout his life when his shyness with women prevented a possible relationship. "There was a girl down there I kind of liked, but of course I never spoke to her about it," he recalled more than sixty years afterward. "She died a couple of years later. I can still remember her name — it was Margaret."[23]

The following summer, Jackson made the first of several sketching trips to Danville,

Quebec, a picturesque farming community on the Nicolet River, a day's hike east of Montreal. Harry had been out there the previous summer, visiting friends of the family while Alex was in Nova Scotia. During this trip Harry had met the Morrells — a hearty clan of homesteaders who had been settled in the region for many years.[24] The rolling hills, barns, and the local covered bridge provided ample subject matter for Harry, whose paintings and enthusiasm prompted his younger brother to head out that way the next year.

Alex Jackson made an impression on the local folk, not only as an artist but also as an outgoing character with a penchant for adventure. On one outing, he and the Morrells' grandson, Lindsay Evans, came upon the deserted McDevitt house, a crumbling homestead near the Grand Trunk tracks, where rail-riding tramps often sought shelter. Despite young Evans's nervous warnings that the place was reputed to be haunted, Jackson rushed inside and explored the dark, damp interior. Finding nothing more than traces of bedding and piles of straw in the corners, he pulled a piece of chalk from his pocket and added to the graffiti on the walls by drawing comic directional signs. One pointed the way to a hot dog stand upstairs; others read, "Two beds with feather mattresses to the left" and "Gentlemen to the right, bums to the left."[25]

Another sketching trip along the Nicolet River ended with Jackson and Evans deciding to straddle logs bound for the local mill and riding them downstream. But the river was swollen from a recent rain, and the rapids were much stronger than they expected. Clinging to their logs, the two were carried away by the swift water, swept under the covered bridge, and came ashore far past their intended destination. Getting back to where they had left their clothes and Jackson's sketching materials proved to be equally harrowing, for the riverbank was thick with mosquitoes and blackflies.[26] As Evans later recalled, "When we reached our clothes we were in agony so we just sort of hung our clothes on us and made it up the hill. When Alex pushed the rolling door back in the wood shed, Grandma had just finished churning butter. She took one look at us and ordered us to drop our clothes and she went all over our bodies with buttermilk. We were badly poisoned and swollen and spent most of the night in a chair."[27]

Jackson found time to participate in outdoor activities and attend various social functions while staying in Danville. In 1904 he once again found himself smitten with a girl — this one was apparently one of three sisters named Telfer who were visiting from New Jersey. The extent of their relationship is not known, but Jackson did manage to acquire a photo of the young woman and brag about a certain "dazzling damsel" in a letter to brother Ernest.[28]

In April 1905, a friend invited Jackson out to sketch in Hemmingford, Quebec, near the New York border. "I walked out one day to investigate it," is how casually he later described the journey, a clear example of how he thought nothing of covering fifty kilometres on foot in a single day.[29]

In Hemmingford, he found ideal sketching conditions — rugged farmland with plenty of trees and log fences, scattered with boulders and patches of snow. His best-known work from this trip, the watercolour *Early Spring, Hemmingford*, contains those very elements. Springtime in Quebec, with its bare trees and melting snow, was a subject he would return to nearly every year for the rest of his working life.

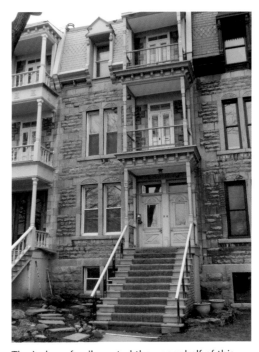

The Jackson family rented the upper half of this duplex at 69 Hallowell Street in Westmount from 1904 to 1922. This was A.Y.'s home base until he moved to Toronto in 1919.
Collection of the author.

Over the Atlantic

Second-hand stories about Europe and its thriving art scene were one thing, but seeing it all first-hand was something altogether different. Inspired by the very few Impressionist canvases they had seen in Montreal, Harry and Alex saved enough money from their commercial art jobs — about a hundred dollars each — to take a trip to Europe in the summer of 1905.[30] To stretch their budget even further, they worked their way across the Atlantic, signing on as deckhands on the *Devona,* a barge carrying four hundred head of cattle from Montreal to London. In exchange for their services, they were promised five shillings and free passage home on the return trip.

The two-week crossing, as Jackson recalled, was a rough one. The brothers worked all day long, pitching hay and shovelling manure in cramped quarters while "the Atlantic and our environment combined to test our stomachs."[31] They were filthy and exhausted at the end of the first day, only to find that their sleeping accommodations would be a pigpen above the propeller. To make matters worse, they were never paid their five shillings when they docked in London — but that was the least of their problems.[32] "We were lucky to have advance knowledge of a petty racket the ship owners were running," Jackson recalled. "They would guarantee a boy a return trip and leave him to believe he would have time in Europe for a look-around. But once you got there you found that your return sailing was in two days. You had the choice of going home immediately or of paying your own way when you were ready. We had saved up $100 each and were ready, if necessary, to follow the latter course. It turned out to be necessary."[33]

Set loose in London, the Jackson brothers made the best of their time. It is unclear whether they looked up any of their English relatives at this time, but it is certain that they crammed in as much sightseeing as they could during their brief stay. The famous canvases of Turner and Constable were there for close inspection, as were Buckingham Palace, Westminster Abbey, the Tower of London, and all the other famous landmarks they had grown up hearing about. After about two weeks they crossed the English Channel and went on to Paris — the art capital of Europe. Soon they were face to face with the Impressionist canvases of Claude Monet, Pierre-Auguste Renoir, Alfred Sisley, Camille Pissarro, and Paul Cézanne — names they had obviously read much about but whose paintings they would only have seen at an occasional exhibition organized by the Art Association of Montreal or at one of the few small galleries that supported Morrice and Cullen. Aside from that, the only other modern paintings they would have seen in Montreal came in the form of crude black and white photographs published in magazines or newspapers — and that could never do justice to the blazing colours of Impressionism.

A small group of Montreal artists and former Brymner students — Clarence Gagnon, Henri Hébert, William H. Clapp, and Edward Boyd — were sharing an apartment in Montparnasse at this time.[34] The Jackson brothers dropped in on them, and their trips to the local galleries no doubt took on a lively dimension, filled with loud discussions and good-natured arguments over the merits of certain canvases. Gagnon, Clapp, and the others were studying at the prestigious Académie Julian, which seemed to be obligatory for anyone who aspired to a career as an artist — and that was exactly what this month-long trip to Europe did for Jackson. From Brussels and Antwerp to Rotterdam, Alex and Harry

took in as much as their budget would allow. After visiting the world's fair at Liège, they sailed for home. But by now Alex was convinced that his destiny lay firmly in the arts — and not just a quiet career as a commercial artist.

Back in Montreal, once again surrounded by the dull Dutch paintings so cherished by the collectors, Harry returned to his job as a designer, but his younger brother remained completely consumed by the Impressionist paintings he had seen in Paris. He couldn't wait to get back to France, where he would study at the Académie Julian — following in the footsteps of Morrice, Brymner, Gagnon, Clapp, Marc-Aurèle Suzor-Coté, and other Canadian artists whose work he admired. But an extended trip to France would cost a lot of money — so he resolved to save every penny he could, even working at two jobs whenever possible.

A Year in Chicago

Upon his return from Europe, Jackson's painting technique underwent a radical change. The trip had inspired him to make the jump from watercolour to oil — a change so permanent that for the rest of his life he would rarely work in watercolour again. Not surprisingly, his first few attempts in the new medium remained firmly rooted in the watercolour technique; the sketches he made at Danville in the summer of 1906 were done on paper in a transparent wash of oil and turpentine, and closely resemble watercolours.[35] This would all change in time, as Jackson became more familiar with the textures of oil and canvas.

The return to commercial artwork in Montreal was sheer drudgery compared to the exciting memories of Europe, but it was not long before Jackson was on the move again. After a few months of scrimping and saving his wages, he was put out of work. A prolonged printers' strike closed many Montreal lithography firms, so Jackson had to look elsewhere for an income. In September 1906 he set off for Chicago, where his father was still living.

Henry Jackson had not seen his son in fifteen years, and the two would dine together on Sundays — along with Henry's lawyer brother, Sam, whom Jackson had never met — but that seems to be the extent of their rekindled relationship.[36] It is unlikely that Henry was able to help his son find work in the commercial art field, as he was still relatively unsuccessful, working as a clerk in a firm that manufactured lodge regalia.[37] Jackson soon found work as a commercial designer at the Lammers-Schilling Company, where the wages were much higher than in Montreal, and he continued his education four evenings per week at the Art Institute of Chicago.[38]

Little is known about any landscape painting Jackson undertook while living in Chicago, if in fact he managed to do any serious painting at all. His stay there seems to have been devoted to hard work — designing by day and studying by night. He did, however, find enough free time to browse through the Chicago Art Gallery, where some canvases by his favourite Impressionists — Monet, Sisley, and Pissarro — were on permanent exhibit. Whereas he had seen the work of these artists only during rushed visits to galleries while in France, now he could study them at his leisure, returning day after day to

re-examine them if he wished. "They influenced me deeply and for the first time I saw what could be done with landscape," he wrote. "I got a glimpse of how the story of the land could be told with a deep individual feeling, with all the drama of an adventure story."[39]

By living frugally over the course of a year, Jackson managed to save no less than $1,500 — quite a substantial sum in those days, and more than enough to live well for two years in France.[40] He loved Chicago; the people were friendly and he gained valuable experience both as a designer and as a student, and he claimed he would very well have stayed there permanently if not for his unrelenting will to return to Europe.[41]

Jackson arrived back in Montreal with his savings in the summer of 1907, but he wouldn't be staying long — Paris was waiting.

4

ROAMING THE CONTINENT

"ALL RIGHT-MINDED MONTREAL ARTISTS aspired to go to Paris and most of them wanted to study at the Académie Julian."[1] This was how Jackson summed up the importance of one school to his generation of fellow students, particularly those under the influence of William Brymner. With that same goal still firmly in mind, he crossed the Atlantic on the steamship *Sardinian* and arrived in Paris on September 20, 1907, eager to begin his European training at the Académie Julian.[2]

It would be the happiest time of his life.

Situated in a former dance hall at 31 rue du Dragon, the Académie Julian was a beacon for aspiring artists from around the world. It had been established in 1873 by artist Rodolphe Julian, and was originally intended to prepare students for the more prestigious École des Beaux-Arts.[3] But as it grew in popularity, it evolved into a choice destination for foreign students who were attracted by its flexible rules. There were no entry requirements, its tuition was equivalent to about five Canadian dollars per month, and its studios remained open six days per week, from morning to night.

Julian's own skills as an artist were dubious; in fact, he was best known as a prize-fighter.[4] But he did have the sense to hire such well-known and respected artists as William Bouguereau as instructors.[5] However, the lack of rules quickly led to a lack of discipline among the students, and chaos often ensued in the crowded studios. "The noise at times was deafening," one student recalled. "Sometimes for a few minutes there was silence; then suddenly the men would burst into song. Songs of all kinds and all nations were sung … There was merciless chaff among the students and frequently practical jokes, some of them very cruel."[6]

To Jackson, it seemed that every important Canadian artist had received his education at the Académie Julian, including Brymner and Morrice years earlier — although, due to the cruel practical jokes, Morrice's stay was a short one. As a wealthy young Montrealer, he sometimes carried himself with an air of self-importance that made him a natural target for his fun-loving fellow students. One day in the early 1890s, as he perhaps a bit pompously took his place at his easel and prepared for the day's lesson, the student directly behind him pulled out a long baguette and, choosing his target carefully, brought the bread down squarely onto Morrice's prematurely bald head. The resulting explosion of laughter was too much for Morrice's pride. He quickly collected his things and stormed out of the Académie, never to return.[7]

Morrice remained one of Jackson's heroes throughout his life, but there is no evidence that the two ever met. They had many close friends and acquaintances in common, including Gagnon, Cullen, Brymner, and countless other artists and dealers in both

Montreal and Paris. They were in Paris at the same time, and Jackson would later visit several of Morrice's favourite painting spots in Brittany — but neither artist ever acknowledged knowing the other. This is curious, as Jackson normally made full use of his contacts and would certainly have made at least one pilgrimage to the legendary studio in a squalid riverside building at 45 Quai des Grands Augustins, where Morrice lived and worked for many years

As it happened, Jackson landed in the right place at the right time. In 1907, Paris — the very cradle of Impressionism — was still very much a thriving centre for the arts, both past and present. Cézanne had died the year before, but several other influential painters, including Monet, Renoir, and Degas, were still active. There was also a bold new spirit sweeping through the city — a loud, modern style that made the Impressionists seem quite tame by comparison. That summer, in his Montmartre studio, the Spanish artist Pablo Picasso had been working on a large, colourful canvas he called *Les Desmoiselles d'Avignon*. This bizarre brothel scene, with its grotesque images of distorted nude women, would eventually be hailed as the first major work of Modern art, and its young creator — just a year older than Jackson — would become the twentieth century's most famous artist.

But at the Académie Julian, the works of Picasso, Georges Braque, and all other new radicals were firmly rejected by Jackson's instructor, Jean-Paul Laurens. At age sixty-nine, Laurens was a contemporary of the Impressionist artists, but he was definitely not a part of their movement. He was not a famous painter, but he was respected by the French art establishment and his work hung in the Panthéon in Paris.[8] "Laurens had little encouragement for students who departed from established traditions," Jackson recalled. "He frowned on superficiality or slickness, as on any effort at self-expression that departed from realism. Neither Bouguereau nor Cézanne were approved of by Laurens."[9] Instead, Laurens was devoted to the traditional methods of painting and drawing. His own paintings, Jackson pointed out, were deeply influenced by the Renaissance and bore a close resemblance to the work of Michelangelo Caravaggio.[10]

Being taught the theories and technical values of three hundred years earlier does not seem to have bothered Jackson, nor did he mind the fact that most of the lessons consisted of drawing from the nude figure — a subject that held very little interest for him, for he was never anything but a landscape painter. A group photograph of his Académie class shows about forty-five young men posing in the high-ceilinged main classroom, the walls of which are covered by paintings of nude models; there is not a landscape in sight.

Instructor Jean-Paul Laurens's life class at the Académie Julian, Paris, in 1907. The ever-casual Alex Jackson can be seen in the back, leaning against the wall.

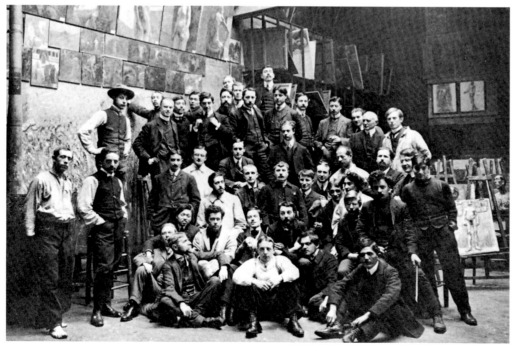

Laurens only taught for about ten minutes per week, but the instruction was not what attracted most of the students. "The training wasn't anything very much, but it was worth-while watching the other students work, and the standard was very high, too," Jackson later recalled.[11] Instead, the Académie Julian was a stimulating meeting place for students from around the world — including some from as far away as New Zealand and Japan — and it provided them all with a valuable forum to discuss new ideas. Jackson's class was filled with high-spirited young artists, most of whom were probably living away from home for the first time and eager to drink in all that the "City of Light" had to offer. Two of his closest friends at the Académie were New Zealanders Spencer Macky and Frederick Porter, with whom he shared lodgings at 13 rue de l'Abbé Grégoire, not far from the Luxembourg Gardens.[12] He described them as "serious students and good companions both."[13]

Living was cheap in France in those days; a good meal cost the equivalent of twenty-five cents, and six hundred dollars was more than enough to cover Jackson's expenses for a year — including room and board, art supplies, and tuition at the Académie.[14] The atmosphere was also stimulating. "France was a wonderful place in 1907," Jackson recalled. "You never thought about war; people were friendly. I don't think I was cheated out of a franc all the time I was over there. I think those were the happiest days of my life — when I was a student over in France."[15]

Back and Forth Across Europe

After working long days for six months at the Académie, Jackson and a few of his class-mates took a trip to Italy. They arrived for a ten-day stay in Rome on April 14, 1908,[16] and thanks to one of their friends — a young Scotsman who had lived there for several years — were expertly guided around the ancient city and shown its many art treasures.[17] From Rome they travelled on to Florence, world-renowned for its countless Renaissance paintings and sculptures. Few of Jackson's paintings from this period have survived; he did, however, make extensive use of his sketchbook, filling it with pencil studies of buildings, figures, and landscapes. As a result, dozens of his drawings from 1907–08 were preserved and are now in the National Gallery of Canada.

On May 1, the Académie Julian classmates arrived in Venice, where the canals and gondolas have attracted artists for hundreds of years — including Morrice, Cullen, and several of the Impressionists — and Jackson proved to be no exception. The colourful old buildings, the sunlight playing on the water, the striped poles — everything about Venice's Grand Canal begged to be put down on canvas. These vibrant Venetian images would remain with him for years, and he knew he had to return.

Later that month, Jackson and Macky decided against returning to the Académie. They had heard about Étaples, a town in Artois on the coast of the English Channel, which had become well known as a small artists' colony populated mainly by British and American painters. They thought they might pay it a visit before returning to Paris, but the atmosphere proved to be so positive that they ended up staying from about May 14 through to the end of the year.[18] As Jackson recalled, Étaples had everything for the artist—"studios, models and hotels, all at moderate prices, a fishing fleet, sand dunes, and a bathing beach

A Palace on the Grand Canal, Venice, 1913. Inspired by Morrice and Cullen, both of whom had visited Venice a few years earlier, Jackson's oil sketch captures the moving reflections on the canal. *Oil on wood panel, 21.5 x 26.3 cm. McMichael Canadian Art Collection, gift of Mr. S. Walter Stewart. 1968.8.9.*

at Paris Plage."[19] He also noted that although there had always been some animosity between the Britons and Americans, he and Macky, as a Canadian and New Zealander, respectively, were readily accepted as compatriots by both groups.[20]

The picturesque landscape of pine trees and sand dunes at Étaples particularly attracted Jackson. One foggy day he painted a canvas of the dunes, entitled *Paysage Embrumé* (*Misty Landscape*), which he submitted to the Paris Salon, where, no doubt to his complete surprise, it was accepted for exhibition. It did not win a medal — in fact, it attracted no attention aside from the briefest nominal mention in a small local newspaper — but Jackson knew that just being exhibited at the Paris Salon would help to further his reputation back home in Montreal.

After Étaples, Jackson's next prolonged stay in France was at Episy, a small town on the Canal du Loing, not far from the legendary Fontainebleau Forest, about sixty kilometres south of Paris. This was where artists had been coming to work for more than a century; the Barbizon school of painters, which preceded the Impressionists, took their name from a village in the Fontainebleau region. An American artist had told Jackson of the canal, lined with tall Picardy poplar trees, its barges pulled by mules. It was described as an ideal place to paint, and Jackson was intrigued. He arrived at Moret-sur-Loing with Frederick Porter in April 1909, and he immediately knew that the American had been right. He would stay in the vicinity for several months.

It is unclear if they ran into each other by chance or had previously arranged to meet, but Jackson and Porter met at Moret their Académie Julian classmate Randolph S. Hewton — a fellow Montrealer who would soon become one of Jackson's closest friends. Hewton was from Lachine, a town on the St. Lawrence River known to Alex and Harry Jackson from their early westward hikes across the island of Montreal. Hewton had also studied under Brymner at the Art Association of Montreal and had come to France with the same intentions as Jackson. But unlike Jackson and Porter, Hewton was still studying under Laurens and using this April school break to paint a series of canvases that he intended to send back to Montreal for the Art Association's Spring Exhibition the following year.[21]

Canal du Loing near Episy, 1909. The tree-lined canal and its mule-powered barges provided Jackson with the subject for one of his most successful early canvases.

Oil on canvas, 64.6 x 69.5 cm. © National Gallery of Canada, Ottawa, gift of Naomi Jackson Groves, Ottawa, 1979. Courtesy of the estate of the late Dr. Naomi Jackson Groves.

After six days in Moret, the artists moved on to Episy. There they found the same inviting painting conditions, but there was no place to stay. The village had no hotel, only a farming family named Goix whose constant struggle to save a franc or two prompted them to take in boarders. Jackson would always remember the farmer and his wife as two of the most memorable characters he ever encountered: the mischievous Monsieur Goix, whose only peace came in the few minutes each day when he could sneak away to the stable for a few gulps from a bottle of strong wine he kept hidden from his wife, and Madame Goix, who was known throughout the town as such a miser that she would often run out after a passing horse to scoop up its manure. "This was my first contact with people who lived so close to, and off the soil,"[22] Jackson later wrote of the couple's rustic lifestyle.

Inspired by their surroundings and fortified by Madame Goix's simple breakfast of cocoa and bread, the artists dutifully pursued their painting every day. At this time Jackson produced what is probably the best known of his French canvases, the shimmering *Canal du Loing near Episy* — a bright, freely brushed view of the canal, complete with long shadows and reflections of the poplars in the water, all rendered in the light palette of the Impressionists.

Jackson would remain in Episy, living in the Goix family's whitewashed stone farmhouse, for the entire spring of 1909. In June he returned to the rue de l'Abbé Grégoire apartment in Paris, for he had arranged to meet one of his aunts, Geneva Jackson, who was visiting Europe.[23] He then set off for Belgium at the beginning of July. Between sketches of the old buildings in Antwerp, he spent much of his time "sightseeing, sleeping in the park, and visiting the zoo."[24] A week later he was in Dordrecht, Holland, where his sketching was hindered by two annoyances — incessant rain and curious villagers. "The people are awfully inquisitive," he wrote home to his mother. "You couldn't sharpen a pencil without fifty of them milling round ... Managed to make a few sketches but nothing much, had to hold the umbrella up at the same time, which is no easy job."[25]

After moving on to Amsterdam, Jackson painted along the North Sea coast throughout the summer of 1909, staying in villages such as Katwijk and Veere.[26] But the serene setting of the Fontainebleau region lured him back, and he returned to Episy by the end of the summer. He would stay there, sketching along the Canal du Loing and the surrounding countryside, throughout the fall.

By mid-November, funds were running low. The $1,500 had lasted well over two years and had financed extensive travels through Europe, but now it was time to replenish the coffers. The only way to do that was to return to Montreal and find work. With great reluctance, Jackson bade farewell to his friends and sailed for Canada, arriving safely back home on Hallowell Avenue shortly before Christmas 1909.

An Impressionist in Canada

To his dismay, Jackson found that little had changed in Montreal during his absence; collectors and dealers were still convinced of the merits of old-fashioned Dutch art. "It was boasted in Montreal that more Dutch art was sold there than in any other city on this

St. Henry from Hallowell Ave., 1910. Jackson sketched this view of his old working-class neighbourhood from the family's new home in affluent Westmount. The Jacksons had lived across the street from the buildings with the blue rear sheds, next to the railway yard.
Oil on wood, 18.3 x 24 cm. © National Gallery of Canada, Ottawa. Courtesy of the estate of the late Dr. Naomi Jackson Groves.

continent," he later recalled with some bitterness. "Dutch pictures became a symbol of social position and wealth. It was also whispered that they were a sound investment. They collected them like cigaret cards. You had to complete your set. One would say to another, 'Oh, I see you have not a De Bock yet.' 'No — have you your Blommers?' The houses bulged with cows, old women peeling potatoes, and windmills."[27]

The many European canvases Jackson attempted to sell in Montreal, among them the striking *Canal du Loing*, received no interest among the conservative dealers. Even if they happened to like what they saw, they feared that Impressionist paintings would never

Montreal Harbour, 1910. The ships and locomotives working along Montreal's busy waterfront always pro-
vided interesting subject matter for an Impressionistic sketch.
*Oil on wood, 18.3 x 24 cm. © National Gallery of Canada, Ottawa. Courtesy of the estate of the late Dr. Naomi
Jackson Groves.*

find buyers. This placed Jackson firmly in the same dubious situation as his heroes, Morrice and Cullen, whose canvases had still found few buyers in Canada. Although this must have given him some satisfaction, for it only confirmed that his work was ahead of its time, the rejection must have stung him. But Jackson was never one to wallow in self-pity. Undaunted, he wrapped up many of his European canvases and gave them to family and friends as Christmas presents, while keeping a few for himself.[28] Harry and his wife, Coralie, received *Canal du Loing,* which would remain in the family for many years.[29]

Knowing that a return to commercial art was all but inevitable, Jackson kept painting through the winter of 1910, though he appears to have remained close to home. One of his oil sketches that survives from this period is *Saint Henry From Hallowell Ave. —* a sombre vista of his old neighbourhood painted from the Jackson home, probably while sitting out on the balcony or on the railway tracks that still run along the edge of the Montreal escarpment. Executed on panel in the broad, thick brushstrokes of Impressionism, *Saint Henry From Hallowell Ave.* depicts the back view of triplexes on Park Avenue, the houses directly across the street from the Jacksons' former home. Behind them, in the foreground, is the Canadian Pacific Railway yard, and in the distance, dominating the skyline, is the Saint-Henri Roman Catholic Church. Jackson probably chose this subject out of sheer sentiment — a backward glance at his difficult childhood in working-class Saint-Henri from the comfortable perspective of the much more affluent Westmount.

Another sketch that survives from this period is *Montreal Harbour,* a loosely brushed composition of steam, fog, ship, and locomotive — most likely the result of discussions in France regarding Monet's 1877 canvas *La Gare Saint-Lazare,* which featured billows of steam from a locomotive as an integral part of the overall composition. Jackson had painted the Montreal waterfront as a teenager; now he had returned, more experienced and completely sure of himself in both style and technique, to paint the same subject in the Impressionist manner.

These two sketches, among the first paintings Jackson undertook after his return from Europe, show a distinct progression from his earlier Quebec sketches; he was no longer concerned with achieving photographic accuracy in his work. He had learned that above all, a good painting of any style must show a strong sense of design.

By February 1910, Jackson had not yet committed himself to a commercial art job. Instead, he packed up his painting materials and headed for "the crisp air and sharp shadows" of Sweetsburg, a farming community near Cowansville, Quebec. [30]

He did not know it at the time, but the result of this trip would alter not only his life, but the entire course of Canadian art.

The Edge of the Maple Wood

Jackson's intention was to see if he could paint the Canadian landscape in the Impressionist style he had developed in Europe over the past two years, and he found in Sweetsburg the ideal landscape to suit his purposes. "It was good country to paint, with its snake fences and weathered barns, the pasture fields that had never been under the plough, the

boulders too big to remove, the ground all bumps and hollows,"[31] he wrote. Thus inspired, Jackson brought his canvases outdoors and worked diligently. One of the first paintings he produced was a view of an ancient, dilapidated barn, which he titled simply *Sweetsburg, Quebec*. The foreground is a messy mixture of snow, mud, puddles, and wagon tracks, rendered in thick brush strokes that reflect the rugged texture of the ground. Jackson used the Impressionist method of varying shades of white for the snow, having learned that snow is never completely white — it takes on the colours of the sun and sky. For the rest of his life, as a well-known painter of winter landscapes, he would never render snow in pure white.

As the winter's snow continued to disappear from the fields and hills of the Eastern Townships, Jackson's painting reflected the changing season. By late March the only remaining snow was hidden in the deepest shadows, under fences and boulders, away from the warm sun. It was time for Quebec's annual maple syrup harvest, and throughout the region farmers were hanging buckets on their maple trees to catch the running sap. The air in Sweetsburg was scented with smoke from wood fires when Jackson set up his easel in an old farmyard one bright day to paint the effects of sunlight playing on the spongy wet ground. With a weathered old grey barn in the distance — possibly the same one depicted in *Sweetsburg, Quebec* — and a log fence providing a sense of depth, he dabbed away at the canvas for several hours, using short brush strokes loaded with both bright and dark earth tones. Once he had covered the entire canvas, he mixed a few dark shades of greens and browns and gave the painting its most striking feature — shadows of trees behind the viewer that extend along the rocky, mushy terrain from the foreground, carrying the viewer's eye into the middle of the composition.

Jackson was happy with the painting. The experiment had worked: he had succeeded in adapting his modern Impressionist techniques to the Canadian landscape. He returned to Montreal with his latest canvases and, determined to advance his reputation both at home and abroad, arranged for exhibitions.

Whenever Jackson was away from home, either in Europe or off on a sketching trip to places such as Sweetsburg, his mother, Georgina, was instrumental in looking after his professional interests — not that there were any actual sales to speak of. The two kept in constant touch through letters, usually on a weekly basis. Much of their correspondence was about sending certain canvases to exhibitions, as "his mother seems to have acted as his agent in arranging for the movement of the works and in informing him of their acceptance by the juries."[32]

As soon as it was dry, Jackson shipped *The Edge of the Maple Wood* — called *Corner of Maplewood* at this early stage — off to London, England, where it had been accepted to hang throughout the summer in the Royal Canadian Academy's Exhibition of Canadian Art, part of the huge Festival of Empire show at London's Crystal Palace.[33] The painting was back in Montreal by the fall, where it was included in the RCA's 32nd Annual Exhibition.[34] After that, Jackson would send it off to the Ontario Society of Artists' 1911 spring show in Toronto — where it would finally be noticed.

Sweetsburg, Quebec, 1910. Eager to apply his European training to the Canadian landscape, Jackson painted this old barn during the same visit to Sweetsburg that produced *The Edge of the Maple Wood*. *Oil on canvas, 54.0 x 64.1 cm. © National Gallery of Canada, Ottawa, bequest of Dr. J.M. MacCallum, Toronto, 1944. Courtesy of the estate of the late Dr. Naomi Jackson Groves.*

The Islands of Georgian Bay

In May 1910, while *The Edge of the Maple Wood* was on its way to England, Jackson was on his way to Berlin, Ontario, to visit two aunts — Henry's sisters Geneva Jackson and Isabella Hayward — who had returned to their childhood home after the death of their father, H.F.J. Jackson, some twenty years earlier.[35] He was not impressed with Berlin; in fact, the only things that seem to have stood out for him on this trip were the fact that it coincided with the death of King Edward VII and the sisters' art collection, which included the old Krieghoff canvases his grandfather had acquired in Longueuil back in the 1840s.[36]

Berlin offered little for the landscape painter, he found, but creatively the trip was far from a waste of time. It was through his aunts that he met his cousins, the Clement family, who owned an island at Portage Point on Georgian Bay. Jackson had never seen that part of the country, so he jumped at their invitation to stay with them at their cottage.[37] What he found there, in the summer of 1910, was not a case of love at first sight. "It's great country to have a holiday in … but it's nothing but little islands covered with scrub and pine trees, and not quite paintable," he wrote home. "Sketching simply won't go."[38]

Only on subsequent trips to his cousins' cottage did he realize that the network of islands and channels in fact offered a wide variety of subject matter for the landscape painter — big, moody skies, blue water, white rock, sandy beaches, ancient pine trees, and thick woods. "This land," Jackson later said of Georgian Bay, "Le Bon Dieu made on a holiday, out of sheer joy."[39] To prove that statement, he would return again and again throughout his life, never tiring of the endless possibilities the diverse landscape presented to him.

But before Jackson could spend any more time at Georgian Bay — or anywhere else, for that matter — he had to earn some money. It had been three years since his last commercial art job, with Lammers-Schilling in Chicago, so he returned to Montreal in the late summer of 1910 to begin work as an illustrator for Smeaton Brothers Ltd.[40] This was the beginning of "a miserable year drawing shoes and farm implements"[41] for mail-order catalogues, which was supplemented in early 1911 by a second job, this one designing cigar labels for a manufacturing firm owned by prominent Canadian entrepreneur Sir Adam Beck, best known as the "father of Ontario Hydro."[42] This position may have been obtained through family connections, for Beck was a cousin and former business associate of William Hespeler, widower of Georgina Jackson's late aunt Mary.

Just as he had in Chicago, Jackson seems to have spent this period painting very little and working hard at commercial art, saving all the money he possibly could. Again, it was all for a definite purpose; he had made up his mind to escape the conservative attitudes in Canada once again and take another extended trip to Europe.

Two More Years in Europe

By the summer of 1911, Jackson had accumulated one thousand dollars.[43] Encouraged by a letter from Randolph Hewton in Paris, he quit his jobs and made plans to head back across the Atlantic.[44] Shortly after returning from a brief vacation at Georgian Bay, he was all packed and ready to go.

On September 24 he was aboard the *Sicilian*, this time in the company of Albert Robinson — a fellow Brymner student and a painter of great ability.[45] Originally from Hamilton, Robinson had also spent some time in France, where he studied at the École des Beaux-Arts. More importantly, he was a colourful character who played the piano and whose lively sense of humour made him one of Jackson's favourite sketching companions. "There was something about Robinson that melted all reserve as the frost disappears when the sun rises," Jackson recalled.[46]

They docked at Le Havre and went to the village of Saint-Malo on the Brittany coast, where they arrived on October 5.[47] Saint-Malo, perhaps best known to Canadians as the birthplace of the explorer Jacques Cartier, had been one of Morrice's favourite sketching grounds. Jackson and Robinson boarded with the Garnier family, whose children were kept amused by Robinson's penchant for jokes and games.[48]

The weather at Saint-Malo was anything but mild, yet it provided plenty of drama for artists, for here the waves crashed heavily against the ramparts. In chilly November, Jackson and Robinson sketched along the top of the wall, fighting against the wind and rain as they struggled to sketch the fishing schooners being tossed by the violent sea. Both artists managed to get some good sketches during this period. Jackson captured the essence of the raging waves in a few broad stokes in the sketch *Saint-Malo*, and then conveyed a much more peaceful mood in *Saint-Malo from the Basin* — a serene study of docked boats during a rare break in the weather.

While Jackson and Robinson were living at Saint-Malo, a small circus came to town. Jackson noticed a certain quality in the green circus tent as it stood in the evening twilight and set about making a sketch, no doubt inspired by Morrice's circus canvases from that region. Robinson was highly complimentary of his friend's finished work, but the self-critical Jackson thought he could have done much better. He kept the sketch anyway, and carried it with him as he and Robinson left for Carhaix on November 8.

It wasn't long before Robinson tired of France, and in December he abruptly left for Le Havre and took the first steamer bound for Montreal.[49] Jackson stayed on at Carhaix for the winter, trying to paint through a miserable season of rain and cold, then he went down to Paris to stay with Hewton for a few weeks. In March 1912 he went to Picquigny

Studio at Etaples, 1912. The old farmhouse at Trépied, near Étaples, where Jackson spent the summer of 1912 with fellow artist Arthur Baker-Clack.
Oil on canvas, 64.8 x 80.7 cm. © National Gallery of Canada, Ottawa. Courtesy of the estate of the late Dr. Naomi Jackson Groves.

Sand Dunes at Cucq, 1912. Complementary colours — yellow leaves and violet shadows — enliven this unusual image of northern France. This would be the first of many Jackson canvases to be bought by the National Gallery of Canada. *Oil on canvas, 54.6 x 65.5 cm. © National Gallery of Canada, Ottawa. Courtesy of the estate of the late Dr. Naomi Jackson Groves.*

on the Somme River with the Australian artist Arthur Baker-Clack, whom he had probably met in 1908 at Étaples.[50]

Jackson and Baker-Clack would end up spending the summer together, living in an old farmhouse rented by Baker-Clack and his wife in the village of Trépied, on the outskirts of Étaples.[51] Jackson's canvas of the artists' home base, entitled *Studio at Étaples*, shows the ancient whitewashed buildings with clay tile roofs surrounded by a dense growth of brush. Jackson loved this region, not only for its artistic community but also for its interesting landscape. Just as he had for his successful *Paysage Embrumé*, he set up his easel on

Assisi From the Plain, 1912. The historic hill town of Assisi inspired Jackson, but when later exhibited in Montreal, this canvas was criticized for its thick impasto and "studied carelessness of handling."
Oil on canvas, 64.7 x 80.6 cm. Art Gallery of Ontario, Toronto, purchased 1946. Courtesy of the estate of the late Dr. Naomi Jackson Groves.

A.Y. Jackson in 1912, living the bohemian life in Assisi, Italy. The canvas on the easel appears to be *Assisi from the Plain*, now in the Art Gallery of Ontario.

the sand dunes, and this time he painted the play of light and shadow from the sun shining through a stand of trees. The result was *Sand Dunes at Cucq*, which just over a year later would be purchased by the National Gallery of Canada.

It wasn't long before Jackson was on the move again. In late August he travelled to England to visit relatives at Leeds.[52] It was here that he painted his only canvases of England, the best known of which is *Factory at Leeds* — a bright, busy composition that shows a further step away from literal representation. It bears no stylistic resemblance to *The Edge of the Maple Wood*, or even *Sand Dunes at Cucq* for that matter, even though the latter was painted just a few months earlier.

At Leeds, Jackson stayed with an elderly cousin, Will Beck,[53] who introduced him to a local portrait painter by the name of Brooke.[54] The two artists must have hit it off right away, for Brooke was planning a trip to central Italy that fall, and he invited his new friend along. Jackson returned to Étaples for a few weeks, probably to collect his things and say goodbye to the Baker-Clacks, then set off for Italy, where he joined Beck and the Brooke family in the historic town of Assisi on October 25.[55]

Assisi proved to be another fertile ground for Jackson, who spent much time roaming through the hills and painting in the large studio of the Brookes' rented house. A posed photograph from this time has him seated in front of an easel, palette in hand, with what appears to be an unfinished *Assisi from the Plain* on the easel. The local sites included the thirteenth-century church and monastery that housed many frescoes and paintings devoted to the life of Saint Francis of Assisi, most of which were believed to have been the work of Giotto.[56] Inspired by these hallowed surroundings, he worked day and night. One of his most successful canvases from this period, *The Fountain, Assisi*, was painted one evening in the middle of town, where the challenge of capturing the delicate play of moonlight on the falling water was too tempting to pass up.

After nearly two months in Assisi, Jackson bade farewell to his English friends and set off on his own again. This time he moved north, finally keeping his four-year-old resolution to return to Venice. But instead of finding it as quaint as he had in the spring of 1908, this time he arrived in the cold, damp winter. He revisited to his old haunts along the Grand Canal and sketched a few scenes in oil, but was thwarted by inclement weather. One of his pencil drawings from this trip, *Venice in Snow*, shows a row of desolate, empty gondolas lined up along the quay, the familiar tower and domes of the Piazza of San Marco barely visible in the distance through the falling snow.

Jackson stayed in Venice through Christmas and into 1913, but he had to get back to Montreal. Throughout much of 1912, he had been corresponding with his mother and various art dealers, arranging for the shipment of canvases to and from exhibitions in

spell of post-impressionism. No artist comes out of France nowadays who has not done so. But the canvases exhibited at the Art Association show that Mr. Hewton and Mr. Jackson have both profited from the excellent instruction imparted to them in the first place by Mr. Brymner, P.R.C.A., and later by foreign masters.[8]

But not all of it was praise. As the same article pointed out, "It would be idle to say that all of Mr. Jackson's work is good. There is a distinct unevenness about his painting."[9]

Still, no sales meant no financial returns on the venture, and both Jackson and Hewton were practically broke by this time. Jackson also recalled having sold some sketches through a local dealer upon his return from Europe, but for some reason was never paid for them.[10]

The sense of total failure was buoyed only by the prospect of the Art Association of Montreal's annual Spring Exhibition, which opened in the same gallery on March 26, a few weeks after the Jackson-Hewton show had closed. Both had works included in that exhibition, and once again both were singled out in the press — this time not so favourably. Along with fellow Montrealer and Académie Julian classmate John Lyman, Jackson and Hewton were vehemently condemned by the *Montreal Herald* as members of the "Infanticist School" — artistic impostors whose works "do not possess, and do not profess to possess, any merits according to the accepted canons of any existing school of painting. They are as contemptuous of all precedent as the most advanced of the futurist creations."[11]

The *Montreal Daily Witness* was no more sympathetic, attacking all three artists for their radical approach. Jackson's *Assisi from the Plain* was singled out for its thick application of paint and its "studied carelessness of handling,"[12] but he was given a veiled compliment when it was noted that *The Fountain, Assisi* "shows that he can paint and paint well when he does not try to shock."[13] These faint words of praise did work in Jackson's favour, however, as the newly formed Montreal Arts Club offered him a lifetime membership in exchange for the painting.[14] It may not have been an official sale, but it must have boosted his morale during this time of overwhelming rejection.

The debate in Montreal heated up as the letters to the editor began appearing in the papers, many complaining of the unconventional paintings exhibited by Jackson, Hewton, and Lyman. Jackson was defended to some degree by Samuel Morgan-Powell of the *Montreal Star*, whose disdain for the newer styles of painting was made clear: "Post-Impressionism is a fad, an inartistic fetish for the amusement of bad draughtsmen, incompetent colourists, and other[s] who find themselves unqualified to paint pictures," he wrote on March 29. "It was founded by a couple of Montmartre cranks, Van Gogh and Gauguin … Van Gogh died in a lunatic asylum and it is understood that Gauguin died in Tahiti, after having endeavoured in vain to persuade the Tahitians to adopt Post-Impressionism."[15] But Jackson, he pointed out, "knows the line where sanity ends and the kingdom of freaks begins. He pushes the impressionist technique to the limit but he does not overstep it. Such work as *The Fountain* and *Assisi from the Plain* stamp him as an earnest student, a skilled draughtsman, a colorist who is likely to make a name for himself and an artist of acute perceptions."[16]

The publicity was like gold to the artists. Readers' curiosity was piqued and they flocked to the AAM's Spring Exhibition to see what was causing all the controversy.

Cedar Swamp, Émileville, 1913. The farming community of *Émileville* provided a welcome respite for Jackson and Randolph Hewton after their unsuccessful AAM exhibition. This is one of the canvases Jackson was working on when he received a letter from Toronto that changed his life.

Oil on canvas, 65.2 x 80.5 cm. Art Gallery of Ontario, Toronto, purchase 1946. Courtesy of the estate of the late Dr. Naomi Jackson Groves.

Morning After Sleet

Meanwhile, Jackson and Hewton were nowhere to be found. Frustrated and stung by the failure of their joint exhibition, they had left Montreal on March 20, a week before the Spring Exhibition opened.[17] Their destination was the tiny community of Émileville, near Farnham, about sixty-five kilometres southeast of Montreal. Jackson had hiked out that way several years earlier and remembered its maple woods, rolling hills, and rugged farmland. He had heard that a French Protestant family named Guertin took in boarders, so they packed up their painting gear and headed out to the country — where they could live cheaply, having barely any money left over from their joint exhibition.[18] The Guertins, he wrote, "treated them with great consideration and kindness, and being sympathetic and

generous hosts did not even want to accept payment for their board."[19] After much protest, they finally agreed to accept a nominal fifty cents per day from the artists.[20]

Spring in rural Quebec was Jackson's favourite time to paint. Since his early water-colours in Hemmingford to his popular — but yet unsold — *The Edge of the Maple Wood* in Sweetsburg, he revelled in the effects of sunlight, wet ground, and melting snow. "We forgot all our troubles while we painted to our hearts' content,"[21] Jackson recalled, but it is unlikely that they achieved any peace of mind — for it was all but inevitable that if they wanted to avoid working at commercial art, they would soon have to leave the conservative artistic climate in Canada and head down to New York City, where the art scene was flourishing. The famous Armory Show had just taken place there, and new ideas were not only being accepted, it seemed, but encouraged. They had plenty of contacts in the States, having met several American artists in Paris and Étaples, and Jackson still knew many people in Chicago, so a move south was looking very attractive to them at this time.

Jackson and Hewton pushed themselves hard, often bringing their canvases outdoors instead of working with small oil sketches on panel. One morning they awoke to the sight of a nearby birch grove covered in a layer of ice, the result of an overnight shower of freezing rain. Light from the rising sun twinkled brightly through the icy branches, giving everything a frosty, frozen appearance. Jackson and Hewton hurried outside with their canvases and set to work, but as they painted, the ice rapidly melted and the effect they had hoped to capture was gone. Jackson was disappointed, but just as he was about to scrape the fresh paint off his canvas, Hewton stopped him. "That's good," he said. "If you don't want it, I'll trade you a clean canvas for it."

Jackson accepted the trade, gave his friend the painting, and thought no more about it. A decade later, Hewton sent Jackson's *Morning After Sleet* to the AAM's Spring Exhibition, where it was awarded the prestigious Jessie Dow Prize.

Those Poor Dutchmen!

Less than a week after the two painters arrived in Émileville, a package of letters arrived from Montreal, forwarded by Georgina Jackson. In it was an envelope bearing a Toronto postmark, sent by J.E.H. MacDonald, the artist with whom Jackson had recently corresponded. As Jackson read the letter, he realized it was not MacDonald's apology for missing the joint exhibition. Instead, it was an offer to buy one of his paintings — *The Edge of the Maple Wood*. "If I still possessed it, he wrote, a young Toronto artist, Lawren Harris, wanted to buy it," Jackson recalled. "If I still possessed it! I still possessed everything I had ever painted."[22]

If that wasn't enough, MacDonald also informed him that "six Venetian sketches he had sent to the little picture show in Toronto had been sold."[23]

Instead of moving to New York right away, Jackson and Hewton stayed for a few more weeks of sketching in the spring woods while the sale of *The Edge of the Maple Wood* to Harris was arranged for two hundred dollars. This was done through a rapid exchange of letters between Émileville and Toronto. MacDonald and Harris sensed a kindred spirit in Jackson, whose tastes and staunch devotion to a modern Canadian art were very close to their own.

Harris sent Jackson a cheque, accompanied by "a long screed full of enthusiasm, enlarging on the possibilities of painting the Canadian scene as no one yet had painted it except himself in *The Edge of the Maple Wood*."[24]

"MacDonald tells me you are a real enthusiast, a good live artist; one who can practise and preach and wallop the Dutchmen when occasion calls, and judging from your letter, I strongly suspect that MacDonald is right," a jubilant Jackson replied to Harris on March 26 — the same day his work was being ridiculed in the Montreal press. "Those poor Dutchmen! If they were not already dead, I would shed a few tears for them."[25]

The enthusiastic correspondence led to an invitation to Toronto, where Jackson could meet these kindred spirits face to face and see more of their work. He had been planning to put some of the proceeds from the sale of *The Edge of the Maple Wood* toward a trip back to Berlin to visit his aunts, then he thought he might spend a leisurely summer with his cousins, the Clement family, on Georgian Bay before moving to New York in the fall. Toronto was on the way to Berlin, so Jackson eagerly accepted MacDonald's invitation to lunch at the Arts and Letters Club.

It would prove to be a major turning point in his career.

The Old Courtroom on Adelaide Street

By 1913, European trends of the past forty years had made no more of an impact on Toronto's artistic circles than they had in Montreal. The preoccupation with Dutch art may not have been as strong as it was in Jackson's hometown, but the art establishment was similarly ruled by conservative teachers and critics who systematically shunned any new ideas in favour of the tried-and-true traditional values. Some Toronto critics, such as H.F. Gadsby of the *Star* and Hector Charlesworth of *Saturday Night* — both of whom would soon be known as fierce opponents of Jackson, Harris, MacDonald, and the other young Toronto painters — could be just as vicious in their attacks as their Montreal counterparts.

There was, however, a place where all ideas — old and new — came together in a neutral environment where all creative endeavour was celebrated. The Arts and Letters Club had been the hub of Toronto's artistic life since its founding in 1908.[26] Among its members were the city's most prominent painters, illustrators, sculptors, writers, actors, musicians, and critics, as well as a few wealthy businessmen whose families served as Toronto's patrons of the arts. Here, in a large dining room that was once a municipal courtroom at Adelaide and Court streets, members met for lunch each day, and often returned in the evening for small theatrical performances or concerts — some of which featured world-renowned musicians such as Pablo Casals and Sergei Rachmaninoff.[27]

MacDonald and Harris

The idea of a uniquely Canadian art movement was certainly not new; in fact, the notion is likely to have predated Confederation. But the first stirrings of artistic nationalism that would lead to the formation of the Group of Seven can be traced directly to Lawren Harris and J.E.H MacDonald, the two Toronto artists who met in 1911 at the Arts and Letters Club.

Morning After Sleet, 1913. Jackson hurriedly painted this canvas on the spot as the ice melted from the trees, but was unsatisfied with it and traded it with Randolph Hewton for a clean canvas. It later won the prestigious Jessie Dow Prize.

Oil on canvas, 64.0 x 79.4 cm. © National Gallery of Canada, Ottawa. Courtesy of the estate of the late Dr. Naomi Jackson Groves.

James Edward Hervey MacDonald was born to Canadian parents in 1873 in County Durham, in northern England. His family's North American roots could be traced back "several hundred years ... [They] did not come over on the *Mayflower,* but did arrive a few vessels later, on board the *Arabella*, and generations later made their way north to Quebec as United Empire Loyalists."[28] The MacDonalds returned to Canada when James was thirteen, settling in Hamilton, Ontario. He was educated at the Hamilton Art School, and when the family moved to Toronto in 1889, he took a job as a commercial artist at the Toronto Lithographing Company.[29] This, combined with Saturday afternoon studies at the Central Ontario School of Art under George A. Reid, eventually led MacDonald to what would be a twenty-year career with Grip Limited, a prominent commercial art firm where he would rise to the position of head designer.[30]

MacDonald was from all accounts a frail, soft-spoken man — the very antithesis of the rugged outdoorsman image adopted by Jackson and other future Group of Seven members. A devoted family man, MacDonald worked as a commercial designer and taught art in order to support his wife, Joan, and son, Thoreau. He wrote poetry and painted in his spare time, often sketching in High Park, near his home on Quebec Avenue. These sketches and small canvases were frequently exhibited at the Arts and Letters Club, where he and most other Grip Limited employees were members. It was here, in 1911, that he met fellow member Lawren Harris.

Born in 1885 in Brantford, Ontario, Lawren Stewart Harris was an heir to the considerable Massey-Harris farm equipment fortune — a source of income that allowed him to devote his life to art without the common disadvantage of having to earn a living working for others. His family occupied prominent positions not only in the Baptist Church and the Canadian business community but also in Toronto society, which meant he knew many of the right people who could help him in any of his ventures. Harris's life of privilege brought with it a certain amount of social and cultural responsibility — something he took seriously his entire life. He had the means to get things done, and throughout his career he often took the initiative, gladly financing various artistic projects and acting as chief organizer for exhibitions and sketching trips.

After the death of his father in 1894, Harris moved to Toronto with his mother and younger brother, Howard. The young heirs were educated at Saint Andrew's College in the Rosedale section of Toronto.[31] Having decided to become an artist, he studied art in Berlin, Germany, from 1904 to 1908, and later travelled through the Middle East.[32] He settled back in Toronto and by 1912 was painting seriously.

As an artist, Harris was drawn to the very opposite of his natural surroundings. He lived most of his life in large houses in wealthy neighbourhoods, but in his formative years he preferred to paint the side streets, corner stores, and tiny, dilapidated buildings in Toronto's Ward district. While it is unlikely the inhabitants themselves saw any romance or novelty in their ramshackle homes and rubbish-strewn yards, Harris found a sort of visual poetry in the rows of modest shacks. His earliest efforts were mainly pencil sketches and paintings rendered in dull shades to convey the sense of poverty, but he eventually expanded his palette to show the presence of bright colours in even the meanest of surroundings. He noticed subtle shades of red and violet in the sun-blanched fence boards and different browns and yellows in the cheap clapboard walls.

Buoyed by similar ideas about art, Harris and MacDonald became fast friends and frequent sketching companions. They often worked together in and around Toronto, producing sketches that would result in such works as Harris's *The Gas Works* of 1912 and MacDonald's *Tracks and Traffic* of the same year.

As a full-time artist, Harris kept abreast of the latest trends and styles that were coming out of Europe and elsewhere. The idea of Canada's own style of painting came to be discussed seriously in early 1913 when he and MacDonald travelled to the Albright Gallery in Buffalo, New York, to visit an exhibition of Scandinavian landscapes.

Both men were surprised and excited by what they saw. The snowy mountains and icy fields of Norway and Sweden bore an uncanny resemblance to the rugged Canadian landscape in deepest winter. Here were spruce boughs sagging under the weight of snow, vast panoramas of rocky tundra, and forests glistening with a light coating of frost. Harris was particularly attracted to a Harald Sohlberg canvas entitled *Mountains, Winter Landscape*,[33] which displayed hints of the style he would adopt himself in his Rocky Mountain works more than a decade later. MacDonald was most impressed by the work of Gustaf A.F. Fjaestad,[34] whose canvases *Ripples* and *Hoar Frost* demonstrated a unique vision that bore no resemblance to anything he had ever seen. "Here were a large number of paintings which gave body to our rather nebulous ideas," Harris later wrote. "Here were paintings of northern lands created in the spirit of those lands. Here was a landscape as seen through the eyes, felt in the hearts, and understood by the minds of people who knew and loved it. Here was an art, bold, vigorous and uncompromising, embodying direct experience of the great North."[35]

In short, what Harris and MacDonald saw in Buffalo was exactly what they were trying to do in Canada. They returned to Toronto with a renewed enthusiasm and determination to initiate a landscape-based style of painting that Canada could call its own.

Around this time Harris met the Toronto ophthalmologist Dr. James MacCallum, whose love of Canadian art had drawn him into the Arts and Letters Club. Dr. MacCallum was not only a keen patron of struggling artists but also a lover of the great outdoors who spent much of his free time at his cottage on Go Home Bay, along the eastern shore of Georgian Bay. Harris described him as "an expert woodsman and canoe man and a man of the north on his summer holidays."[36] Within a short period, MacCallum became a prominent figure among the circle of artists who gathered for lunch each day at the Arts and Letters Club. He welcomed artists at his cottage and remained a constant source of inspiration to them — always ready with a few words of encouragement and willing to buy their sketches for a few dollars.

It was on this wave of enthusiasm that Harris began making arrangements for the first concrete step in his and MacDonald's vision. With some financial backing from MacCallum, Harris bought a plot of land on quiet Severn Street in Rosedale Ravine and hired architect Eden Smith — a friend from the Arts and Letters Club — to design a three-storey building to house six spacious studios. The Studio Building for Canadian Art, as Harris envisioned it, would be "a workshop for artists doing distinctly Canadian work"[37] — a centre of creativity for the Toronto art community, where new ideas could be discussed and nurtured. Original plans called for a small theatre and art gallery to be included in the complex, but those additions would be cancelled with the onset of war a few months after the studios were completed.[38]

Meeting the "Bunch"

Jackson accepted MacDonald's invitation to lunch at the Arts and Letters Club and stopped off in Toronto in late May 1913, while on his way to Berlin. He may have had some trouble finding the place, for the club's entrance was accessible only through a dark, foul-smelling alley behind police headquarters. In order to reach its nondescript door, one had to pass "along a dingy wall in Court Lane, between a manure pile and a stalk of firewood."[39] Members themselves did not seem to mind the squalid surroundings, even if etiquette required that each was obliged to stop first at the woodpile and carry upstairs a "snow-plastered stick of cordwood on one shoulder"[40] for the fireplace whenever they entered. Inside, the former Assize Court room was known as "the most impressive, inaccessible room in Toronto,"[41] whose inhabitants "prided themselves on the inaccessibility of the club."[42]

MacDonald turned out to be a quiet man with red hair and a gentle demeanour that contradicted the subject matter of his canvases. Exactly who else was actually present at the club that day is not known for certain, though Jackson recalled being introduced to members of what MacDonald affectionately referred to as "the Bunch." There were two Englishmen from Sheffield — the tall, wiry, and quick-witted Arthur "Lefty" Lismer and the square-jawed, red-haired Fred Varley — both of whom were commercial artists at the firm Rous and Mann. Their boss, Albert "Ab" Robson, may also have been present, as well as other regulars at the artists' table — William Broadhead, Tom McLean, Franklin Carmichael, and Frank Johnston. Most of these men had until recently worked at the firm of Grip Limited, and followed Robson over to Rous and Mann in 1912. Jackson was probably introduced to the club's president, the painter J.W. "Bill" Beatty, at this time, as well as the newspapermen and art critics congregated around a nearby table — Gadsby, Charlesworth, and the others who would later be leading the attack against the young artists.[43]

It was certainly an eye-opening experience for Jackson, who was quick to pick up on the prevailing atmosphere of ambition and camaraderie among MacDonald and the others. Plans for the Studio Building, the local sketching trips, the exhibitions at the Arts and Letters Club — it was certainly an encouraging sign that things were beginning to happen in Toronto, unlike Montreal. But Jackson remained unconvinced. Artists in Toronto, he found, "were woefully lacking in information about trends in art in other parts of the world. A few good paintings by Monet, Sisley and Pissarro would have been an inspiration to them. They saw nothing at all to give them direction."[44]

As it happened, Lawren Harris — the man whose passion for Canadian art was the driving force behind this new spirit in Toronto — was out of town during Jackson's brief visit. He was still determined to meet the artist who had painted his recently acquired *The Edge of the Maple Wood*, so he arranged with Jackson to meet him in Berlin a few days later. The man who turned up at Jackson's aunts' house was like none of the pompous millionaires Jackson had known in Montreal. Harris was a polite and well-mannered young man whose down-to-earth personality and enthusiasm proved instantly contagious. Their views on landscape painting and Canadian art were very similar, and, as both no doubt expected from their exchange of letters, the two artists became instant friends.

"To Lawren Harris art was almost a mission," Jackson wrote of their meeting. "He believed that a country that ignored the arts left no record of itself worth preserving. He

deplored our neglect of the artist in Canada and believed that we, a young vigorous people, who had pioneered in so many ways, should put the same spirit of adventure into our cultivation of the arts."[45]

Harris spoke passionately about his and MacCallum's plans for the Studio Building near the Rosedale Ravine and "the need for Canadian artists to assume a more aggressive role."[46] Jackson, he said, should come to Toronto and join the movement that would soon be headquartered in the Studio Building.

Still, Jackson was not immediately convinced. He had spent many years as a struggling painter and knew that he had to be assured of a living in Toronto. The meeting ended with Jackson promising to think about Harris's invitation over the summer.[47]

White Rocks and Bent Pines

From Berlin, Jackson went to stay with cousins, the Clement family, at their summer cottage on Georgian Bay. This was his third trip to the area, and by now he had fallen in love with the bay and its rugged landscape of islands, white rocks, and oddly shaped pine trees. He had cultivated several close friendships with his cousins' neighbours, and was considered a member of their close-knit community. The isolated cottagers were so far from the nearest town that a daily trip to the store was impractical. Instead, they relied on a supply boat for their provisions. The boat — or possibly two boats, the *Trader* and the *John Lee* — ran north from Midland or Penetanguishene, calling in at the islands along the way.[48] When the boat service stopped for the summer, or in times of emergency, the Clement and Williams families relied on the services of an American gentleman who lived nearby. He owned a large, fast boat and often picked up milk for them when he went to town. "And who do you think we have as a milkman?" Jackson and his friends would say to impress people. Their "milkman" was no less a person than aviation pioneer Orville Wright, who ten years earlier had co-invented the airplane with his late brother, Wilbur.[49]

Although he later recalled this time as a happy period, filled with carefree activities — "swimming, paddling, fishing, exploring, and looking for wild flowers,"[50] not to mention sketching the ever changing moods of Georgian Bay — Jackson pondered his meeting with Harris and worried about how he would be earning his living once the summer was over. At nearly thirty-one years old he was still determined to become a full-time landscape painter. But with no prospects in that area, and no signs of any new markets for Canadian art opening up anytime soon, he realized he would likely have to swallow his pride and return to the drudgery of commercial art.

The alternative of moving to the United States remained a strong possibility. A.Y. Jackson, the Impressionist painter who had exhibited

Blue Gentians, 1913. A rare still life from the Jackson oeuvre, this was painted during Jackson's productive stay at Georgian Bay in the autumn of 1913 — probably while confined indoors by inclement weather. *Oil on canvas, 53.0 x 48.3 cm. McMichael Canadian Art Collection, gift of Miss D.E. Williams. 1975.1.1.*

Autumn Snowfall, 1913. Jackson captured the wind and snow on Georgian Bay, painted during the prolific autumn shortly before his move to Toronto.
Oil on canvas, 53.8 x 64.8 cm. © National Gallery of Canada, Ottawa, bequest of Dr. J.M. MacCallum, Toronto, 1944. Courtesy of the estate of the late Dr. Naomi Jackson Groves.

in the Paris Salon, would likely have found a warm reception in the Greenwich Village artistic community he had heard so much about while in Europe. Then again there was his inspiring meeting with the like-minded MacDonald and Harris in Toronto.

Jackson seems to have weathered this period of inner turmoil with hard work, and he resolved to do some serious painting.[51] He evidently had canvases as well as sketching panels with him, for he accumulated a considerable number of canvases over the summer and early fall. Among these are *Night, Georgian Bay* and *Huckleberry Country* — two paintings that were completed during the same period but display entirely different styles and moods. As the title suggests, the former is a view of the rocky Georgian Bay shoreline at

blatant disregard for the proper rules of painting was taken as a slap in the face by those who judged good art by traditional academic standards.

Terre Sauvage

Harris, whose time was taken up by overseeing the construction project on nearby Severn Street, would not be doing much painting, so Jackson wasted no time in putting the empty studio to use. The first painting he undertook was also his largest to date. From his collection of Georgian Bay sketches he chose a simple composition of rock and trees, which he proceeded to sketch out on a large stretched canvas. But as he worked, he allowed his imagination to take over, and soon he was painting in a way that would have made his old teachers — Brymner, Dyonnet, and especially Jean-Paul Laurens — gasp in horror.

MacDonald, a frequent visitor to Harris's studio, watched Jackson's big Georgian Bay canvas evolve from its earliest stages. He was impressed by the way the white rock rose slowly up to a plateau of tall, scraggy spruce trees, and suggested the title *Mount Ararat* because it reminded him of the high ground where Noah's Ark came to rest after the Flood.[4] Jackson had another title in mind at the time. He decided to call it *The Northland*. Years later, it would be retitled *Terre Sauvage*.

A close examination of *Terre Sauvage* reveals many instances of dragging — the application of wet paint over previously painted portions that have been allowed to dry — evidence that Jackson worked and reworked the canvas over a period of several weeks. During this time, the simple Georgian Bay composition turned more and more into an experimental piece where the spruce trees were reduced to their basic shapes, resembling simple green cones, the dark blue sky was dotted with dashes of purple, and the overhead clouds became brooding masses of greys, whites, and a wide variety of subtle colours.

As *Terre Sauvage* progressed, word spread throughout the tightly knit circle of Toronto artists that Jackson — the new arrival from Montreal with the formal European training — was joyfully breaking all the rules of academic painting and would soon be completing the most radical canvas any of them had produced to date.

A Student of the Wilderness

One of the curious visitors attracted to Harris's studio while *Terre Sauvage* was still in progress was a tall, quiet commercial artist named Tom Thomson, who arrived one day with Dr. MacCallum. This was the "student" MacCallum had asked Jackson to take under his wing when he had offered him a year's financial support. Thomson was a colleague of Lismer, Varley, McLean, and the others, having spent several years working under director Albert Robson and senior artist J.E.H. MacDonald, first at the Grip Limited engraving company on Temperance Street, and more recently at Rous and Mann Press Limited on York Street.[5] He was known as a diligent and talented designer, but at the urging of his colleagues had lately been pondering the possibility of becoming a serious painter.[6] He spent hours standing behind Jackson while he worked, puffing on his pipe and asking

questions about Jackson's brushwork, his use of complementary colours, and the basics of composition. Sensing a kindred spirit — for the two men obviously had much in common — Jackson gladly shared with Thomson the finer points of rendering the northern landscape on canvas.

"He was a very likeable fellow; you just took to him right away," was Jackson's first impression of Thomson. "He was rather shy and was almost afraid to show the sketches that he had with him. They were very honest."[7]

Thomson was five years Jackson's senior, but still far behind when it came to rendering the northern landscape in oils. He had never studied art; instead he had briefly attended a business college run by his brother, where his interest in advertising led to experiments in photoengraving. Before long he was an accomplished commercial artist with a keen sense of design — one of the most important attributes for any painter who hoped to reduce the tangled, chaotic natural landscape into a coherent balance of composition and colour. MacCallum had spotted this quality in Thomson's sketches and made him the same offer as Jackson — a year's financial support if he moved into the Studio Building and devoted himself to painting.

As the story goes, MacCallum made the offer as dramatically as he had with Jackson, but instead of searching the islands of Georgian Bay in a motorboat, he rang doorbells all along Toronto's Isabella Street until he found the rooming house where Thomson lived. The artist was not home at the time, but when he came in he found MacCallum waiting in his room, inspecting his sketches.[8] Unlike Jackson, Thomson was at first apprehensive about the offer; he didn't have enough confidence in his own abilities and feared he might only make a fool of himself.[9]

Thomson's greatest strength at this point was his love and understanding of the northern wilderness. Although his reputation as an expert woodsman has probably been greatly exaggerated over the years, it is certain that he was at least comfortable in a canoe and could make his way quite easily in the bush. Unlike the city-bred Jackson, Thomson was born and raised in rural Ontario. He had grown up on a farm in Leith, near Owen Sound, where he spent much time hunting, fishing, and learning how to get around in the nearby woods.[10] Years later, while working at Grip Limited, he joined his colleagues on weekend sketching expeditions to the outskirts of Toronto. But it was in the spring of 1912 — a year and a half before he met Jackson — that Thomson made his first trip to Algonquin Park, a vast region of virtually untouched wilderness between Georgian Bay and the upper Ottawa River.[11] He fell in love with the park immediately, and from that point forward arranged his life around the single purpose of spending as much time there as possible. His stays in Toronto became shorter and less frequent, while up in Algonquin Park he became well known among the locals. He picked up odd jobs and sometimes worked as a guide for tourist fishing parties, while in his spare time he worked hard on his sketching — always striving to capture in paint the brooding summer sky above a northern lake, the snow-covered spruce trees, or a blaze of golden tamaracks against the bare hills of late October. This, he quickly realized, was much harder than it might seem.

It is hardly surprising that Thomson found his greatest inspiration as a landscape painter in Algonquin Park, for it offered a wide variety of lakes, rivers, forests, and hills — all of which took on very different appearances with each season. Added to the mix were

swamps, beaver dams, and logging chutes, providing Thomson with no end of subjects to sketch. From the moment they met, Jackson was well aware of Thomson's love for Algonquin Park. It seemed to be all he could talk about.

The First Public Attack

Appropriately, the opening of the Studio Building came in the midst of a public controversy — and not surprisingly, A.Y. Jackson was in the midst of it. A month earlier, on December 12, the *Toronto Star* had published a witty attack on the young Toronto artists when critic H.F. Gadsby viewed Jackson's Georgian Bay sketches at the Arts and Letters Club. Their frank and deliberate break with the guidelines of conventional painting angered the conservative-minded Gadsby, who composed his denunciation partially in the form of a dialogue between himself and a friend named Peter:

"What it this picture, Peter?" he asks, pointing to a spasm in green and yellow.
"That," says Peter, "is a Plesiosaurus in a fit as depicted by an industrious but misguided Japanese who scorns foreground or middle distance."
"And this one," says Big Bill, indicating another in sullen reds.
"A Hob-Nailed Liver," says Peter quick as a flash, "painted from memory by the Elevator Man at the General Hospital."[12]

Gadsby's attack has survived as the first and most barbed critical shot at Jackson and his new Toronto friends, and the article's headline, "The Hot Mush School," has become permanently attached to the fledgling Canadian landscape movement they were promoting. The "Hot Mush" idea came from Gadsby's assertion that "all their pictures look pretty much alike, the net result being more like a gargle or gob of porridge than a work of art."[13]

The article was clearly meant to discourage the artists by ridiculing modern art, but it actually had the opposite effect. It was publicity — and even at this early stage Harris, MacDonald, and Jackson knew that any publicity, favourable or otherwise, was good for them because it stimulated interest. The Impressionists, after all, had been ridiculed in the French press for years before attaining any degree of respectability. The idea was to generate controversy, then let people view the paintings in order to form their own opinion. Some would like it, and others wouldn't — but it was all worth the effort to publicize their work and their ideas.

Eager to keep the controversy alive, MacDonald sharpened his pencil and composed a scathing rebuttal to Gadsby, likely with contributions from the others, which the *Star* published a week later under the title "The Hot Mush School: A Rebuttal." Gadsby's critique "got my goat, my horse, my ass and everything which is mine,"[14] he wrote before coming to the main point of the article, which was to promote the idea of a uniquely Canadian art movement: "Now I want to put it to Gadsby and Peter and the rest of us. Let us support our distinctly native art, if only for the sake of experiment."[15]

The first major press battle had been fought, and it was completely successful in putting the Hot Mush School idea before the Toronto public. They no doubt would have

preferred to be known by another name, of course, but getting their message out there was of far greater importance. For years afterward, MacDonald and Jackson would rejoice at the sight of any adverse criticism in the press, for it meant an opportunity to further their reputations as groundbreaking radicals.

The "Hot Mush" controversy did not go unnoticed; in February, Jackson once again drew the attention of critics when some of his sketches were included in the Royal Canadian Academy's Second Annual Exhibition of Little Pictures by Canadian Artists. "One of the most interesting exhibits is that by A.Y. Jackson, not only on account of the vividness of his color and his extremely broad method of treatment, but also because of the considerable discussion that has been aroused by this artist's work," a reviewer wrote in Saturday Night — obviously in reference to Gadsby's attack in the Star and MacDonald's subsequent rebuttal.[16]

The pen, they knew, could be even more powerful than the paintbrush.

25 Severn Street

The Studio Building was finally ready to admit tenants on January 19, 1914.[17] It was a square, three-storey brick building on the south side of quiet Severn Street in the Rosedale Ravine, a five-minute walk from Harris's studio at the corner of Yonge and Bloor streets. Eden Smith's modern design featured six huge windows facing north — traditionally the ideal situation for studio windows because the absence of direct sunlight means no shifting shadows to hamper work with models or still life studies. Inside, "the vast studios, with their fourteen-foot ceilings and large north windows, invited the production of large, major works, and most of the painters took advantage of the opportunity."[18]

After Jackson's repeated urging, Thomson finally accepted Dr. MacCallum's offer of a year's support, and the two artists moved into Studio One on the ground floor while carpenters were still busy putting the finishing touches on the studios above. Jackson made a quick trip to Montreal to fetch some personal effects for his year in Toronto, but between them "they had little to put into [the big studio] but their books and painting gear."[19]

Harris and MacDonald soon followed, and before long the remaining three spaces were taken by Bill Beatty, Arthur Heming, and Curtis Williamson[20] — all older, well-established artists from the Arts and Letters Club, and certainly not members the radical "Hot Mush" movement. The Studio Building, as conceived by Harris and MacCallum, was to be a non-profit venture for the sake of promoting Canadian art, so they agreed from the outset that the rent for each studio would remain fixed at the easily affordable rate of twenty-two dollars per month.

Settling into the Studio Building, Jackson quickly learned to live frugally. Lunch at the Arts and Letters Club was by no means an everyday event, and since there were no cooking facilities in the studio, he and Thomson usually took their meals at a bar around the corner on Yonge Street, which served hearty meals in a rear dining room for just twenty-five cents. For more homey meals, they frequented a nearby restaurant called the Busy Bee,[21] and the only entertainment they could afford was the occasional silent film at a local cinema on Saturday night.[22]

During this period, Jackson taught Thomson much about theory and technique. He

showed him his books on Impressionism and no doubt passed on helpful tips he had picked up in Europe.[23] Learning how to handle the varying effects of sunlight on water and snow, as developed by the Impressionists, was especially important for anyone who hoped to paint the northern landscape. And whereas Thomson's early paintings show a tendency to record a scene in photographic detail, "trying to paint every twig,"[24] Jackson steered him toward simpler compositions that eliminated clutter and emphasized a cohesive design. The canvas Thomson is known to have painted at this time, the shimmering *Moonlight*, is just that — a simple composition of a half moon shining high above a lake. It shows definite Impressionist influence in the sky and water, and the circular sweep of brushstrokes to suggest the moon's radiance is reminiscent of van Gogh — one of Jackson's early heroes. There can be no doubt that *Moonlight* was painted under Jackson's direct guidance.

The Studio Building on Severn Street in Toronto was built by Lawren Harris and Dr. James MacCallum in 1913–14 and has remained virtually unchanged for nearly a century.
Photo by Karen Forbes Cutler. Collection of the author.

Forty Below in Algonquin Park

Throughout his life, Jackson could never resist the chance to visit some new territory, so after hearing about Algonquin Park from Thomson and Harris, who had also been there, he decided to see it for himself. Armed with warm clothes, his sketch box, and a list of contact names supplied by Thomson, who stayed behind in Toronto, Jackson set off alone for Algonquin Park in February 1914. Getting up there by train in those days was no simple matter — he had to take the Grand Trunk line north to Scotia Junction, near Huntsville, then transfer to the Ottawa, Arnprior and Parry Sound Railway, which then took him into the park.[25]

His reception was certainly not a warm one. When his train pulled into Canoe Lake station late at night, Jackson found the temperature to be a stinging -40°C — so cold that he could get away with exaggerating the temperature each time he told the story. It soon became forty-three below, and when he wrote his autobiography four decades years later, he had himself disembarking at Canoe Lake with the thermometer at forty-five degrees below zero.[26]

Despite the bone-chilling cold, Jackson found Algonquin Park to be a hospitable place. Thomson was well known and well liked by many of the park's year-round residents, so any friend of Thomson's was welcomed graciously. He was met at the train station by Shannon Fraser, proprietor of Mowat Camp (later renamed Mowat Lodge), the main boarding house in the area. Fraser would have introduced Jackson to other residents, including park rangers Mark Robinson and Bud Callighen,[27] as well as guide and part-time poacher Larry Dickson. [28]

The temperature rose considerably by the next morning — it was then just -29°C.

"I landed last night and found it just as Harris had said," Jackson wrote to MacDonald on February 14. "You don't notice the cold one bit."[29] So Jackson set off on snowshoes to explore the region. From a stand of spruce trees that harboured a pack of howling wolves with a fresh kill — which he thought best to avoid — to the frozen-over Canoe Lake, Jackson was glad to find Algonquin Park quite paintable. It was easy to see why Thomson was so enthralled. Some places simply don't have the right atmosphere or interesting subject matter. But in the mutual language of the landscape painter he shared with Thomson and the others, Jackson immediately saw interesting rhythms and motifs in the frozen northland wilderness. The only problems he seems to have faced during this trip resulted from working in the extreme cold. A bare hand is prone to frostbite after just a few minutes, and wearing gloves makes it difficult to properly control the brush. Moreover, the paint itself tends to stiffen in low temperatures, rendering it nearly useless as a medium. Still, he managed to complete quite a few sketches for later canvases.

In March, after Jackson had been working alone for about a month, he was joined in the park by MacDonald and Beatty. MacDonald was clearly not as inspired by the Algonquin spring as Jackson and Thomson, for most of his sketches from this trip are not counted among his best.[30] He did, however, produce *March Evening, Northland* — a quiet snowscape under a brooding sky that seems to have more in common with the traditional realism of Beatty than MacDonald's radical "Hot Mush" allies.

Jackson was back in the Toronto studio with Thomson by late spring, painting up his Algonquin Park sketches onto canvases. The trip had been a great success; the resulting paintings show a major step forward for Jackson as a painter of snow, because it marked the first time in four years that he was able to paint the Canadian woods in the middle of winter and to put into practice the Impressionist theories of light, shadow, and colour. His best-known canvas from this trip, *Frozen Lake, Early Spring, Algonquin Park*, depicts an ice-bound lake seen through a partial screen of leafless birch trees. The foreground is a patchwork pattern of sunlight and shadow on the snow, but instead of using just pure white and blue-grey, Jackson's palette featured a wide range of subtle blues, violets, and mauves for the shadows and several shades of near-white for the sunny areas. The same technique and similar colours were also used for the flat surface of the frozen lake. By carefully juxtaposing different shades, Jackson not only followed nature but also created a pronounced sense of depth. Another canvas from this period, *Birches in Winter, Algonquin Park*, is a peaceful view of a birch forest in the morning sunlight. Again, the long shadows and contours of the snow-covered ground are rendered in an array of different colours while the sunlit snow is shown in dashes of pale yellows and creamy whites.

A First Taste of the Rockies

Shortly after Thomson and Lismer left for Algonquin Park in mid-spring, Jackson accepted an invitation to join Bill Beatty on an extended trip to the Rockies. They had been commissioned to sketch in the construction camps of the Canadian Northern Railway, which was laying a stretch of track through the rugged mountains along the Fraser River between Alberta and British Columbia. This was to be Jackson's first visit to the

Birches in Winter, Algonquin Park, 1914. Jackson's first trip to Algonquin Park produced several winter scenes, including this delicate study of sunlight and shadow on snow.
Oil on canvas, 63.5 x 81.2 cm. Private collection, Trevor Mills.

Rockies, and he fully expected to be overwhelmed by their grandeur. They set out in June, and after a rough train ride west across the Prairies — during which the locomotive repeatedly came uncoupled from the cars and had to return for them — he finally had the chance to sit down with his sketch box and attempt to capture images of the majestic ranges on panel or paper.[31]

But no sooner did he begin than he realized that this part of the country presented a whole new set of challenges to the landscape painter. He was accustomed to painting and drawing landscapes based on a horizontal plane; now he found himself dealing with steep verticals and other visual motifs that were entirely new to him. To make matters worse, the commission was to create large canvases to be hung in the lobbies of Canadian

Northern Railway hotels, which meant that experimentation and artistic licence were all but out of the question. Each mountain had to be rendered faithfully, so as to be instantly recognizable to guests and tourists.[32]

But despite these creative hardships, Jackson plugged away. From Jasper to Yellowhead Pass, he ventured far from the construction camps, climbing mountains and crossing glaciers in search of interesting subject matter. Beatty had worked as a fireman in his younger days — "a burly hock-and-ladderist in the Toronto Fire Brigade"[33] — but now, at age forty-five, he was considerably less athletic than the thirty-one-year-old Jackson and often declined to follow him when the going got too rough. "We'd start to climb a mountain but about halfway up Old Bill would have to lie down, panting," Jackson later remembered. "So I'd go on alone."[34] But the camp's chief engineer, who was responsible for the artists' safety, refused to allow Jackson to venture too far on his own. For the longer treks up the rugged slopes, he usually assigned one of the engineers to go along with Jackson to serve as a guide. A frequent climbing companion was an engineer named Bert Wilson, who knew his way around the mountains. He and Jackson would go for days at a time, camping out on the steep, rocky terrain in an open-sided tent fashioned from one large piece of canvas and a few poles consisting of stripped tree trunks.[35]

"You ought to see those prospector's boots I brought out with me, worn all to bits," Jackson proudly wrote to Dr. MacCallum. "I've been climbing eight and nine thousand feet to sketch, and using them for a pillow at night."[36]

On these trips, Jackson picked up much from Wilson and the other railway engineers about survival in the back country. "I learned from them how to get about in the mountains with neither blankets nor tent, on a diet restricted to bread, oatmeal, bacon and tea," he later wrote.[37] He also found mountain hiking to be exhilarating, not unlike many of the adventure stories he had loved as a child: "We took many chances, sliding down snow slopes with just a stick for a brake, climbing over glaciers without ropes, and crossing rivers too swift to wade, by felling trees across them."[38]

But despite the adventure, Jackson eventually had to admit that he did not find the Rockies very interesting to paint. He worked at it, hoping to capture the essence of the region on a panel, but the unavoidable truth, he wrote, was that "mountains were not in my line."[39] Just how well or badly Jackson managed to handle the Rockies will never be known because most of his sketches from this trip were subsequently destroyed. The Canadian Northern Railway soon went bankrupt, and the commissions promised Beatty and Jackson never came through. With no use for them, Jackson took to tossing his Yellowhead Pass and Mount Robson sketches into the furnace one by one until only a very few were left.[40] Among the surviving works are the oil sketch *Mount Robson*, now in the McMichael Collection in Kleinburg, Ontario, the pen-and-ink drawing *Vista from Yellowhead* in the National Gallery, and the odd pencil sketch that the artist evidently overlooked when feeding the furnace.

Jackson did, however, paint up at least one large canvas from this trip — *Mount Robson by Moonlight* — which hung in the Arts and Letters Club for the next four years. "Nobody seemed to like it much," Jackson recalled, "so when I came back to Toronto in 1919 I had it returned to the studio, and later I painted something else on top of it — I think it was *October, Algoma*."[41] When that painting, now titled *October Morning, Algoma*, was bought

for the University of Toronto's Hart House in 1932, it prompted Jackson to quip that they ended up acquiring two paintings for the price of one.

It may have amounted to an artistic failure for Jackson, but he always retained fond memories of his Rocky Mountain trip in the summer of 1914 — even though it ended on an extremely sour note. After one of his prolonged treks through the mountains, he returned to hear stunning news — word had reached the isolated construction camp that Canada was at war. It was not expected to last long, they said, but as one of the allied forces fighting against Germany, Canada was preparing to send men overseas.

The Red Maple in Algonquin Park

Through a series of letters between Jackson in British Columbia, Thomson in Algonquin Park, and Dr. MacCallum in Toronto, it was decided that instead of returning to the Studio Building, Jackson would continue straight through to Algonquin Park in time to sketch the early autumn foliage. Arthur Lismer and Fred Varley were also invited, and were expected in early October.[42] Jackson arrived at Canoe Lake around the second week of September and set up a camp with Thomson below Tea Lake Dam.[43] From there the two artists roamed the southwestern corner of the park, paddling through its network of lakes and rivers, carrying their canoe and supplies over rough portages, and sketching the rugged northern wilderness.

On this trip — the only time Jackson and Thomson would ever sketch together — the teacher-student relationship continued, but out in the bush the roles were reversed. Thomson could handle a canoe and get a roaring campfire going with seemingly little effort, and Jackson quickly picked up on these skills. The woodsmanship he learned from Thomson would prove useful for the rest of his life.

But when it came to painting, Jackson remained the patient teacher. As Thomson worked hard to perfect his technique, there was a danger that he might inadvertently adopt Jackson's unique style instead of developing his own. MacCallum knew this, and just before Lismer and Varley left Toronto for Algonquin Park, he took Lismer aside and asked him to relay this caution to Thomson. Up at the park a few days later, Lismer told Thomson he had a message from MacCallum. "Yes, and I know what it is," a stung Thomson replied, unable to hide his anger. "He said, 'You tell Thomson not to let that fellow Jackson influence him!'"[44]

This was certainly not the only time Thomson displayed a volatile temper. Jackson recalled an incident when Thomson, after struggling to get a sketch just right, suddenly threw his sketch box into the woods in a fit of frustration. Familiar with his friend's moods, Jackson wisely said nothing, and sure enough the next morning Thomson's confidence had returned. They crawled through the bush to recover Thomson's supplies, then took the broken sketch box to Bud Callighen for repairs.[45]

The arrival of Lismer, Varley, and their families no doubt livened up the trip, which was a productive one for all four artists. Thomson and Lismer both made sketches of Larry Dickson's shack, set amidst a stand of white birch trees. But while Thomson never worked his sketch up onto canvas, Lismer's *The Guide's Home*, later painted back in

Toronto, is a well-known example of Canadian Impressionism. By placing complementary colours side by side — dabbing dots of yellow and orange birch leaves against a deep blue sky — he was, as Jackson recalled, putting into practice a theory "which was probably the result of the animated discussions we used to have on the French Impressionists."[46] But while this technique worked well for Lismer on *The Guide's Home*, it was not effective in rendering many other Algonquin Park subjects. "We were all experimenting with broken colour at that time," Jackson wrote, "but it was too involved a technique to express the movement and complex character of our northern wilds."[47]

In a well-known photograph of the sketching party in Algonquin Park, probably taken by Maud Varley — the only known photo of Thomson and Jackson together — the myth of the rugged wilderness campers is quickly dispelled. Not only have the Lismers brought along their baby daughter, Marjorie, but while Thomson, Varley, and Jackson are dressed as woodsmen, Lismer sports a smart white collar and tie — hardly the attire of anyone spending a week in the bush. As it turns out, the Lismers and Varleys actually lived comfortably at Mowat Lodge for the duration of their stay while Jackson and Thomson remained camped in a tent among a secluded stand of birch trees.[48] Still, those few weeks in Algonquin Park proved to be extremely beneficial for all four artists, introducing Varley to the northern wilderness and providing Jackson, Lismer, and Thomson with sketches for canvases that would be hanging in the National Gallery within a year — respectively *The Red Maple*, *The Guide's Home*, and *Northern River*.

But throughout the otherwise happy sketching trip, the ongoing events in Europe weighed heavily on everyone's mind. The news from overseas was still bleak as they prepared to leave Algonquin Park, and "the return to town, that should have been jubilant, was sobered by the menacing, unfamiliar spectre of war."[49] This was especially worrisome for the bachelors Jackson and Thomson, who knew they might soon be obliged to trade their paintbrushes for rifles — and the very idea horrified them.

7

CALLED TO THE TRENCHES

"YOU SAID YOU WOULD GO WHEN YOU were needed; you are needed *now*!"

"Get into a man's uniform!"

The urgent words on recruiting posters seemed to be everywhere one looked in the big cities by the autumn of 1914. Boldly illustrated with caricatures of the noble John Bull and the sinister Kaiser Wilhelm, they stood as a constant reminder of the chaos and carnage spreading across Europe. Like the war itself, they were impossible to ignore.

Even deep in the peaceful wilderness of Algonquin Park, about as far removed from the battlefields of France and Belgium as one could get, the war was foremost on everyone's mind. The Toronto newspapers, arriving at Mowat Lodge by mail or carried in from nearby Huntsville, kept the artists well informed on the latest developments overseas. As the bright autumn colours gave way to the dull greys and browns of November, the dominant subject of conversation was how Germany was proving to be a much more formidable foe than anyone had anticipated. Still, the common belief was that the Allied forces would soon prevail and it would all be over before Christmas.

This was likely the main factor in Jackson's decision to put off joining the war effort. It seemed pointless to go through the whole process of enlistment and physical training, only to be told the war was over. But by late autumn of 1914, when he returned to Toronto from Algonquin Park, "the recruiting sergeants were on every downtown corner."[1] To make matters worse, the war was having a devastating effect on the art market. It had been difficult enough earning a living as a landscape painter before the war — now it would be almost impossible. Even commercial art jobs had become scarce, as all eyes were on Europe.

Thomson was especially upset by the war. Soon after returning from Algonquin Park, he spent one November afternoon standing on the corner of Yonge and Bloor streets with Fred and Maud Varley, watching as thousands of recruits marched past, eight abreast. "Gun fodder for a day," Thomson muttered. "Six months, hell! Three or four years it must be!"[2]

War had recently been declared in Europe when four artists gathered in peaceful Algonquin Park in the autumn of 1914. In the back, from the left, are Tom Thomson, A.Y. Jackson, and Arthur Lismer; in front are Fred Varley, baby Marjorie Lismer, and her mother, Esther

Jackson spent most of November in the Studio Building, painting canvases from his Rocky Mountain and Algonquin Park sketches — most notably *The Red Maple*, a study of crimson leaves against the dark water of a rushing brook he had come across while camping with Thomson below Tea Lake Dam.[3] But as he worked on the canvas, adding dashes of bright autumn colours to the opposite shore and swirls of foamy white to the water,

the problems of the war and his own immediate future weighed heavily upon him. Dr. MacCallum's year of support was about to expire, and there were no financial prospects on the horizon. He decided to return to Montreal — where his official place of residence was still the Jackson home on Hallowell Avenue — to spend Christmas with family and friends. Then, if the war still had not ended, he would enlist. If nothing else, a stint in the army would certainly solve his immediate problem of how to earn a living.

The Home Front

Montreal had changed in the nearly two years since Jackson's return from Europe. It was now a city at war. Newspaper headlines boldly relayed battle news from overseas on a daily basis, and everywhere Jackson turned were carefully worded recruiting posters designed to play on the conscience of any able-bodied young man yet to don a uniform. The war even dominated everyday life in the Jackson home, as younger brother Bill had enlisted in the 14th Battalion (Harry, the eldest brother, was by now a family man living in Montreal West, and Ernest had moved to Lethbridge in 1906).[4] Directly across the street from the house, the Montreal Amateur Athletics Association grounds had been handed over to the military. The playing field was now being used for training and drilling, and the clubhouse would soon be pressed into service as a small convalescent facility for wounded soldiers.[5]

Lawren Harris offered to pull some family strings to help Jackson secure an officer's commission, and would contribute toward any costs involved. This was probably because at age thirty-two, Jackson was sure to be considerably older than most of his fellow recruits. But Jackson declined his friend's kind offer, insisting that he knew nothing about the military and should therefore start at the bottom of the ladder, like everyone else, as a private.[6]

Still hoping for news of a German surrender, Jackson bided his time. His old Paris friend William Clapp — recently returned to Montreal from Europe a deeply committed Impressionist who was producing striking canvases consisting entirely of tiny dabs of colour, clearly inspired by both Claude Monet and the Pointillist Georges Seurat — fell ill and asked Jackson to substitute teach the life class he taught. The prospect of earning a few dollars could not be turned down, so enlistment was delayed while Jackson spent much of January 1915 in a classroom.[7]

The urgency for recruits seemed to suddenly decline as fresh rumours of imminent victory spread through Montreal. Again, Jackson decided to wait; as soon as March arrived, he packed up his painting materials and headed for the familiar serenity of Émileville and the hospitality of the Guertin family.[8]

Émileville was a happy place for Jackson; it was here that he had received the momentous letter from Jim MacDonald that led to his move to Ontario and the heady events of the past two years. He was in his element here, and the trip was a productive one. During this time he painted *Spring, Lower Canada* — a warm, tranquil study of bare trees and patches of melting snow for which he was able to bring a canvas outdoors and paint on the spot, just as he had for *The Edge of the Maple Wood* five years earlier.[9] From bold foreground shadows to metal buckets hanging on maple tree trunks, the mood of *Spring,*

Lower Canada is quite similar to the Sweetsburg canvas which had opened so many eyes in Toronto.

But even the peaceful farmland and rolling hills of Quebec's Eastern Townships could not provide complete respite from the war, and the obligation to enlist weighed heavily upon Jackson during this trip. He had spent some of the happiest years of his life in France and felt a deep attachment to the country and its people.[10]

"The war has disturbed me too much to make any great progress," he wrote to Dr. MacCallum.[11] After all, Randolph Hewton, who had accompanied him to Émileville in early 1913, was about to be sent to England with the 24th Battalion,[12] and Albert Robinson had joined the war effort as an inspector at Dominion Copper Products, Ltd., a munitions plant at Longue Pointe, in Montreal's east end.[13] It seemed that everyone Jackson knew was either joining up or had already been sent overseas.

While at Émileville, Jackson heard about the brave stand by Canadian infantrymen at Saint-Julien during the Second Battle of Ypres, which raged in northwest Belgium from April 22 to May 25. This was when the Germans surprised the Allied forces with their new deadly weapon — clouds of poisonous chlorine gas that drifted out over the front lines and asphyxiated anyone in their path. Those who were not killed outright by the fifteen-foot-high walls of gas were flushed out of their trenches and into the sights of German rifles. At Saint-Julien, however, Canadian troops managed to fight through the deadly fog and hold the line — despite devastating losses. Back home, news of Germany's new advantage and accounts of the Canadians' heroics caused anger and resentment — and another rush to recruiting offices. For Jackson, it proved to be the decisive moment: "At the railway station one morning I heard the first news of the Battle of Saint-Julien," he later wrote. "I knew then that all the wishful thinking about the war being of short duration was over."[14]

Things moved swiftly from there. Jackson returned to Montreal, and on the morning of June 14, 1915, he enlisted as a private in the 60th Infantry Battalion[15] — nicknamed the "Silent Sixtieth" — and prepared for transfer to the military base at Valcartier, north of Quebec City, for basic training. As expected, he was as much as twice the age of the youngest recruits on the train, and from the outset was probably expected to fill an unofficial leadership role for his fellow privates. Jackson was certainly self-conscious of his age, for on his enlistment papers the year of his birth is repeatedly given as 1883 and his age thirty-one years and eight months — a year younger than he actually was.[16] This date remains consistent on official documents throughout his military career — even those filled out by Jackson himself — evidence that it was deliberate rather than a mere clerical error.

With only two weeks before he was to be transferred to Valcartier, Jackson was issued his uniform and spent time with family and friends, not sure if this was the last time he would ever see them. During this time he dropped in to see Hewton's mother, Marion Miller Hewton, at the Miller home on Bishop Street, probably to hear the latest news of his friend, who had shipped out a month earlier. It was here that Private Jackson was photographed in his immaculate new uniform, his chest thrust out proudly.

But just as Jackson the soldier had committed himself to the war effort, Jackson the artist received some good news from Ottawa: after being shown in the Royal Canadian Academy exhibition, *The Red Maple* had been bought by the National Gallery. Along with *Autumn in Picardy* and *Sand Dunes at Cucq*, it became one of three works in the gallery to

represent Jackson, all acquired within the space of a year. Of course this was a source of great pride for the novice infantryman, and it turned out to be this accomplishment, not his age, that singled Jackson out among the recruits. The gallery's purchase of *The Red Maple* and Lismer's *The Guide's Home* was soon announced in the press, and on June 29 the *Montreal Gazette*, encouraging enlistment by running a series of articles about the high calibre of men who were joining up, published an item about Jackson as a well-known artist who had joined the war effort:

> When the first five hundred men of the 60th Battalion, under Lieut.-Col. F.A. Gascoigne, entrain at the Windsor street station tomorrow night for Valcartier, the force will have on its strength Private A.Y. Jackson, artist, and an associate of the Royal Canadian Academy ... Mr. Jackson a few years ago travelled through Belgium, sketched its landscapes and its historic monuments, and in that time of peace and prosperity saw the cities that have since been devastated by the Germans — Bruges, Brussels, Antwerp, Liege and Namur. Now he is anxious to battle on that soil in the common cause.[17]

The article also mentioned the recent enlistments of Hewton and artist Leigh Keene, as well as brother Bill Jackson's promotion to first lieutenant after surviving the Second Battle of Ypres. This information was erroneously attributed to Henry A. Jackson, the soldiers' father, who was living in Chicago, not at 69 Hallowell Avenue, Westmount, as indicated.[18]

Though no doubt flattered by the attention after struggling for so long to establish a name for himself as a painter, Jackson later recalled that upon reading the article his immediate superior was so embarrassed to have a minor celebrity in his platoon that he took to addressing the recruit as Mr. Jackson.[19]

Basic training at Valcartier lasted four months, during which time the rowdy young Montrealers were forced to test the limits of their endurance and were slowly transformed into soldiers. They were subjected to intense physical exercise, trained in hand-to-hand combat, and taught how to handle a rifle and bayonet. "Sunburned, hardened, disciplined, few would have recognized in us the ill-assorted, motley crowd of civilians that had left the city such a brief time before," was how Jackson later described the recruits' homecoming following basic training.[20] But after only a few days' rest in Montreal in early November 1915, Private Jackson was back with his comrades aboard the steamer SS *Scandinavian*, bound for England as part of the Third Canadian Division. Three more months of marching, musketry, and bayonet training awaited them in the mud and rain at Bramshott Camp in Hampshire.[21] After that, it was down to business; as Jackson described the atmosphere among the ranks, "the flag waving was over."[22]

The Trenches of Flanders

The "Silent Sixtieth" of Montreal became part of the Ninth Infantry Brigade, along with the 43rd Battalion from Winnipeg, the 52nd from Port Arthur, Ontario, and the 58th

from the Niagara region. They arrived in Le Havre, France, on February 22, 1916, Jackson recalled, marching "in snow and slush, with no one taking any notice of us."[23]

Perhaps because of his maturity, Jackson was soon assigned to the battalion's signal section, where he oversaw the operation of a telephone station some distance behind the front lines.[24] Sketching was all but out of the question. Aside from the odd pencil drawing dashed off during a few quiet moments, the hectic life of an infantry private left no room for him to practise his craft. He did, however, put his talents to use on several occasions by copying maps and drawing plans for strategic manoeuvres.

Although he was eventually moved up to the front lines and certainly saw plenty of action throughout the spring of 1916, for Jackson the horrors of trench warfare actually lasted less than four months. His unit was in the thick of the fighting in the notorious region of Sanctuary Wood, just outside Ypres — the scene of some of the most brutal battles of the war. The lines of Allied trenches that cut through the forest formed a complex network of tunnels, bunkers, and listening posts, all fortified by sandbags, wooden planks, and barbed wire. More often than not, the trenches were filled with rainwater and mud. The men were filthy, wet, cold, hungry, deprived of sleep, and crawling with lice — and things got worse with every German offensive. Many of the men prayed for a blighty (British slang for England, adopted by soldiers to mean a wound serious enough to require safe shipment back across the Channel).[25]

Jackson would write very little of his actual combat experiences, but did recall one particular day, June 3, 1916, in a letter written on that same date in 1932: "I was just think-

The Red Maple, November 1914. Jackson painted this canvas in the Studio Building from a sketch he had made near Tea Lake Dam in Algonquin Park. Within months it would be bought by the National Gallery of Canada — and cause him some embarrassment when he joined the army. *Oil on canvas, 82.0 x 99.5 cm. © National Gallery of Canada, Ottawa. Courtesy of the estate of the late Dr. Naomi Jackson Groves.*

ing back to another June 3rd crawling along a trench in Sanctuary Wood, and an aeroplane circling overhead like a big hawk, signalling to the artillery who were trying to blow us up. It was a day of glorious sunshine and only man was vile, in general, individually they were magnificent. I thought a cup of cocoa in a dressing station was an undreamed of luxury."[26]

The use of biplanes was a new development in modern warfare that proved effective for both sides. That they were invented by Jackson's Georgian Bay neighbour and "milkman" Orville Wright was a bitter irony that could not have been lost on him as he huddled in the mud, desperately trying to avoid detection from above.

Just over a week later, on June 11, during a heavy barrage by German artillery at nearby Maple Copse, Jackson received his blighty. This came in the form of either a bullet or shrapnel in his left shoulder and an unspecified wound to his hip. Though

not life-threatening, the wounds qualified Jackson for a long period of convalescence that began with a dreary train ride straight into familiar territory on the French coast — a small medical unit run by McGill University amidst the sand dunes and pine trees of Éta-ples.

As good fortune would have it, old friend Arthur Baker-Clack and his wife were still living at Étaples, and Jackson was able to send word of his arrival to them through the efforts of the unit chaplain.[27] The two artists had the most cheerful reunion possible under such circumstances, reminiscing about their carefree days of 1912 — just four years earlier, but seemingly a lifetime ago.

"Where were you hit, Jackie?" Baker-Clack asked.

Upon hearing the hoarse reply, Baker-Clack burst out laughing and recalled a letter Jackson had written from Montreal about a year earlier, in which he had wryly predicted that he would soon end up in Étaples with a bullet in his shoulder.[28]

The stopover in northern France was a short one, and the next year was difficult for Jackson — possibly the lowest point of his life. His wounds healed well, but he soon found himself back in England, shuttled from one dreary convalescent hospital to another. It was a miserable existence; from Norwich to Brundall to Epsom he was sent, then on to the Channel coast at Hastings, where he managed to wrangle himself a light-duty assignment in the army post office. This he quickly came to regret, for the detail was excruciatingly dull; there was so little to do that the biggest challenge was to appear busy whenever an officer appeared. To relieve the boredom, the men frequently opened letters and searched them for intimate, racy passages — intended for or written by wives and girlfriends — which they would read aloud to each other.[29]

Throughout it all, the war showed no signs of slowing down. Now nearly fully recovered from his wounds, Jackson lived under the constant threat of being sent back for more action in the "suicide ditches" — soldier slang for the front-line trenches.

At War in Toronto

Despite these constant upheavals, Jackson remained a prolific letter writer throughout the war. He managed to keep in touch with dozens of friends, relatives, and fellow artists back home, and was even able to arrange for his paintings to be included in various exhibitions. Georgina Jackson continued to promote her son's interests in Montreal, while J.E.H. MacDonald acted as a kind of unofficial agent in Toronto.

MacDonald, too old and physically unfit for military service, faithfully kept Jackson up to date on all the latest developments on the Toronto art scene. The mild-mannered artist had much to write about in March 1916, when he inadvertently became known as the most radical painter in Toronto after some of his new canvases where shown in the Ontario Society of Artists exhibition. Conservative critic Hector Charlesworth, writing in *Saturday Night*, viciously attacked MacDonald's work, accusing him of throwing his paint pots in the face of the public — a well-known line appropriated from John Ruskin's notorious attack on Whistler more than a generation earlier.

Charlesworth liked MacDonald's *Laurentian Village, October*, but continued:

Across the gallery from it, however, is his *Tangled Garden* which a discriminating spectator attempted to praise by saying it was not half so bad as it looked. In the first place the canvas is much too large for the relative importance of the subject, and the crudity of the colours, rather than the delicate tracery of all vegetation seems to have appealed to the painter; but it is a masterpiece as compared with *The Elements* or *Rock and Maple* which for all they really convey might just as well have been called *Hungarian Goulash* and *Drunkard's Stomach*.[30]

The artist, from all accounts a quiet, polite man not normally given to confrontation, rose to the occasion and struck back at Charlesworth with his pen. Nine days later Toronto's *Globe* ran MacDonald's rebuttal, entitled "Bouquets from a Tangled Garden," in which he made it clear that he and his fellow Studio Building artists were committed to seeing their vision of a new Canadian style of art through to fruition. He wrote:

One makes no claim that *The Tangled Garden* and other pictures abusively condemned by the critics are genuine works of art merely because of their effect upon them, but they may be assured they were honestly and sincerely produced. If they planned to "hit" anyone anywhere it was in the heart and understanding. They expect Canadian critics to know the distinctive character of their own country and to approve, at least, any effort made by an artist to communicate his own knowledge of that character … *The Tangled Garden* and a host more, are but items in a big idea, the spirit of our native land. The artists hope to keep on striving to enlarge their own conception of that spirit.[31]

With this, MacDonald was pushed to the forefront of the critical battle. His reputation as an outspoken rebel was assured — much to his own dismay, as the war had placed a significant strain on the art market and the cash-strapped family man could not afford to lose sales in conservative Toronto as a perceived radical.

Tragic News from Home

From Hastings, Jackson was sent down the coast to a reserve unit at Shoreham, which was described as more of a prison than a training camp.[32] The food was terrible and in short supply — much worse than the already low-quality rations to which the infantrymen were accustomed. The base was run by tough, overly zealous military policemen, and, worst of all, the men were being trained for reassignment to the front lines by incompetent officers who had never been to France or Belgium themselves. It was so bad, Jackson recalled, that during a German air raid some men actually prayed for a bomb to find the base.[33]

Jackson was miserable at Shoreham; a medical officer had refused to endorse his application for a promotion to lieutenant, citing physical unfitness — yet was only too glad to recommend his return to active duty.[34] But things hit rock bottom when he received the devastating letter from MacDonald in the late summer of 1917, which told of an "empty canoe and an artist missing in far away Algonquin Park."[35]

The news of Tom Thomson's drowning in Canoe Lake hit Jackson hard. Throughout the war, no matter how tough things got, he had always been able to keep his spirits up by reminding himself that once it was all over he would soon be back in Algonquin Park, sketching with Thomson. Now, he realized, that could never be. "I could sit down and cry to think that while in all this turmoil over here ... the peace and quietness of the north country should be the scene of such a tragedy," a grief-stricken Jackson wrote back to MacDonald from Shoreham in early August. "Without Tom the north country seems a desolation of bush and rock. He was the guide, the interpreter, and we the guests partaking of his hospitality so generously given."[36]

Thomson's Legacy

After Jackson had left for Montreal in late 1914, Thomson found that he could not afford even the nominal rent charged by Harris, so he ended up sharing Studio One with the young commercial artist Frank Carmichael for a few months. When Carmichael left to get married, Thomson moved his fishing gear and painting supplies into a large, somewhat dilapidated old shed behind the Studio Building. Harris and Dr. MacCallum paid to have the shack renovated and charged Thomson just one dollar per month to live there. The rustic conditions suited Thomson perfectly; he spent two winters living in that shack as if it were a cabin in the deep woods — even though he was a five-minute walk from the corner of Yonge and Bloor streets. At the first sign of spring he headed north to Algonquin Park, where he remained until late autumn. He only retreated back to the shack behind the Studio Building for the coldest winter months of 1915–16 and 1916–17, which was when he painted most of his major canvases, including *The Jack Pine* and *The West Wind*.

The bitter irony of Thomson's death was twofold: Unlike thousands of other Canadians, he had not been killed on the battlefield, but instead in the peaceful, safe environment of Algonquin Park. It was also considered absurd that an expert canoeist should overturn his boat and drown just a few yards from shore in a lake he knew intimately.

The story of Thomson's mysterious death has been retold many times and has evolved over the decades into one of the great legends in Canadian culture. Theories that he was murdered — which were either supported or denied by his friends, depending on the source — grew from rumours that he was carrying on an affair with a local woman who had a jealous husband. Evidence found on the body, which turned up a week later, support the murder theory to some extent. Fishing line was wrapped around Thomson's leg and there was a gash on his forehead — but that has been countered by the equally feasible hypothesis that Thomson died alone as the result of a freak accident. The fishing line could have served as a splint to support a twisted ankle, and Thomson, who was known to enjoy a drink and sometimes brought a bottle of whiskey along on fishing trips, could easily have stood up in the canoe to relieve himself, lost his balance through either a bad ankle or tipsiness, and knocked himself unconscious on the rim of the overturning canoe.

But for Jackson, an ocean away and facing the bleak prospect of being ordered back into the trenches any day — most likely to die himself — the means of Thomson's demise was irrelevant. Either way, he had lost his friend and Canada had lost its most promising

talent. From their first meeting in Harris's studio in late 1913 to the few weeks in the Studio Building after their return from Algonquin Park in late 1914, Jackson had known Thomson for only a year, and the two had been on just one sketching trip together. But the influence the two painters had on each other was profound. Jackson had taught Thomson much about the art of painting, and Thomson had taught Jackson much about handling a canoe and camping in the wilderness — skills that would serve him well for the next fifty years.

For the rest of his life, Jackson would never commit himself to any of the theories surrounding Thomson's death, probably because he was so far removed from Algonquin Park when it occurred. "The mystery surrounding Thomson's death will never be cleared up. Was he drowned in the quiet waters of a small lake? A man who had paddled all over the Park, generally alone, in all kinds of weather, run rapids, and carried his canoe over rough portages and made his camp in the bush in wolf-ridden country?" he wrote half a century later. "There were theories — suicide, heart attack, foul play, but the verdict was 'Accidental drowning' — not very convincing; but with no evidence of anything to the contrary, it stands, and must be accepted."[37]

Jackson could not mourn his friend for long; he had his own problems to worry about. By the summer of 1917, the 60th Battalion had been officially disbanded. Those of its members who were not dead, maimed, gassed, or shell-shocked were scattered throughout Western Europe. The Allied forces were preparing for a major offensive against the Germans, and every able-bodied man was needed — much to the horror of those who had already been at the front.

It was at this lowest point that Jackson was saved from what seemed a certain death in the trenches. One day shortly after receiving the news of Thomson's drowning, he was hard at work digging a latrine at the Shoreham base, "adding his own quiet curses to the more outspoken ones of his comrades,"[38] when he suddenly heard his name called out by the commanding officer. Dropping his shovel, he quickly brushed away the dirt from his fatigues and presented himself. He was told he had a visitor — Captain Ernest Fosbery, a well-known Canadian portrait painter in civilian life, now attached to the Canadian War Memorials Fund. The two had never met, but they knew each other by reputation. Private Jackson's first impulse was to snap to attention and salute the captain, but Fosbery quickly put him at ease. "Forget all that stuff," he said with a friendly wave of his hand. "We're both artists together."[39]

The ensuing conversation changed everything for Jackson.

8

ART ON THE BATTLEFIELD

MAX AITKEN, THE FIRST BARON BEAVERBROOK, was a short, balding, dapper man only three years older than Jackson, but his presence was enormous. As director of the Canadian War Memorials, the New Brunswick–born newspaper tycoon was all-powerful; with the stroke of a pen he could remove a man from the infantry and secure his reassignment as a war artist.

Jackson had taken the train up to London and arrived early for his appointment with Beaverbrook at his Clifford Street office. He waited nervously until the door burst open and, with an air of pomp and authority, Lord Beaverbrook breezed in and sized up the thin, scruffy private with a glance. After shuffling some papers on his desk, he looked Jackson straight in the eye. "So you are an artist! Are you a good artist?"

"That is not for me to say, sir," Jackson replied modestly.

"Have you any of your work with you?"

"I have been in the infantry for over two years and cannot carry it with me."[1]

From there the conversation centred around where Beaverbrook might see examples of Jackson's painting. He was not about to hire an artist for the Canadian War Memorials staff without approving his work, but there was no way Jackson could have his canvases sent over to England for inspection. Luckily, he remembered *The Studio*, a London-based magazine that had published articles on him — one of which even went so far as to call him the "coming man" and "a young artist of unusual promise."[2] Desperate to get away from Shoreham and certain death in the trenches, Jackson hurried over to the magazine's headquarters and managed to find the back issues in which his work had been reproduced. These he brought back to Beaverbrook, who was impressed not only by the artwork but by the article that mentioned the sale of Jackson's Algonquin Park canvas *The Red Maple* to the National Gallery of Canada. Jackson tactfully neglected to tell him, however, that the flattering articles had been written by his good friend Montreal-based art critic Harold Mortimer-Lamb.[3]

As Fosbery had explained to Jackson during their meeting at Shoreham, the Canadian War Memorials Fund was a pet project of Lord Beaverbrook, who was the owner of the *Daily Express* newspaper and several other enterprises in London. He had set up the CWMF to ensure that the deeds of Canadian soldiers would not go unrecognized. Beaverbrook had written a book on the early stages of the war, *Canada in Flanders*, and in doing so realized there was a woeful lack of photographs showing the Canadian troops in the field. Their valiant efforts, he believed, were going largely unrecorded. This was especially true of the Second Battle of Ypres, where there had been no photographers present to chronicle the Canadian forces' heroic stand against the German gas attacks.[4]

Beaverbrook also felt that mere photos could never capture the emotional impact of life at the front — the horrors and heroics of trench warfare. Moreover, photographs could easily be doctored or faked. There was also the question of permanency. In 1917, the problem of eventual deterioration of photographic prints and negatives had not been fully solved. On the other hand, a painting could last for centuries.

When Beaverbrook first established the CWMF, only British artists were employed. Fosbery had seen the English painter Richard Jack's portrait of General Arthur Currie, commander of the Canadian Corps in Europe, and wondered why Canadians could not also be recruited for the job. Although he later learned that Jack had not painted Currie as a CWMF assignment, Fosbery took his idea to Beaverbrook, who rewarded his initiative by assigning him the difficult task of tracking down artists currently serving in the Canadian forces. Naturally, Fosbery put himself forward as an ideal candidate, while the names of A.Y. Jackson and J.L. Graham also topped the list.

Seeking an informed opinion on these artists, Beaverbrook cabled his friend Sir Edmund Walker, a familiar face at the Arts and Letters Club who was by now well acquainted with Jackson, Harris, and the other young Toronto painters. Walker replied that Fosbery and Graham were "good draughtsmen" and described Jackson as an "able impressionist."[5]

In the meantime, Fosbery set out on his search for Jackson, who could be in any trench or reserve unit in England, France, or Belgium. As luck would have it, Lilias Torrance, the Montreal artist who would later become one of Canada's foremost portrait painters and a member of the Beaver Hall Group, was working at a Red Cross information desk. She knew Jackson through the tightly knit Montreal art circle, and happened to know where he was stationed. She directed Fosbery to Shoreham.[6]

Sure enough, Jackson was summoned to London a few days after meeting Fosbery, this time to be interviewed by Beaverbrook himself. Armed with the copy of *Canada in Flanders* he had hastily purchased at the Shoreham station to read on the train in order to fully prepare himself for the meeting, the nervous artist turned up at the Clifford Street office of the CWMF.

But despite making a favourable impression on Beaverbrook with his *Studio* magazine articles, Jackson was not taken on right away. He reluctantly returned to dreary Shoreham after the interview and continued his training for reassignment to the front. Morale at the base was worse than ever, and Jackson found himself in the middle of a mutiny — the men of his company refused to go on parade, and they elected the older, more mature "Jackie" as their spokesman.[7] He spent a few days in this awkward position, careful to remain on friendly terms with his commanding officers so as not to jeopardize his impending reassignment, and not daring to let on to his fellow privates that he was about to leave them for a safe, privileged posting while they were all going back to the trenches. Luckily, his CWMF orders came through before the call to the front, and he was dispatched to London.

Shortly after his departure, he learned that his Shoreham comrades had all been sent to fight in the bloody Passchendaele campaign, where most perished.[8]

In a subsequent meeting with Beaverbrook, Jackson was duly informed that war artists, in order to properly carry out their duties, required a degree of authority considerably

beyond that of a mere private. Beaverbrook solved that problem with one sentence: "Make this man a lieutenant!" he barked at his assistant.[9] And, as Jackson later recalled, it was done — his temporary commission of honorary lieutenant came through on August 13, 1917. With that, Jackson became the first Canadian war artist to join the CWMF staff.[10] He had been saved from the trenches and instead would spent the rest of the war as a soldier in the "Konodian Army" — named for the Hungarian-born art critic Paul Konody, Beaverbrook's close advisor on the war art project.[11]

As the War Records program was in its infancy, there were inevitably a few bugs in the system. The first glitch manifested itself on Jackson's very first assignment. Expecting to paint some kind of landscape, he was instead ordered to paint the portrait of Private J.C. Kerr of the 49th Battalion, who had recently been awarded the Victoria Cross. Despite his immediate protests that a portrait artist would be much better suited for the task, Jackson was assigned a studio at 3 Earl's Court and sent there to meet Kerr and paint his portrait. He worried that failure might mean dismissal from the CWMF staff and an unceremonious return to Shoreham — or worse, the trenches.

The portrait progressed slowly. As a confirmed landscape artist, it had been years since Jackson had made any serious attempt to paint the figure. He was repeatedly forced to scrape down the canvas and start again — much to the amusement of his sitter, who was just grateful for the ten-day leave he had been granted to sit for the portrait. Between Kerr's repeated suggestions that they forget the day's work altogether and visit some local pubs,[12] Jackson struggled through the assignment and finally managed to capture a passable likeness — although it has been pointed out that he left Kerr's legs looking like a pair of wooden matchsticks.[13] Though still officially a private when he began the portrait, Jackson received his promotion and new uniform the day before his final appointment with Kerr, who was amused to have had his portrait begun by a private and finished by a lieutenant.

The rank of lieutenant and war artist provided Jackson with the freedom and respect he had missed as an infantryman. The promotion also meant a substantial raise in salary to two dollars per day, subsidized by a sixty-cent field allowance to help cover daily expenses. This was more money than he had ever earned in his life.[14] But the new rank and position did nothing to better his opinion of military protocol. He found the compulsory act of saluting particularly embarrassing. Whereas Private Jackson had avoided saluting officers by taking alternate routes down quiet side streets, Lieutenant Jackson now had to keep to the busy main roads to avoid being saluted.[15]

Shattered Landscapes

There was one year left in the war when Jackson embarked upon the first of his two excursions to paint the battlefields of France and Belgium. He crossed the Channel after completing the portraits of Kerr and a few other Canadian heroes, and went directly to the region of Vimy Ridge in France, where the Canadian Forces had distinguished themselves the previous Easter by slamming the German lines with a concentrated assault that ended in their taking the six-kilometre ridge in a single day.[16] From there he followed

infantry units as they moved up and down the front lines. He sketched throughout the Vimy-Lens sector, from the ruins of Ablain Saint-Nazaire and Cité Jeanne d'Arc near Hill 70, eventually making his way north to the familiar wasteland of trenches in Flanders.

When attached to infantry units in the field, Jackson often found that he was not immediately welcomed by the men. Naturally, they resented his safe, privileged role of war artist — painting the battlefields from well behind the lines while they were risking their lives up at the front. But this all changed as soon as they learned he had served two years in the infantry and had received a serious blighty near Sanctuary Wood. Then, Jackson recalled, they couldn't do enough for him.[17]

"I was a little bit ashamed of meeting my old friends," he later said of his fellow infantrymen. "They were trudging around in the mud while I was going around in a car — kind of a bigshot, you know, making studies."[18]

Back in the Belgian town of Ypres, not far from where he had been wounded, Jackson sketched poignant scenes that conveyed the horrors of war without showing any actual combat. "War had gone underground, and there was little to see," he wrote of the frustrations he first encountered.[19] From chlorine gas to artillery that could shell a position from several kilometres away, modern technology had in many cases eliminated the need for adversaries to face each other. Even in the trenches, much of the fighting was done at night, the enemy fire often coming from an unseen point somewhere off in the darkness. These innovations forced war artists to rethink the entire concept of rendering modern warfare, as Jackson wrote:

When the War Records of World War I were organized, the artists started off thinking in terms of the kind of war art popularized by the *Graphic* and the *Illustrated London News*. It gave one the feeling of something left over from previous wars, the old stock poses, the same old debris lying around like still life, and smoke drifting around whenever the composition gave trouble.

The machine gun had destroyed the old death and glory picture which depended on a mass of cavalry or infantry hurtling forward with the shot-riddled flag clutched in the stricken hero's hand. There pictures were mostly painted by artists who had no first-hand information and it was not long before we realized how ineffective they were.[20]

Jackson found a way to express himself in his familiar landscape style by showing the horrible aftermath of battle. He painted burnt-out buildings, shattered trees, bomb craters filled with stagnant water, and open areas criss-crossed by barbed wire and strewn with heaps of debris. He knew that by painting what would have otherwise been peaceful landscapes, now battered beyond recognition by the modern war machine, he could instil in the viewer a sense of devastation that could be measured in human terms.

Nowhere is this more evident than in *Houses of Ypres*, which Jackson sketched on

Houses of Ypres, 1917. Jackson used a unique composition to convey the harrowing effects of battle on the historic Belgian town.
Oil on canvas, 63.5 x 76.2 cm. Beaverbrook Collection of War Art, © Canadian War Museum. 19710261.0189.

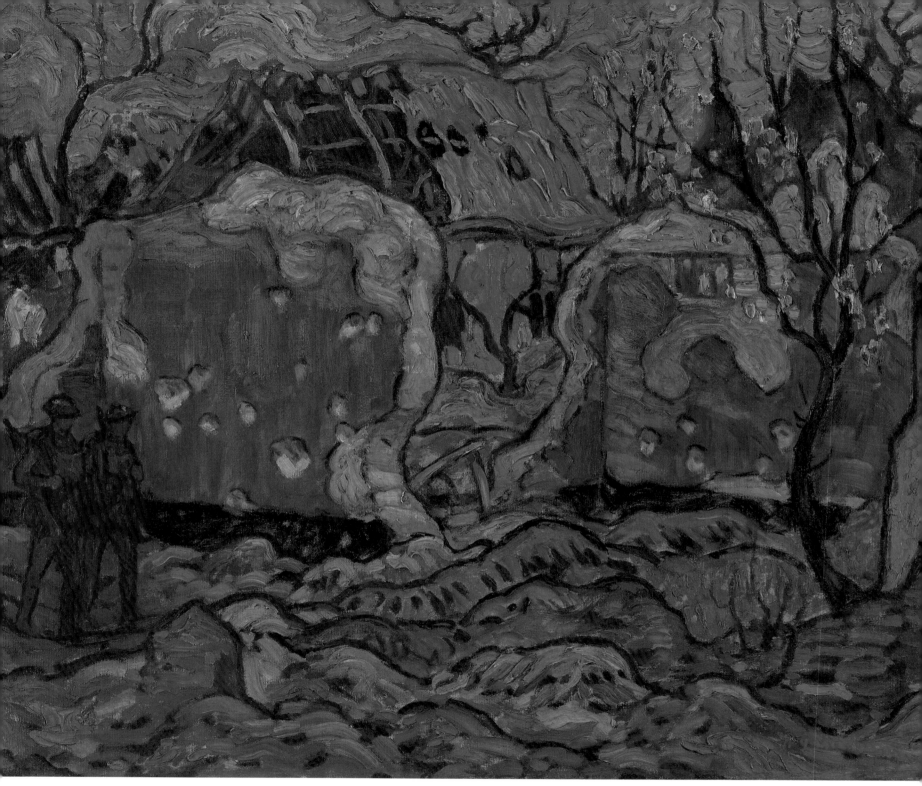

Springtime in Picardy, 1919. Jackson emulated the style of Vincent van Gogh to show the devastated farm-house — which could have been painted by van Gogh in happier times, thirty years earlier. This remained Jackson's favourite among all his war paintings.

Oil on canvas, 65.1 x 77.5 cm, 2544 2951. Art Gallery of Ontario, Toronto, gift from the Albert H. Robson Memorial Subscription Fund, 1940. Courtesy of the estate of the late Dr. Naomi Jackson Groves.

November 2, 1917.[21] The finished canvas, rendered in sombre earth tones of brown, ochre, and green, shows a row of houses so badly bombed that the central building is little more than a bare frame. A few members of a passing cavalry unit can be seen through the resulting gap, and beyond them the devastation extends all the way down the street. The domestic subject matter reminds the viewer that until recently a family was living here. Their home is no more. Of course Jackson could not show what happened to them; the viewer is left to fill in the blanks. *Houses of Ypres* is typical of Jackson's approach to war art. While other artists flocked to paint the ruins of the town's prominent public buildings, most notably the Flemish Cloth Hall — "one of the medieval architectural marvels of Northern Europe"[22] — Jackson preferred to focus on the smaller, private tragedies.

Near the town of Lens in northern France, Jackson came across a house that inspired him to sketch what would become his favourite canvas from the war. It was a simple farmhouse, probably several centuries old, which had been destroyed by artillery shells. An entire side had been blown off, exposing the interior rooms, whose walls were painted a deep blue. With the exception of soldiers prodding through the rubble, the entire area was deserted. There can be no doubt that Jackson was conscious of how this peaceful farmhouse scene would have attracted Vincent van Gogh, had the Dutch artist stopped there some thirty years earlier — for in the finished canvas, *Springtime in Picardy*, Jackson purposely emulated van Gogh's style from the intensely bright colours to the long, swirling brushstrokes. He even added a touch of overt symbolism — in the midst of the devastation grows a healthy young peach tree, its pink blossoms suggesting hope for the future.

Field Notes

It was during this period that Jackson perfected a system of taking visual notes that he would use for the rest of his life. In the field, often close to the front lines, he had very little time to sketch in oil, as was his custom back home. He worked mostly in pencil on paper, quickly adding as much detail as possible, then using a series of shorthand notes to later remind himself of the colours. To this he incorporated a self-conceived system of numbers to indicate "the relative light-dark values of parts of the composition, the range being one to ten, light to dark."[23] His scrawled notations would appear as "warm grey 7 ½ or highlights cool 2."[24] As this quickly became Jackson's preferred method whenever he worked in pencil on his sketchpad, cryptic notes such as "bright red 3" and "warm brown 5" commonly appear within the actual composition in the hundreds of pencil sketches he produced during his career.

Jackson spent the winter of 1918 back at his small Charlotte Street studio in London, painting up canvases from the many pencil and oil sketches he had brought back from the battlefields. Here he was reunited with his old Académie Julian classmate Frederick Porter, who happened to have a studio nearby.[25] Although the two friends likely spent much time reminiscing over their travels together a decade earlier, Jackson kept busy at his easel and his finished canvases accumulated quickly. Two years in the infantry had served to reinforce his already strong work ethic. Though naturally prolific, he turned out many more sketches and canvases than most of his fellow war artists. When it was

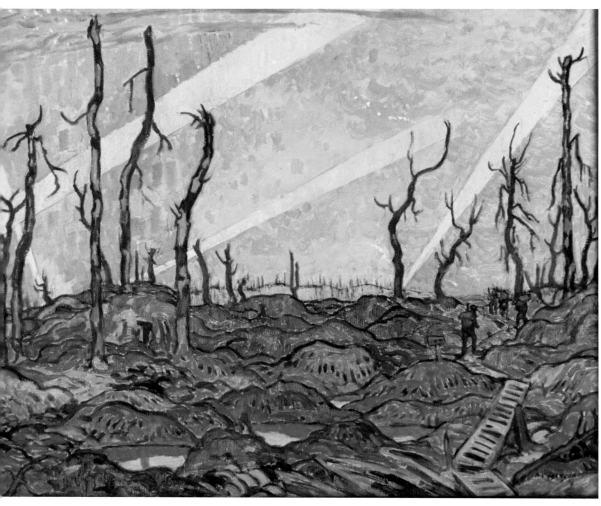

A Copse, Evening, 1918. This eerie image of No Man's Land inspired one critic to write, "Do the mothers and wives think it hard to know that their men are dead? Let them look at this picture."
Oil on canvas, 86.8 x 111.8 cm. Beaverbrook Collection of War Art, © Canadian War Museum. CN8204.

brought to his attention that he was producing more work yet costing the CWMF less money than anyone else on staff, he modestly replied, "If the others had been in the ranks for two years they would know when they had a cushy job."[26]

In March, he returned to northern France, where he accompanied the British artist Augustus John on an expedition to observe and sketch an Allied gas attack on the German lines at Liévin. The experience thrilled him — the night sky in the distance, as Jackson described it, was "like a wonderful display of fireworks with our clouds of gas and the German flares and rockets of all colours."[27] In order to capture the dramatic scene before him, Jackson drew three separate images on one page of his sketchbook, each depicting a different view and different trajectories of the rockets. For these sketches, Jackson wrote more than just notes on colour; he also jotted down visual impressions of details he would surely forget: "Sudden bursts of flame ... coloured glow ... old house silhouette ... Bright green lights behind clouds shining through gas clouds ... Below star a shower of orange ..."[28] The finished canvas, *Gas Attack, Liévin*, is a dark, nighttime landscape with no outward evidence of the title's deadly event. Except for their odd configurations, the colourful flashes of light seen through the clouds along the horizon could be easily mistaken for a distant lightning storm on a summer evening.

Just west of Liévin, Jackson sketched what would prove to be one of his most striking and memorable wartime images — *A Copse, Evening*. This eerie scene of dead tree trunks in a wasteland of shell craters and war debris shows a few tiny figures of soldiers making their way along a makeshift walkway of planks. Above them, diagonal searchlight beams slash the sky. The atmosphere is chilling enough, but Jackson's bitterly ironic title drives home the anti-war message — the copse itself is no more; all that's left are the skeletal remains of the shattered trees.

When this canvas was shown in the CWMF exhibition the following January, it moved one critic to write, "Do the mothers and wives think it hard to know that their men are dead? Let them look at this picture."[29]

The Horrors of War

As the bitter campaign raged on, the CWMF staff increased. The artists had been driven out of France by a massive German offensive in the spring of 1918,[30] so Jackson was back in London when four of his friends arrived from Canada — Charles Simpson, Bill Beatty, Fred Varley, and Maurice Cullen — all with the honorary rank of captain. Cullen, the senior member of the party at age fifty-two, had four stepsons, including the painter Robert Pilot, serving in the front lines. He had always been one of Jackson's heroes — a dedicated landscape man who boldly adapted colourful Impressionist techniques to the Quebec landscape. Around this time it was also learned that Cullen's good friend and fellow painting pioneer, James Wilson Morrice, had also been called up from his home in Paris to serve the country of his birth as a war artist. It appears that Jackson and Morrice were working in different sectors, for again there is no record of their paths crossing.

But while Cullen, Beatty, Simpson, Morrice, and other war artists would produce their share of moving wartime images, it was Varley who truly blossomed as an artist when confronted with the gut-wrenching realities of the Western Front. The acknowledged bohemian of the Toronto "bunch," Varley was able to convey his utter horror in words as well as pictures. Jackson had prepared him for the worst, showing him his sketches and recounting his experiences in France and Belgium before Varley crossed the Channel, but no amount of briefing could brace him for what he saw when he arrived.[31]

In letters home to wife Maud and Arthur Lismer, Varley poured his horror and despair onto paper. Portions of a now-famous letter he wrote to Lismer after arriving in Belgium have often been repeated for their brutal imagery. "I tell you, Arthur, your wildest nightmares pale before reality," Varley wrote. "You pass over swamps on rotting duckboards, past bleached bones of horses with their harness still on, past isolated rude crosses sticking up from the filth and the stink of decay is flung all over. There was a lovely wood there once with a stream running thro' it but now the trees are powdered up and mingle with the soil."[32]

Not surprisingly, the canvases Varley produced for the CWMF still stand among Canada's strongest anti-war statements. In *For What?*, a pair of gravediggers pause to reflect on their dreadful task — burying a cartful of dead comrades in a muddy field, each to be remembered by a tiny white cross. In *The Sunken Road*, a row of German corpses lie rotting amidst the debris of battle, the bodies themselves beginning to "mingle with the soil." Rising up from the horizon is a rainbow — an obvious symbol of hope, perhaps inspired by a similar one in Jackson's groundbreaking canvas *Terre Sauvage* of five years earlier.

Varley was relieved to find his friend Jackson on the CWMF staff, and the two spent much time together in London. But something was different, Varley noticed — Jackson had changed. The war had worn down the bright, gregarious personality Varley had known in Toronto and Algonquin Park. "I'm sure if he had to go through the fight any more he would be broken," Varley observed in a letter home.[33]

Jackson's reunion with his fellow Canadian painters was short-lived, for he soon found himself on his way back to Canada. In September, he and Simpson were ordered to accompany a force of Canadian troops to Siberia and were sent home to prepare for the trip. Hearing that the northeast region of Russia was a bleak, wintery wasteland, Jackson

bought twenty tubes of white paint to be sure he would have enough to render the snow-covered fields and hills.

On November 11, he was in Montreal, walking down Sainte-Catherine Street, when church bells started ringing out and people began cheering.[34] The war was finally over — and of course the trip to Siberia was automatically cancelled. This left Jackson with more white paint than he would need for many years to come, and for the rest of his life he liked to joke that the surplus was responsible for his becoming a painter of snowy landscapes, "as I had to find some use for it."[35]

Halifax Harbour

With the end of the war came the old worry that had dogged Jackson for years — how was he to earn a living now? After all he had been through, and after all his successes as a landscape painter, the only prospect for a guaranteed income would be a staff position at a commercial art firm, and that was the last thing he wanted. So when he heard of an opportunity to prolong his commission as a war artist, he went to Ottawa to enlist the aid of National Gallery Director Eric Brown, who could be counted upon to support his request to remain on the national payroll with the CWMF. Sure enough, he soon received two different sets of orders — one to report for discharge in Montreal, the other ordering him to Halifax to paint scenes of the returning troop ships. Needless to say, he chose the latter and was soon heading east.

In Halifax, he was reunited with Arthur Lismer, who had moved his family to Nova Scotia, where he had been serving as principal of the Victoria School of Art and Design since the summer of 1916. Lismer's Halifax period had been bleak; the war had greatly reduced the number of art students, and the devastating explosion in Halifax Harbour in December 1917 had destroyed much of the city. But Lismer, ever the optimist, worked hard at the college and succeeded in keeping the school afloat through the turbulent wartime period. His work for the CWMF consisted mainly of large, dramatic canvases depicting the camouflaged battleships in the harbour.

Throughout the early spring of 1919, Jackson and Lismer frequently sketched together in the harbour and the picturesque fishing villages along the coast. They both had plenty of war stories to swap. Even though Lismer had not served overseas, he had escaped certain death on the morning of December 6, 1917, when the train he would normally have been on was close to the harbour the moment the French ship *Mont Blanc* collided with the Belgian vessel *Imo* and its cargo of explosives blew up — killing or injuring thousands of people and flattening much of the city's north end.[36]

While working alongside Lismer, Jackson made sketches for what would later prove to be one of the most significant canvases of his career: *Entrance to Halifax Harbour*. This panoramic view of the Herring Cove[37] area signalled Jackson's return to the landscape proper, as the painting would contain no military references at all if not for three camouflaged troop ships making their way along the coast in the distance. Most of the composition consists of the hilly terrain under a spring snow and the quaint, colourful buildings

near the water — none of which exhibit any obvious damage from the terrible explosion of just over a year earlier.

The CWMF exhibition opened at the Royal Academy of Art in Burlington House, London, on January 4, 1919. Prime Minister Robert Borden took a break from his preparations for the Paris Peace Talks to help open the show, which attracted approximately two thousand visitors on the first day. It was, from all accounts, a great success. Jackson was not present at the opening, of course, as he was already back in Canada — but of all the artists represented in the exhibition, it was in fact Jackson who made the strongest showing, with several major canvases and no less than thirty-five oil sketches.[38] From his awkward portrait of J.C. Kerr to a view of the massive liner *Olympic* dwarfing everything surrounding it as it steamed into Halifax Harbour filled with returning soldiers, Jackson had in less than two years created the largest body of work of any artist on the CWMF staff.

After he had received his official discharge in Montreal and arrived back in Toronto in the late spring of 1919, where a permanent home on the top floor of the Studio Building awaited him, he kept busy working on the last of his war canvases, hoping they might be bought by the government or at least exhibited and sold at subsequent CWMF exhibitions in Canada. This was not to be, for the CWMF had run out of money and had ceased buying artwork.[39] Many of the last war canvases Jackson painted would remain stacked in his studio for years; *Springtime in Picardy* would not be sold until 1940, when it was bought by the Art Gallery of Ontario, and *Evening, Riaumont* went unsold until it was acquired by the Art Gallery of Hamilton as late as 1953. The fate of *The Olympic in Halifax Harbour*, however, was much less fortunate. After showing it in a CWMF exhibition, Jackson found the large canvas to be particularly cumbersome to store, so it finally ended up in the Studio Building furnace.[40]

The war was over, and the close-knit group of Toronto artists had much to catch up on as they gathered in the Studio Building or met for lunch in the familiar old confines of the Arts and Letters Club. After four years of carnage and tragedy, a profound sense of loss hung over the country — but with it came a certain sense of hope for the future. It had now been half a century since Confederation, and Canada had recently asserted itself on the world stage, participating in the war on an equal basis with other countries. With this came the feeling that Canada had finally come of age as a nation — and Harris, MacDonald, Jackson, and the others knew this was the perfect time for Canada to establish an art movement it could call its own.

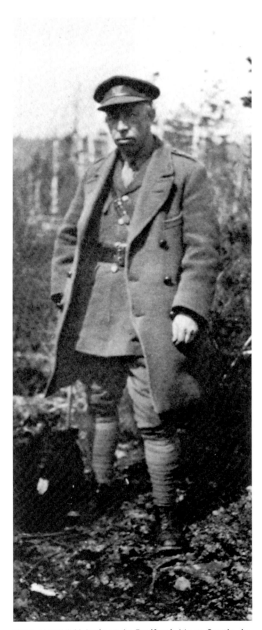

Lieutenant A.Y. Jackson in Bedford, Nova Scotia, in 1919. After the Great War, Jackson extended his Canadian War Memorials commission by painting the troop ships returning to Canada. He painted *Entrance to Halifax Harbour* during this period.

9

ARS LONGA, VITA BREVIS

IN FEBRUARY 1920, JACKSON WAS BACK IN one of his favourite places — the east-
ern coast of Georgian Bay. This time, however, it was not a painter's paradise of blue water
and white rock. Instead, the channels were frozen over and the islands were covered in a
deep blanket of snow that caused the big pine boughs to sag under the weight.

 This was the first time Jackson had ever seen Georgian Bay in winter; he knew that
few people ever ventured up there during this time of year, and he was grateful for the
opportunity to sketch the familiar sites under these conditions.[1] He had escaped the bus-
tle of post-war Toronto and, after briefly visiting Harris at his summer home on Lake Sim-
coe, arrived at Penetanguishene on February 20.[2] He intended to go straight to Franceville,
where he would spend a few weeks with Billy France and his family, but a blizzard kept
him in Penetanguishene for a few days.[3]

 Once the weather cleared, he strapped on his snowshoes and, with his gear and
sketching materials loaded firmly on his back, set off on the twenty-four-kilometre trek
across the frozen bay. Once he was in familiar territory — the region of Freddy Channel
and Portage Island — he stopped to rest at the deserted island owned by his friends, the
Williams family. "It was strange to see all frozen up and lifeless, the little bays and chan-
nels where I had paddled in summer-time with various charming companions," he
wrote.[4] Struck by the eerie stillness, Jackson set down his pack and sat for a while on the
Williamses' dock, where he ate a chocolate bar and pondered the events of the past year.[5]

 Much had happened since his return from the war, and now exciting things were tak-
ing shape in Toronto. The mysterious death of Tom Thomson had been a great loss, of
course, but neither that nor the carnage of the war had discouraged Harris, MacDonald,
and the others from promoting their vision of a uniquely Canadian style of painting. By
the time Jackson left for Georgian Bay, they were talking about organizing a group exhibi-
tion in the spring — a big, brash event that would make both the critics and the public
finally take notice.

A Tribute to Thomson

Jackson's return to civilian life officially began on April 16, 1919, when he arrived in
Montreal from Nova Scotia to receive his final discharge papers from the army.[6] He
missed by just a few days the Tom Thomson memorial exhibition at the Art Association
of Montreal gallery, which ended on April 12.[7] He had not missed much, of course,
because he not only knew Thomson's work very well but was also the exhibition's prime

organizer. He became involved in the project soon after his arrival back in Canada in October 1918, during a brief visit to Toronto while on leave from his War Memorials duties. He had been awestruck by the sight of his late friend's nearly entire body of work — some three hundred sketches and about two dozen canvases — all stacked and sorted neatly in an unoccupied third-floor room in the Studio Building.[8] The sketches, most of which Thomson left unsigned, were authenticated by MacDonald and Beatty in the form of a specially designed stamp bearing the initials "T.T." and the year "1917." Using permanent dye, they had as unobtrusively as possible stamped the circular logo onto a bottom corner or the back of each unsigned panel.

With the help of Jackson's Montreal friend critic Harold Mortimer-Lamb, the first of several Thomson memorial exhibitions was organized for the Montreal Arts Club in March, and another soon after at the Art Association.[9] Jackson, who wrote the foreword to the exhibition catalogue, hoped that the bold colours of Thomson's thickly painted panels and the striking compositions of his canvases might be just the thing to finally turn a few heads in conservative Montreal. Having battled against the old-fashioned tastes in that city for more than a decade, he certainly could not have expected a sudden change — but when he saw the newspaper reviews he was bitterly disappointed. "I thought the Thomson exhibition would wake them up," he wrote to Eric Brown at the National Gallery. "It has been a revelation to many of the younger artists but rather frowned upon by the academics who call it crude and fail to see its tremendous vitality."[10]

Jackson did, however, attend the Art Association of Montreal's 1919 spring exhibition, which immediately followed the Thomson show — and that proved even more frustrating. "The spring show was very tame," he reported to Brown. "It was mostly Dutch and the Dutchier they were the better they sold … To my mind the Canadian artists should drop the Montreal Art Association and let it stand on its own legs as the champion of the art dealer and the Dutchman."[11]

Despite the best efforts of critics like Mortimer-Lamb and a handful of others, nothing had changed in Montreal. Disgusted, Jackson continued on to Toronto, his luggage weighed down by war sketches he still hoped to work up onto canvas.

Studio Six

Jackson arrived on Severn Street with the air of a conquering hero, not only for his military accomplishments and contributions to the CWMF, but also through his newfound prestige in the art establishment. He had been an associate of the Royal Canadian Academy for years, having exhibited work in Academy shows since his itinerant days in Europe, but now, after serving his country as an artist on the battlefields of France and Belgium — and no doubt after making such a strong showing in the CWMF exhibition in London — Jackson received the news that he had been elected a full member of the Academy. Now he could be officially known as A.Y. Jackson, RCA.

Studio Six, on the top floor of the three-storey building, was a high-ceilinged workplace with few domestic comforts, which meant it suited the rugged artist perfectly. There was no kitchen, only a small storeroom that he used as his bedroom. At one end was a

large window that flooded the room with northern light. At the other end was a small gallery that could be used to store his camping gear and supplies. MacDonald, the studio's original tenant before the war, had decorated the base of the gallery with a work of calligraphy that quoted an ancient Chinese text: "With the breath of the four seasons in one's breast one can create on paper. The five colours well applied enlighten the world." Jackson admired the lettering, and while he knew the message was meant to inspire, he had to admit that he was never sure what it actually meant.[12]

Over the years, Jackson added touches of decor to his studio by hanging items such as a Native mask and prints of paintings by his favourite European Post-Impressionists, Cézanne and van Gogh. But for the most part his studio remained completely appointed for the single purpose of painting, with canvases and sketches piled everywhere and the thick odour of turpentine and linseed oil hanging permanently in the air. It was anything but luxurious, but as he proudly pointed out, "compared with most of the studios I occupied in Europe, it was palatial."[13]

The Studio Building, 25 Severn Street in Toronto's Rosedale neighbourhood, would be Jackson's permanent address for the next thirty-six years.

A Boxcar in Algoma

As Jackson readjusted himself to civilian life by settling into his new Toronto studio and painting up the last of his Canadian War Memorial canvases from his Halifax sketches, a major event was taking place — an exhibition of 144 brand new works created by Lawren Harris, J.E.H. MacDonald, and Frank Johnston. The show, which opened at the Art Gallery of Toronto on April 26, 1919,[14] consisted of 128 sketches and sixteen canvases, most of which had been painted over just a few months.[15] They were the result of an extended sketching trip the three had taken with Dr. MacCallum up to the Algoma region, just east of Lake Superior, in the autumn of 1918. It was a sudden burst of creativity, obviously inspired by the fresh new sketching grounds. Jackson was obviously thrilled when he saw what his friends had been producing in his absence. MacDonald, he noticed, had come out particularly strongly; from that point forward he would always consider Algoma to be MacDonald's domain.

Not surprisingly, the exhibition also drew the wrath of the Toronto critics — and once again it was mild-mannered MacDonald who took the brunt of the attack. His canvas *Wild River* was roundly condemned by all, its descriptions ranging from "a large colour riot" in one paper to "so wild you would never dream it was a river unless the catalogue vouched for the fact."[16]

The story behind the first Algoma trip has been repeated many times as a key event in the Group of Seven's history. Harris, who had joined the 10th Royal Grenadiers as a lieutenant in the spring of 1916 but had not been sent overseas, spent most of his service teaching musketry to recruits at Camp Borden, a short drive from his summer home in Allandale.[17] He was by no means a natural soldier, and the stress of military life weighed heavily upon him to the point where he became "nervous and unstrung under the discipline of the machine."[18] News of Tom Thomson's death was obviously a severe emotional

blow; seven months later, in February 1918, his only brother, Howard Kilborne Harris, was killed in Europe while inspecting a German trench. These events are commonly believed to have triggered in Harris what appears to have been a nervous breakdown. He was honourably discharged on May 1, 1918, for health reasons, and a prolonged period of rest was prescribed for his recuperation.[19] To Harris, this meant a relaxing sketching trip up north, which he made in the company of Dr. MacCallum.

"Dr. MacCallum and I went on an exploration trip to Manitoulin Island in northern Lake Huron, but finding it offered little for the painter, we went to Sault Ste. Marie and from there up the ramshackle Algoma Central Railway to a lumber camp at Mile 129," Harris wrote of the trip. "We found Algoma a rugged, wild land packed with an amazing variety of subjects. It was a veritable paradise for the creative adventurer in paint in the Canadian north."[20]

Inspired by the diverse Algoma landscape of mountains, lakes, forests, rushing rivers, swamps, canyons, and cliffs — everything imaginable for the artist — Harris immediately made plans to return with his friends when the autumn foliage would be ablaze with colour. Upon his arrival back at his Allandale residence, he wrote to the Algoma Central Railway and arranged for the loan of a caboose in which the artists could live while sketching the diverse landscape. The idea was to have the caboose left on a remote siding for a few days, then be picked up by a passing freight train and hauled several kilometres up the tracks, where it could be left on another siding in completely different surroundings. It was a strange request, of course, and Harris appears to have gone through considerable trouble to make the arrangements with the baffled railway executives. Once an agreement was reached, Harris wrote to MacDonald in triumph: "Well James, Me boy, down on your knees and give great gobs of thanks to Allah! ... We have a car awaiting us on the Algoma Central!!!"[21]

Just as Harris had planned, on September 10, MacCallum and three artists — Harris, MacDonald, and Frank Johnston, a commercial artist and fellow landscape painter they knew from the Arts and Letters Club — left Toronto on their much-anticipated trip to Algoma. They travelled up to Sault Ste. Marie, where a railway car was in fact awaiting them — but it wasn't a caboose. Instead, the Algoma Central had lent them a converted boxcar, complete with bunk beds, a stove, a table and chairs, as well as a canoe and a handcar for short trips along the tracks. The boxcar was painted a bright red, with its identification number — ACR 10557 — in large black numerals on the side. This number, MacDonald later quipped, would serve as their street address as they travelled throughout the deep wilderness of Algoma. Inside, the boxcar was decorated by evergreen boughs and a moose skull. This would soon be supplemented by an inspiring Latin phrase on the wall, "*Ars Longa, Vita Brevis*" — no doubt created through the calligraphic skills of Mac-Donald, who later reproduced the decoration in a drawing for *The Lamps*, the house organ for the Arts and Letters Club.[22]

There was in fact no shortage of art to be found in Algoma. The three artists, encouraged by MacCallum, worked rapidly in what all seem to agree was a landscape painter's paradise of striking compositions and vibrant colours. They stopped first at Canyon, the northernmost point on their itinerary, with the intention of working their way south back toward Sault Ste. Marie. Harris could not have chosen a more dramatic region to

begin the trip — a lush landscape dominated by tall, steep cliffs looming high over the Agawa River. MacDonald, whose delicate constitution did not allow him to fully participate in the rugged lifestyle enjoyed by the others, found his imagination stirred by the grand setting.

"The country is certainly all that Lawren and the Dr. said about it," he wrote to his wife, Joan, upon their arrival. "The great perpendicular rocks seemed to overhang as though they might fall any minute and the dark Agawa moving quietly through it all had an uncanny snakiness ... There are beautiful waterfalls on all sides, and the finest trees — spruce, elm, and pine."[23]

The autumn colours were brightening as ACR 10557 was picked up by a southbound freight train, as planned, and dropped off at Hubert, near the falls and rapids of the Montreal River. A few days later they were again moved down the line, this time to Batchewana. Long days of sketching the surrounding landscape ended in lively evenings of discussion and critique as each painter displayed his latest sketches for constructive criticism by the other two and MacCallum. Throughout the month of September in Algoma, "they witnessed the exciting change of colour as it swept over the landscape, turning from green to orange to red and finally, to the whiteness of a snow-covered landscape."[24]

Soon after their arrival back in Toronto on the first week of October 1918, an exhilarated Harris contacted Sir Edmund Walker, who quickly picked up on the enthusiasm and helped to arrange what would be the most significant event in the three artists' careers so far — an exhibition of their Algoma work at the Art Gallery of Toronto.[25]

Such was the climate of rejuvenation and hope in the Studio Building when Jackson arrived in Toronto for a brief visit after a four-year absence. The war was still on, and he was still in uniform, having recently returned to Canada to prepare for his trip to Siberia with the Canadian War Memorials. He no doubt knew much about Algoma already, for he had been corresponding regularly with his Toronto friends throughout the war — particularly MacDonald. This was his first opportunity to see the Algoma sketches and, to an even greater degree than Walker, sense the freshness and dynamic character of the Algoma landscape.

Jackson's enthusiasm to visit Algoma did not abate over the passing year — through his CWMF work in Halifax, his move back into the Studio Building, and a summer sketching trip to visit friends and relatives at Georgian Bay. So when Harris arranged a second boxcar trip for the fall of 1919, Jackson was firmly on board, replacing MacCallum as the fourth member of the sketching party. This trip was very much like the first, with ACR 10557 hauled north to Canyon in mid-September, then shunted south to Hubert at the end of the month, and finally down to Batchewana on October 7.[26]

The others had been to Algoma the previous year, and already knew some of the most promising sketching sites. Little time was wasted in searching for subjects — and time, they had learned, was an important factor here. Much like the rapidly shifting moods of Georgian Bay, the atmosphere in Algoma could change in a matter of minutes, so sketching had to be done quickly. Jackson described the dazzling visuals he found in Algoma — and the problems they presented — in an article he wrote for *Canadian Forum* two years later:

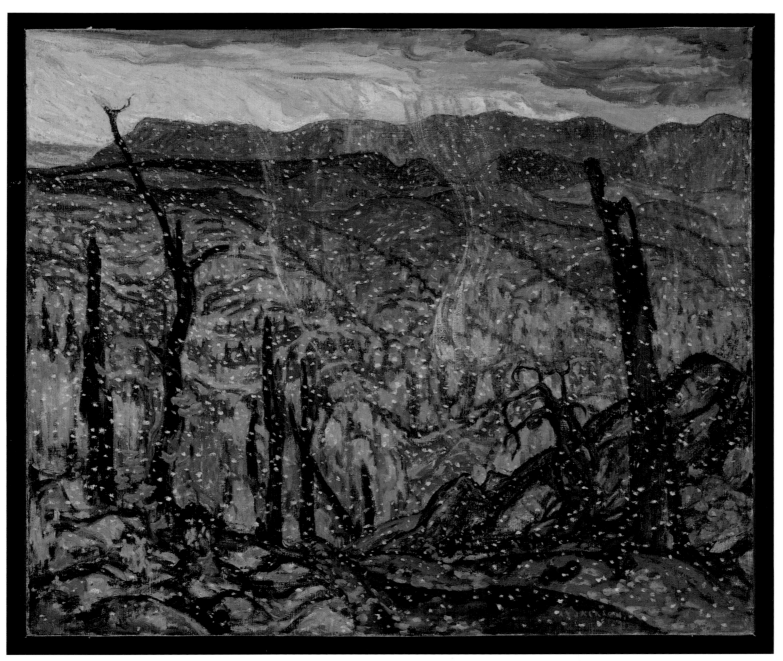

First Snow, Algoma, 1919–20. Viewed from a plateau of burnt-out tree stumps, the Algoma forest was an ocean of red maples and orange birches when Jackson first saw it in the autumn of 1919.
Oil on canvas, 107.1 x 127.7 cm. McMichael Canadian Collection. In Memory of Gertrude Wells Hilborn. 1966.7.

From sunlight in the hardwoods with bleached violet-white tree trunks against a blaze of red and orange, we wander into the denser spruce and pine woods, where the sunlight filters through — gold and silver splashes — playing with startling vividness on a birch trunk or patch of green moss. Such a subject would change entirely every ten minutes and, unless the first impression was firmly adhered to, the sketch would end in confusion.[27]

Some of the most familiar images of Algoma are sweeping vistas that show the vast expanse of the landscape. One spot Jackson and MacDonald found one day while exploring along the railway tracks near Hubert was a panoramic view of the Montreal River. Both were attracted to the composition of mountains and river receding into the distance, providing an interesting sense of depth, so they sat down and sketched the scene from their elevated vantage point on the tracks. But while one artist would never paint his version up onto a canvas, the other did. The result was *Solemn Land*, widely considered to be one of MacDonald's masterpieces.

First Snow, Algoma

Another striking panorama was painted by Johnston, who found a plateau covered in burnt tree stumps, apparently the site of a forest fire a few years earlier. His sketch would lead to a large canvas called *Fire-Swept, Algoma* — a dramatic view of the hillside and distant mountains with so much of the landscape in view that the sky is hardly more than a horizontal strip along the top of the canvas.

Jackson was also attracted to that same plateau, for he painted a nearly identical composition. His version, *First Snow, Algoma*, shows what appears to be the same hillside and charred, dead tree trunks — an image eerily similar to the shattered trees he had recently been painting in war-torn Europe. It is not known if Jackson and Johnston were together when they found that plateau; if they were, they chose to paint the landscape in different stages of the season. Johnston's canvas features a background rendered in cool blues and light greens while Jackson's is a blazing autumn forest of reds and oranges.

In order to suggest a light snowfall, he carefully dotted the entire area of the large canvas with tiny dabs of white. This technique was certainly not new; it had been done by Monet in his 1874 painting *Snow at Argenteuil I*,[28] and Jackson himself had tried it on previous occasions — most notably in *Autumn Snowfall*, which he painted while living at Dr. MacCallum's cottage on Go Home Bay, shortly before moving to Toronto in late 1913. But dabbing white dots over an image can be a difficult and risky undertaking; there must be just enough snowflakes to make the image come alive. Too little will not be effective, and too many might obscure the scene and ruin the entire painting. As it turned out, the foreground screen of snowflakes added just the right touch to *First Snow, Algoma*, which is today one of Jackson's most instantly recognizable images.

For Harris, MacDonald, and Jackson, the Algoma region would be an enduring source of inspiration. The boxcar trips provided them with not only dynamic landscapes to paint but also a spirit of camaraderie and sense of purpose. While exploring the wilderness network

of rivers and lakes, most of which were unnamed, the artists kept their bearings by whimsically naming the lakes themselves. "The bright, sparkling lakes we named after people we admired like Thomson and MacCallum," Jackson recalled. "To the swampy ones, all messed up with moose tracks, we gave the names of the critics who disparaged us."[29]

It is likely that plans for the Group of Seven were discussed, at least tentatively, while the four artists were living together in the ACR 10557 boxcar. Jackson would always look back at the 1919 Algoma trip with fondness. His description of their evenings together indicates that they did a lot of talking after each day's work:

> The nights were frosty, but in the box car, with the fire in the stove, we were snug and warm. Discussions and arguments would last until late in the night, ranging from Plato to Picasso, to Madame Blavatsky and Mary Baker Eddy. Harris, a Baptist who later became a theosophist, and MacDonald, a Presbyterian who was interested in Christian Science, inspired many of the arguments. Outside, the aurora played antics in the sky, and the murmur of the rapids or a distant waterfall blended with the silence of the night.[30]

The Algoma trips had not only inspired countless ideas for new canvases, there was also talk of the artists striking back at hostile critics through a publication of their own. "There are so many art activities these days that it's hard to turn out any work," Jackson wrote home to Montreal on November 28, 1919. "We are trying to start an art magazine and a lot of trouble. The Dutch patriots are getting scared."[31]

Safety in Numbers

In early 1920, buoyed by the post-war spirit of optimism, and certainly inspired by the seemingly endless artistic possibilities offered by the opulent landscape of Algoma, the Studio Building artists were talking about holding a large group exhibition in the spring. Harris, as usual the prime organizer, was taking care of most of the arrangements. He seemed to have everything under control, and was ably aided in this venture by MacDonald. The walls of the Art Gallery of Toronto were currently ablaze with the colourful sketches and canvases of Tom Thomson's memorial exhibition,[32] and gallery officials were once again approached to host a show in a few months' time. Jackson found himself with no pressing obligations in Toronto, and since the prospect of returning to Georgian Bay during the winter had always appealed to him, he seized the opportunity and set off for Penetanguishene in February.

Plans for the May exhibition continued in Jackson's absence. In March, those interested in contributing work to the show were invited to Harris's house at 63 Queen's Park, where Saint Michael's College stands today, to discuss the arrangements.[33] MacDonald, Lismer, Varley, Carmichael, and Johnston were there; Thomson, had he lived, would certainly have been there as well. The three other Studio Building tenants — Bill Beatty, Curtis Williamson, and Arthur Heming — did not share their neighbours' "continuous blaze of enthusiasm" and chose not to be involved.

The exact details of what was discussed in Harris's posh sitting room on that momentous night will never be known; the best record of the meeting was left by Lismer, who jotted down a few words in his sketchbook along with doodles of logo suggestions and whimsical portraits of his colleagues. Coming up with a name for the group was probably the most difficult decision of all: "A title such as the 'Algonquin School' or the 'Algoma School' would have been too restricting, and one like the 'New Canadian School' too pretentious. Since there were seven artists with similar ideas, why not call it the Group of Seven?"[34]

In choosing the name, the artists must have been aware of its close proximity to The Eight — the official name of the Ashcan School of painters in New York City, whose distinctly American subject matter was certainly a partial model for what Harris, MacDonald, and the others were hoping to do for Canadian art.

From Lismer's notes, it appears that the number seven was considered for a logo from the beginning.[35] They also indicate that Johnston was to design a poster for the exhibition and Professor Barker Fairley, a friend from the Arts and Letters Club, would be asked to write the foreword for the catalogue. These assignments were probably just suggestions, as the foreword would in fact be written by Harris and the catalogue designed by Carmichael, whose simple logo of the numeral seven crossed horizontally by "Group Of" — echoing the European and French-Canadian way of writing the number — would long survive as a familiar icon of Canadian culture.

The Group of Seven was born as an informal but united front against hostile art critics and an indifferent Canadian public — both of which, it seemed, were determined to cling stubbornly to old-fashioned ideas and conservative styles of art. As Jackson would later point out, the Group had no officers, no bylaws, and no fees, but it did have a distinct purpose — to establish a modern style of uniquely Canadian art, one that broke away from outdated European traditions, and, most importantly, to "interpret Canada and to express, in paint, the spirit of our country."[36]

As plans for the exhibition were coming together, Lismer wrote to Eric Brown at the National Gallery, hoping he would attend. "We are having a show at the Toronto Art Gallery in May," he wrote. "It will be a group show — Harris, Jackson, MacD, Johnston, Carmichael, Varley and myself — 'Group of Seven' is the idea. There is to be no feeling of secession or antagonism in any way, but we hope to get a show together that will demonstrate the 'spirit' of painting in Canada — we hope you will be able to get down to it."[37]

Brown's reply, dated three days later, shows that the Group of Seven had a firm ally in Ottawa. "I am glad to hear of the show and I certainly shall come to see it," he wrote to Lismer. "I think the present situation of Canadian painting demands a lot of exhibitions. It is only by seeing it that the man in the street can get familiar with it."[38]

Stranded on the Islands

Meanwhile, Jackson would be spending two months working at Franceville, on Georgian Bay — from late February to late April 1920.[39] He stayed at a boarding house run by the

family of Billy France — the friend of Dr. MacCallum whom Jackson had met for the first time in 1913, when France ferried him from Portage Island to Go Home Bay.[40] Franceville was so isolated in winter that the mail was delivered only sporadically. This was important to Jackson, of course, as letters provided his only contact with the outside world. But at this time, with his Toronto friends planning a major exhibition, regular correspondence was crucial.

The days were cold but mostly clear, and Jackson took advantage of the good weather by setting off on his snowshoes each day, carrying his sketch box throughout the area. Every evening, he joined the others as they gathered around the wood stove and listened to the news on the radio, fortified against the cold by a few sips of Billy France's potent home brew.[41]

During this time he produced a prodigious amount of sketches — so many that he ran out of blank panels and was forced to flip over some dry sketches and paint on the reverse side.[42] As the winter yielded gradually to spring, Jackson's work reflected the changing season. The first sketches led to canvases such as *Winter, Georgian Bay* — a sunny image of weather-beaten pine trees looming over a snow-covered shoreline, the long shadows rendered in varying shades of blue to reflect the crisp, clear sky.[43]

Later, as the snow receded, Jackson was able to make some of his most dramatic sketches, among them *Freddy Channel*, a view of the local waterway partially covered by ice and snow. For this sketch he dotted the panel with tiny white snowflakes, the same technique he had used with *First Snow, Algoma*. Perhaps the most turbulent of all Jackson's canvases, *March Storm, Georgian Bay* was sketched around this time as well. A dark, brooding view of an ice-covered channel, *March Storm* also provides one of Jackson's most dynamic compositions. The strong horizontal motif along the bottom half of the canvas — an unbroken line of wind-bent pine trees and a rugged shoreline — is countered by striking vertical columns of dark snow clouds that appear to be moving swiftly across the canvas.

While moving around the islands and bays, some of which were only partially frozen over, Jackson carried a pole with him as a precaution in case he fell through the thin ice. This amused the local inhabitants, who were used to this annual hazard. Later, as more and more ice disappeared, he took to traveling around in a dinghy outfitted with sled runners — a hybrid vehicle that allowed him to cross both ice and water with equal ease.[44]

Jackson was clearly happy with both the quality and quantity of his new Georgian Bay material, and his original plan was to return to Toronto in plenty of time to paint up a few canvases for the group exhibition, which was due to open on May 7. While staying at Franceville, he kept in touch with MacDonald and the others by letter, and as the exhibition plans were coming together throughout March and April, he also managed to arrange for three of his Montreal friends — Randolph Hewton, Albert Robinson, and Robert Pilot — to be included in the show as guest exhibitors.[45]

But by mid-April, as Jackson prepared to leave Georgian Bay, the weather thwarted his travel plans — the ice had not broken in many places, ruling out the possibility of crossing back to the mainland by boat. Travel by foot was also impossible, for the ice was too thin to support the weight of a man. In isolated Franceville, supplies could not be replenished; the family's horse ran out of feed and had to resort to a diet of maple twigs.[46] Jackson had no choice but to anxiously wait for the ice to melt. The delay meant the loss of

several days that he could have spent in his studio, preparing works for the big exhibition that was now just two weeks away.

Finally, in late April,[47] "the ice got honeycombed, turned almost black and suddenly disappeared."[48] Jackson wasted no time in catching a boat to Penetanguishene, then hurried down to Toronto. Arriving back at the Studio Building, anxious to get to work on a few Georgian Bay canvases, he was told — probably by MacDonald — that the Group of Seven had been formed and that he was a member.[49]

In the brief time that followed — probably less than two weeks — Jackson painted up several canvases that he hoped to include in the Group of Seven exhibition. In the end, he sent four brand new paintings to be framed for the show — so new, in fact, that it is unlikely that they were completely dry when they arrived at the Art Gallery of Toronto. These were *The Freddy Channel*, *Storm — Georgian Bay*, *Lake Cognaschene*, and *March Storm, Georgian Bay* (known then as *A Storm in March*). The rest of Jackson's contribution to the show included three Georgian Bay canvases dating back to 1913: *Terre Sauvage* (known then as *The Northland*), *A Summer Cottage*, and *Night, Georgian Bay*. Three canvases from 1919, *A Fishing Village*, *A Nova Scotia Village*, and *Three Rock Falls*, rounded out the selection along with just one War Memorials canvas, the van Gogh–inspired *Springtime in Picardy* (known then as *Spring in Liévin*), and seven small oil sketches, including his favourite Algonquin Park sketch, his study for *The Red Maple*. Jackson chose to price his canvases moderately, from two to three hundred dollars, with only *Terre Sauvage* going for eight hundred dollars. By contrast, Harris was asking between four and six hundred dollars, with two as much as a thousand dollars.[50]

Finally, the exhibition opened on May 7, 1920. The artists expected a storm of controversy to erupt in the newspapers. There was no doubt in their minds that the critics — especially their old foes Charlesworth and Gadsby — had sharpened their pencils and were poised to attack. The common front of Jackson, Harris, MacDonald, Lismer, Varley, Carmichael, and Johnston, along with Jackson's invited friends Hewton, Robinson, and Pilot, braced themselves for the worst.

Early Spring, Georgian Bay, 1920. The sketch for this canvas was probably painted while Jackson was stranded up at Georgian Bay by a late thaw, shortly after the Group of Seven was formed in Toronto.
Oil on canvas, 50.0 x 65.8 cm. © National Gallery of Canada, Ottawa. Courtesy of the estate of the late Dr. Naomi Jackson Groves.

was nothing new, of course, as Jackson had done it seven years earlier with *Terre Sauvage* — but Harris was venturing well beyond Jackson's original idea and reducing everything to its most basic elements.

Perhaps out of friendly competition, and certainly as a result of the long conversations around the campfire each night, Jackson was actively experimenting with the autumn colours in Algoma. One of the canvases he painted shortly after returning from the 1920 fall trip was *Maple Woods, Algoma* — certainly one of the boldest expressions of autumn foliage ever painted at the time. If not for the recognizable forms of tree trunks, shaded nearly black in some places and nearly white in the sunlight, *Maple Woods, Algoma* would be a completely abstract arrangement of oranges, yellows, and reds. Although that painting was included in several exhibitions and was eventually bought by the Art Gallery of Ontario, it remains unique in Jackson's body of work as the only canvas that nearly crossed over into the realm of abstraction.

The Loss of Georgina

The Algoma trips were from all accounts happy occasions, where the artists could escape the city and relax in the middle of a vast wilderness — sometimes as much as an entire day's journey from the nearest town. But they were careful to never completely isolate themselves, for with the exception of Jackson, all members of the Algoma sketching parties were family men who could be reached by telegram through the Algoma Central Railway in case of emergency. The May 1921 trip was in fact marred by such a wire from home, but it was addressed to the bachelor. And the news was indeed grim — Georgina Jackson was gravely ill in Montreal and not expected to live much longer. Given his current location up in the remote wilds of Ontario, there was little Jackson could do. This must have been terribly frustrating, for Georgina had been one of his main sources of moral support during his early days as a struggling artist, not to mention a tireless agent who looked after her son's affairs while he was away in Europe, arranging for his canvases to be sent to various exhibitions and relaying his correspondence across the Atlantic.

"She died on her seventieth birthday before I arrived home," Jackson later wrote.[23] "My mother was always frail, and housekeeping in those days was not the simple matter it is today. She lived to see all her six children grow up; that we were devoted to her was all she ever hoped for. She was a sweet and gentle soul."[24]

On to Lake Superior

By the time the Group of Seven was established, Jackson's painting style was almost fully developed. For the rest of his career, he would rarely stray from his tried-and-true landscapes characterized by curving lines and careful emphasis on the rhythms of nature. But Harris's work was another story. As his painting style and spiritual interests continued to develop, he realized that the lush, busy landscape of Algoma was becoming far too opulent for his purposes.

Although Harris regularly returned to Algoma throughout the early 1920s, by the autumn 1921 trip with Lismer and Jackson, he was evidently anxious to explore new territory. Lismer had to cut this sketching trip short, for he soon had to be back in Toronto to teach at the Ontario College of Art. Still, Lismer did manage to produce a few sketches that led to his most familiar Algoma canvas, *Isles of Spruce* — a quiet image of conical fir trees towering above the shore of a mirror-calm lake, punctuated by a striking blaze of yellow birch leaves in the middle of the composition.

Neither the wealthy Harris nor the unmarried Jackson had any professional or personal obligations back home, so they opted to stay on after Lismer's departure. They packed up their camping gear and caught a freight train at Franz, which took them up toward the north shore of Lake Superior.[25] After stopping to sketch near Schreiber, they continued on foot to the lakeside village of Rossport — and it was here that Harris found what he considered the perfect landscape through which he could express himself on a more spiritual level. Rossport itself was a quaint cluster of small houses and boat shacks nestled against the steep hillside, but there is no evidence of either artist tackling that subject during this visit.

To Jackson, the shore of Lake Superior was at first cold, grey, and uninviting. From a colourless gravel beach to an ocean-like expanse of water, there seemed to be very little worth painting. But Harris was exhilarated by the wide open spaces, the ever changing sky sending shafts of bright sunlight down on the water, and the rounded islands just offshore.

Despite Jackson's first impressions, Harris's enthusiasm finally convinced him to open his sketch box. He soon realized that Lake Superior did in fact offer him a wide variety of subject matter if he turned away from the lake and sky and instead focused on the burnt-over hills high above the shore. The broken trees, rounded rocks, and isolated pools gave him all the material he needed, and he set happily to work. Harris may have found his greatest spiritual inspiration in the infinite spaces over the lake, but for Jackson, who never expressed an interest in painting the sublime, the great expanse of Lake Superior in the distance would serve merely as a backdrop for his rugged landscapes of rolling hills, rocks, and twisted tree trunks.

That one trip to Rossport lasted just a few days, but it was a key turning point in the Group of Seven's creative life. From then on, the north shore of Lake Superior replaced Algoma as the favourite sketching ground, and for the next six years it would be visited regularly by various members of the Group.

Frank Johnston Resigns

One member who would not be joining Harris and Jackson on any Lake Superior sketching trips was Frank Johnston. The jovial and energetic painter had always been an avid member of the Toronto art scene, the Arts and Letters Club, and the Group of Seven; in fact, his Algoma works had far outnumbered those of Harris and MacDonald in the 1919 exhibition. But as a family man whose first priority was to earn a living, Johnston felt increasingly at odds with the Group of Seven's carefully cultivated image as the radical *enfants terrible* of Canadian art. He had fared very well at the first Group of

March Storm, Georgian Bay, 1920. Jackson used contrasting horizontal and vertical motifs to express the dramatic effects of wind and snow clouds in this striking canvas — hastily painted in Toronto in time for the first Group of Seven exhibition.

Oil on canvas, 63.5 x 81.3 cm. © National Gallery of Canada, Ottawa, bequest of Dr. J.M. MacCallum, Toronto, 1944. Courtesy of the estate of the late Dr. Naomi Jackson Groves.

Seven exhibition, praised by critics and selling his large *Fire-Swept, Algoma* to the National Gallery, yet the need to exert his individuality far outweighed his loyalty to the Group. A successful one-man show at Toronto's T. Eaton Company Galleries, at which about two hundred of his canvases were exhibited, widened the gap between Johnston and the Group, and when offered the position of principal of the Winnipeg School of Art in 1921, he packed up his family and moved to Manitoba.[26]

At first, there was no formal announcement of Johnston's resignation from the Group of Seven, because he did not formally resign. He simply moved away and stopped exhibiting with the Group — an organization so loosely structured that a formal announcement was probably deemed unnecessary, if anyone thought of it at all. The departure was noted three years later, when Johnston returned to Toronto and an item appeared in the *Toronto Star Weekly*: "One Canadian Artist Deserts Extremist School of Seven." In a blatant swipe at the Group of Seven, the article stated that "Mr. Johnston, in announcing that he has progressed beyond that phase of Canadian art, says he is convinced that there is such a thing as 'inexcusable irredeemable ugliness.'"[27]

From all accounts, Johnston's departure was entirely amicable; he had a family to support, as did most of his fellow Group members, so no one could fault him for accepting an attractive job offer in another city. The *Star Weekly* article prompted a speedy rebuttal from Johnston, who could not afford to compromise his position in Toronto art circles. "To state that I had left the Group of Seven gives an entirely erroneous idea of rupture or repudiation," he wrote in the *Star Weekly*. "All these painters and many other Toronto artists are my friends. I admire their talents and I consider that they have contributed valuable ideas to Canadian art. I was never a member of the Group of Seven in the sense of taking a formal oath of allegiance to an art brotherhood or subscribing to rigid doctrines. They were my friends."[28]

Johnston would remain active in Toronto for many years afterward, changing his first name to Franz in 1927 and often marketing his work through the lucrative department store galleries.[29] His departure from their ranks did nothing to dampen the Group of Seven's enthusiasm. They continued exhibiting without him, even if it meant setting themselves up for more sniping from critics. Their 1921 exhibition catalogue listed only six artists instead of the expected seven, prompting the inevitable quips that the artists were no better at counting than they were at painting.[30]

11

SPRING IN QUEBEC WITH PÈRE RAQUETTE

IN 1921, ONE OF THE ACTIVITIES ORGANIZED by the Arts and Letters Club was a contest for the best self-portrait. As the story goes, Jackson began his entry in a conventional manner — it was to be a formal portrait of himself in a suit and tie. Jackson was never a portrait painter; in fact, it is doubtful that he had ever even attempted to paint a recognizable face since his portrait commissions in the early stages of his Canadian War Memorials assignment four years earlier.

After struggling for some time with his own weather-beaten features (he looked much older than his thirty-eight years), he no doubt realized that everyone else was doing the same thing. This entry would be judged against the work of some of the most distinguished portrait artists in the country. That was when his keen sense of humour and life-long disdain for pretence took over. He impulsively flipped over the board and immediately set to work on a humorous caricature of himself.[1]

The resulting painting, rendered in pencil, gouache, and watercolour — an oil portrait might not have dried quickly enough to meet the contest deadline — shows the rear view of a rotund Jackson bundled up in a thick winter coat, standing in the snow on a pair of round bear-paw snowshoes. Holding his sketch box in his left hand, he is busy painting what appears to be an outhouse half-buried in the deep snow. Not surprisingly, Jackson's whimsical lampoon of himself won the Arts and Letters Club contest. He subsequently titled the painting *Père Raquette* (*Father Snowshoe*) — the nickname he would bear with pride for the rest of his life.

From 1921 to 1947, with only one exception, Jackson observed the Ides of March by packing up his warm clothes, sketch box, and a supply of blank panels. He closed up his studio and caught a train for Montreal, where he usually spent a few days with friends and relatives. From there, his destination was any of the small villages dotting the shores of the St. Lawrence below Quebec City. Townspeople as far east as the mouth of the Saguenay River on the north shore, and as far as Rimouski on the south, would become familiar with the white-haired, English-speaking gentleman who came into their midst to paint small panels of their snow-covered landscape. Sometimes he travelled alone, but often he was accompanied by one or two fellow artists from Montreal. Their arrival always caused a stir in the quiet French-Canadian communities, and it was said that in some villages the surest sign of spring was the annual arrival of Père Raquette and his friends.

The name Père Raquette was bestowed upon Jackson by the Montreal artist Edwin Holgate, who could not resist poking fun at the way his fellow Beaver Hall Group member insisted on plodding along on old-fashioned snowshoes while he, Randolph Hewton, Albert Robinson, and other sketching companions preferred the more modern — and much faster

— method of zipping across the snowy fields on cross-country skis. But Jackson had a more practical reason for resisting that mode of transportation. When asked why he never took up skiing, he was known to reply, "Have you ever tried painting with skis on?"[2]

Marius Barbeau, the French-Canadian folklorist and anthropologist who was one of Jackson's close associates throughout the 1920s and a lifelong friend, pointed out that Père Raquette was much more than a simple nickname. It symbolized Jackson's closeness to his fellow Quebecers and his understanding of the rural culture in that province.[3] This understanding allowed him to move freely among the farming communities, where he was always a welcome guest in the homes of devout Roman Catholic families who spoke little English and in many cases remained largely unfamiliar with the rest of Canada. He knew the customs of his hosts; he knew the rules of their card games and the lyrics to their folk songs. As Barbeau wrote of Jackson:

> Père Raquette characterizes the man of the country who moves slowly but surely over the snow, and for whom the snowshoe is not an article of sport, but a necessity. A man of this type is well planted, is sure of eye and foot, like a hunter tracking the deer, or a woodsman who, in the spring, runs the maple and makes sugar. In descending a hill, if he cannot follow the skier from the city, at least he climbs the slope more easily, jumps the fences and finds himself unhampered in the underbrush. And the painter using snowshoes can station himself comfortably while he sketches a landscape.[4]

Down the St. Lawrence

Jackson's first annual springtime trip to rural Quebec, in March 1921, took him past Rivière du Loup to the yellow farmhouse of a family named Plourde, near the village of Cacouna.[5] "It was old, settled country," Jackson recalled. "The farms ran back from the highway, long and narrow, and all the houses on the highway were close together."[6] The narrow layout of the farms was a direct result of the seigneurial system of New France, dating back to the early seventeenth century, which divided the land into sections measuring 2.4 kilometres long by just 230 metres wide.[7]

Jackson set out from the old Plourde farmhouse on his snowshoes each morning, sketching the surrounding barns and the rural landscape that was still slumbering under the deep snow. After a few weeks he moved on to the town of Cacouna itself, where he

Père Raquette, circa 1921. Originally painted for a self-portrait contest, *Père Raquette* not only displayed Jackson's sense of humour, it also established the public persona that would remain with him for the rest of his life.
Gouache and watercolour over graphite on paper board, 80.0 x 64.5 cm. McMichael Canadian Art Collection, gift of Mr. S. Walter Stewart. 1968.8.25.R.

checked into the local hotel run by the Lafleur family and continued his sketching.[8]

The colourful houses in Cacouna, along with the melting snow throughout the countryside, offered Jackson a rich array of subjects to paint. He was particularly attracted by the view of Cacouna from the main road that led into the town. Here he stood and sketched several different views, some in oil on panel and others — when it was too cold to paint — in pencil on paper. The dominant features that attracted his eye were the triangular shapes of the tiny A-frame houses that stood in tight, colourful clusters, as well as the spiral of the parish church.

This is most apparent in Jackson's two best-known canvases that resulted from sketches on this trip, *A Quebec Village* and *Winter Road, Quebec*. Both are lively studies of

Barns, circa 1926. From 1921 to the mid-1940s, Jackson was usually back in Quebec by mid-March, while the snow still lay heavily on the fields. He was especially attracted to rustic subjects that had survived from a bygone era. *Oil on canvas, 81.6 x 102.1 cm. Art Gallery of Ontario, Toronto, gift from the Reuben and Kate Leonard Canadian Fund, 1926. Courtesy of the estate of the late Dr. Naomi Jackson Groves.*

the pastel-coloured buildings of Cacouna, and both convey the quaintness of a remote village largely untouched by the outside world.

A Quebec Village is a sunny scene of children sliding down a gentle slope on small sleds or toboggans. Jackson applied the off-white shades of the late spring snow with a palette knife, dragging it across a much darker undercoat — a technique that resulted in the dry dark paint showing through the gaps in the fresh white, giving the appearance of tiny patches of ground showing through the disappearing snow. But the most striking feature of *A Quebec Village* can be seen along the upper portion of the canvas. Instead of rendering the blue sky in one uniform shade, Jackson applied one coat of pale blue, then added vertical strokes of a slightly darker shade in various places, giving the sky an odd, patchwork appearance. This was further evidence of Jackson's love of modern art and its tendency toward bold experimentation — something he took even further in his next canvas.

Winter Road, Quebec is a complete departure from conventional painting in that Jackson eliminated all detail to the point where the village of Cacouna is rendered as a series of simple triangles, each a different shade of yellow, orange, light brown, or green. The composition is perfectly symmetrical, with tall fence poles forming a gateway through which the road runs from the foreground and into the town, leading the eye straight into the centre of the canvas. The scene would be cold and still, but Jackson added a small but significant element that brought it to life — a horse-drawn sleigh in the distance, making its way toward the town.

From this point forward, Jackson would often include a sleigh in his Quebec landscapes. This was not only a deliberate attempt to enhance the rustic atmosphere he was trying to evoke, but also a subtle way of expressing his contempt for the creeping modernization of remote villages. By 1921 automobiles were rapidly replacing the horse-drawn sleigh in rural Quebec, and before long the tranquility would be shattered even further by snowmobiles roaring across the fields.[9]

Jackson was enthusiastic about the sketching at Cacouna, but at the same time bored by the lack of activity in the evenings, so he wrote to Albert Robinson and invited him to join him. Robinson arrived a few days later and, just as he had in France ten years earlier, immediately turned the quiet Cacouna hotel into a lively place where the evenings were filled with laughter and music. The worldly Robinson wasted no time in winning over the Lafleurs' dour son with his tales of the boxing world, and soon had one daughter playing the piano while he danced around the room with Madame Lafleur's sister.[10]

Robinson was equally enthusiastic about working in the region, and it was on one of his hikes with Jackson that he made sketches for what would become one of his best-known canvases, *Return from Easter Mass*. It was agreed that the two would return to the area the following spring, and in doing so Jackson would establish a regular schedule of annual visits that eventually became the very backbone of his creative life.

Back to Lake Superior

For the next few years, rural Quebec and Lake Superior would dominate Jackson's itinerary. In the autumn of 1922, he and Harris travelled to the village of Coldwell, Ontario, on

the north shore of Lake Superior. They picked up where they had left off the previous autumn at Rossport, sketching the vast open spaces along the cold and forbidding banks of the grey, ocean-like lake. "I know of no more impressive scenery in Canada for the landscape painter," Jackson wrote. "There is a sublime order to it, the long curves of the beaches, the sweeping ranges of hills, and headlands that push out into the lake. Inland there are intimate little lakes, stretches of muskeg, outcrops of rock; there is little soil for agriculture. In the autumn the whole country glows with colour; the huckleberry and pincherry turn crimson, the mountain ash is loaded with red berries, the poplar and the birch turn yellow and the tamarac greenish gold."[11]

The two painters spent several weeks camped in a tent above the rocky embankment, enduring spells of heavy rain and cold. They built a big stone fireplace for warmth during the day, and protected themselves from the bone-chilling cold each night by pouring glowing embers into a shallow trench between their sleeping bags. They often had trouble with local wildlife trying to make off with their cache of food, but their most formidable opponent was the weather. Their tent had to be secured in a sheltered spot, for, as Jackson described it, "the elements in that country could break loose with wild and malicious fury."[12] It would rain for several days at a time, testing even Jackson's patience, but it made no difference to Harris, who would rise early each morning and be noisily preparing breakfast while raindrops pelted down on the tent. "What's the use of getting up — it's raining," Jackson muttered groggily from his sleeping bag one particularly bleak morning.

"But it's clearing in the west," Harris replied optimistically. Three dreary days later, when the sun finally broke through the clouds and shone down on the lake in golden shafts, Harris turned to his gruff companion and said, "I told you it was clearing!"[13]

"Harris's cheerfulness was rather trying," Jackson quipped while reminiscing over their Lake Superior camping trips.[14] It was Harris who encouraged a skeptical Jackson to join him in an invigorating swim in the frigid lake; Harris was convinced that their minds would be distracted from the cold if they took a long run down the beach toward the shore, waving their arms in the air and shrieking wildly before plunging into the surf. Whether this actually worked is not known, but even the fearless Jackson refused to follow when Harris "chopped a hole in the ice of a creek and let himself in."[15]

It was on one of these trips with Jackson that Harris made the first few sketches for what would become one of his most recognizable paintings, *North Shore, Lake Superior* — the stark image of a single pine stump, split and weathered by the elements, standing straight and strong against the infinite backdrop of the lake. Jackson recalled that he was with Harris when he discovered the stump one day while they were pushing their way through the bush. They were well inland at the time; in fact, Lake Superior was not even visible from where Harris made his sketches.[16] *The Grand Trunk,* as it was known by Harris and his friends, went through several stages of sketches until Harris was satisfied with the finished canvas. Giving it a much grander setting, lit from above by beams of sunlight reminiscent of religious paintings from the Renaissance, Harris managed to transform a humble tree stump into a symbol of the Canadian north, much the way Thomson, Lismer, and Varley had done with their canvases of single, weather-beaten pine trees.

Lake Superior Country, 1924. While Lawren Harris's creative attention was drawn to the vast lake, Jackson often turned away from the water and sketched the surrounding landscape.
Oil on canvas, 117.0 x 148.0 cm. McMichael Canadian Art Collection, gift of Mr. S. Walter Stewart. 1968.8.26.

The Battle over Wembley

Group of Seven exhibitions continued throughout the 1920s, and critical response remained varied. Sometimes they were lauded as a breath of fresh air blown into the face of the staunch conservative values that continued to be a dominant force in Canadian culture. Other times they were ridiculed for their blatant disregard for the traditional values in painting.

But certainly the most controversial episode in the Group's history began in 1923 with the organization of the British Empire Exhibition to be held at Wembley, England. A large collection of modern Canadian art was to be sent overseas for the exhibition, all of which would normally have been selected by the Royal Canadian Academy. But when National Gallery director Eric Brown first heard about the Wembley show, he worried that the notoriously conservative Academy would ignore Canada's most vibrant modern artists when making the selection. He immediately wrote to England and offered to oversee the selection of the Canadian works. Organizers readily accepted, not realizing that this was officially the Academy's responsibility — not the National Gallery's.

Naturally, Academy president George Horne Russell was outraged when he learned that Brown had intervened where he clearly had no jurisdiction. As a close associate of past president William Brymner and long-time secretary Edmond Dyonnet — Jackson's two earliest art instructors — Russell was a member of the old guard. He had little sympathy for the Group of Seven and their admirers, and was backed by many conservative critics such as Hector Charlesworth. Knowing that the National Gallery supported the Group of Seven and had acquired many canvases by its members over the past decade, Russell feared the gallery would embarrass Canada by sending a selection of work dominated by unsettling images of Harris's Lake Superior, Thomson's Algonquin Park, and Jackson's Georgian Bay. He believed these radical works were sure to offend the cultivated tastes of the British public.

Russell immediately called for Academy members to boycott the Wembley exhibition by declining any offer to include their work in the show. This of course proved unpopular with the artists, as no one wanted to pass up an opportunity to be exhibited abroad and possibly cultivate an international reputation. As a full member of the Academy — and arguably the most radical of all the modern painters — Jackson was caught in the middle of the controversy.

Ironically, when Brown and Sir Edmund Walker put together the National Gallery's eight-member selection jury, it consisted of full Academy members Franklin Brownwell, F.S. Challener, Clarence Gagnon, Wyly Grier, and Horatio Walker, along with associate members Randolph Hewton, Florence Wyle, and the Group of Seven's own Arthur Lismer. Russell himself had been invited to participate, but refused.[17]

The Wembley controversy dragged on into 1924, even after 270 works by 108 Canadian artists were chosen and sent to England. As it turned out, Russell's fears were totally unfounded. Thomson and the Group of Seven were represented by only twenty canvases, with other modern artists such as Cullen and Morrice also given nominal recognition, while the vast majority of selected works were conservative canvases by Academy members whose names and reputations have faded over the years.[18] Among the Group works chosen were Jackson's *Terre Sauvage* and *Entrance to Halifax Harbour*, Harris's *Shacks* and *Grey Day in Town*, Carmichael's *Spring* and *Autumn Hillside*, MacDonald's *The Beaver Dam* and *The Solemn Land*, and Varley's portrait *Vincent Massey* and *Stormy Weather*, as well as its Go Home Bay counterpart, Lismer's *September Gale*. Thomson was represented by *The West Wind*, *The Jack Pine*, and *Northern River*.[19]

Charlesworth railed against the National Gallery in the pages of *Saturday Night* while defenders of the modernist movement struck back with their own articles and letters to

the editor. The entire Wembley affair mushroomed into a nationwide *cause célèbre*, with volleys of harsh words bouncing back and forth between the two camps. Jackson himself admitted to penning some of the more outlandish attacks against the Group of Seven and their fellow modernists in letters that appeared in the Toronto press, which he signed with clever pseudonyms such as Rose Madder and Sap Green — both taken straight from the labels of paint tubes.[20]

Letters were also written to the British press, ostensibly to apologize for the modern monstrosities on the walls of the exhibition, but Russell, Dyonnet, Charlesworth, and other Academy supporters were shocked when word came from across the Atlantic that British reviews of the Canadian contingent were actually favourable. "Canada is developing a school of landscape painters that is strongly racy of the soil," wrote the London *Times*. "The foundation of what may become one of the greatest schools of landscape painting," agreed the London *Morning Post*.[21] The *London Daily Chronicle* also raved, stating, "These Canadian landscapes, I think, are the most vivid group of paintings produced since the War — indeed in this century," while *The Field* best summed up the Group of Seven's success: "Canada, above all other countries, has reason to be proud of her contribution, her canvases are real triumphs … Canada has arrived. She has a real national style."[22]

A stung Charlesworth was quick to rebut the British critics. "Flub-dub, every word of it," he wrote in *Saturday Night,* "but no doubt sincere flub-dub, based on the conviction that this is the pure-quill Canadian stuff: and that other types of landscape painting which represent the beautiful pastoral phases of this country are false and insincere … This school of painting is not of the soil, but of the rocks … Unfortunately, one must also add; for the areas of primeval rock and jack-pine constitute Canada's gravest problem in an economic sense and the most serious barrier to her political and social unity."[23]

Despite the overwhelmingly positive reception from the British public and press, only one Canadian painting found a permanent home in England — and it was not one of the 250 quiet, conservative canvases by long-time Academy members. Instead, it was Jackson's *Entrance to Halifax Harbour* that was purchased for the Tate Gallery, Great Britain's most prestigious museum. It was never made clear if the choice of that particular canvas was perhaps a gesture of gratitude for Canada's full participation in the Great War, as the subject matter might suggest, but in Canada the news was greeted by celebration at the Studio Building and by stunned outrage among the Academicians.

To this day, the very name Wembley remains synonymous with what is arguably the most catalytic event in Canada's creative history. For the Group of Seven, and Jackson in particular, it was nothing short of a complete triumph — a clear turning point in the crusade against the outdated values of previous generations. The glowing reviews and the sale of *Entrance to Halifax Harbour* to the Tate meant an endorsement beyond measure to the modernist camp, and the split was decisive. The Academy came out looking ridiculous, and for years Jackson could not resist poking fun at its officers:

We the academy now consists of Horne, Dyonnet, Nobbs, Reid and Grier. A priceless crew. All out for number one. It's kind of fun skating around them and knocking the puck between their silly legs. In the meanwhile everything they touch fades away and dies. And people come to us for advice on art matters more and more.[24]

Teacher and Debater

Jackson's Wembley success did not make him rich, but the newfound prestige certainly boosted his reputation — and soon drew him into yet another political skirmish that would benefit him financially. By 1924 his army savings had been nearly depleted, and his income from selling paintings averaged about $600 per year[25] — by no means a great sum even by 1924 standards, as his annual rent at the Studio Building amounted to $264. So when Arthur Lismer invited him to apply for a teaching job at the Ontario College of Art, he did not hesitate.

Lismer, who for the past few years had been vice-principal of the Ontario College of Art, was an outspoken bundle of creative energy who frequently found himself at odds with his boss, the conservative Academician George Reid. When Reid proposed the hiring of ex-Group member Frank Johnston to fill a vacant teaching post, Lismer interpreted this as a hostile gesture against himself and the Group, so he urged Jackson to apply for the job as well. As a full member of the Academy, Jackson was certainly qualified, so he submitted his application. "A few days later, the Board of Governors met, my application was read, and accepted," Jackson recalled.[26]

Jackson joined the staff of the Ontario College of Art as a part-time instructor in the fall of 1924. But no sooner had he arrived than Reid, obviously angry at the appointment of Jackson over Johnston, delegated his newest teacher to a class devoted to drawing from the antique. Jackson was appalled at the models, which consisted only of poor copies of famous sculptures, probably made by former students.[27] Then he was put in charge of a still life class. This was well out of Jackson's field of interest; in fact, the only known still life paintings in his entire body of work are a few small oils of flower arrangements — one called *Blue Gentians*[28] — painted eleven years earlier at Georgian Bay.[29] But Jackson persevered, and soon came to enjoy the class. The previous teacher had had the students draw the same collection of bottles, which he simply rearranged into different positions each week, a practice that naturally bored the students. Jackson would have none of that; he got rid of the bottles and collected a new assortment of still life subjects — glass and ceramic items, as well as colourful fruits and vegetables.[30] With A.Y. Jackson as their teacher, the students never knew what awaited them when they arrived in the classroom.

While Jackson was otherwise occupied as an instructor, the battle of opinion over modern Canadian art was far from over. Controversy re-erupted when a second Wembley exhibition was held in 1925, and once again a large selection of Canadian canvases was shipped over to England. Again, the British press praised the modern work while conservative critics in Canada shook their heads, sat down at their typewriters, and pounded out their own denunciations. Arguments had persisted for more than a year, especially in Toronto, where the Academicians and moderns remained at odds with each other. The Empire Club of Canada, an organization dedicated to "the advancement of the interests of Canada and a united [British] empire,"[31] encouraged discussion on the topic, and invited a representative from each side to hold a friendly debate as one of its weekly lecture events.

Veteran painter Wyly Grier, who had served on the Wembley selection jury, came to present the Academy's views, while the obvious choice to plead the younger generation's case was the outspoken A.Y. Jackson. The two artists were friends, so it was understood

from the outset that the potential for verbal fireworks was minimal. Instead, what club members and guests got on the evening of February 26, 1925, were two frank, lively, and informative speeches that often elicited laughter and cheers of support from the audience.

Following an introduction by club president Dr. R.N. Burns, who briefly described the newfound popularity of Canadian art in Europe, Grier took the podium and immediately admitted that while he and Jackson had been on the same side of the now-infamous Wembley controversy, there was a pronounced "cleavage" in Canadian art, with the older academic painters and the younger modern artists growing further apart.[32]

Grier indicated that the split had been initiated and encouraged by Harris, MacDonald, Jackson, and their colleagues: "Out of the tumult emerged a seven-headed hydra — the modernists will perhaps forgive a classical illustration by a confessed academician. This amphibious monster, coming from the rocky fastness and abysmal depths of the Georgian Bay, settled in Toronto and put up its shingle with the harmless legend — 'Group of Seven.' It had had several annual exhibitions which had charmed, bewildered, or offended the public."[33]

Though careful not to attack landscape painting in general, Grier noted that it was being favoured above the more respected discipline of figure painting. "I am going to admit that Canada, in my opinion in its artistic make-up has a serious weakness, and that is its lack of figure-painting," he said. "It is just as necessary for the artist as it is for the surgeon to have a scientific and accurate knowledge of the human form, and until that knowledge is more widespread and better founded than it is at present we shall never have the finest really complete Canadian art. It will be lopsided, and 'lopsided' begins with the same letter as 'landscape.'"[34]

Before relinquishing the podium to Jackson, Grier made what he thought was a joke, not realizing that the idea was not so far-fetched. "They continually go further north," he said of the Group of Seven. "They have deserted the Georgian Bay, and I dare say they will emerge at the North Pole some day and give us a more simple type of landscape."[35]

Jackson opened his speech with a joke of his own, about an old woman who was rushing out of a Group of Seven exhibition. When asked why she was in such a hurry, she replied, "I hate these pictures, but I am afraid if I stay around here longer I am going to like them."[36] When the laughter subsided, Jackson got right to his main point: "The academic bodies, instead of looking forward, look backwards … The academic bodies rush forward with their heads turned backwards to get direction. Now, Canadians are not much good at looking backwards; it hurts their necks; so we are going forward, and we are not going to sell our souls to dealers, either."

After pointing out the recent successes achieved by modern Canadian artists at Wembley, Jackson recalled his early struggles in Montreal, when his work was shunned in favour of the traditional Dutch art. "The houses bulged with cows, old women peeling potatoes, and windmills. If you were a millionaire, you bought the Maris Brothers and Israels. If you were poor, and had only half a million, there were Dutchmen to cater to your humbler circumstances. Art in Canada meant a cow or a windmill."[37]

On the other hand, he said, Canada's own features were much more vibrant. "In summer it was green, raw greens all in a tangle; in autumn it flamed with red and gold;

in winter it was wrapped in a blanket of dazzling snow, and in the springtime it roared with running water and surged with new life — and our artists were advised to go to Europe and paint smelly canals! We argued that if a cow could stay in the drawing room, then why couldn't a bull moose?"[38]

Jackson ended his speech by predicting how future generations would view the radical Group of Seven. "Tomorrow we shall all be academic," he said. "When the last cow is taken from the drawing room and the walls are alive with red maple, yellow birch, blue lakes and sparkling snow-scapes, I can hear the young modern painter up north say to his pal, 'There's the trail that those old academic Johnnies, the Group of Seven, blazed.'"[39]

The Empire Club event was given considerable coverage in the Toronto press, including a cartoon in the *Star* depicting the two speakers and their respective ideas. The publicity may have brought Jackson considerable acclaim as a public speaker, but at this point he felt that his painting was being neglected in favour of other activities. Teaching at the Ontario College of Art was also taking up a lot of his time. "I had some good students in that class and was very proud of the work they did," he said, but it was not long before he realized that the regimented life of a teacher might not be for him.[40] The long semesters would keep him in Toronto throughout the fall and spring — his favourite sketching seasons. When he was forced to miss his annual trip to the villages of rural Quebec in the early spring of 1925, he took a long look at his priorities and decided that although he would certainly miss the eighty-three-dollar monthly paycheque, he needed to be out in the open air with his sketch box — not standing in a classroom.[41]

So at the end of the semester in the late spring of 1925, Jackson wrote his letter of resignation to George Reid and immediately prepared to spend a few weeks up in Algoma with Lismer and Harris.

village — crude wooden buildings clustered beneath the backdrop of a mighty, snow-capped mountain range — it soon became apparent that Campbell's work was having an adverse affect on Jackson's compositions. As an artist whose style was dominated by curving lines and odd angles, he found it difficult to handle the straight, upright totem poles Campbell had recently reset. "For our purposes, we preferred the poles leaning forward or backward, and suggested to Campbell he set them that way," recalled Jackson, whose sense of humour rarely flagged when he was sketching with friends.[34]

"I would do anything I could to please you artists," was Campbell's straight-faced reply. "But as an engineer I cannot put up leaning totem poles. You can make them lean any way you like in your drawings."[35]

Still, Jackson and Holgate managed to get plenty of slightly leaning totem poles into their sketches and subsequent canvases, nearly all of which feature the striking vertical rhythms of the poles to offset the strong horizontal elements of the mountains and river. One of Holgate's best-known canvases, *Totem Poles, Gitsegiuklas*, provided a close-up view of the structures, while Jackson tended to place the poles in a wider setting that included the vast mountains and humble houses. Rising nearly three kilometres high out of the mist, nearby Mount Gitsegyulka gave the painters an especially attractive visual element — a mountain that "gleams white in the dawn, or bulks up black as a panther against the setting sun, making a dramatic backdrop for the pageant of events along the Skeena."[36] It was here that Jackson sketched *Skeena Crossing*, a simple composition of shacks and figures dwarfed by eleven totem poles, each topped by a massive carved raven.

Together Jackson and Holgate sketched the small villages, the sacred grave houses, and other aspects of the Gitksan settlements. At one point Barbeau led them deep into the bush to look for an abandoned village "that had completely disappeared in the jungle."[37] After hours of hacking their way through the dense, almost impenetrable overgrowth with machetes and axes, they came across the rotted remains of a settlement whose totem poles had "had fallen to the ground and in the dank woods had almost disintegrated."[38]

In October, after several weeks working nearly 320 kilometres upriver, Jackson and Holgate travelled all the way down to the mouth of the Skeena at Port Essington, a small, rough town on the Pacific Ocean where the salmon cannery was the main industry.[39] The Native settlement outside the town attracted the artists, and there Jackson found the subject that inspired what would become one of his favourite

Totem Poles, Kitwanga, 1926. Jackson's 1926 trip to northern British Columbia with Edwin Holgate and Marius Barbeau produced many sketches documenting Native villages and the totem poles that were in danger of disappearing.
Oil on wood panel, 21.0 x 26.7 cm. Private Collection, Fred and Beverly Schaeffer.

Skeena Crossing, B.C. (Gitsegyukla), circa 1926.
From the crude shacks to the carved ravens atop
each totem pole, Jackson captured the essence of
a village steeped in tradition. This is one of only
three canvases painted from his 1926 trip up the
Skeena River.
*Oil on canvas, 53.5 x 66.1 cm. McMichael Canadian
Art Collection, gift of Mr. S. Walter Stewart.
1968.8.27.*

works — *Indian Home*. Judging from the original pencil sketch, the house appears abandoned, almost lost in the overgrowth of tall grass, weeds, and spruce saplings.[40] But when he later painted the canvas in Toronto, Jackson made several major alterations, adding three totem poles in place of two young trees and placing three figures — a mother and her two children — in front of the tiny house.

Like most of Jackson's Quebec landscapes, all of his work from the Skeena trip included figures in the composition. This may have been a deliberate concession to Barbeau and the requirements for his book, or perhaps merely a result of being in the company of the anthropologist, whose work emphasized the human aspect of local history rather than the landscape. But Jackson was never interested in painting people; in each case his figures are merely incidental. His friends Holgate, Hewton, and Varley were ardent portrait painters, but Jackson remained firmly dedicated to the landscape. His figures were rarely more than a few dabs of paint, barely noticeable within the composition. The implication was that they were part of the landscape — an indigenous people rooted to their environment.

Emily Carr Meets the Group of Seven

Jackson, Holgate, and Barbeau could not have known it at the time, but their 1926 trip to the Skeena River would lead directly to a major development in Canadian art — the emergence of Emily Carr as a creative powerhouse. Carr was eleven years Jackson's senior and had long been a painter of great vision and ability. Through the efforts of Jackson's old Montreal friend and art critic Harold Mortimer Lamb, now a mining engineer in Vancouver but still writing part-time, Carr had been brought to the attention of Eric Brown at the National Gallery in the early 1920s.[41] Lamb had also informed Jackson about the tiny, talented woman on the West Coast, but, as Jackson recalled, with the Group of Seven still in its infancy at the time, it was felt that the Ontario artists could do little for Carr except

"invite her to share the abuse being hurled at the Group."[42]

Throughout the long Wembley controversy, Lamb had railed angrily against the National Gallery for neglecting Carr's work, and by 1927 his efforts paid off. When Barbeau and Brown set about organizing an exhibition of West Coast art for the Gallery, they not only invited Carr to contribute work but also arranged for her to come east for the show. The trip included a stop in Toronto, where she would meet the famous Group of Seven — famous, that is, in most art circles, but not the least bit familiar to Carr until she read *A Canadian Art Movement* on the recommendation of Brown.[43]

After meeting Varley in Vancouver on November 10, Carr travelled to Toronto on a CNR pass arranged through Brown. She checked into the Tuxedo Hotel on Sherbourne Street on November 13. The next day she visited Jackson at the Studio Building, accompanied by a Miss Buell of the Women's Art Association and Bess Housser, wife of *A Canadian Art Movement*'s author.[44] The reception was no doubt more than Carr had expected: "Fourteen or fifteen young students were gathered to meet her in Jackson's studio. They had tea, and sweets were passed around on the tops of cake tins. Carl Schafer — then a student — has recalled that Emily 'appeared jolly and so pleased to meet us,' and was 'enthusiastic about what was going on in Toronto.'"[45]

Carr inspected Jackson's three major Skeena canvases from the previous summer — *Skeena Crossing*, *Kispayaks Village*, and *Indian Home* — and was inspired. "I felt a little as if beaten at my own game," she wrote. "His Indian pictures have something mine lack — rhythm, poetry. Mine are so downright. But perhaps his haven't quite the love in them of the people and the country that mine have."[46] Of her jovial host she wrote, "Mr. Jackson is steady and strong. His feet are planted firmly and he has the gift to push and struggle and square his shoulders and stand by the others and by his convictions. He is still young in years but old. Probably the war did that."[47]

Two days later, Carr visited Lismer's studio — a small house built on the lot adjoining his home at 69 Bedford Park Avenue. This meeting had a more profound effect on her, leading her to write passionately in her diary, "He is extremely nice. I wonder if these men feel, as I do, that there is a common chord struck between us? No, I don't believe they feel so toward a woman. I'm way behind them in drawing and in composition and rhythm and planes, but I know inside me what they're after and I feel that perhaps, given a chance, I could get it too."[48]

This strong feeling of creative kinship was solidified with Carr's visit to Harris's studio, next door to Jackson's, that same week. His stark, spiritual images of Lake Superior and the Rockies not only inspired her to continue painting when she got back home, but also led her to immediately begin to develop a new style that would become her instantly recognized trademark — fir trees and totems rendered as simple, geometric shapes, with strong emphasis on the spiritual qualities within her subjects.

From this point forward, the Group of Seven had a creative ally on the West Coast. Carr grew particularly close to Harris, and the two would correspond regularly for many years to come. "Oh they're very fine!" Carr wrote about the Group's profound influence on her. "I'm glad, glad I have seen them and their work … Ah, how I have wasted the years! But there are still a few left."[49]

13

EXPLORING THE NORTHERN FRONTIERS

ON A FREEZING COLD AFTERNOON IN March 1927, A.Y. Jackson and a friend were sketching at Saint-Jean-Port-Joli, a farming village far down on the south shore of the St. Lawrence, near Rimouski. A bitter wind was howling in off the river, blowing snow everywhere as the two painters tried to sketch the rustic barns that stood in frozen, open fields.

At one point, Jackson paused and looked over to where his shivering friend was huddled against a fence, blowing on his hands and struggling to paint as the snow drifted right into his sketch box. "And I thought this was a sissy game!" he shouted at Jackson, his voice nearly lost in the wind.[1]

Jackson could only chuckle modestly. He was impervious to the cold and only thought to complain when it made the paint too stiff and gummy to spread with his brush. But this was his friend's first sketching trip to lower Quebec, and he wasn't accustomed to working outdoors in such harsh weather. He was, however, no stranger to hard work of a completely different nature, and had a Nobel Prize to prove it. He was Dr. Frederick Grant Banting, the co-discoverer of insulin and Canada's most famous son at the time. Just a few years earlier, his work had led to a breakthrough in the treatment of diabetes, and by this time his name was known around the world. An amateur landscape painter in his spare time, Banting's curiosity about the Group of Seven led him into their circle through the Arts and Letters Club, and lately he had become a frequent visitor to Jackson's studio.

"The Group of Seven were a disturbing element at that time," Jackson wrote of Banting's introduction to the Studio Building artists. "A big Lake Superior canvas by Lawren Harris upset Banting so much that he went to the art gallery six times to see it. It made him angry. Then he tried to analyse his own feelings. Why should some paint on a canvas so disturb him? So he came round to the studio to see Harris and hear his reasons for painting the picture. He was willing to believe that artists did research work, too. He began to see a kinship between scientists and artists."[2]

From there, Jackson and Banting became fast friends, and it wasn't long before they were regular sketching companions. To Jackson, Banting's worldwide fame was irrelevant. When they were out in the snow-covered fields of rural Quebec, he was not the illustrious scientist but simply Fred Banting — a fellow veteran of the Great War, a keen artist, and a pleasant travelling companion who could carry his share of the load on sketching trips. It was a great source of amusement to Jackson whenever the modest Banting insisted on dropping his surname and introduced himself as simply Fred Grant when they arrived in the small French-Canadian villages along the lower St. Lawrence. He even wore shabby old clothes to help conceal his true identity, but more often than not, Jackson observed, the famous doctor was eventually recognized and would soon find himself attending a bedridden patient or advising a diabetic on how to properly inject insulin.[3]

Banting was an avid student of the Canadian Arctic. He owned many books on the subject and had always been keen to visit the region. This was not easy in the 1920s, for the entire northern frontier was inaccessible by road or rail, and a long-distance aviation service had yet to be established. Besides, the Arctic was vastly undeveloped. The only populated areas consisted of a few Inuit villages and tiny RCMP outposts spread over hundreds of thousands of square kilometres. The only access was by boat — a government supply ship that made a run up through the icy channels each summer to deliver supplies, livestock, and officers to the RCMP posts. This annual shuttle service was the sole contact these residents had with the outside world, and the ship's arrival was a major event in their lives.

Jackson claimed that the idea to visit the Arctic was originally planted by Wyly Grier, during their public debate at the Empire Club. When Grier asserted that the Group of Seven seemed to be pushing further and further north in their sketching expeditions, and soon the only remaining objective would be the North Pole, Jackson's reaction to that was a hearty "Well, why not?!"[4] The Arctic had long been a favourite subject at the Arts and Letters Club; in fact, "roving non-resident member" Robert Flaherty occasionally stopped by to display Inuit relics and costumes in the years prior to completing his groundbreaking documentary film *Nanook of the North* in 1922.[5]

Jackson harboured the idea in the back of his mind for a year, and the following New Year's Eve, while listening to a radio broadcast in which people extended greetings to friends and relatives living at remote outposts in the Far North — many of which were addressed to an apparently popular Sergeant Joy of the RCMP, living "on top of the world" — he decided he should go.[6] In early 1927, he wrote to Charles Stewart, Minister of the Interior, requesting passage aboard the SS *Beothic*, the government-chartered supply ship that made the annual voyage. Eric Brown, the Group of Seven's long-time supporter at the National Gallery, also wrote to Stewart on Jackson's behalf.[7] In exchange for his passage, Jackson offered to paint a landscape of Ellesmere Island, the northernmost inhabited point in Canada, which he would present as a gift to the Ministry of the Interior. He did not expect to receive a reply, but Stewart immediately wrote back and suggested he contact Deputy Minister O.S. Finnie with more details. Jackson did so, mentioning that one of his friends, the famous Dr. Frederick Banting, would also like to come along, and soon the arrangements were underway.

In the ensuing exchange of letters between Toronto and Ottawa, Jackson was accepted for the summer's voyage, but Banting's application to join his friend was flatly refused. There was not enough room aboard the *Beothic* to accommodate another passenger, he was told. Jackson pressed the matter, refusing to believe such a feeble excuse. In doing so, his suspicions were confirmed when he was told, off the record, that the Canadian government was extremely reluctant to expose its most venerable scientist to the hazards of an Arctic voyage.

"And why not," an indignant Jackson barked back, "when you're taking responsibility for *me*?!"[8]

He was certainly not the first artist to undertake such a trip; William Hind had worked in northern Labrador in 1890, and the American artist Rockwell Kent had painted several Arctic landscapes.[9] Still, once the press was informed of Jackson's itinerary, it was hailed as an original move that promised to breathe new life into the country's artistic spirit.

"During the coming summer, a distinguished member of the Group, A.Y. Jackson, will work in a field hitherto untouched by any artist," the *Sault Ste. Marie Star* reported. "He will paint the barren lands of the Canadian Arctic, the bleak, untimbered hills and grey seas within 600 miles of the pole. It is anticipated by the adherents of the new school that the fruit of this 'farthest North' venture will lend a fresh impetus to Canadian landscape painting."[10]

Always eager to face a new challenge, Jackson himself outlined his plans with enthusiasm. "I think the ordinary pastoral painting, as practised now, is a dead letter," he told a reporter from the *Regina Leader-Post*. "New art forms are necessary if the artist would develop. I think I will find new art values in the far north."[11]

As the departure date neared, it appeared that Jackson would indeed be taking the trip alone. Banting was bitterly disappointed, but that did not prevent him from attending Jackson's going-away party, thrown by the sculptors Frances Loring and Florence Wyle at their studio — a converted church on Glenrose Avenue. After what has been described as a "particularly boisterous occasion,"[12] an exhausted Jackson went back to Banting's house, where a telegram from Ottawa awaited. Happily, the Ministry of the Interior had reconsidered its decision and Banting's application to accompany Jackson aboard the *Beothic* was accepted — leaving him little more than a day to settle his affairs in Toronto for the summer and find an appropriate wardrobe for the voyage before catching a train to Nova Scotia.[13]

Aboard the *Beothic* in Sydney Harbour on July 16, 1927, shortly before departing for the Arctic. A.Y. Jackson is standing second from left, and his sketching companion, Dr. Frederick Banting, is standing third from right, smoking a pipe.

North to Greenland

And so on the rainy morning of Saturday, July 16, 1927, Jackson and Banting joined the other members of the *Beothic* party on the dock in Sydney Harbour, preparing for an unprecedented event — the departure of a member of the Group of Seven for a sketching trip at the top of the world. Even the mayor of North Sydney was on hand to see the ship off.[14] As the last items of the diverse cargo — everything from coal to sled dogs — were secured below, a photographer from the *Toronto Star* lined up a group portrait on the wet deck as RCMP officers, missionaries, Hudson's Bay Company agents, and government scientists posed in the rain with the two artists.

The old steamer was under the command of Captain Falke, a veteran seaman who had been born in Norway, within the Arctic Circle.[15] The crew consisted of hearty lads from Newfoundland, most of whom had been on several previous Arctic voyages.[16] Jackson and Banting were billeted with Dr. Malte, a rotund, jolly botanist who hoped to find new species of vegetation in the far north. To the pleased surprise of his cabin mates, he had brought aboard an ample supply of rum to celebrate any new discovery or even the sighting of certain plants further north than previously recorded.[17]

The ship pulled out just after noon. As it headed toward open water, Banting was struck by a sudden sense of freedom, realizing that he was about to spend nearly two months without any professional responsibilities whatsoever. He impulsively pulled off his detachable collar and happily tossed it overboard, shouting, "No more white collars!" This spirit proved contagious, as a few other men on the deck quickly followed Banting's example and sent their own collars floating out over the murky water.[18]

The government of Canada was obliged to maintain settlements throughout the Arctic — even if they were just a few tiny buildings — in order to keep its claim to the territory. If the region were not inhabited, it would be easier for countries such as Norway, Russia, and the United States to claim huge portions of land.[19] The RCMP officers on board were going up to relieve fellow officers who had been manning these posts for a year. The policemen's duties were minimal, Jackson learned. They had to "make patrols, report on weather and ice conditions, administer the law, and preserve order. It was also part of their task to restrain the Eskimos from throwing away girl babies and leaving their old people to die of starvation, and to advise the hunters of the folly of killing more game than they could use."[20]

For nearly a week the *Beothic* steamed northward, past drifting icebergs on calm waters and rolling through thick fog over choppy waves. Finally, on the following Friday afternoon, July 22, gulls and ducks were spotted near the ship and the coast of Greenland came visible through the fog — a tall ridge of grey hills capped with snow. The *Beothic* continued up the coast, and the next morning emerged from the fog at Godhavn, the first port of call. "How we did it I don't know," Jackson wrote in his diary. "There was nothing to go by, neither horn, light or beacon, but we nosed into the snug little harbour, with the frowning snow-covered hills rising behind it, and the heatless sun shining down, about 6 a.m."[21]

The ensuing scene was memorable for the two artists. The *Beothic*'s arrival was cause for celebration in the village: a happy contingent — including the Governor of North Greenland himself — came out in a motorboat to officially welcome the ship, and a

public holiday was proclaimed in the tiny hamlet. After being at sea for seven days, Jackson and Banting were anxious to get to work on their painting and slipped ashore during the festivities. They were not disappointed. Godhavn consisted of colourful Danish-style cottages, with steep roofs and ornate trim, standing side by side with Inuit shacks built from whatever material happened to be handy — wood, tarpaper, and whale bones.[22]

With the RCMP officers' scarlet uniforms mingling with the bright colours of the Inuit women's dress, the scene appeared surreal to Jackson. "It's an unbelievable village," he wrote in his diary the following day, "and you keep pinching yourself to find out if it was a dream or part of the Chauve Souris, or a fairy tale ... Everybody was laughing, and all in gala attire — such gorgeousness, vermillion top boots or moccasins, fur pants, and jackets of every color, and woolen caps or toques."[23]

Jackson also noted that dogs far outnumbered humans in Godhavn. They lay sleeping everywhere, seemingly oblivious to the excitement around them. Every so often one would raise its head and let out a long howl, which would be answered by other dogs, one by one, until the village was filled with an eerie chorus of high-pitched canine voices.

The festive atmosphere continued well into the afternoon as a tarpaulin was rigged up on the ship to serve as a movie screen and the entire population of Godhavn was invited aboard for two showings of Felix the Cat cartoons and other silent films, certainly a rare treat for the isolated Greenlanders.[24]

Mountains of Ice

Before long the *Beothic* was steaming westward across the Davis Strait to keep its busy itinerary of calls at remote posts. It was understood that the schedule of stops was entirely tentative, for shifting ice fields often prevented the ship from reaching some of the settlements. This became apparent when icebergs began to appear on the horizon. As more and more drifted closer, the *Beothic* was soon surrounded by massive white and blue-green mountains of ice — many of which were hundreds of years old, Jackson and Banting were told. Sketching them from the ship's deck was difficult, as the pilot had to manoeuvre the big vessel in and out of the path of oncoming bergs. Still, the two artists could not help but marvel at the sheer size and beauty of them. Some were shaped like mushrooms; others carried chunks of mud and rock along their edges — souvenirs of scrapes against the shore, perhaps centuries earlier.

Banting was especially impressed by the shapes and colours that were drifting past at a rate of about twelve kilometres per hour. "I hope we park somewhere in this kind of stuff," he said, but was immediately informed of the dangers they posed to the ship.[25] This was the dreaded Melville Pack, a group of icebergs that drifted around the Baffin Bay region and had terrorized Arctic explorers throughout the eighteenth and nineteenth centuries.[26] Ships could easily become trapped in the Pack and remain icebound for weeks, even months. As the *Beothic* slowed to a crawl, with Captain Falke up in the crow's nest for hours at a time, it appeared that the Melville Pack might claim another ship. The big steamer was bumped repeatedly as the captain and pilot searched the horizon for a passage through the walls of ice. Finally, they managed to steer the *Beothic* through the maze to open water, and steamed up toward the northern tip of Baffin Island

and their next port of call, Pond Inlet.

As it turned out, the first Canadian stop on the itinerary was impossible to reach. They approached the coast on July 26 and found thirty-two kilometres of ice between themselves and the shore. There was no way for the *Beothic* to push through, so the captain sent a radio message to the settlement, informing them of the ship's arrival and offering to wait a few hours so that someone could come out over the ice to receive the supplies.

As they waited, Jackson took many notes, describing the distant landscape as "rocky mountains as far as the eye can see, with cloud banks lying thickly over them, so that you could not tell cloud from mountain, only the steep ridges or spines were bare of snow."[27] Jackson and Banting both made several sketches of the pointed hills set back from the cloudy shore, with noisy seals flopping around on the ice around them as they worked.[28] Finally, when there was no sign of any RCMP officers coming out to meet the ship, Captain Falke gave the order to move on, and soon Jackson and Banting were treated to a view of Bylot Island, "the loveliest island in the Arctic … crowded with sharp peaks, all snow covered; between them ran the curved line of slow-moving glaciers; at the base lay a stretch of flat country where the snow was disappearing."[29]

Further north, the *Beothic* pulled into the outpost at North Devon, where two RCMP officers went ashore to relieve two of their colleagues. Jackson, Banting, and Dr. Malte went with them. Although it had appeared from the ship that the coast was bare of any vegetation, as soon as they landed Dr. Malte went running along with his specimen bag, joyfully grabbing a wide variety of wildflowers and moss. Between sketches the artists visited the police barracks and an Inuit hut, "at the side the size of a packing case."[30] Again, sled dogs far outnumbered humans. Jackson noted that they were "powerful brutes, but noisy, a dog fight every two minutes."[31]

A working pattern was soon established for Jackson and Banting. Whenever possible, they would go ashore with the supplies and record their impressions of the landscape in either pencil or paint, depending on the conditions. Nothing daunted Jackson, who would bravely leap from one ice floe to another in an attempt to reach a desired vantage point, leaving Banting with no choice but to reluctantly follow. As Banting later wrote admiringly of his companion:

> Sketching was done under considerable difficulty; cold and wind would have chilled the enthusiasm of a less ardent worker. Jackson cherishes an illusion that the finest colour is generally to be found on the most exposed spots. A restless desire to find what lies beyond the distant hills makes it hard to keep up with him. The barren wastes proved to be rich in form and colour, strange rhythms and unexpected vistas. During our all too brief and exciting scrambles ashore, he would be chuckling and laughing all day — a mood I found contagious. On the ship he would watch the changing landscape, following the wind-blown clouds, drinking in the beauty of colour of the coast formations, and studying the subtle effects of light on the moving ice.[32]

After calling in at Craig Harbour, the *Beothic* turned west, back to Greenland, where it stopped at Etah. Here they met a group of Inuit families who had come upon hard times. Many of their dogs had died of starvation, and they hoped to be taken to a better envi-

ronment. As Captain Falke planned to make another attempt at reaching Pond Inlet on the way back, he offered to drop them off there. To this they agreed and eagerly climbed aboard with all their possessions — which did not amount to much.

At the Top of the World

With its decks covered in snow and flocks of ducks circling above it, the *Beothic* reached its most northerly point at the end of July when it nudged its way up through the pack ice of Kane Basin along the edge of Ellesmere Island and anchored just off the coast. Bache Post was a tiny settlement consisting of three small shacks by the foot of a huge cliff, with a total population of "only three Eskimos and four police."[33] Ice floes prevented the big ship from approaching the shore, so a small motor launch came out and who should climb aboard but Sergeant Joy — the popular RCMP officer of whom Jackson had heard so much during the previous New Year's Eve radio broadcast.

With the ice quickly moving in, threatening to trap the ship, there was little time to get the supplies ashore. Two RCMP motorboats were used to make several trips back and forth with everything from a year's supply of food to twenty tons of coal.[34] Jackson and Banting hurried ashore in one of the boats, and immediately set about sketching. They found nothing but shale, gravel, and ice along the coast, with no signs of vegetation. The only colour they could find were traces of ochre and violet in some of the rocks.[35]

There was no time to work in oil, so they made pencil sketches. It was at this time that Banting photographed Jackson standing on the shore, quickly sketching the Bache coast, the *Beothic* anchored in the distance behind him. Jackson was able to make a pencil sketch of the ship, surrounded by ice, which he later worked up as an oil sketch in the safety of his cabin.

As the treacherous ice closed in, the *Beothic* prepared to leave. Jackson and Banting did not relish the prospect of being stranded at Bache for a year, so they had to catch the last boat going out for provisions, just as the ship's anchor was about to come up. Even as it moved out ahead of the ice, finding open water proved to be extremely difficult. Again, Captain Falke went up to the crow's nest with his binoculars to search for a safe passage while the ice pilot, Morin, dodged oncoming icebergs. Jackson later noted that the hazardous ice conditions compelled the government to eventually close the Bache Post.[36]

Traces of Franklin

Four days later, on August 4, the *Beothic* had steamed west through Lancaster Sound and stopped at Beechy Head, on the southwestern edge of North Devon Island. Jackson described the scene as "a desolate looking landscape. A big pile of rock rises about a thousand feet out of the water almost straight up. On the east side it drops down to in a series of shale slopes to a bay full of ice."[37] At first the ship remained anchored off the coast, tossed by a storm and bumped by ice floes. The rough weather eventually gave way to a fog so thick that nothing was visible from the deck. It was only on the third day, August 6, that the sun came out and conditions were clear enough for Jackson and Banting to venture ashore aboard the motorboat.

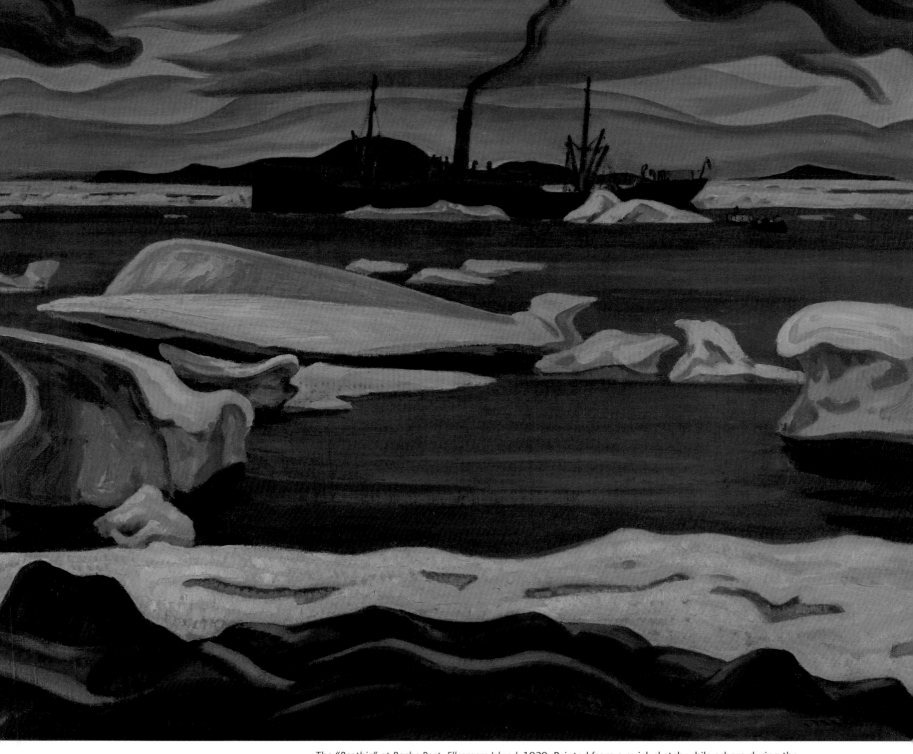

The "Beothic" at Bache Post, Ellesmere Island, 1929. Painted from a quick sketch while ashore during the unloading of cargo at Ellesmere Island, this is the canvas Jackson presented to the Canadian government in exchange for his passage on the supply ship.

Oil on canvas, 81.6 x 102.1 cm. © National Gallery of Canada, Ottawa, gift of the Honourable Charles Stewart, minister of the interior, 1930, to commemorate the establishment on August 6, 1926, of Bache Peninsula post. Courtesy of the estate of the late Dr. Naomi Jackson Groves.

They landed on a grey gravel beach at the foot of the tall cliff, and found themselves standing amidst relics of a tragic chapter in Canadian history, for this was where British explorer Sir John Franklin and the crews of his two ships, the *Erebus* and the *Terror,* had camped during the winter of 1845–46. After leaving Beechy, they had pushed further west and were trapped by ice for nearly two years. Unable to find any wild game once their supplies ran out, their ill-fated quest to find the Northwest Passage ended in the eventual starvation of all members of the expedition.[38] Now, in 1927, the shoreline of Beechy Head was still strewn with evidence of Franklin's winter camp — rusted tin cans, bottles, barrels, scraps of canvas, boat parts, and the remains of a small shelter, the wood perfectly preserved even after eighty years.

This must have been an eerie scene for Jackson and Banting, both of whom were certainly familiar with the tragic story of Franklin's last voyage. As they walked along the rocky shore, the silence broken only by the screech of gulls overhead, they came across a memorial to the Franklin expedition erected by Captain F.L. McClintock, commander of one of several search parties. They also found the skeletal remains of the small schooner *Mary*, left on the beach in 1850 along with a cache of provisions in the hope that any survivors from Franklin's party might find their way back to Beechy. The boat had remained there through the years, stripped clean by subsequent visitors. Jackson took the time to make a detailed pencil drawing of the *Mary*, turned on its side at the foot of a cliff so tall that it ran straight up the right-hand half of the composition with no top in sight.

A Controversial Homecoming

As the *Beothic* headed for home, it made another attempt to reach Pond Inlet. This time it approached from the north instead of the east, and was able to find its way through the ice. Here the Inuit families from Etah disembarked, and once again Jackson and Banting were able to venture ashore with their sketch pads. This pattern continued at several more ports of call as the ship continued on its southward journey toward Sydney. Further down Baffin Island, the two artists were able to sketch the Native villages at Clyde, Pangnirtung, and Lake Harbour.[39]

Banting, whose interest in the Arctic extended beyond its landscape to include anthropology and sociology, was becoming increasingly convinced of the ill effects modern society was having on the Native people of the region. Many of the Inuit he and Jackson encountered on the voyage were employed as trappers by the Hudson's Bay Company; this was not surprising in itself, but as Banting realized, they were no longer living off the land. "Banting's argument was that the Eskimos had existed for hundreds of years by hunting," Jackson wrote. "The fur company had turned them into trappers, leaving them little time to hunt, so the Company supplied them with food — the wrong kind of food for that country."[40]

This, Banting firmly believed, was the reason behind the steadily declining Inuit population. Shortly after the *Beothic* docked back in Sydney on September 4, he inadvertently fell into an earnest conversation on the subject with a reporter on the train back to Toronto, and the resulting story created a small scandal. Here was Canada's most famous

scientist criticizing the Hudson's Bay Company — the country's oldest and most vener-
ated institution. This would not do, of course, and no sooner had Banting arrived home
than he received a summons to Ottawa, where he was obliged to explain himself to
Deputy Minister Finnie. Soon after, when the Hudson's Bay Company demanded a
retraction, Banting visited the Company's general manager: well-armed with research
that included population statistics culled from the Company's own reports, he success-
fully made his point and the matter was quietly dropped.[41] Still, it was tacitly understood
that Banting should not expect another invitation to visit the Far North as a guest of the
Canadian government.

For Jackson, the autumn of 1927 was taken up by painting canvases from the many
sketches he had accumulated on the voyage. One of the first projects to be undertaken
was the canvas he had promised the government — a portrait of the *Beothic* itself, moored
off the coast of Ellesmere Island at Bache Post, the northernmost inhabited point in
Canada. This was a direct result of the pencil drawing Jackson had hurriedly made while
he and Banting were ashore that day when the ice was closing in. Later, back aboard the
ship, he'd painted an oil sketch. The *Beothic* is seen in the distance, its black hull silhouet-
ted against a vast white ice field. The most striking aspect of *The Beothic at Bache Post,
Ellesmere Island* is Jackson's palette. In order to express the dreariness of the bleak north-
ern landscape, he painted the cloudy sky in various greys and whites — but the calm
water is surprisingly rendered in much warmer shades of yellow ochres and umbers.

True to his word, Jackson presented the finished canvas to Charles Stewart, Minister
of the Interior, who in turn gave it to the National Gallery two years later in commemora-
tion of the 1926 establishment of the Bache Peninsula Post.[42] The oil sketch went to
Deputy Minister Finnie, where it remained in the Finnie family for many years.[43]

But painting was not Jackson's only priority upon his arrival back in Toronto. He
immediately began preparing a small exhibition of his most recent work — a selection of
the oil sketches and ink drawings he had produced from the deck of the *Beothic*. "Sketches
and Black and White Drawings of the Canadian Arctic Regions by A.Y. Jackson, RCA"
opened on September 21 at the Art Gallery of Toronto. These unique Arctic scenes proved
to be so enlightening that Jackson was approached by Rous and Mann, the firm that had
once employed most of his fellow Group of Seven members. It was proposed that his
sketches be published in a book — a venture to which Jackson readily agreed. The result
was *The Far North*, "a fine little vivid-green-covered book"[44] that came out in a limited
press run in 1928. Banting contributed a brief introduction to his friend's collection of
seventeen ink drawings, each one showing part of a vast territory virtually unknown to
most Canadians. But despite the best efforts of all concerned, the book was a commercial
failure. "Not a review or the slightest notice taken of it," Jackson wrote about it few years
later. "They printed a thousand and sold three hundred. It's dead as a door nail."[45]

Jackson's voyage up to the country's northernmost frontiers may not have been seen
by all as a heroic quest to seek out new aspects of the Canadian landscape. On the con-
trary, it could have just as easily been interpreted by the Group of Seven's detractors as
another publicity stunt. But the one thing that could not be denied by anyone was that
the voyage solidified Jackson's reputation as the Group's most adventurous outdoorsman,
who would brave even the harshest northern climate to further his own art.

14

BLACKFLIES, ICE, AND FOG

DR. BANTING WAS NOT THE ONLY ONE TO find himself in hot water over a newspaper article immediately following the Arctic voyage. Jackson's comments to *Toronto Star* reporter C.R. Greenaway caused a stir when they were published on September 10, but exploded into a squall of controversy when news of the article — "Jackson Says Montreal Most Bigoted City" — reached the artist's hometown.

Provocative as always, Jackson never wasted an opportunity to lash out at Montreal's conservative art establishment, which he considered still far behind the times. His own years of frustration in Montreal remained etched in his memory, and he steadfastly believed that the city's struggling modern artists — among them members and close associates of the defunct Beaver Hall Group — needed as much support as they could get. When the *Montreal Star* picked up the story and ran it as a local news item under the sub-headline "Ontario's 'Group of Seven' Would Starve to Death Here," Jackson might have appeared somewhat as a loose cannon. But as a spokesman for the Group of Seven — Canada's foremost artistic movement — his words took on a stinging quality:

> "There is no more bigoted place than Montreal." Toronto parlour anarchists to the contrary, A.Y. Jackson, one of Toronto's "Group of Seven," just back from a painting trip farther north than any other Canadian painter, showed himself quite prepared to stick to his guns during an interview published in the *Toronto Star*.
>
> "I mean what I say," said Mr. Jackson, noting the look of doubt on the interviewer's face. "It's certainly true of Montreal in art. About the only freedom they have in Montreal is for booze.
>
> "Certainly," said Mr. Jackson, "the Group of Seven could not exist in Montreal … The Group of Seven couldn't get an opportunity to exhibit their work here. They wouldn't be allowed the use of an art gallery."
>
> "What I criticize in Montreal is the lack of direction among its younger generation," Jackson said. "What they do, they do remarkably well. They've got dignity and poise. But they have no great Canadianism. They do what other people do. They go to the Riviera and Paris, but they don't lead expeditions of discovery in their own land. It is sad to see a city the size of Montreal, where there is such a tremendous wealth, so lacking in appreciation of the tremendous possibilities of their own country. We need to blaze our own trails now."[1]

Jackson had obviously exaggerated his comments for dramatic effect, for the Group of Seven was well known across Canada by 1927 and it is doubtful that they would have

It was also an ominous sign of things to come, for the next two weeks would be plagued by rough weather that tossed the ship up and down on mountain-like waves for hours, and long, worrisome encounters with pack ice threatened to imprison the *Beothic* for days — perhaps even weeks. As the ship crawled along through rapidly shifting corridors of ice, sometimes so close that the crewmen could reach out and touch the ice from the deck, it was probably difficult not to think of the Franklin expedition and how its two ships became permanently trapped, leaving the crew no choice but to set off on foot across the vast frozen sea, where a cruel fate of exposure and starvation awaited them. Luckily, the *Beothic* was once again able to negotiate its way through the ice, some of it so blue that Jackson and Harris could not resist grabbing their sketching materials in the midst of the crisis.

In Lancaster Sound, as the ship was forced to inch its way blindly through the treacherous ice while engulfed in a thick fog, even the seasoned Captain Falke could no longer hide his utter frustration. "He swore that in the Arctic everything is against you: God, the Devil, Satan, the whole lot of them," Jackson recalled. "As for the magnetic pole, he wished the Russians owned it and kept it in the middle of Siberia."[28]

Conditions improved as the *Beothic* made its way along the top of Baffin Island, passing the mighty peaks of Bylot Island and stopping to unload supplies at Pond Inlet. From there it continued for nine hundred kilometres down the coastline to Cumberland Sound and reached Pangnirtung by the first week of September. It was here that Saint Luke's, a small Anglican hospital that would serve all of Baffin Island, was being built, so the ship stayed a few days while the lumber was unloaded, offering Jackson and Harris ample time to explore the surrounding country. [29]

During his previous visit, a thick fog had prevented Jackson from sketching the mountains along the Pangnirtung Fjord. Now, in clear weather, he was amazed to see what he had missed — a colourful vista of hills, lakes, and grass-covered meadows, all dwarfed by a grand range of snow-peaked mountains. It was impossible to resist, so he immediately climbed high into the hills and made several sketches of the landscape below.[30] He also spent much time sketching the village itself, finding interesting compositions in the Inuit tents, igloos, and white shacks that lined the shore along with an array of boulders, bones, and other debris. Some of these sketches would form the basis of his canvas *Summer, Pangnirtung,* which shows an Inuit family and two of their dogs next to an animal-skin tent that juts up from a rough terrain of pointed rocks. One of the figures is likely a young man named Killabuk, who took it upon himself to show Jackson and Harris around his village, proudly pointing out places of interest and explaining his people's customs.

On the last leg of the trip, which took the *Beothic* west across the top of Hudson Bay, the ship's cook informed Harris that his supply of Roman Meal had been depleted. This was hardly surprising, as both Falke and Joy had also become addicted. To Harris, this catastrophe was made even more alarming by the slim chance of finding Roman Meal in any of the tiny settlements. At Chesterfield, on the northwestern shore of Hudson Bay, Jackson and Harris went ashore on a barge to explore the "long unsociable line of buildings: Hudson's Bay Company post, Roman Catholic Mission, an unfinished hospital, the doctor's shack, the RCMP post and the wireless station."[31] It was a windy, rainy morning, and the two artists were weary in both body and spirit. At the tiny Hudson's Bay Com-

pany store, Harris half-heartedly asked the clerk if he happened to have any Roman Meal in stock.

"I've never heard of it," was the reply, just as expected.

But then, as Harris scanned the shelves, his eye caught a familiar sight behind some items stacked away on the highest shelf. The surprised clerk got a ladder and sure enough brought down four dusty packages of Roman Meal — enough to last them through the rest of the trip.[32] Jackson and Harris returned to the ship in triumph, but even a regular diet of Roman Meal could not keep them safe from the perils of the return voyage.

As the *Beothic* headed home, it once again encountered rough seas. As Jackson recalled, the violent rocking on the huge waves often led to chaos in their cramped quarters below deck:

> The *Beothic* creaked and groaned; in the crowded cabin everything rattled and banged. Smash! What was that? It was only Harris's hair tonic, but it was followed by an avalanche of clothes, boxes, books, trunks, all shooting back and forth across the cabin in hopeless confusion. In the bunk above, Harris lay, choking with laughter. He looked down to see me reach out to stop a runaway suitcase; a stool rushing at me gave me a whack on the head. I probably seemed very funny seen from above.[33]

After nearly two months at sea, the weary passengers and crew of the *Beothic* arrived back at Sydney Harbour on September 27. Jackson had accumulated enough sketches to keep himself busy at his easel for months, but once again the prolific Harris had been inspired to produce dozens of oil sketches and major canvases — among them the haunting *Icebergs, Davis Strait* and *Bylot Island*. Harris also brought back home movie footage that featured thrilling sequences of storm waves crashing over the *Beothic*'s deck, candid glimpses of Inuit life, and breathtaking vistas of fog-shrouded mountains shot from the ship as it was "steaming through channels or while being bumped by pack ice."[34]

The 1930 Arctic voyage proved to be a major milestone, for it would be the last time the two old friends Jackson and Harris sketched together; in fact it was, for all intents and purposes, the last Group of Seven sketching excursion. Economic pressures, shifting interests, and changing styles were all taking their toll on the Group. Depression-era Canada was a much different place than it had been when a few friends of the late Tom Thomson banded together in a spirit of post-war optimism and painted their bold statements. By the beginning of the 1930s, it was becoming increasingly obvious that the Group of Seven in its present form could not continue much longer.

15

HEARTBREAK AND DEPRESSION

ON A COLD AUTUMN NIGHT IN 1933, A.Y. Jackson sat in his tent on the silent shore of Grace Lake, trying to write a letter by the dim flickering of a candle. High above, beyond the darkened La Cloche Hills just north of Lake Huron, the aurora borealis flashed curtains of light across the sky. He would normally have been sitting outside the tent, warming himself next to a crackling campfire as he watched the spectacular display over-head, but on this night he had more important matters on his mind. Working alone in the wilderness, often completing as many as three colourful sketches per day, he had had plenty of time to think.

The past two years had brought significant changes — both professional and personal — forcing Jackson to take a long, hard look at his life. Now he was taking a bold step toward a major change. He was carefully composing a letter to Anne Savage, the woman with whom he had finally made up his mind to share the rest of his life. He knew there were several daunting obstacles to overcome: she was firmly rooted in Montreal, where she taught art at Baron Byng High School, and she was responsible for the care of her aging mother. But despite the fourteen-year gap in their ages, the two artists had grown increasingly close since they first met when the Beaver Hall Group was formed back in 1920. Hardly a week passed without a letter between them, and she was often at the sta-tion to greet him whenever his train or bus pulled into Montreal. Although they led busy lives in two different cities and saw each other only a few times a year, emotionally they were inseparable by the early 1930s.

But when Jackson turned fifty in 1932, he suddenly felt a more immediate urge to set-tle down and form a permanent relationship. "This birthday rather bewilders me," he wrote to Savage while on a sketching trip to the mining town of Cobalt, Ontario. "I'm a complex individual. I have many friends and contacts; for some reason I'm popular socially without wanting to be very much and here I am getting on in years. Next door to me the horrible example of [Curtis] Williamson, soured, lonely and helpless."[1]

By 1933, Jackson was determined to take his relationship with Savage to the next level — but he was afraid. He had experienced the horrors of trench warfare, slept soundly in wolf-infested woods, hiked for days through grizzly country, and braved the Arctic's enor-mous ice floes, but proposing marriage took more courage than Jackson could muster. His first attempt, for which he invited Savage on an extended camping trip up at Georgian Bay that summer, had failed miserably. He'd often managed to get her alone in the romantic setting of picturesque little islands, but no matter how hard he'd tried, the words would not come out. Now, in early October, isolated in the wilderness, he poured it all out on paper for her.

"What do you want me to do, Anne?" he wrote, summoning up his courage. "You are the dearest and sweetest soul I know and if you will be my wife I will try so much to make you happy. If you want me to help you as you say it seems the only way to do it. We can go on being friends for the rest of our lives as we would no doubt. Whether marriage would mean perfect happiness or not it is no use being afraid of life."[2]

He carried the letter in his knapsack and, no doubt with his heart beating quickly, mailed it the next day from tiny Willisville — sixteen kilometres by canoe and portage, then another six on foot from Jackson's camp high in the La Cloche Hills.[3]

Art for Hard Times

The early 1930s were a time of upheaval for Jackson and other members of the Group of Seven. The Great Depression had taken its toll on the artists, virtually wiping out their sales. Obviously, the National Gallery and other art institutions could not justify expenditures on such frivolous commodities as paintings when so many thousands of people across the country were destitute. Of the Studio Building artists, Harris and Jackson were the least affected by the economic crisis: Harris was independently wealthy, and Jackson's frugal, modest lifestyle had never required much money. He rarely sold a painting anyway; in fact, the National Gallery had not purchased anything directly from him since 1927 and would not do so until 1938.[4] The only real difficulty he had was raising a few dollars for travelling expenses whenever he set off on one of his regular sketching trips. And when he planned to be gone for extended periods, he often found someone to sublet his studio, thus saving himself the cost of rent.

Throughout the Depression years, Jackson's life at the Studio Building was one of economic austerity. He took most of his meals with Keith MacIver, a Scottish prospector who had been living in Tom Thomson's shack behind the Studio Building since the late 1920s. MacIver had renovated the shack to the point where it was a comfortable winter home and official headquarters of his small mining company. Jackson started each day in Toronto by descending the Studio Building stairs and making his way out back, where he whistled for MacIver's dog, Brownie, then joined his friend in a frugal but hearty breakfast in the shack. Money was scarce, but the rustic lifestyle did not require much of it.

As for MacDonald, Lismer, Varley, Carmichael, and Casson — as well as most other artists across the country — the Depression hit them hard. Their jobs as teachers and commercial artists became precarious and they were forced to take on other projects in order to support their families. MacDonald and his artist son, Thoreau, painted designs and murals in public buildings, and Lismer took on a major mural commission for Toronto's Humberside Collegiate Institute.[5] Jackson even helped to arrange commissions for his friends, most notably a mural of wild geese by the younger MacDonald for Baron Byng High School. "[Thoreau] says they are hard up and would do it for what ever you could collect," he wrote in a 1931 letter to Savage, who was in charge of the mural project.[6] It is not known exactly how much Thoreau MacDonald was eventually paid for the large painting, but it was to become a cherished part of the school, still on display in a main stairway some forty-five years later.[7]

Another major project spearheaded by Jackson in the late 1920s was the creation and sale of Christmas cards designed by Canadian artists. He secured the services of Rous and Mann to print them, then solicited designs from his friends in Toronto and Montreal. "Would you and Nora Collyer like to send me each a couple of designs to show Rous and Mann," he wrote to Savage in January 1931. "Flat colours or wash. Lively colours and Canadian motifs."[8] Savage did send a few designs, as did her fellow Montrealers Sarah Robertson, Kathleen Morris, Mabel Lockerby, and Ethel Seath.[9]

Creating Christmas cards was an excellent idea. Not only would the exposure help boost the artists' careers, but most of them already had a large number of sketches to choose from, having frequently tackled rural winter scenes with horse-drawn sleighs and snowy landscapes — the rustic atmosphere that lent itself so well to the Christmas season. Financially, the prospects were bright, for even the Great Depression could not dash the annual holiday spirit, and there were still plenty of people who could afford to buy even just a few cards. As the project got off the ground, Jackson grew unsatisfied with the original payment scheme of one cent per card and was eventually able to negotiate a rate of twenty-five dollars per design — a considerable amount of money at the time, about the same as he might get for the sale of an oil sketch.

Still, the Christmas card project was not the success Jackson had hoped for. As the main organizer and motivator behind the venture, he was disappointed when, after a while, some of his friends no longer shared his unflagging enthusiasm. "I wrote Holgate four times and he never even answered," Jackson reported bitterly to Savage in the summer of 1931. "I asked Robinson to send a couple of his old sketches up. He replied to the effect that he couldn't be bothered."[10]

In the end, a series of forty-six different cards were produced through the silkscreen process by the William E. Coutts Company. Issued under the collective title Painters of Canada, the cards featured the work of twenty-six different artists.[11]

The Mysterious Mr. Zuppa

Though greeting cards and murals were perfectly reasonable commercial sidelines for any serious artist during the Depression, Jackson did undertake at least one series of paintings that seriously compromised his creative integrity — but only when economic necessity absolutely demanded it. It came about after a visit to the studio of former Group member Frank — now Franz — Johnston, who was having no trouble selling his colourful landscapes through the Eaton's department store. Hungry and broke, Jackson watched enviously as his friend worked on several canvases at once, producing a series of nearly identical paintings that were sure to find buyers.

If Johnston could do it, then so could Jackson; he returned to the Studio Building and began a series of small, dark, Dutch-styled landscapes of canals and old European buildings — the very type of paintings he had loathed as a youth but knew from bitter experience were popular with the public. He put them up for sale as soon as they were dry, and, not surprisingly, they sold immediately. This brought in some much-needed money at the time, but after no small amount of soul searching, Jackson refused to keep it up. It was

too much of an ethical compromise. He could not even bring himself to sign the canvases with his own name. Instead, they bore the signature "Zuppa" — Italian for soup — no doubt Jackson's wry comment on their quality.[12] Whatever happened to them once they were sold is unknown. They might still be out there somewhere, undiscovered curiosities whose value is considerably higher than their owners realize.

Three Deaths

Despite the bleak economic conditions at the Studio Building, where there had been precious few sales for any of the resident artists, 1932 began routinely enough for Jackson. He began his fiftieth year by making his usual late winter trip down to lower Quebec, this time returning to favourite sketching grounds at Les Eboulements and Saint-Urbain with his old friend Randolph Hewton. But these happy days with their sketch boxes and snowshoes, topped off by boisterous evenings in the company of their French-Canadian hosts, would be among the last carefree moments Jackson would experience for the next few years.

Tragedy struck in late April, when he received word from Montreal that his sister Isobel had committed suicide.[13] At age forty-seven, the family's dear "Aunty Belle" was the closest to Jackson in age, yet she was the only sibling of whom he carefully omitted any mention in his autobiographical writings. She was still living at home when Georgina died in 1921, and she continued to live in the upper duplex on Hallowell Avenue until it was rented to new tenants the following year.[14] Belle had been in frail health throughout her life and, convinced that she had contracted a fatal disease, opted to take her own life.[15]

During this low period, Jackson's spirits were further dashed by news from Alberta that his estranged father had died. The shadowy figure of Henry Allen Jackson had always remained far in the background of his third son's life, and he does not appear to have had much contact with the rest of the family for forty years after fleeing to Chicago in 1891. "Except for the very occasional letter, that was the last we heard of him," was how Jackson dismissed his father in a 1954 account of his childhood.[16] This is not entirely accurate, for Jackson did spend time with his father during his stay in Chicago in 1906–07, and, toward the end of his life — when he was in his early eighties — Henry turned up in Lethbridge to spend his last days living with his second son, Ernest, and his family.[17]

There were possibly several other occasions where Henry had contact with his children, who appear to have held little animosity toward the father who abandoned them — although Jackson's accounts of Henry never hinted of any affection. Instead he chose to remember his father simply as an inept businessman who, as a perpetual "square peg in a round hole," remained a failure his entire life and never represented a formidable father figure for his children.[18]

But even if Jackson did find it in himself to mourn the death of his biological father, it was nothing compared to the loss he would suffer a few months later. Shortly after his return from a therapeutic sketching trip to Frankville and Cobalt in northern Ontario with Dr. Banting — where he quietly dealt with the reality of his fiftieth birthday — he learned that Jim MacDonald's fragile health had given out once more.

Despite increasing fame in art circles as a key member of the Group of Seven, MacDon-

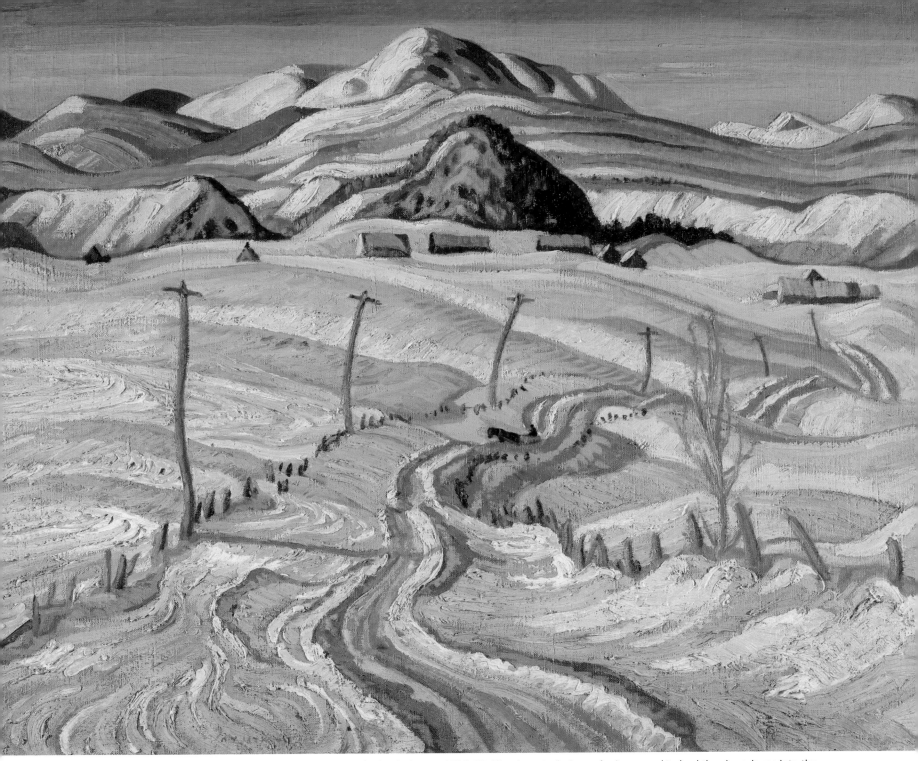

Winter, Charlevoix County, 1932–33. The clever technique of using a road to lead the viewer's eye into the composition had more practical origins: Jackson claimed that the middle of the road was often the only place he could sit to sketch. This is a brighter, more colourful reworking of *Grey Day, Laurentians* (Montreal Museum of Fine Arts).

Oil on canvas, 63.5 x 81.3 cm. Art Gallery of Ontario, Toronto, purchase 1933. Courtesy of the estate of the late Dr. Naomi Jackson Groves.

became too cluttered with old newspapers, sketches, dirty cups, and other debris, his women friends would organize a full-scale cleanup of the premises, deaf to his half-hearted protests. And then there were the Montreal women artists who had also grown close to him — but none captured his heart the way Anne Savage had.

That summer, Jackson and Savage painted together among the islands of Georgian Bay. Savage returned to Montreal in high spirits with many new sketches to work on — including one that she would later paint up on canvas as *The Little Pool* — but she had not been asked to be Mrs. A.Y. Jackson. Despite all his plans and determination, Jackson could never summon up the courage to propose. His frustration continued to build up until, two months later, sitting in his tent on a cold October night among the La Cloche Hills, he put everything down on paper instead.

But the next letter from Montreal brought grave disappointment. Although Jackson did not keep the letter in which Savage declined his proposal, it has always been assumed that she gave at least three excellent reasons for deciding against relocating to Toronto and a bohemian life in the Studio Building — her aging mother, her cherished job, and her career as an artist, which would certainly have suffered in the shadow of a famous husband. In those days it was hard enough for a woman to succeed in any field, and after all her work she risked becoming known forever as Mrs. A.Y. Jackson — part-time artist and full-time housewife to a husband who spent most of his time away on sketching trips to remote corners of the country.

Savage knew it would never have worked, and deep down Jackson knew she was right. He was too set in his ways and could not reasonably expect anyone to share his unique itinerant lifestyle that meant living out of a knapsack and spending more nights in a sleeping bag than a warm bed. She was accustomed to living in her large, comfortable house on Highland Avenue, shopping at the best stores, and meeting her fellow women artists for lunch in the city's finest restaurants. High tea at the Ritz-Carlton Hotel with Prudence Heward and Sarah Robertson was one thing; bacon and beans in a tent with A.Y. Jackson and his cronies was quite another. The sacrifices on her part would have been enormous.

As Jackson ruefully pointed out years later, it would have been unfair of him to expect Savage, or any other woman, to take on the thankless role of Mrs. A.Y. Jackson: "A wife of mine would have had to come with me on sketching trips, rough country and rough weather, or she would have had to stay home, waiting for me for weeks on end. Perhaps it's just as well I stayed a bachelor."[37]

Whether their relationship was ever physically consummated will probably never be fully revealed, although it is very likely they were full-fledged lovers. Jackson was a lifelong bohemian, a nonconformist whose first instinct was to rebel against the social conventions of the day, and as "a healthy and vigorous male who liked the ladies and could be expected to behave like any other normal male" he would have made every effort to seduce Savage whenever an opportunity arose.[38] There were certainly plenty of chances, especially on camping trips to Georgian Bay and other remote areas, as well as the many sketching trips in the Laurentians, when they found themselves alone for extended periods.

But it is important to remember that as products of the Victorian era, when the Church still played an important role in daily life, Anne and her Alex were extremely

careful about making any public display of their affection. She was "a Presbyterian who deeply believed in the Christian teachings,"[39] and he was from a strict Anglican household with rigid moral standards. They were unmarried, after all, and both had worked hard to establish careers that would have suffered if rumours of impropriety had surfaced.

To all appearances, their relationship remained officially platonic, that of an older, established artist and his younger protégé. The only real evidence of their deep affection is the large body of correspondence between them — but any written proof of a more intense, physical relationship has not survived, for there are several missing letters, especially at key emotional points in their lives. True to their Victorian sensibilities, it appears that if one of them wrote anything even remotely racy, that letter would be promptly destroyed in case it accidentally fell into the wrong hands and caused a scandal.

Another curious aspect of the Jackson-Savage relationship is that they were probably never photographed together, even as two good friends. Jackson kept a large photo portrait of Savage on the window ledge of his studio, and there are snapshots of them together as part of larger groups on sketching trips in the Laurentians, but there seems to be no extant photo of them as a couple.[40]

Throughout their long, close friendship, Jackson and Savage remained staunchly supportive of each other. He was well known as an outspoken advocate for the Montreal circles, but every so often the favour had to be reciprocated. Savage recalled one incident that occurred while she was teaching at the Baron Byng High School. A group of ten girls in the graduating class decided to leave the school a gift, and so through Savage arranged for the purchase of a Jackson canvas. Each contributed ten dollars from their summer earnings, and Jackson sold them a landscape of Sainte-Adele, Quebec. No sooner was it up on the wall than the trouble began, as Savage would later remember:

> We put it right at the front of the stairs when you come up into the hall, and this was the tragic thing that happened. On the staff were a very few people who knew anything about art. Unfortunately, there were a group of men who had been overseas. They had fought in the Canadian Forces as such. They thought they were the authority on Canada. They said that they thought that it was a disgrace to the country and ought to be taken down. It was perfectly appalling — that that wasn't Canada at all and they weren't going to have it desecrating the walls of their school. So I met the crowd in the office and I said, "Very well, I resign if you won't have that painting. Leave that painting where it is … If you don't recognize something that is beyond you, (I was in a perfect fury) I'll leave!" And so the painting stayed.[41]

Witness to Scandal

Around the same time Jackson was going through his own personal crises, Lawren Harris's life entered a new phase — one that placed him at the centre of a scandal that turned heads across Toronto, from the elegant drawing rooms of Queen's Park to the scuffed tables of the Arts and Letters Club.

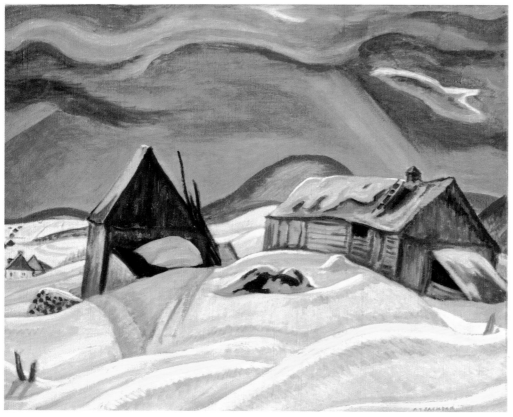

March Day, Laurentians, circa 1933. Jackson's unique handling of sky and snow are among his most striking trademarks. Here he uses unusual colours to render a brooding sky that still has enough sunlight to cast pronounced shadows on the snow.
Oil on canvas, 54.0 x 66.9 cm. McMichael Canadian Art Collection, gift of Mrs. H.P. de Pencier. 1966.2.6.

In June 1934, Harris moved out of his Ava Crescent home, leaving Trixie and their three children, and took up with Bess Housser — the wife of one of his closest friends and colleagues. Harris and the Houssers had shared a deep interest in theosophy for several years; in fact, Fred Housser's seminal book on the Group of Seven contained several references to Harris's beliefs. Bess was also an artist, and her friendship with Harris had been growing stronger for more than a decade. He felt that she understood him more than anyone else. As Harris's spirituality deepened in the early 1930s, he and Bess were drawn closer together as kindred spirits. This left Fred out altogether, and he eventually struck up a romance with artist Yvonne McKague. He obtained a divorce from Bess, leaving her free to embark upon an intense but entirely platonic relationship with Harris — a union that would endure for the rest of their lives.

The Harris affair rocked Toronto society. As a well-known artist and member of one the city's most prominent families, his actions were shocking. Needless to say, Trixie's family was especially outraged, and soon most of Harris's friends and colleagues had sided with them against him. But to the new couple, their relationship was not only entirely innocent, but the logical progression of their mutual spirituality. They were certainly not so naive as to be bewildered by the overwhelmingly hostile reaction, but their strong faith provided a constant reassurance: "What they were doing had the highest spiritual motive. In their eyes their conduct was above laws, moral codes, ethical systems and the conventions of Toronto morality. They wished to allow their contact with beauty, that is, with the realm of the universal spirit, to dictate to them how they should behave, rather than follow what seemed to be merely local traditions."[42]

Jackson was also close to Trixie and known as fun-loving Uncle Alex to the Harris children, so it was easy for him to be drawn into the scandal. He had never shared Harris's spiritual awareness and could not relate to whatever bond had developed between one friend and the wife of another. If he had to choose sides, he chose the abandoned wife and children — although Trixie Harris had certainly not been left in the same dire financial circumstances as his own mother — and he was quite frank in expressing his opinion on the subject. Sometimes his blunt manner and flair for exaggeration could be hurtful, and Bess proved to be an easy target. "Alex bothered me at one time because I felt he

should instinctively know that the things he was saying of me were untrue," she wrote that year. "I forgot that he was not so interested in their truth as in the social usage that he could make of them, and that he got a kick out of that!"[43]

Social opposition to the Harris-Housser union remained so strong that they were forced to leave not only Toronto but Canada — settling first in Hanover, New Hampshire, for four years, then moving on to Santa Fe, New Mexico. They would not return to Canada until 1940, though Harris continued to send his paintings to Canadian Group exhibitions throughout the rest of the 1930s. During this period, his work had become totally abstract. His Arctic canvases from the 1930 *Beothic* voyage gave way to intricate compositions of geometric designs that bore no resemblance to any Group of Seven landscape. That phase of Harris's life was over; he would never return to the landscape again.

In the midst of all the public and private turmoil in his life, Jackson diligently kept up his regular schedule of sketching trips — the villages of lower Quebec in the early spring, Georgian Bay in the summer, the Hewards' country home near Brockville in September, and the Algoma region in the autumn. To this routine he often added an interesting side trip; in the spring of 1934 he spent a few weeks on Cape Breton with Bobs and Peter Haworth, and the following summer he did some sketching in the region of Tadoussac, where the Saguenay River flows into the St. Lawrence.

One of the most memorable sketching trips during this stressful period took place in the summer of 1934, just as the Harris scandal was at its height. It was a good time to get out of the city, away from the unpleasant atmosphere hanging over the Studio Building, so Jackson invited his brother Harry's twenty-four-year-old daughter Naomi and her friend Betty Maw for a ten-day camping trip on the Pine Islands on Georgian Bay.

All the troubles of the previous years fell away as Jackson played host and guide, demonstrating the proper way to build a campfire and how to secure a tent against gale-force winds. He even showed his two skeptical guests that the big snakes living under a nearby rock were completely harmless, proving his point one morning by flushing them out by pouring his warm shaving water into their nest.[44]

"He would be up long before us youngsters and have the fire crackling, the coffee-pot slung over it and steaming fragrantly, while bacon sizzled in the pan, or maybe some fresh-caught fish," Naomi recalled thirty years later. "Between meals we sketched the rosy granite rock, the blue and silver water, and the grand old wind-pushed pine trees. Good days, good memories, even a few good sketches."[45]

16

THE PUBLIC PERSONALITY

THE TURMOIL OF THE PAST FEW YEARS HAD taken its toll, and by 1936 Jackson was ready for a real vacation — an extended break from his routine, a break from Toronto and Montreal. The sordid Harris-Housser affair, the loss of Jim MacDonald, resigning from the Academy — not to mention his own private crisis over Anne Savage and the deaths in his own family — were all compounded by the bleak atmosphere of the Great Depression.

A complete change of scenery was just the thing he needed.

Despite all the upheavals, Jackson had been working hard. Some of his best work from the early 1930s was inspired by the rocky landscape of the La Cloche Hills, a region also favoured by Frank Carmichael.[1] In the fall of 1934, while camping up at Grace Lake, he painted the sketch for *Algoma, November* — a sombre view of the lake under a brooding sky. The finished canvas, rendered in subtle shades of greys, browns, and ochres, would be celebrated as one of Jackson's greatest achievements of the 1930s, but the artist himself was certainly conscious of the creative rut he had inadvertently dug himself into. With the sole exception of that one trip to Cape Breton in the summer of 1934, he had not ventured beyond the familiar sketching grounds of Quebec and Ontario since his return from the Arctic in 1930. Even his palette was becoming predictable: "I had been using Cobalt violet and Isabel McLaughlin called my attention to the fact that I was getting it into everything I painted," he wrote. "I used to think of South Africa as a purple land, so I gave all my Cobalt violet to Lismer."[2]

Arthur Lismer would need plenty of purples and violets, Jackson reasoned, because he had recently accepted an invitation by the South African government to spend a year in that country, teaching and lecturing on art education.[3] The Lismer family was due to leave Toronto at the end of May, and Jackson, recently returned from his annual spring sketching trip to Quebec, casually mentioned that he would see them off at the train station. When Jackson met Arthur, Esther, and Marjorie Lismer at the platform, he was carrying a suitcase. "Oh, I'm going to Montreal to see my niece Naomi off to Europe," he said. "She's taking the same ship as you."

What Jackson didn't say was that he was going all the way to Europe with the Lismers. Naomi Jackson, now twenty-six, had won a University Woman's Scholarship and was going to study in Germany for a year. Just a week before her departure, she phoned her uncle in Toronto and mentioned that she wished he could come with her. Jackson's response was immediate. "Well, maybe I will come if you can get me a ticket!" he said. "There is a Twentieth Reunion in England of my battalion's part at the Vimy Ridge, and I'd rather like to attend that."[4]

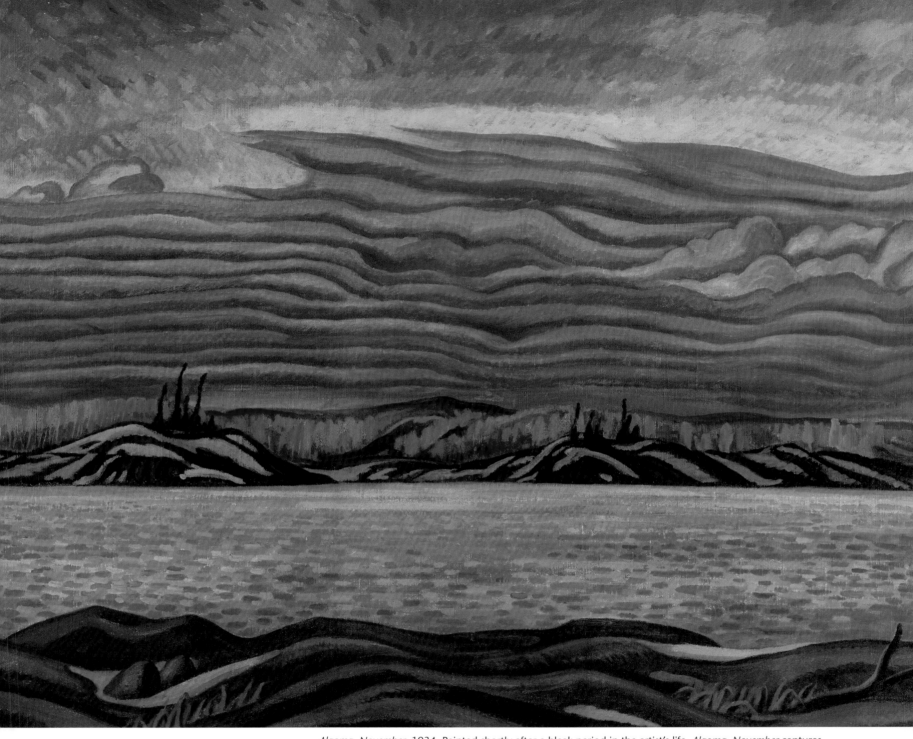

Algoma, November, 1934. Painted shortly after a bleak period in the artist's life, *Algoma, November* captures the cold, sombre atmosphere of the northern wilderness. It is one of Jackson's masterpieces of the 1930s.
Oil on canvas, 81.3 x 102.1 cm. © National Gallery of Canada, Ottawa, gift of H.S. Southam, Ottawa, 1945.
Courtesy of the estate of the late Dr. Naomi Jackson Groves.

Despite Jackson's reduced financial circumstances, he was able to raise the $160 fare and send it to Montreal, where Naomi was arranging for his passage on the *Empress of Australia*. The money likely came from the National Gallery, which was looking to beef up its collection of European art and agreed to send Jackson over to scout possible purchases. "I was given a budget and told to go after the Old Masters," he recalled.[5]

After scrambling for a passport, hastily arranged through Harry McCurry at the National Gallery, Jackson met the Lismers at the train station.[6] The party travelled overnight to Montreal, where they were joined by a crowd of well-wishers at Windsor Station that included Anne Savage and Prudence Heward, as well as brother Harry and his family, who came to see Naomi off.[7] It was only then that Jackson let the Lismers in on the surprise — that he had booked passage and would be crossing the Atlantic with them.

From Montreal they continued on by train to Quebec City, where they boarded the ship. Lismer amused the others by sketching caricature portraits of Jackson and Naomi in charcoal, signing the works with his initials hidden within the titles. The drawings of Jackson show him proudly sporting his military beret in anticipation of his "Silent Sixtieth" Battalion's reunion.[8]

The weeklong crossing was a quiet one. Even on vacation, Jackson the painter was keenly aware of the weather and passing landscape. "Foggy, morning Belle Isle, swell ice bergs. Passed thru straits at noon, snow on hills," he wrote in his diary on the second day out. "Belle Isle looks very exciting, bold snow designs. Quiet sea, slight roll."[9]

When the ship docked at Cherbourg, France, on June 6, the Lismers said their good-byes and went on to England, but Jackson was not long without the camaraderie of an old friend. He and Naomi took the next train to Paris, where they visited Clarence and Lucille Gagnon and set about seeing as much of the old city as they could.

But despite all the familiar sights, the pleasant memories of Paris that Jackson had nurtured since his student days nearly three decades earlier were suddenly dashed in the cold reality of 1936. The once carefree, hospitable city had changed greatly. "People were depressed, rude and greedy, and their discontent was evidenced by the great number of sit-down strikes," he wrote. "I felt disillusioned and unhappy about a country I had greatly loved."[10]

Uncle and niece took in a major Cézanne exhibition, which Jackson enjoyed immensely, and a trip to the local galleries brought him face to face with many canvases by his beloved Impressionists — especially Pissarro and Sisley. This offered him an opportunity to closely inspect the brushwork and subtle differences in colouring through the more critical eyes of a seasoned artist rather than an inexperienced student. But the great paintings of Europe failed to evoke any sense of awe in Jackson, who spent a day at the famous Paris Salon and "saw about three thousand works; few of them left any impression."[11]

As for purchasing works for the National Gallery, anything by the Old Masters was out of the question. Jackson's inquiries into works by Rembrandt, El Greco, and other big names led nowhere. But after speaking to several dealers, he cabled hopeful news back to Ottawa: "One Old Masters canvas would require three times your budget, but you can get 60 Impressionist paintings within the budget." The deal subsequently fell through; the Canadian government decided it could not justify large purchases of art during the Depression, and the National Gallery was forced to give up an opportunity to acquire what could now be one of the world's largest collections of Impressionist paintings.[12]

Hitler's New Germany

If France was a disappointment, pre-war Germany proved to be an eye-opener for Jackson, who arrived at Cologne with Naomi after travelling through Belgium. On the whole he found the German people much friendlier than the French, but noted "one did not need to be very observant to see the sinister side of things."[13] Adolf Hitler had been in power for just three years, and already the rest of the world was aware of real trouble brewing in Germany. This was the year of the Berlin Olympics, at which the National Socialist Party's ideas of Aryan supremacy were made evident, and there was tension everywhere.

At one village tavern, the two Canadian travellers fell into conversation with the proprietor's uncle, a friendly old man named Horn. Over a long lunch of sausages and beer, the chatty Herr Horn became dangerously candid as he spoke to Naomi, who was fluent in German. "There is a lot going on in this country we know nothing about," he said — a remark that quickly prompted his frightened nephew to cut in and end the conversation.[14]

But despite the tense political climate, Jackson did manage to do some sketching. At the village of Saint Goar, near the town of Koblenz, he climbed a steep, grassy hill and drew a pencil sketch of the valley below — a typically European vista accentuated by the pitched roofs of the little houses and the almost vertical angles of the surrounding hills. Nowhere in Canada had he ever encountered this combination of ancient cottages and steep mountainsides. But aside from a few pencil sketches, Jackson did no real painting on this trip. Naomi would later return to Canada with many oil sketches of German towns, churches, and other subjects — all rendered in a style strongly influenced by her uncle — but Jackson seems to have treated his European sojourn as pure vacation.

Jackson and Naomi parted company on July 1 in Heidelberg after a day of sightseeing in Frankfurt. He took a night train to Berlin, where he spent a week meeting with various friends and visiting the city's many museums. By July 9 he was in London, spending a day with his old army buddy Arthur Jackson — a fellow private with whom he had become fast friends during the war when they kept receiving each other's mail.[15]

"Arrived yesterday," Jackson wrote home to Anne Savage on a postcard depicting Cézanne's *The Poplars* — probably purchased at the big show in Paris. "One of the old 60th boys met me at the station. Of course it is raining, the first wet day since we hit Europe. I spent the morning at the British Museum. I went in to get out of the rain. Saw a lot of mummies and lots of stone age stuff."[16]

Throughout a particularly rainy few weeks he was also reunited with even older friends from his carefree days as a painter in France — Arthur Baker-Clack and Frederick Porter. Survival as an artist was no easier in England as it was in Canada; Jackson's diary mentions trying to help Baker-Clack in an unsuccessful attempt to sell a canvas.

Part of the busy sightseeing itinerary was a visit to the Tate Gallery, which had acquired Jackson's canvas *Entrance to Halifax Harbour* more than a decade earlier. But despite his high hopes, he was denied the thrill of seeing his work hanging in one of the world's most prestigious galleries, for the painting happened to be on loan to another museum at the time.

There was much reminiscing and certainly extensive discussions among the artists about an inevitable war with Germany, but Jackson did not document the 60th Battalion reunion he had so hoped to attend. Instead, his brief diary entries indicate a few days in

Scarborough, where he visited a war memorial inscribed with the names of his fallen comrades. A memorial ceremony to mark the anniversary of the Battle of Vimy Ridge was being broadcast on July 26, yet Jackson did not hear it, for there was no radio where he was staying.[17]

But the Great War veteran had seen and heard enough. More trouble with Germany was inevitable. "Half the papers here are demanding a better understanding with Germany — and the others see the end of the Empire if Germany is not checked, and want to work with France and Russia," he wrote to Naomi from London. "I can't do anything to help them, so I am going home to paint."[18]

After two months in Europe, Jackson returned to Canada alone aboard the SS *Montcalm*, which left England on August 1. On board were about eighty of his fellow veterans who had attended the Vimy Ridge ceremony, but he kept mostly to himself — a quiet, solitary figure who was mistaken for a night watchman by his fellow passengers.[19] While he, Naomi, and the Lismers had passed the time by reading detective stories on the way over to Europe, Jackson spent much of the return voyage immersed in Liddell Hart's *The War in Outline* and Hitler's *Mein Kampf*.[20] He arrived back in Canada with a much different perspective on Europe and its bleak future.

Early Snow, Alberta, 1937. A bright autumn day among the fields and hills of southern Alberta, all captured in Jackson's characteristic style of gently curving lines.
Oil on canvas, 82.5 x 116.8 cm. Courtesy Sotheby's Canada.

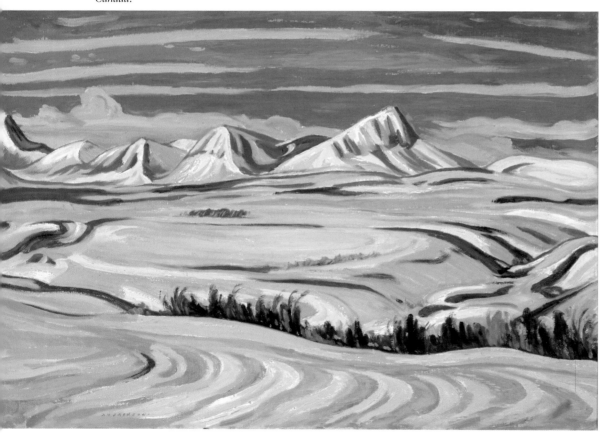

The Rhythms of Southern Alberta

Ernest Jackson had been living in Lethbridge, Alberta, for more than thirty years when his younger brother turned up in the autumn of 1937. Alex had dropped in to visit Ernest and his family on several occasions in the past, whenever he happened to be in the area. But this was the first time he boarded a train and headed west specifically to paint the rolling ranchland and Rocky Mountain foothills. The Jackson home at 1412 Sixth Avenue South would serve as the wandering painter's headquarters for several weeks.

Jackson quickly made friends in southern Alberta. Through Ernest he was introduced to members of the Lethbridge Sketch Club, one of whom was Frederick Cross, a hydraulics engineer by trade but also an amateur watercolour painter who offered to drive him on sketching trips in his car.[21] Cross was an irrigation expert who knew the region well, so he was able

to bring Jackson directly to the most interesting spots along the main road running west from Lethbridge. Using Cross's car as their base of operations, they frequently stopped to capture images of the rolling hills under a thick blanket of late autumn snow. One sketch led to the creation of *Early Snow, Alberta* — a bright, crisp view of the rugged landscape leading up to the foothills, all rendered in Jackson's unique style of carefully composed curving lines and pointed peaks.

One day in early November, as they were passing through the Blood Indian reserve, Jackson got out and sketched the distant Mokowan Butte while standing by the side of the road. From oil on panel to pencil on paper, he worked up a warmly coloured image of gentle, snow-covered hills under a dark, brooding sky. Again he used the tried-and-true technique of having the road lead the viewer's eye from the foreground toward the butte in the distance, just as he had with many of his Quebec winter scenes. But this time there were no quaint red sleighs or pastel-coloured farmhouses; this was a sombre image that stood in sharp contrast to the sunny atmosphere of *Early Snow, Alberta* and other scenes sketched nearby. The subsequent canvas, which Jackson completed shortly after returning to the Studio Building, remained faithful to the original sketches. *Blood Indian Reserve, Alberta* would always rank high among his favourite works, and after he sold it to the Art Gallery of Toronto in 1946, it would be featured prominently in major exhibitions.[22]

Although Jackson always favoured a low profile while he worked, he soon became a regular fixture in the area, but many people had no idea who he was or what he was doing. This was cleared up by Cross, who wrote a descriptive profile of his friend that appeared in the *Lethbridge Herald* on November 13:

> During the past month a distinguished guest has been within our gates. With the countryside full of activity in an effort to garner the last fruits of the season before freeze-up, perhaps only a few noticed his presence. Those who did, no doubt had their curiosity aroused at the sight of a sturdily built man of medium height with genial smile and a touch of white hair showing beneath an expressive fedora hat; a figure standing bolt upright by the side of a road, the edge of a coulee, the outskirts of a little village, close up to a group of elevators, the corner of either a beet field or a pasture of a typical Alberta farm … always the same figure, bolt upright with a small sketchbook and pencil or perhaps canvas and brush; brains and fingers working in unison with startling rapidity and directness.[23]

From Lethbridge to Cowley, Jackson wandered throughout southwestern Alberta, searching for interesting rhythms in the rolling landscape and effects of sunlight on the rocks and snow. He had finally found the right approach to painting in the west — arranging a delicate balance between foreground and background. The latter was rarely a problem, for the mountains provided a constant backdrop, but the foreground usually consisted of little more than a few weeds. Instead of eliminating or rearranging items in the foreground, which he normally had to do when sketching the crowded landscapes of northern Ontario, he often had to find something to place up front in his Alberta sketches. Once he did, everything came together — sometimes with unexpected results. "In one painting I made there was a loose strand of wire from a fence that formed a nice

spiral, and this helped my foreground," he recalled. "I showed the painting to a rancher, who said, 'Do you carry a pair of nippers along when you go sketching?'"[24]

With this trip, Jackson had found a fresh new sketching ground that seemed to offer him endless creative possibilities. When it came time for him to head back to the Studio Building, he had many new friends to thank for their hospitality. He promised to visit again the following year, and in doing so established southern Alberta as a regular autumn sketching destination for years to come.

The Land of Five Hundred Thousand Lakes

A decade had passed since Jackson first visited the Northwest Territories, on that memorable riverboat trip up to Great Slave Lake with Dr. Banting and MacIntosh Bell. He may still have itched at the thought of those aggressive mosquitoes and blackflies, but he had always been anxious to return, to see what lay beyond that northern wilderness — the Barren Lands.

The opportunity came in 1938, when prospector Gilbert La Bine invited him up to visit his Eldorado mine on the shores of Great Bear Lake, another four hundred kilometres north of Yellowknife. La Bine, who most likely met Jackson through Keith MacIver, had discovered a radium deposit by the lake just nine years earlier.[25] Since then, a few crude mine buildings and shacks had grown into the village of Port Radium, which Jackson would describe as "a little centre of industry in a great empty wilderness."[26]

Jackson accepted the invitation immediately, and shortly after returning from a few weeks of summer sketching at Georgian Bay, he gathered up a supply of blank panels for his sketch box and caught a train for Alberta. The original plan called for him to meet La Bine's company seaplane at Cooking Lake, east of Edmonton, and he would be flown up to Port Radium along with two millionaires who had mining business to conduct. As it turned out, there was not enough room for everyone on the small craft, and since business took priority over the arts, Jackson was forced to wait four days until the next flight. This actually worked to his advantage, for he later learned with smug satisfaction that while he was enjoying a leisurely stay in an Edmonton hotel, the two businessmen had to endure four miserable days of rain and bitter cold up at the mine.[27]

When Jackson finally climbed aboard the small plane for what would be his first long-distance flight, he found himself squeezed up against a cargo of steel pipes and several weeks' worth of provisions, not to mention a group of miners from Finland.[28] The long flight offered the painter ample opportunity to study the landscape below — farmland at first, then nothing but forest and lakes stretching off to the horizon. The experience was so thrilling that he could not wait to write about it. No sooner had he settled into his living quarters at the Eldorado mine than he got out his writing pad and dashed off a one-page note to Naomi in Montreal, complete with a pencil sketch of the plane:

> Just arrived and the plane is leaving right away. It was a grand trip... Saw five hundred thousand lakes this morning. You just can't keep looking at them, hour after hour. Great Bear is surrounded by big rocky hills, open patches of spruce in places,

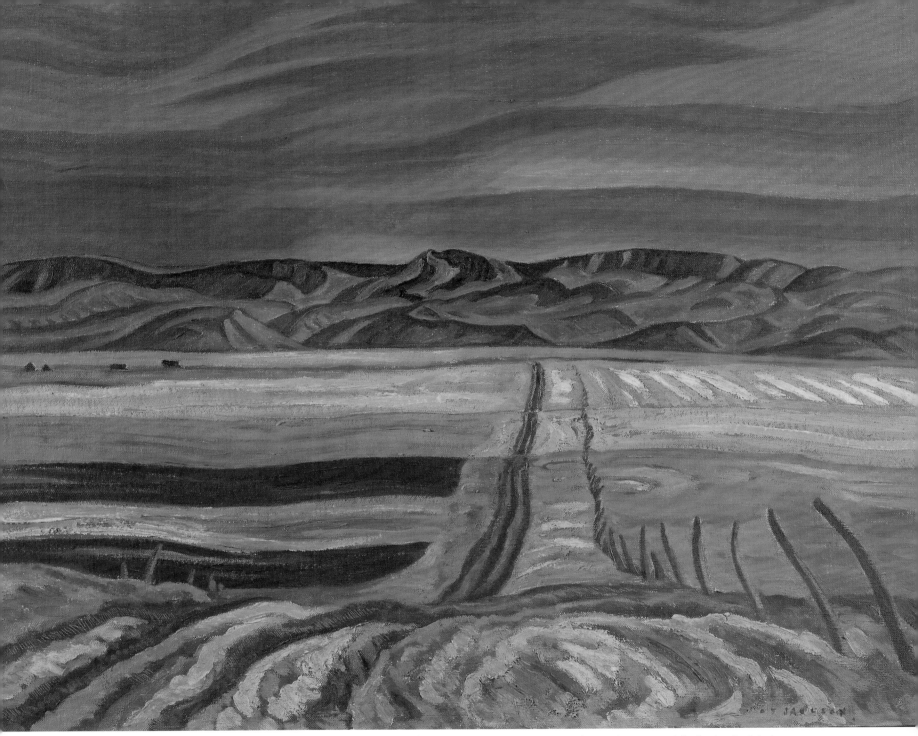

Blood Indian Reserve, Alberta, 1937. This view of the Mokowan Butte was originally sketched during Jackson's first trip to southern Alberta. It remains one of his best-known canvases.
Oil on canvas, 64.0 x 81.6 cm, 2828 2956. Art Gallery of Ontario, Toronto, purchase 1946. Courtesy of the estate of the late Dr. Naomi Jackson Groves.

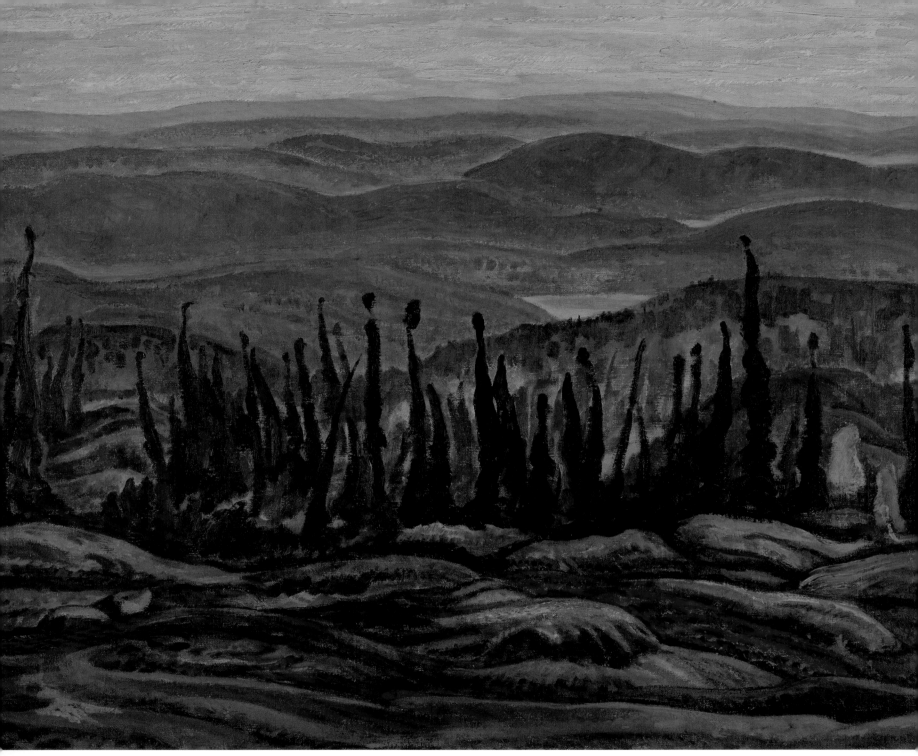

South from Great Bear Lake, circa 1939. Jackson was one of very few artists to venture this far north to paint the scraggly thin fir trees and vast panorama of the Northwest Territories.

Oil on canvas, 81.2 x 101.5 cm. Art Gallery of Ontario, Toronto, Gift from the J.S. McLean Collection, 1969, Donated by the Ontario Heritage Foundation, 1988. Courtesy of the estate of the late Dr. Naomi Jackson Groves.

but no farm lands… Expect to be round about three weeks, but have to get out before freeze-up or stay another six weeks. A mail plane comes in once a week.[29]

From the outset, Jackson found that he could sketch all day without being disturbed. He set off each morning, accompanied by a small Scotch terrier belonging to the mine's manager, Emil Walli. Together they rambled over the surrounding landscape of rocks and muskeg, often with big ravens following the dog at a safe distance.[30] It was on one of these hikes that Jackson made a pencil sketch of the panorama southeast of Port Radium, not far from Contact Lake.[31] Using his characteristic style of curving lines, he captured the vastness of the country, with layers of hills and muskeg lakes extending toward the horizon. The resulting canvas, *South from Great Bear Lake*, would be painted up in rich, warm tones and feature a carefully composed line of very thin spruce trees jutting up from the rocky terrain — a common Jackson technique that put foreground, middle distance, and background into proper perspective.

South from Great Bear Lake was one of the first paintings of the region known as the Barren Lands, and it would be Jackson's most successful canvas of the year, both artistically and commercially. It did not hang around in his studio for very long after it was painted; the Art Gallery of Toronto purchased it that same year, providing Jackson with a much-needed financial boost to see him through the end of the Depression.

The miners showed very little interest in the arts and paid no attention to what Jackson was doing. Many of them mistook him for a greenhorn and condescendingly asked if this was the farthest north he had ever travelled. "Why no," was his stock answer. "I've been up to Ellesmere Island twice — about eight hundred miles north of here."

In all, Jackson spent six weeks up at Port Radium. He used up all his panels in an attempt to express the spirit of this remote outpost in a vast land where "everything that takes place does it over a thousand miles."[32] He left by the company plane at the end of September. After landing near Edmonton, he continued south to Lethbridge, where he kept his promise to spend October back with his brother and the many new friends he had made the previous autumn in southern Alberta.

Up on the Big Screen

For Jackson and his contemporaries, there had never been anything more powerful than the printed word to promote the arts. Even a scathing review in a daily newspaper was sure to attract the curious to the local gallery and drum up more publicity. But by the late 1930s, Canadian mass media had progressed to the point where nationwide radio was the coming thing. One broadcast could reach listeners in both Halifax and Victoria — thousands upon thousands of people with their ears fixed on the voices carried over the airwaves. From the abdication speech of King Edward VIII in England to the fiery speeches of Adolf Hitler in Germany, Canadians were hearing it all, no matter where they lived.

When the Canadian Broadcasting Corporation offered noted Montreal art educator Anne Savage a contract to deliver an eight-part series of weekly talks on the history of art

in Canada, she accepted immediately. This would obviously be a great step in promoting the work of her fellow Canadian artists, and, like Jackson, she was deeply committed to the cause. Jackson was no less excited about the project, news of which spread rapidly through the art circles of Montreal and Toronto, and he readily offered all the moral and editorial support she would need.

The weekly broadcasts were scheduled to run from January 6 to February 24, 1939, when Jackson was at home in Toronto, painting up canvases from the sketches he had accumulated over the past year. After a long day's work at his easel, he would wipe off his brushes, light a cigarette, and settle down in one of the big easy chairs in his studio. As Anne's familiar voice filled the room — high-pitched, overly formal, and somewhat tinny from the radio speaker — Jackson jotted down a few notes on a scrap piece of paper. When the program was over, he would write her a letter filled with observations and helpful suggestions. "Your broadcast came through clear as a bell, so you are off to a good start," he wrote following the first talk. "It was a good way to start the series too by the little talk on Constable. He and Thomson are closely related in their love of the weather and the out of doors."[33]

Savage continued the series with accounts of Paul Kane and Cornelius Krieghoff, and worked her way up to the present through Maurice Cullen and James Wilson Morrice. But when she came to the Group of Seven, Jackson ventured further with his criticism; this was his turf and he remained committed to presenting an accurate and favourable for the mass audience:

> Have messed up your broadcast somewhat. It's your chronology that's a little twisted, not to be wondered at as it all happened when you were a mere child. You mixed up *A Northern Lake* which Thomson painted before I knew him and *A Northern River*, painted while I was overseas. Just what happened during the war I don't know … You have a picture of us all sitting around sketching and Thomson watching us. At various times he worked with Lismer, Harris and me, but no parties of artists.[34]

But when it came time for the broadcast devoted to the works of Jackson and Lismer, Savage spoke of her close friend in glowing, almost heroic terms, conveying the image of artist as rugged traveller:

> East, west and north, his sketching trips have made an intricate network trail from the Maritimes to the Pacific. On the west coast he has worked as far as Alaska, and on the Atlantic seaboard he has twice travelled up the sombre, ice-strewn shores of Labrador and so on to the Arctic Circle. He has sketched in the Rockies and the foothills, has worked up the Skeena River through the Indian country, and has painted in the little fishing villages on the Gaspé coast, on the barren, rock-bound shores of Lake Superior and round the lakes, rivers and mining towns of Northern Ontario. He has gone as far as the Great Slave and Great Bear Lakes in the Northwest Territories, and returned with equal zest to the wind-blown islands of the Georgian Bay. But his native province, Quebec, calls him back at least once a year, and he yearly brings in a raft of sketches — the country itself in all its changing

conditions of light, contour and snow. The subjects that Morrice made so fascinating have been handled here in a different fashion. Not only can Jackson give us the soft gentleness of the opalescent snow bank, but he analyses the snow under every condition and delights in handling the curled edges of great sweeping drifts, the sheen on the ice-caked roads, and the fierce sombreness of the Arctic night, cold and cruel.[35]

The Savage broadcasts were by all accounts a great success, an important step forward in Canadian art. But it would not be long before Jackson attracted the attention of another medium — the motion picture. John Grierson, head of the recently established National Film Board, struck upon the idea of making a short colour documentary on Jackson, the most colourful member of Canada's most colourful group of artists — no doubt his enthusiasm was enhanced by Savage's broadcast. He first approached Jackson with the idea in 1939, soon after the talk had aired, but Jackson would have no part of it at first. "I did not like being singled out for such attention," he said.[36]

The filmmaker persisted, promising that the script would be written by Graham MacInnes, a respected author and art critic who was well-versed in the work and philosophy behind the Group of Seven. Still, the modest Jackson held out until it was agreed that the title of the film would not be *A.Y. Jackson* but the entirely generic *Canadian Landscape*. Only then did he agree to participate — a decision that evoked a burst of enthusiasm from his dear friend in Montreal. "Congratulations about the movie," Savage wrote shortly before shooting was scheduled to begin. "It really is exciting — a completely new idea and it will put Canadian Painting again in the Foreground — and also give some idea of the difficulties of the artist's life and the problems to be faced — bravo — it is really grand Alex."[37]

The film would be made in two major segments — first showing Jackson sketching the bright autumn foliage and white granite ridges in the La Cloche Hills north of Georgian Bay, then in the snow-covered farmland near Saint-Tite-des-Caps the following spring. These would be held together by footage of him working on canvases in his Toronto studio. Arrangements were made, and on October 10, 1940, Jackson hiked from his campsite in the hills to Willisville, where he was to meet the filmmakers, MacInnes and Radford "Budge" Crawley.

With Jackson on this trip was his good friend and neighbour Keith MacIver. Most of Jackson's trips up to Grace Lake in the La Cloche Hills were taken in the company of MacIver, who had staked a number of claims in the area. He would go off for days at a time, checking on various claims several kilometres away, leaving Jackson to man the main camp.

Once Crawley and MacInnes were settled in at Grace Lake, they shot footage of the artist and prospector — each of whom had come to the area for entirely different reasons — as they paddled their canoe on the lake and carried their gear over a three-quarter-mile portage through the woods. Jackson still might not have been pleased with the idea of being so prominently featured in the film, but he allowed Crawley and MacInnes to film him climbing up a rocky cliff and sketching a vista of the orange, red, and white hills. Through a series of close-ups on Jackson's panel over the course of about an hour, this

sequence shows the progress from the very first outlines to the finished sketch — and survives as the most complete and revealing look at Jackson's sketching technique.

Back in Toronto, Jackson was filmed in his studio, dressed in a shirt and tie for the camera as he worked on his large canvases. The next morning he and MacIver were filmed having their customary leisurely breakfast in the shack. These scenes provided a bridge into the next sequence, shot in April 1941 in Saint-Tite-des-Caps while Jackson was working with Randolph Hewton.[38] Here Crawley captured Père Raquette in his natural environment, plodding along on his snowshoes and surrounded by children as he stood sketching a rustic farm scene. Again, close-up shots of his panel showed the viewer exactly how he rendered the scene before him. At night, he was filmed laughing along with his French-Canadian friends as they played a lively card game in the dining room of Jackson's host, Joseph Tremblay.

Canadian Landscape was a success — so much so that the National Film Board quickly made plans to produce similar films on artists. Over the next few years, Arthur Lismer, Emily Carr, and Fred Varley would be featured in short subjects, and in *The West Wind*, Jackson, Harris, and Lismer each appeared onscreen to comment on the life and work of their late friend Tom Thomson.

Jackson had to admit that Savage had been right when she predicted that *Canadian Landscape* would go a long way in promoting Canadian art, bringing it to the attention of movie audiences who normally might not ever hear of A.Y. Jackson or even the Group of Seven. He did not realize the full impact of the film until several years later while sketching in a remote spot near Great Bear Lake. When asked about the white-haired man with the sketch box, one of the locals replied, "Sure, I know who that old fellow is. I seen him in a movie at Norman Wells last winter."[39]

But the "old fellow" audiences saw up on the screen, laughing along with his Saint-Tite-des-Caps friends as they slammed down their cards, was hiding a profound sense of loss. The Second World War had been raging for a year and a half, and the daily news reports were grim. At the time of the filming in Saint-Tite, Jackson and Hewton were painfully aware of an empty chair at the Tremblays' table, for their friend Fred Banting had been killed just two months earlier in a plane crash in Newfoundland while en route to Great Britain on a military mission. Canada had lost its most famous physician, but Jackson and other members of the annual early spring sketching parties in lower Quebec had lost a good friend and sketching companion.

17

MASS PRODUCTION FOR MASS RECOGNITION

IN THE AUTUMN OF 1939, CANADA WAS AT war again. Jackson was disgusted. He had seen the utter devastation caused by one war just twenty years earlier, and more recently had witnessed first-hand the ominous political climate in Nazi Germany. The declaration of war came as no surprise, but nevertheless, Jackson wrote, "it was heart-breaking that the job had to be done all over again. Thousands of those who fought in it were sons of the men who fought in the first war."[1]

The arts were not as badly affected by this war as they had been a generation earlier; this time there was plenty of work for illustrators of posters and other official publications. Many assumed that another group of war artists would soon be recruited and sent overseas, but that did not happen right away. The Canadian government was initially reluctant to revive that program because a long-proposed War Memorial gallery in Ottawa had yet to be built and there were still hundreds of First World War works collecting dust in a National Gallery storeroom.

Jackson thought this was outrageous; Lord Beaverbrook's war art program had been a tremendous artistic success, and Canadians should not be deprived of another valuable contribution to their cultural heritage. He wrote to the National Gallery and the Department of Defence, spoke on the radio, composed newspaper articles and letters to the editor — all in an attempt to convince the government that it should make use of its artists much the same way it had two decades earlier.

"It is not too late yet if it could be got into the heads of people in government that art is an active force in society and therefore has a definite job to do in a nation at war," he wrote in the *Toronto News* in October 1942 — three years into the campaign.[2] Finally, as support for a war art program grew, the government assented and began making the necessary arrangements.

There was no question that Jackson was eager to return to the front as a war artist; in fact, it was likely the main motive behind his aggressive push to have the War Records program re-established. But with his sixtieth birthday upon him, he was obviously too old to receive a commission. There were plenty of younger artists ready and willing to ship out, and they were given priority. Among the many who eventually went overseas and distinguished themselves as Canadian war artists were Alex Colville, Charles Comfort, Ed Hughes, Jack Nichols, Will Ogilvy, Carl Schaefer, Bruno Bobak, and Bobak's future wife, Molly Lamb, daughter of Jackson's old friend and early supporter Harold Mortimer Lamb. Also on the list was Captain Lawren Harris Jr., who was no doubt grateful to his old Uncle Alex for pushing so hard for the Second World War war art program.

Jackson's closest friend among the second generation of war artists was George Pepper, his Studio Building neighbour. Of all the harrowing experiences the artists of both wars had endured near the front, it was Pepper who came closest to giving his life for his country. As Jackson recalled, "George worked with the War Records overseas and in the line of duty with Records he was for a time reported missing. He and the historical officer were given wrong directions and got inside the German lines. George's companion was killed, but George escaped: he hid in a culvert for ten days. It is not an experience that George talks about."[3]

Painting on the Home Front

A second commission as an officer in the Canadian Forces would have benefited Jackson financially after more than a decade of the Depression, but instead he was forced to continue scrambling for work. One handsome offer came from the publishing firm of Farrar and Rinehart, which was producing the Rivers of America series. Having read and admired other books in the series, Jackson immediately accepted a contract to provide illustrations for author Henry Beston's forthcoming book on the St. Lawrence River. This brought him to Montreal and Quebec City in the summer of 1941 — but he would never have taken on the job if he knew of the difficulties he was about to face.[4] As it turned out, he had been freer to sketch in Nazi Germany than in his native province.

The trouble began in Montreal, where Jackson secured permission from the government to sketch along the waterfront — but that did not stop the local harbour police from interrupting him every few minutes. Anyone drawing or photographing ports and bridges could be a German spy and was treated with the utmost suspicion. One day, while standing on the Jacques Cartier Bridge to sketch a wide view of the Montreal port, Jackson was stopped by a guard who demanded to see his permit. That was in order, he was told, but it would still require the verification of a senior port official — a process that could take several days.[5] In the meantime, he was forbidden to sketch the port.

The final straw came a week later near Quebec City, where Jackson set himself up to sketch on the shore of nearby Lévis. No sooner had he opened his drawing pad and started blocking out the composition than he heard a rumbling noise behind him. He turned just as a military truck pulled up and four soldiers jumped out.

"What are you doing?" one of them demanded in French.

"I'm an artist," Jackson replied in his best French. "I'm working on an illustration for a book."

"What kind of book?"

"It's about the St. Lawrence River."

"Do you have permission to draw here?"

Jackson nodded, but the soldiers refused to believe him. Before he knew what was happening, he was forced into the truck and driven to headquarters, where an officer explained to him that the war had made everyone suspicious of spies. "Under such

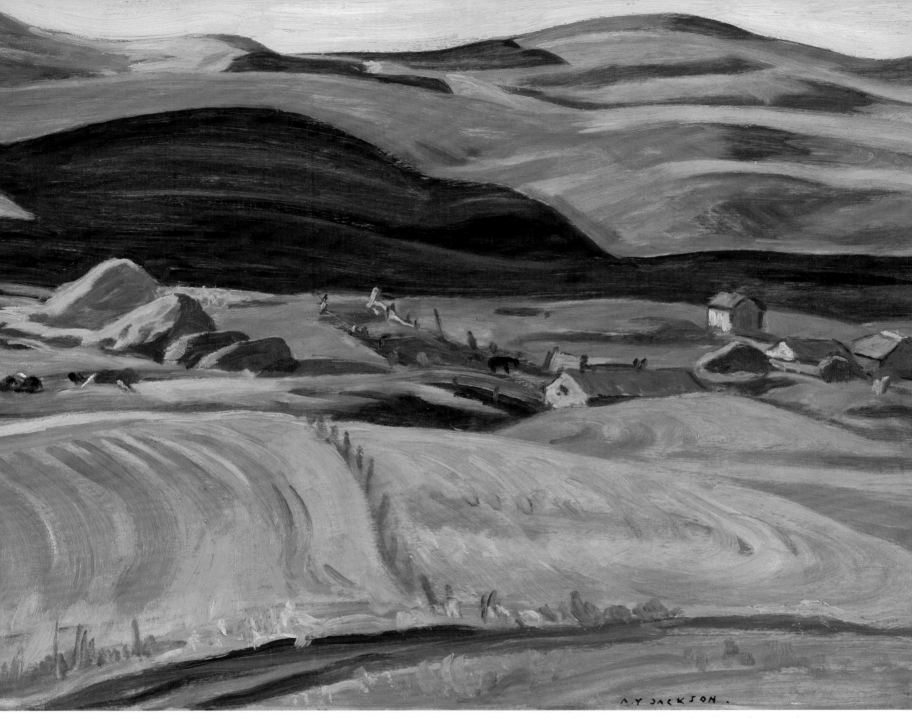

A.Y JACKSON.

Porcupine Hills, Alberta, 1937. The panoramic views and small farming communities of southern Alberta awoke in Jackson the same passion he felt for rural Quebec. For several years, he painted both east and west, noting their differences and similarities.
Oil on wood, 26.6 x 34.3 cm. © National Gallery of Canada, Ottawa. Courtesy of the estate of the late Dr. Naomi Jackson Groves.

conditions I got fed up and had to do what I could from my old notes," he wrote. "I was not happy about the project at all, and my unhappiness increased when I found the book uninteresting."[6]

In the end, Jackson's illustrations were the highlight of the book — and they were far from his best work. Most of the images were simple ink drawings of Old Quebec, including a whimsical copy of Morrice's now-famous *The Ferry, Quebec*.[7]

Coming Together in Kingston

Jackson's stature as an artist may not have been widely recognized in his hometown, but he was certainly acknowledged as a key figure in Canada's artistic community — so much so that in the autumn of 1941 he was invited to Queen's University in Kingston to receive an honorary Doctor of Laws degree.

For the modest painter who had dropped out of Prince Albert Public School at age twelve, this was certainly an unforeseen honour. Jackson — now officially Dr. Jackson — was especially proud of this degree, for it lent academic credibility not only to his painting but, more importantly, to his efforts to promote Canadian art across the country. And that was just the beginning: over the next twenty-six years he would receive four more honorary Doctor of Laws degrees and one honorary Doctor of Letters degree — a list of honours he eventually found embarrassing. In 1946 he was invited to become a Commander of the Order of Saint Michael and Saint George, and so was entitled to add the initials CMG after his name — which he told his friends stood for "Call Me God."[8] The accompanying medal and ribbon were so official looking that he immediately quipped, "I'll put it on when I go swimming."[9] Years later, after receiving the Canada Council Medal, he ended up offering the bronze medal to guests for use as an ashtray.[10]

Jackson was no stranger to the Queen's University campus; just a few months earlier he had been there to participate in the Kingston Conference on the Arts — a large symposium organized by Jackson's friend and fellow artist André Biéler. A Queen's art instructor, Biéler also taught classes at the Banff School of Fine Arts, and during his travels across the country saw a need for artists from different regions to meet and form a creative dialogue. Through his employers at Queen's and with sponsorship from the National Gallery, Biéler was able to bring together a large group of artists, educators, critics, and other related professions for a series of workshops and discussion groups.

Jackson's prominent role in the country's art community meant that he was among the first people Biéler contacted when organizing the conference. During his friendly debate with Wyly Grier at Toronto's Empire Club back in 1925, Jackson had predicted that the Group of Seven would one day be referred to as "old academic Johnnies;" now, with his involvement in the Kingston Conference as somewhat of an elder statesman, he had fulfilled his own prophecy.

It was during this conference that Jackson volunteered to sit on a committee that eventually led to the formation of the Federation of Canadian Artists — a nationwide organization that would be more inclusive and address arts-related issues instead of simply organizing exhibitions. Since much of the Kingston Conference had been Biéler's idea, he was selected to serve as the Federation of Canadian Artist's first president. The

organization proved to be especially durable, and it survives to this day, with most of its members based in the west.[11]

Landscape Classes at Banff

As George Pepper prepared to ship out for what would prove to be his harrowing experience as a war artist in early 1943, he suggested that Jackson take his place as a summer instructor at the Banff School of Fine Arts. Although Jackson's teaching experience was limited to one year at the Ontario College of Art in 1924–25 and before that a few weeks standing in for William Clapp in Montreal in early 1915, he readily accepted and forwarded his application. He never missed an opportunity to head west in any season, so after a brief sketching trip to Georgian Bay in early July, he packed up his gear and caught a train to Alberta — determined to immerse himself in the breathtaking landscape and perhaps finally conquer his lifelong inability to paint the Rockies to his satisfaction.

The school's administration gladly accepted Canada's foremost landscape painter onto the teaching staff, for his name added new prestige and attracted more students. "It is embarrassing to be so well known," he wrote to Naomi shortly after his arrival. "I meet people who have come five hundred miles just to study with me."[12]

At first, the new instructor was taken aback by his students' crude materials. Despite his frugal ways, Jackson was accustomed to buying the best oil paints and finest brushes, but when his Banff students arrived "equipped with colour pencils, or a tin box with old tubes of colour left by their grandmother and watercolours as hard as the Rocky Mountains," he realized the tough economic state of post-Depression Alberta.[13] "At that time there was little money in the West," he wrote. "Some of the students told me that if they arrived home with a dollar they would do well."[14]

Jackson's teaching method was to get the students painting right away, without preliminary training or lectures on theory. He led them outdoors and got them started sketching the most dramatic local landmark — the dark, diagonal slope of Mount Rundle. The students, many of whom were schoolteachers from towns throughout the Western provinces, would get to work with their drawing pads and sketching panels while Jackson moved slowly among them, offering advice here and there and sometimes pausing to add a bold line to someone's composition. "Mount Rundle is the place to try them out," he wrote. "It sticks up like the bow of a battleship. In the morning it is usually a bold silhouette against the sky. You can't miss it. Strange things can be done with it, but you always know it is Rundle."[15]

As his students' skills progressed, Jackson would take them further into the Rockies, where they could work on more demanding subjects. "Cascade Mountain is a subtler problem, with its complex and powerful forms," he wrote. "Then there is Whisky Creek and Bow Falls and the Sunshine Ski Camp. To reach this camp, you climb up by bus until you are above the timberline, overlooking a vast stretch of open country surrounded by snow-covered mountains."[16]

This new role appealed to Jackson; he took great pleasure in taking groups of students out to sketch each day, weather permitting, and was never so pleased as when a novice painter turned in a sketch of admirable quality. The many friendships he formed at Banff

Waterton Lake, circa 1948. Throughout the 1940s, Jackson often remained in the west for a few months after teaching the summer session at the Banff School of Fine Arts. This picturesque lake near the Montana border caught his eye in the late autumn of 1947.

Oil on canvas, 62.2 x 79.7 cm. Buchanan Art Collection, Lethbridge College. Courtesy of the estate of the late Dr. Naomi Jackson Groves.

went by, for it shattered the peaceful atmosphere and reminded him of the changes that were ruining the old-fashioned character of the region. Ramshackle wooden barns and ancient snake fences — the cornerstone of Jackson's rustic style — were disappearing at an alarming rate, to be replaced by modern farm buildings, straight fences, and paved roads.

"I wish they would give the old barns a rest and concentrate on toilets and baths," Jackson wrote plaintively in 1941.[33] Some towns had become so modern that he stopped visiting them altogether. "Baie St. Paul gets worse and worse," he complained to Gagnon. "Garages, box barns, new houses. I could find nothing to do and was glad to get back to St. Urbain."[34]

One pencil sketch from this period shows the extent of Jackson's despair over the encroachment of progress upon the town of Saint-Tite-des-Caps. While standing in the snow at the side of the busy main street, he drew a section of the local Shell gas station — complete with a snow-covered old car under a shelter. Next to it are the remains of an old sleigh, left to rot on a junk pile of tires and broken barrels. The message is clear enough, but Jackson went one step further when he drew the sign. "I left the S off the SHELL sign on purpose," he later admitted. "I even left it off the sketch I painted afterwards from the drawing."[35]

A few years later, the steady modernization of Saint-Tite-des-Caps and other villages had affected Jackson's work; he could find no inspiration in the changes. "We are going modern — snowmobiles all over the place; new houses, and the old ones done over in tin, imitation brick, and other artist-proof abominations," he wrote in 1946. "The village is humming with industry; it used to be such a sleepy old place in winter. A lot of nice little corners where I used to be sure of a sketch have disappeared."[36]

In 1945, Jackson learned that the old hotel Tremblay, his social and domestic base whenever he was in Saint-Tite-des-Caps, had burned down. Moreover, several of his favourite Quebec sketching companions were no longer available to join him: Hewton was busy running his family business, Robinson was ill, Gagnon was in France, Holgate had moved up to Morin Heights, and, of course, Banting had died.

But despite all these setbacks, it was certainly the rampant modernization of the villages along the lower St. Lawrence River that finally prompted Jackson to switch his annual allegiance to the rolling hills of the Gatineau region, near Ottawa. He made his last trip to Saint-Tite-des-Caps in 1946, and after his trip to Port-au-Persil and La Malbaie in the early spring of 1947, he rarely returned to the region.

The Rise of Abstraction

The year 1948 was a relatively quiet one for Jackson. He did not teach at Banff that summer, and aside from sketching in the Ottawa-Gatineau area and spending some time up in the mining region north of Georgian Bay, he stayed close to home.[37] Now president of the Canadian Group of Painters, he spent much of his time organizing the major exhibition of 1947–48 in Montreal and Toronto — overseeing the selection of works by forty-seven Group members and twenty-five invited contributors.

In Quebec, however, things were anything but quiet. On August 9, 1948, a group of modern artists launched the *Refus global*, a three-thousand-word document proclaiming a bold new spirit among the French-speaking intellectuals in Montreal — "perhaps the

single most important social document in Quebec history and the most important aesthetic statement a Canadian has ever made."[38] Penned by abstract painter Paul-Emile Bourduas and other members of the Automatiste group, the *Refus global* was received as an aggressive battle cry that called for the rejection of long-held values that had stifled the progress of French-Canadian society for generations.

"To Hell with the aspergillum and the toque!" Bourduas wrote. "They have extorted from us a thousand times more than they ever gave." This blatant attack on the all-powerful Catholic Church and the oppressive Union Nationale government under Premier Maurice Duplessis was so daring and controversial that Bourduas was promptly fired from his teaching post at the École du Meuble.[39] The ensuing media coverage fuelled a public debate that touched off what would eventually be known as the Quiet Revolution in Quebec society — and at the same time aroused public interest in abstract art.

Twenty-three years earlier, the traditional Quebec woodcarver Louis Jobin told Jackson that the Group of Seven had broken the windows of conventional art. Now the Group's style and values were definitely old-fashioned in comparison to what was going on in Montreal — not to mention New York, where the canvases of Jackson Pollock, Willem de Kooning, and the other Abstract Expressionists were turning heads in galleries and promoted in print by critics Clement Greenberg and Harold Rosenberg. Toronto was not far behind in the trend toward abstraction, with the vibrant Painters Eleven soon to emerge as well.

As a landscape painter whose style had barely changed in thirty years, the once radical Jackson was now unquestionably in the conservative camp — no longer the *enfant terrible*, but rather the respected elder whose opinion of abstract painting remained curiously guarded. He would always be a staunch defender of modern art, and in his official capacity as president of the Canadian Group of Painters was obliged to promote abstract art wholeheartedly. "Confidence in the artists' integrity, whether the painting is traditional or experimental in the field of abstract design, is necessary if our artists are to keep abreast of the times," he wrote in the foreword to the Canadian Group's 1947–48 catalogue.[40] Still, he later seemed puzzled by the popular acceptance of non-figurative art — especially when he remembered the outright critical rejection of his early Impressionist-inspired canvases. "They called us the Hot Mush School," he wrote in 1954. "Yet people today calmly accept ladies with eyes in the middle of their foreheads, pastiches of Technicolored worms, and even the outpourings of a genius in the U.S. who simply walks over his canvas in bare feet pouring paint out of a can."[41] The latter reference is obviously aimed at Pollock, the reluctant hero of the New York School who was widely credited with taking abstract painting to an unprecedented level by dripping and flinging paint onto huge sheets of unprimed canvas spread out on the floor.

Jackson himself may have been tempted to try an abstract painting, but he knew it would be difficult for someone so set in his ways. "There are enough people doing it so much better than I would," he said. "It's best for me to leave it alone, at my age anyway. I would probably make a fool of myself."[42] He also pointed out that if an older artist were to suddenly switch over to abstract art, it would be interpreted as a sign that he was "not sure of his convictions."[44]

There could be no denying that a new generation had come to the fore, this one much more radical than Jackson, Harris, or MacDonald had ever been.

The Loss of Two Franks

Times were changing quickly. Of the original Group of Seven, only four were still alive by the end of the 1940s. Frank Carmichael, the youngest of the founding members, died in 1945 at the age of just fifty-five. "A lyrical painter of great ability and a fine craftsman,"[45] as Jackson described him, Carmichael had remained a dedicated landscape artist, but the everyday responsibilities of raising a family had prevented him from turning out many canvases. Instead, much of his creative energy was taken up with commercial work and teaching at the Ontario College of Art. Equally adept with oil or watercolour, he devoted his leisure time to painting in the La Cloche Hills region, where he had built a cabin on Cranberry Lake in the mid-1930s.[46]

The multi-talented Carmichael was not only a painter and a skilled designer who turned out hundreds of commercial works — from book jackets, illustrations, and posters to stained glass windows — he was also a musician who, in his later years, played the bassoon with the University of Toronto Symphony Orchestra.[47] Of all the Group of Seven painters, it was Carmichael alone who painted exclusively in Ontario; he never felt the need to travel outside of his native province to find inspiration.

Franz Johnston, the early defector from the original seven, died of cerebral hemorrhage in Toronto in 1949 at the age of sixty-one. Always gregarious and full of fun, Johnston enjoyed a successful career after leaving the Group, exhibiting widely and balancing steady commercial work with his boldly coloured landscapes that became increasingly tailored to popular tastes. Like Jackson, he had painted at Georgian Bay and the Eldorado Mine at Great Bear Lake, but unlike his former Group colleague, he never had trouble selling his work. He was harshly criticized for "selling out" when he exhibited his work through retail department stores such as Eaton's and Simpson's.[48] This strategy brought him financial success, and by 1931 Simpson's had established its own "Franz Johnston Room," devoted exclusively to selling the work of the popular painter.[49]

Jackson always maintained mixed feelings about Johnston. He saw the name change to Franz as a transparent ploy to become more commercially viable — but could not fault Johnston for wanting to make money. "Can't blame him, because I know what it means to be poor," he once remarked. "I guess he did make more money than I did selling those pretty little pictures of his during the twenties."[50]

Five surviving members of the Group of Seven gathered for the opening of Lawren Harris's 1948 retrospective exhibition in Toronto. Once the young "Hot Mush" radicals, they were now the old "Academic Johnnies" of Jackson's 1925 prophecy. From the left are A.J. Casson, Lawren Harris, Fred Varley, A.Y. Jackson, and Arthur Lismer.

Back to the Northwest Territories

For Jackson, there was little time to mourn his old friends; he was still busy making new ones and taking extended trips to remote regions of Canada. From the small mining towns of northern Ontario to the foothills of southern Alberta, whenever he found an interesting area to work, he always tried to return, even if it took a few years. In 1949, upon completing his last summer teaching at Banff, he got back to the Northwest Territories to visit two favourite spots — Port Radium on Great Bear Lake and the friendly town of Yellowknife on Great Slave Lake — this time with Maurice Haycock, a geologist he had first met aboard the *Beothic* back in 1927.[51]

THE STUDIO BUILDING

THE CONSTRUCTION OF THE STUDIO BUILDING FOR CANADIAN ART WAS COMMISSIONED BY RENOWNED CANADIAN ARTIST LAWREN HARRIS (1885–1970), AN HEIR TO THE MASSEY–HARRIS FARM MACHINERY FORTUNE, AND ARTS PATRON DR. JAMES MACCALLUM. DESIGNED BY TORONTO ARCHITECT EDEN SMITH (1859 – 1949) AND COMPLETED IN 1914, IT SOON BECAME AN IMPORTANT CENTRE FOR NEW DEVELOPMENTS IN CANADIAN PAINTING. GROUP OF SEVEN MEMBERS, HARRIS, J.E.H. MACDONALD AND A.Y. JACKSON WERE AMONG THE ORIGINAL OCCUPANTS. TOM THOMSON AND FREDERICK VARLEY WORKED AT VARIOUS TIMES IN THE REAR SHACK, WHICH WAS MOVED IN 1962 TO THE MCMICHAEL CANADIAN ART COLLECTION IN KLEINBURG. THE STUDIO BUILDING WAS SOLD BY HARRIS TO ARTIST GORDON MACNAMARA IN 1948.

TORONTO HISTORICAL BOARD, 1996

The commemorative plaque placed in front of the Studio Building in 1996 by the Toronto Historical Board.

Photo by Karen Forbes Cutler. Collection of the author.

A year later he was back, again with Haycock, camping in the Barren Lands north of Port Radium, in the Teshierpi Mountains. They were flown in by a bush pilot who promised to return in a week, leaving Jackson, Haycock, and a mine employee named Bob Jenkins alone in the vast Barren Lands, not far from the aptly named Dismal Lakes. Sketching was difficult; it was bitterly cold and the east wind blew so hard that Jackson was often forced to crouch behind a boulder to protect himself and his sketch from the wind.[52] It was only October, but high above the permafrost line there were daily snow flurries, and the temperature dropped well below freezing every night, forcing the campers to break through a layer of ice in their water bucket each morning.

Despite the rough conditions, the western Arctic was Jackson's favourite sketching destination during this period, and he returned to Great Bear Lake yet again in the summer of 1951, this time in the company of John Rennie, who worked for the Giant Yellowknife Mines.[53] He found the region exciting — the rocks and dead trees provided vibrant foregrounds to contrast the lakes and rolling hills beyond. He rendered the Barren Lands in warm shades of reds and browns, with skies in varying shades of blues and greys and the mountains as dark silhouettes.

"Every chance I get I go by plane up into the tundra, into the Barren Lands," Jackson wrote in 1954. "I'm perfectly happy to be put down with my pack up among those lonely rivers and lakes, perhaps two or three hundred miles from the nearest human being."[54]

The Pinnacle of a Career

A dozen years after Jackson accepted his honorary doctorate from Queen's University in 1941, he was once again invited to receive a Doctor of Laws degree, this time from McMaster University. He proudly attended the ceremony on October 16, 1953, but was not able to stay in Hamilton for very long; he had to hurry home to make final preparations for his major retrospective exhibition at the Art Gallery of Toronto, which was to open less than a week later.

A.Y. Jackson: Paintings 1902–1953 was truly a complete tribute to Jackson's life as an artist. As he walked from room to room, examining his old canvases — many of which he had not seen in years—it was like viewing a diary of images from the past fifty years. Here were the products of his life, set out in chronological order. The watercolours *River St. Pierre, Montreal* from 1902, *Shawbridge Farm* from 1904, and *Early Spring, Hemmingford* from 1905 represented his youthful wanderings in Quebec. The European canvases included *Canal du Loing* as well as *Studio at Étaples* and *The Fountain, Assisi*. Jackson's only surviving English work, *Factory at Leeds*, was also there, as well as the sketches *Veere, Holland* from 1909 and *Village Near Fiume* from 1913. Then there was *Terre Sauvage*, the groundbreaking Georgian Bay canvas that heralded Jackson's arrival on the Toronto scene back in 1913; *The Red Maple*, the result of his only sketching trip with Tom Thomson, in 1914; and *Spring, Lower Canada*, painted in Émileville in 1915 while he struggled with his conscience over enlisting. Ten Canadian War Memorial paintings were on display, including *Houses of Ypres, The Green Crassier*, and, Jackson's personal favourite wartime canvas, *Springtime in Picardy*.

The Group of Seven period was represented by such works as *Maple Woods, Algoma* and *The Freddy Channel*, hurriedly painted just days before the first Group exhibition in 1920; *Winter Road, Quebec*, from Jackson's first annual springtime visit to the lower St. Lawrence; and *Lake Superior Country*, from the autumn trips with Harris. The Skeena River trip of 1926 was represented by *Indian Home*, and of course there was *The Beothic at Bache Post*, the canvas Jackson presented to the federal government in exchange for his first trip up to Ellesmere Island. The post-Group period included canvases from not only familiar destinations — *Algoma, November* and *Farm, Saint-Tite-des-Caps* — but also his trips to Alberta with 1937's *Blood Indian Reserve* and his stays at Port Radium with *Radium Mine, Great Bear Lake*. The most recent canvas, *Arctic Summer*, was just a few months old.

And of course there was *The Edge of the Maple Wood*, the 1910 canvas whose existence inadvertently changed the direction of art in Canada.

The exhibition succeeded in placing Jackson back in the national spotlight. Praise was heaped on him from all directions — a new generation of newspaper and magazine reviewers treated the exhibition with the reverence of a historical event, while younger artists came to pay homage to this elder statesman and trailblazer. Then there was Arthur Lismer, whose catalogue essay on his old friend painted a vivid picture of the hearty outdoorsman, passionate painter, and outspoken champion of Canadian art.

Interviewed shortly after the opening, Jackson summed up his feelings at seeing such a large collection of his life's work gather under one roof. "There were a few canvases I would have liked to retouch here and there," he said with characteristic modesty. "And there were many I hadn't seen in thirty years. It was like coming across old friends."[55]

18

THE *Y* STANDS FOR YOUNG

JACKSON'S WORKING METHODS AND itinerant lifestyle demanded a centrally located home base where he could paint undisturbed. That was the great advantage of the Studio Building — a cheap, comfortable workspace that was an easy walk from the train station and bus depot. But in 1954, he was forced to make a drastic change in his life. He had to move out.

The final decision was a long time in coming; Jackson probably began thinking about moving back in 1948, soon after the Art Gallery of Toronto mounted a major Lawren Harris retrospective exhibition. While in Toronto to attend the opening, Harris decided to sell the Severn Street property. He and Bess had been away since 1934; after living in the United States for nearly six years, they had settled in Vancouver in 1940, where they were now living in a majestic white house at 4760 Belmont Avenue. Dr. MacCallum, Harris's partner in the Studio Building venture, had died in 1943, leaving him the sole proprietor. The sale was purely a business move rather than a severing of ties, for Harris not only remained a key member of the Canadian Group of Painters — serving as second vice-president under vice-president Fritz Brandtner and president Jackson — he also maintained the friendliest of relationships with his former Group of Seven colleagues and could always be counted on to send a few colourful abstract canvases to each Canadian Group exhibition.

But for Jackson, the sale of his long-time home would have major consequences; life at the Studio Building rapidly lost its appeal for him once Harris sold the property to Gordon MacNamara and Charles Redfern.[1]

A lawyer by profession, MacNamara was a talented artist who had exhibited with the Canadian Group, but any spirit of camaraderie he may have shared with his fellow painters did not extend to the tenant-landlord relationship. The freedom Jackson had enjoyed while paying rent to a close friend was gone; now he was the tenant of a relative stranger who made it clear from the outset that he would not tolerate any noise — even from a member of the legendary Group of Seven. Now the rent had to be paid on time, no exceptions, and over the next few years the bohemian spirit of the place disintegrated into one of tension and stress.

"After the changeover, whatever glamour it had left departed," Jackson wrote of the building. "Admonitory notes began to appear, advising tenants that hammering, slamming doors, and other similar misdemeanours were forbidden."[2]

One of the first tenants whose frequent run-ins with MacNamara prompted him to hand in his notice was Thoreau MacDonald, who had occupied a studio since the mid-1920s. Soon to follow were long-time neighbours George Pepper and his wife, Kathleen

Daly. Jackson had often considered moving back to Montreal, but he ended up staying on in his cluttered, homey studio for several more years, weathering these new inconveniences with the same hearty imperviousness as he had any violent windstorm on Georgian Bay.

But despite Jackson's well-documented bitterness toward MacNamara, it would be wrong to assume that tenant and landlord were always at odds with each other. In a 1999 CBC *Evening News* feature on the Studio Building, an elderly MacNamara recalled Jackson without any hint of animosity, telling the story of how Jackson rushed to the aid of his fellow artists when the Studio Building's basement storeroom flooded — endangering many important paintings. "There were a lot of floods from the city; storm sewers were backing up," MacNamara remembered. "So I wrote to Mr. Harris, saying this was a serious situation for his paintings … I recall Jackson and a friend of his heaving the stuff out the back window. [They] made a bonfire of some of them and rolled up the others and sent them off to Vancouver, where Mr. Harris then was."[3]

Jackson would never have stood for any abuse at the hands of an overly zealous landlord, but after tolerating the reduced conditions for six years, he decided he could take no more. Even after his major retrospective exhibition, which established him as one of Canada's most venerated painters, he had reason to believe he was being singled out by MacNamara. "My turn came when I was informed that I must wear felt shoes while in the studio and that when I stretched a canvas I had to go down to the basement," he wrote.[4] For someone so set in his ways, this came as a major affront, and he immediately began looking into alternate arrangements.

To make matters even worse, the initial convenience of Severn Street came to an abrupt end with the arrival of the Toronto subway. Easy access to Yonge Street was cut off by a stretch of above-ground track emerging from a tunnel right next to the Studio Building, forcing the tenants to take a much longer way around.

Off to Manotick

A solution was not long in coming, as Jackson remembered a plot of land for sale next to his niece Constance Hamilton's house in Manotick, south of Ottawa. Fortunately, he was now on solid financial ground; he was receiving an average of $300 to $400 for a medium-sized canvas, and $500 to $750 for one of the larger works. Although these prices were not much higher than what he was charging in the 1920s, the difference now was that his work was in greater demand by collectors — thanks to the combined impact of the 1953 retrospective exhibition and its nationwide publicity, the mass-produced silkscreen reproductions, and, of course, the ever growing influence of the venerated Group of Seven. Add to this the average of $60 apiece he was receiving for the backlog of oil-on-panel sketches, and it was obvious that the frugal Jackson had put away enough money to easily finance the Manotick project.

Once he made up his mind to move, he contacted his frequent sketching companion Maurice Haycock, who agreed to inspect the property. Upon Haycock's approval, Jackson bought the Manotick land and hired architect G.M. Nixon to design a combination

studio and house.[5] The proposed living arrangement sounded ideal for the aging painter; he would be right next door to his niece and her family, and still close to Ottawa, which connected him to the rest of the country. But best of all, he would not have to venture too far from home to sketch the Gatineau region's "rocky hills rising out of the farmlands, rivers, lakes and old settlements all quite close to Ottawa."[6]

News of Jackson's departure quickly spread through the Canadian art community, and his last weeks on Severn Street were marked by several farewell parties — and he didn't care if he made too much noise; he was leaving anyway. The impending move attracted a fair amount of publicity, and Jackson was photographed from the gallery of his studio as he cleaned out his cluttered workspace, so full of memories and souvenirs of his itinerant lifestyle. One thing Jackson left behind was his easel — the big handmade support built by Tom Thomson for use in the shack. Before he left, Jackson presented it to artist Jack Nichols, his next-door neighbour on the Studio Building's third floor.[7]

So after thirty-six years in the Studio Building — or forty-one years since taking that first studio with Thomson in 1914 — Jackson gave up Toronto for the life of a country gentleman and property owner. This was seen as the end of an era, or as an article in *Weekend Magazine* put it, "here was the breaking of the last link, the closing of a door on the first great important movement in Canadian art."[8]

By late March 1955 he was all moved into his brand new home on Highcroft Drive, Manotick — a two-storey white stucco house and adjoining studio built into the hillside overlooking the main highway and the Rideau River in the distance.[9]

But even the idyllic new surroundings could not alleviate the bitterness he continued to harbour over his departure from Severn Street, and he remained outspoken in his dislike for his former landlord. "MacNamara is a mean, selfish cuss and never does anything without a profit motif," he wrote to a friend in 1961.[10]

As for MacNamara, he would retain ownership of the Studio Building until his death in 2006. Ever protective of the building and its heritage value, he reluctantly allowed a commemorative plaque to be installed in the front hedge in 1996 by the Toronto Historical Board. During his later years he was frequently at odds with the City of Toronto over various plans to erect tall buildings near the Severn Street property, which would cast afternoon shadows on the Studio Building — a blatant infringement of the artists' requirement for plenty of natural light.

A Man of Property

"I settled easily into my new home," Jackson wrote of his move to Manotick. "It was a two-bedroom bungalow, comfortable, and a good place to work."[11]

Now Jackson had everything he needed for a quiet, productive period of creativity. The new house and studio had been built to his specifications, from major features like eleven-foot-high windows along the north side of the studio to such details as the initials A.Y.J. in the floor tiles at the main entrance. There was no phone installed; instead, a loud doorbell-like system was connected between his studio and Constance's house, so the hard-of-hearing painter could be summoned from next door at meal time or if he was wanted on the phone.[12]

after Prudence Heward's untimely death from acute asthma at age fifty-one, Jackson continued to visit her mother at Fernbank and would sleep in Prudence's bed in a screened porch facing the river, where he would be lulled to sleep by the sound of waves lapping against the shore.[18]

Jackson and Grafftey had become fast friends since their first meeting in 1948, at the opening of the Prudence Heward memorial exhibition at the National Gallery. Their common bond was not only a love of art but also their affection for the same woman — one for a dear friend and colleague, the other for a beloved aunt. Not long after their first meeting, Grafftey casually asked Jackson if his aunt ranked among Canada's best woman painters.

A Jackson family reunion in the 1950s. From the left: A.Y. Jackson with siblings Ernest, Kay, Bill, and Harry.
Photo courtesy of Alex Hamilton.

"What's this about *woman* painter?" Jackson snorted in reply. "Heward, your Aunt Prue was the finest painter in Canada, but she never received the recognition she deserved! I wanted her to join the Group of Seven, but no women were allowed to join."

"Why not?"

"Well," he admitted after a long, thoughtful pause. "I guess you could say we liked our brandy and cigars too much."[19]

MacLaren Street, Ottawa

Even if Jackson was driven to Ottawa by Constance and got a lift back out to Manotick with Grafftey, he had to concede that his isolated home was inconvenient for everything except sketching. When he heard that an apartment in Ottawa would soon be available, he decided to put his house up for rent and began packing up his belongings.

By the summer of 1962, Jackson was comfortably ensconced in a ground-floor suite at 192 MacLaren Street — a sprawling brick building that was once the home of lumber baron Fred Booth.[20] The wood-panelled apartment was not as well suited to painting as his two previous homes, for there was not as much natural light and the rooms were quite a bit smaller. But the advantages of living in the city were much greater, for now he was within easy walking distance of everything from banks and restaurants to art supply shops and the National Gallery, not to mention busses, trains, and the airport.

The apartment was also just a block from Saint John's Anglican Church, where the eighty-year-old painter soon became a fixture at Sunday morning services.[21] Jackson had not been a regular churchgoer in Toronto or Manotick, but he easily fell into the habit of attending the local church, where he proved to be a gregarious and popular parishioner — often at the centre of a crowd, shaking hands and chatting amiably. Jack Firestone, who regularly looked in on his elderly friend during this period, often asked him how he had liked that week's sermon. "It was a very good sermon," Jackson would invariably reply without adding any details, leading Firestone to suspect that Jackson's gradually increasing deafness had prevented him from actually hearing the minister at all.[22]

In Ottawa, Jackson found himself back in the middle of the social activity he had missed in Manotick, and he thrived on the interaction with his many friends and acquaintances. Nearly seventy people showed up at his moving-in party in December 1962, many of them lending their own Jackson paintings to spruce up the walls because their host's success was now such that he no longer owned anything he had ever painted.[23] There was always someone around who was willing to drive him out into the country to sketch, and he was forever being invited out to supper at friends' homes. From large National Gallery openings to small, private social gatherings, Jackson's presence was requested several times per week, and during these parties he was usually urged to recount some of his adventures. This had never presented a problem, for he was a natural raconteur with plenty of anecdotes and decades of experience in reciting them with his own brand of gruff, self-effacing humour.

But as old age advanced, he began to falter — dates got mixed up in his mind and his memory could fail in the middle of a sentence. As Firestone observed, "He became increasingly long-winded, straying from the subject and at times unable to remember the

point he was trying to make."[24] If this were not frustrating enough, his deafness was progressing to the point where anyone addressing him was forced to speak in a loud, clear voice. He did own a hearing aid, but rarely bothered to turn it on.[25]

The Red Maple Revisited

Life on MacLaren Street was supposed to be quiet for the aging Jackson, but barely two years went by before he found himself in the middle of a debate that consumed the entire nation — the question of a new Canadian flag. He would never have become involved if not for Firestone, who dropped by the apartment one day in June 1964 and chanced upon a piece of cardboard on which Jackson had scrawled a list of names and phone numbers. After noting with some amusement that his name and number appeared three times — evidence of his friend's faltering memory — Firestone flipped over the cardboard and found a bright watercolour rendering of what appeared to be a flag.

"You're looking at the Jackson flag of Canada," Firestone was told as he examined the simple design of three red maple leaves between wavy blue lines running horizontally across the top and bottom.[26]

Firestone was immediately struck with an idea. The newspapers had lately been full of reports on the government's initiative to create a new Canadian flag to replace the old-fashioned Red Ensign in time for the upcoming centennial in 1967. Firestone believed Jackson's flag was far superior to the designs currently under consideration. It might be a suitable compromise, and especially appropriate coming from one of Canada's best-known landscape artists. He enthusiastically pumped Jackson for more information, and learned that he had painted it about five years earlier, while living in Manotick. He had all but forgotten about it, and had been using the back for phone numbers.

But when Firestone suggested submitting the design to the government, Jackson flatly refused.

"I don't trust politicians," he said. "The government has probably already made up its mind, and it's going to get the design it proposed … I don't see the point of getting involved. We'll just get a run-around. It's useless."[27]

But Firestone refused to drop the matter. As a government economist he had many connections on Parliament Hill, including Secretary of State Maurice Lamontagne, and offered to act on Jackson's behalf. Still, the painter refused to budge, citing his utter contempt for government bureaucracy. Eventually, Firestone's persistence won out and Jackson reluctantly agreed to officially enter his design for consideration. He found his watercolours and carefully painted a new version of his flag idea, then wrote an accompanying letter to the Prime Minister, dated June 10:

Dear Mr. Pearson,

Several years ago I made a design for a Canadian flag. It was not shown to anyone and I had forgotten all about it. I had scribbled some phone numbers on the back of it. A visitor to the studio the other day saw it and remarked he liked it more than the one being reproduced in the press, and asked if he could show it to Mr. Lamon-

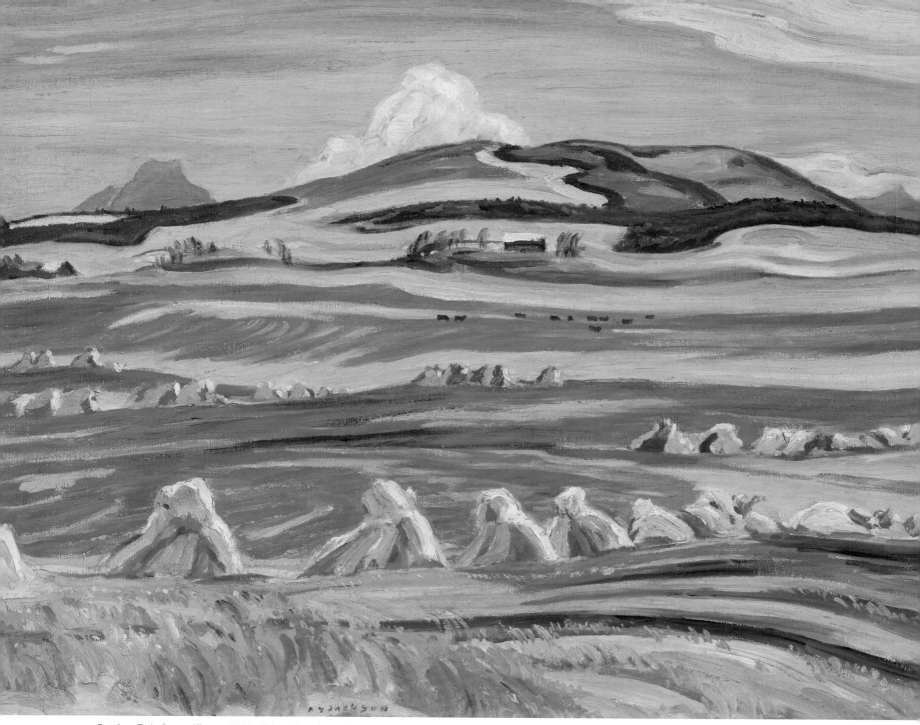

October, Twin Butte, Alberta, 1951. Although Jackson didn't begin sketching in southern Alberta until 1937, he returned frequently throughout the 1940s and 1950s.

Oil on canvas, 64.2 x 81.5 cm. © National Gallery of Canada, Ottawa. Courtesy of the estate of the late Dr. Naomi Jackson Groves.

tagne. I imagine that back of my mind was the memory of camping with Tom Thomson in Algonquin Park just fifty years ago. I made a sketch which became a canvas entitled "The Red Maple" and was purchased by the National Gallery that same year 1914. It represented a tree with red leaves and the Ox Tongue River prancing by in the background.[28]

True to his word, Firestone sent the design to his friend Lamontagne, and before long Jackson's name was being mentioned in press releases and reports from Parliament Hill as the flag debate heated up between Lester Pearson's Liberals and John Diefenbaker's Conservatives. He gave several press interviews and even appeared as a special witness in the House of Commons, explaining the main difference between his design and the other red maple proposals, which featured vertical blue lines on either side, representing the Atlantic and Pacific oceans. As he had stated in his letter to Pearson, Jackson's horizontal blue lines along the top and bottom represented the network of rivers throughout the land, which he believed were more significant in the development of the country because they served as the main routes for the canoes used by the early explorers.[29]

The flag debate dragged on in Ottawa for several months, and on October 20, 1964, there was a major breakthrough when Canadian Press reported that "famed artist A.Y. Jackson is on the road to becoming Canada's Betsy Ross. His flag design is reliably reported to be preferred by the majority of the members of the Commons flag committee."[30] It is doubtful that Jackson even heard the news at the time. He had always remained aloof to the reports, and when this one came out the eighty-two-year-old painter was far away — camping and sketching up in the Yukon and Alaska region with the two closest friends of his later years, Ralph Burton and Maurice Haycock.

But just as Jackson had predicted all along, the entire effort ended in disappointment. Another design, featuring a single red maple leaf, was adopted by the government late in 1964 and made its official debut on February 15, 1965. Instead of feeling sorry for himself, Jackson simply got back to work and awaited his next opportunity for adventure.

It was not long in coming.

Baffin Island — Again

Soon after the drawn-out flag controversy, Jackson returned to his regular routine of sketching trips in the nearby Gatineau region. To his friends, he was a marvel of nature — a tireless maverick who continued to defy age and convention by carrying his sketching gear over long distances and spending hours at his easel in his MacLaren Street apartment. His eighty-second birthday, in October 1964, had done nothing to slow him down; he remained impervious to the cold and damp, and never complained about the weather unless it somehow prevented him from painting.

But there was no denying that age was creeping up on him; in 1962 he had been diagnosed with diabetes and was forced to modify his diet. He had to give up sugar entirely and was no longer allowed to drink his favourite beverage, ginger ale. From then on, he had to settle for rye and water instead of his usual rye and ginger at parties and recep-

tions.[31] The following year he was hospitalized for a week over a bone infection in a finger on his left hand.[32]

But despite these minor setbacks, Jackson continued to appear at a wide variety of social functions that included meetings of arts clubs and other cultural organizations. He rarely declined an invitation to present a slide show on his own career and those of his fellow Group of Seven members. Whenever he spoke about his two Arctic voyages, with Banting and Harris, it was obvious that he wished to return. But at his advanced age that prospect seemed very unlikely. The harsh climate would certainly damage his health, if not kill him altogether.

But when an invitation arrived from niece Geneva's friend Patrick Baird, leader of McGill University's Alpine Club of Canada, to join a mountain climbing expedition to Baffin Island in the summer of 1965, Jackson readily accepted. "I am all in favour of joining your party," he replied to Baird's letter. "I don't require a lot of feather bedding."[33]

As unlikely as it sounded, Jackson had every intention of making one last trip up to the forbidding Arctic, and when he made the announcement at a birthday celebration for his old friend A.J. Casson in Ottawa, those in attendance were shocked. "And why not?" he growled with a big grin. "The Y in A.Y. stands for Young! I'm young in spirit, and I'm willing. Anyway, I'll leave the mountain climbing to others and concentrate on painting."[34]

"How will you be able to paint if you get too tired?" asked Firestone, his host.

"Only two things keep me from painting," Jackson replied matter-of-factly. "One is if people talk to me while I'm painting. The other is fog."[35]

Friends and relatives tried to dissuade Jackson from taking the trip, but he would not hear of it; he was ready, willing, and able to endure a month in the Arctic, despite any warnings from those closest to him. Sure enough, in early July he joined the party aboard a Nordair big-wheel Otter that flew direct from Montreal up to Frobisher Bay — a flight of just a few hours, much unlike the two-week journey the *Beothic* had taken thirty-five years earlier.

The mountain climbing party consisted of Baird, Dr. James MacDougall, and eleven climbers from Canada and the United States. Geneva Jackson and a friend came along to do the cooking. The elderly painter would be sharing a tent with the doctor. The club's destination was a range of rugged mountains on Baffin Island — a series of previously unscaled peaks that rose up dramatically from the gravel beach. More often than not, it seemed, the tops of the mountains were obscured by thick fog.

"We landed on a long stretch of silt along the shores of the lake," Jackson wrote. "Normally, we would have put down on the lake itself. But this was July; the lake was still frozen, although the ice wasn't firm enough to land on."[36]

The attractive prospect of camping in a tent with nothing more substantial than a ground sheet and sleeping bag was soon lost on Jackson, for when the provisions were unpacked it was discovered that the expected supply of powdered milk had never been shipped; instead, they had been sent a double supply of sugar — which was of no use to the diabetic Jackson. He had worked under much worse conditions, so he took the lack of powdered milk in good stride and concentrated on his painting. While the other members of the party went out mountain climbing each morning, he carried his sketch box down the rocky beach, found a suitable subject, and set to work.

Dr. MacDougall awoke one cold morning to the sound of his tent mate muttering to himself. "Fog, fog, fog!" Jackson complained. "It's enough to make you swear. In fact I think I will swear — Damn! Now I feel better."[37]

From the jagged peaks his friends were climbing to the Inuit villages on Frobisher Bay, Jackson had no trouble finding subjects. He showed remarkable energy for his age, producing several sketches each day — most of which were of exceptionally high quality and were sure to provide a basis for successful canvases. Many of the oil sketches were rendered in varying shades of brown, ochre, and red, resulting in vibrant images that showed a very different Arctic from the vast white wasteland most Canadians envisioned. Before long, the camp's supply tent was a makeshift gallery, full of fresh sketches propped up against the cases of canned stew and extra boxes of sugar.[38]

For Jackson, the trip took a particularly nostalgic turn when the returning party stopped in at Pangnirtung — the settlement that he had visited on his trips with Banting in 1927 and Harris in 1930 and that resulted in his well-known canvas *Summer, Pangnirtung*, now hanging in the McMichael Canadian Collection in Kleinburg. There was a familiar face in the crowd of Inuit villagers who came out to greet the climbers. He made his way up to Jackson and extended his hand. It was Killabuk, Jackson's friend from his last stop in Pangnirtung — thirty-five years older but largely unchanged.[39] The two enjoyed a nostalgic evening, talking about how much things had changed. From Killabuk's comments and his own observations, Jackson formed a new perspective on Inuit life:

It was interesting to see how the Eskimo way of life had changed since my first visit. Then the Eskimos lived in igloos and skin tents and even, on occasion, in caves. Now many of them lived in bungalows and wore white man's clothing. The Eskimos seem to adapt to civilization much better than the Indians do. They are quite handy around the airport, and I have heard that they can take an automobile engine apart and put it together again the first time they see it. Down at Frobisher Bay, the Eskimos have their own automobile repair shop, bakery, stores, and a little hot dog stand. Eventually they may live just like other Canadians.[40]

It had been a highly productive trip, and Jackson happily returned to Ottawa in early August with no less than one hundred new sketches.[41] He was proud of this accomplishment, but now he found himself with far more work than he could comfortably handle. He was quite used to meeting the increased demand for canvases, but it seemed that every member of the Alpine Club expedition had requested a sketch, which Jackson promised for a hundred dollars apiece. He intended to oblige them all, but it would take time because he first needed the sketches to create his Arctic canvases. As the weeks went by, his phone kept ringing with mountain climbers impatiently inquiring about their promised sketch. "Never fear," was his stock reply. "I have your sketch and you will get it soon."[42] True to his word, Jackson made sure that each of the promised Arctic sketches eventually reached its rightful recipient — and he still had plenty left over for dozens of new canvases.

A decade earlier he had written, "I'll have to live to be 200 to get around to painting half the things I want to paint."[43] Now, as he turned eighty-three, those words seemed truer than ever.

19

A FORCE OF NATURE

JACKSON'S DIZZY SPELLS GREW NOTICEABLY worse following the Arctic trip, and now he often had trouble staying awake.[1] He could be speaking to someone and, right in mid-sentence, suddenly fall fast asleep. After a few minutes he would awaken, completely refreshed, and continue speaking. This did not seem to bother him, for he often joked about it — but his dizziness and ever diminishing hearing were becoming major nuisances.

His Ottawa friend and neighbour, Dr. Robert Starrs, insisted he receive a proper checkup, and the diagnosis was Ménières syndrome — a painful affliction characterized by pressure in the middle ear, muffled hearing, and bouts of vertigo — and Jackson was promptly hospitalized for ten days in late 1965.[2] Again, his many friends rallied around and tried to convince him to give up his gruelling lifestyle. "The doctor advised Alec to cut down on his many extracurricular activities. I mentioned to him what you, dear Edwin, had said to me: 'When will Alec take it easier?' Alec replied: 'I have too much fun in doing what I am doing,'" Firestone wrote to Edwin Holgate in December. "However, after he left the hospital Alec confided to me that he would listen to his doctor's advice and would turn down many of the invitations he was getting to go out for social engagements and to make speeches."[3]

These incidents were an obvious warning, prompting the eighty-three-year-old Jackson to confront his own mortality. He began looking ahead into arrangements for his final resting place. Though he had always hoped to be buried in his native Quebec, the political climate had taken a dramatic change in the early 1960s. Radical separatists were setting off bombs in Montreal, and the movement for Quebec independence was gaining momentum throughout the province. The anti-English atmosphere in some quarters was offensive to Jackson, who had always been a proudly bilingual Quebecer with deep ties to the French-Canadian people and their culture — but he wanted his grave to remain on Canadian soil.

Knowing that his friends Robert and Signe McMichael had established a shrine to the Group of Seven with a gallery on their property in Kleinburg, just north of Toronto, he struck upon the idea of a permanent resting place for himself and possibly other Group members in that area. "Some time when you are not busy you might enquire about a lot in some quiet little cemetery near to Kleinburg," he wrote to the McMichaels in early 1968. "I was going to acquire one in Hemmingford, Que. where some old friends are buried but I don't like the direction Quebec is taking."[4]

The idea was accepted by the McMichaels; Jackson's letter was the beginning of a major heritage initiative, for today the Kleinburg gravesite contains the remains of six Group of Seven members — Casson, Harris, Johnston, Lismer, and Varley, as well as Jackson.

It was around this time that the McMichaels asked Jackson if he might consider moving to Kleinburg permanently when he decided to retire. He could live in an apartment above one of the galleries, they said, surrounded by dozens of Group of Seven paintings. The expansive grounds provided plenty of subjects for sketching, including the old Tom Thomson/Keith MacIver shack, which the McMichaels had bought from Gordon MacNamara in 1962. The "humble wooden structure" behind the Studio Building, where Jackson regularly ate breakfast with MacIver over more than twenty winters, had been dismantled, restored, and reassembled at Kleinburg.[5] It was now filled with artifacts from Thomson's life — including the big easel Jackson had used throughout most of his career.

The Last Sketching Trips

But the gregarious A.Y. Jackson had no plans to retire to Kleinburg or anywhere else. He unflinchingly maintained his busy schedule of sketching trips well into the second half of the 1960s. Even at the ripe old age of eighty-four, he showed no signs of slowing down. He had a network of devoted friends throughout the Gatineau region who were only too happy to put him up at their country homes for a few days, allowing him to work undisturbed. All he had to do was pack up his sketching materials, fill a knapsack with warm clothes, and he was off, ready for yet another challenge. He became a familiar fixture in the area — an elderly figure in a heavy overcoat and weather-beaten fedora, squatting on a tiny camp stool by the side of a road or on a riverbank, dabbing at a panel in an open sketch box that was either balanced on his lap or resting on another camp stool.

With the combined discomfort of his diabetes and increasing dizzy spells brought on by the Ménières syndrome, he had to admit that he was no longer as agile as he used to be; now the act of going out and sketching was strenuous and demanding. Old age was definitely upon him, but he refused to surrender to it. As long as he had a brush in his hand and a blank panel or canvas in front of him, he would paint — and this kept him going through the difficult period following his return from the Arctic.

He continued to travel, making his usual summer visits to Lake Superior and Georgian Bay, and in June 1967 he spent a few days in Montreal. McGill University had invited him to receive an honorary doctoral degree, so he took advantage of the opportunity to visit Expo 67 — the huge world's fair organized to celebrate Canada's centennial.

He attended several social functions while in Montreal, including the opening of an exhibition by his close friend and frequent sketching companion Ralph Burton at the West End Gallery. Also in attendance was a frail Arthur Lismer, who made a grand appearance at the top of the stairs, only to stumble on his way down. Jackson grabbed him before he could fall. "Here I am, supporting you again, you old coot!" Jackson growled in a voice loud enough to draw a round of laughter from the assembled guests.[6]

Anne Savage, now long since retired from her distinguished teaching career, also turned up at the Burton show, and was able to spend some time with her special friend. Though hard of hearing, Jackson enjoyed the brief reunion with these two oldest and dearest friends, but he had to return to Ottawa. As it turned out, this was the last time he would ever see old "Lefty" Lismer or his beloved Annie.

"The Grand Old Man of Canadian Art" entertains guests at the opening of his friend Ralph Burton's exhibition at Montreal's West End Gallery in 1967. This was the last occasion on which he would see his close friends Arthur Lismer (right) and Anne Savage, who would die in 1969 and 1971, respectively.
Photo courtesy of Gabor Szilasi and West End Gallery.

In February 1968, Jackson took what would be remembered as the last of his productive sketching trips — a day's outing with Betty Kirk, one of the many friends he had made over the past few years. He was a frequent guest in Kirk's home in Buckingham, Quebec, and the two had grown very close during the early 1960s — so close in fact that the eighty-year-old painter asked Kirk, a widow in her forties and the mother of a young son, to marry him.

"I was a little taken aback when Alec asked me to be his wife," Kirk later told Firestone. "He really cared for me, and I cared for him."[7] But just as it had been with Anne Savage thirty years earlier, Jackson's proposal was turned down — and for the same reasons. Not only did Kirk realize that she would not fit well in Jackson's busy life of sketching trips and social engagements, but both her parents were ill in Nova Scotia, and she was obliged to visit them several times per year. Again, there was no animosity following the rejection, and the two parties remained the closest of friends for the rest of Jackson's life.

Notre-Dame-de-la-Salette, a picturesque village about twenty-five kilometres north of Buckingham, was a favourite destination for Jackson, as well as for Kirk, who would also paint once she had parked the car and got Jackson set up with his two camp stools and sketch box. Once, while Jackson was busily sketching by the side of the road, a yellow school bus pulled up and several children hurried out. The bus driver apologetically explained that his young passengers had recognized Jackson and insisted on stopping to meet him. Jackson was overjoyed; he stopped working and patiently chatted with the

children in French, showing them his sketch and answering their questions until the driver insisted they pile back into the bus.[8]

Not long after this, on February 26, the familiar figure made its final appearance in Notre-Dame-de-la-Salette. Once Kirk had helped Jackson set up his camp stool between snow drifts by the side of the road, Jackson set to work capturing an image of the town against the backdrop of a snow-covered hill. There was nothing remarkable about the finished panel, for it featured many of Jackson's old Quebec trademarks — subtly different shades of snow, a careful arrangement of small village buildings, and, of course, the local church placed prominently in the middle of the composition.[9] Neither Jackson nor Kirk knew it at the time, but that panel was the last one he would complete while in full possession of his abilities. Kirk admired the sketch, and Jackson immediately offered to paint it up onto a canvas for her.

Jackson did venture out to paint a few times after the last Notre-Dame-de-la-Salette trip, but he was unable to produce any satisfactory sketches. In fact, in April 1968 it became obvious that he was now too frail to work outdoors. He was being driven by his friend Munro Putnam along a little-used country road near Grenville when the car got hopelessly stuck in the early spring mud. The wheels were just spinning, sinking Putnam's car lower and lower into the ruts, so the two got out and shoved branches into the mud in an attempt to provide some traction for the tires. Knowing Jackson could not drive, Putnam asked him to sit behind the wheel and simply turn off the ignition if the car started to move. He left Jackson in the car with the engine running in reverse and tried to get the rear wheels to engage. This tactic worked, and the car lurched out of its hole — and kept going. Putnam shouted at Jackson to turn the key, but the car continued on and got mired in even deeper mud. When Putnam arrived back at the car, there was Jackson — fast asleep in the driver's seat.[10]

The incident made for an amusing anecdote, but the unavoidable truth was that Jackson's physical condition was such that he could no longer handle the rigors of even a brief car trip to the nearby countryside. After seventy years of outdoor sketching, that day with Putnam turned out to be the last real outing Jackson would ever make.

The Stroke

Although it appeared to the general public that the "Grand Old Man" of Canadian art might continue working well past his ninetieth — or even one hundredth — birthday, those close to Jackson realized that the beginning of the end was at hand. He came down with a bad cold and was in a generally weakened condition for several weeks in early 1968, but he refused to curtail his activities. Besides, he had something important to look forward to — his investiture as a Companion of the Order of Canada. This was a tremendous honour for Jackson, and the date April 26 was circled on his calendar. Not only did he see the Order as the highest possible recognition for his life's work, but it would give him the opportunity to meet one of his recent heroes, Nancy Greene. The Olympic skier had recently won a gold medal at the Grenoble Winter Games, a feat he saw as one similar to his own life's work. "To him, she was doing for her country what he was also trying

Still hearty at age eighty-four, A.Y. Jackson arrives at the opening of his friend Ralph Burton's exhibition at the West End Gallery in Montreal in 1967 — less than a year before a stroke put an end to his cross-country sketching trips.
Photo courtesy of Gabor Szilasi.

to do: making Canadians aware of and proud of their country in the way she knew best," Firestone observed. "In achieving world acclaim as a sports-woman, she was putting Canada on the map."[11]

Dogged by a bad cold that kept him coughing incessantly, the eighty-five-year-old painter kept up his routine of full days at his easel. Against the advice of friends, he took a bus trip to Toronto in mid-April to attend the wedding of a cousin, and upon his return in the early hours of April 22, he attempted to work on a few canvases in his MacLaren Street apartment.[12] It would be the last studio work he would ever undertake, for in the middle of it all he collapsed. That afternoon, Naomi dropped in to visit her uncle and found him sprawled on the floor, unconscious. He had suffered a massive stroke. Alarmed, she immediately summoned Jackson's close friend, Dr. Starrs, who lived just a block away.[13] He arrived moments later and after a preliminary examination decided that the patient should be moved to the nearby home of their mutual friend Ralph Burton, where he could be kept under close observation.[14]

The next day, Jackson's condition worsened; he drifted in and out of consciousness, and when he did awaken, he was disoriented. An ambulance was summoned, and he was rushed to Ottawa Civic Hospital, where it was determined that he had a blood clot on the brain. As Jackson lay in a coma, three doctors were brought in to assess the situation, and on April 26, his next of kin — Harry's daughters Naomi, Constance, and Geneva — were consulted on whether or not a delicate operation should be performed on their uncle. Dr. Starrs was dubious, fearing residual brain damage, but the three sisters decided in favour of the surgery.[15]

That same night, Naomi had to rush over to Government House, where she accepted the Companion of the Order of Canada on behalf of her ailing uncle. At the reception

following the ceremony, she introduced herself to Nancy Greene and told her how much her uncle admired her accomplishments on the ski hill. Greene was flattered by the compliment and agreed to visit Jackson in the hospital.

The operation was performed on Saturday. On Sunday, Jackson was in a deep sleep, slowly recovering from the surgery, when Dr. Starrs led Naomi, Nancy Greene, and her mother into his room. "You have a special visitor," the doctor repeated several times in a loud voice. "Nancy Greene is here to see you!"

Jackson's eyes fluttered open, and he stared blankly at the faces looming over him. Although Naomi had been warned that the brain damage might be extensive and there was a distinct possibility that her uncle would never recognize her again, Jackson stared groggily up at the skier and moved his lips. "What a lovely child," he said hoarsely.[16]

"Do you know who this is?" Naomi asked.

"Of course I do," Jackson replied. "I know you, Nancy. I paint mountains and you ski down them."[17]

Recovery was slow, but as the days went by, signs of the rugged old A.Y. continued to emerge. Private nurses were hired to ensure that he received round-the-clock care, but that did not sit well with the reluctant patient. When Jack and Isobel Firestone came to visit, they heard a commotion from far down the hall and, arriving at Jackson's room, found him wrestling with a nurse.

"Getting up, getting up," Jackson muttered, managing to swing one foot onto the floor while the exasperated nurse held him around the chest, desperately trying to keep him down on the bed.[18] The Firestones quickly intervened and calmed Jackson down, but it was clear that the fiercely independent painter would not be confined against his will.

His determination to get up and out of the hospital went far in the recovery process, and within a few weeks he was well enough to write letters to his friends, filled with the traces of the old Jackson humour. "I am becoming a bum," he wrote to Joyce and Munro Putnam from his hospital bed. "The doctor said sleep and rest will get me better, and I am steadier now. Hope to see you before year end. I may break loose."[19]

Kleinburg's Artist-in-Residence

When Jackson was finally able to convince his doctors that he was ready to break loose from the hospital, a serious problem presented itself: where would he go?

He wanted nothing more than to return to his MacLaren Street apartment and continue working as if nothing had happened, but that was out of the question. He was partially paralyzed on his left side and more feeble than ever. It was clear that he could no longer take care of himself, but neither Naomi, Constance, nor Geneva was in a position to have their uncle move in with them. A nursing home was suggested, but the sisters quickly vetoed that idea, citing the obvious fact that Jackson would be an extremely problematic patient who would keep sneaking off to sketch the minute his caregivers' backs were turned.

In the midst of this dilemma, Robert and Signe McMichael repeated their invitation for Jackson to live with them on the grounds of their gallery — an unusual proposal, but

one that made sense to all concerned. With a private nurse-companion to take care of his health needs, they said Jackson could live happily in a private apartment with all the comforts, including a swimming pool.

Once the McMichaels convinced Jackson's nieces and Dr. Starrs that they were fully aware of the immense responsibility they were taking on, it was agreed that Jackson would live out the last of his days as artist-in-residence at the Kleinburg gallery. For the sentimental Jackson, it meant being close to many of his old paintings, including the canvas *First Snow, Algoma* from that first boxcar trip with Harris, MacDonald, and Johnston, and, perhaps most memorable of all, the original sketch for *The Red Maple*, painted in Algonquin Park with Tom Thomson back in 1914. With those paintings on the wall, and the old Thomson/MacIver shack close by, it would almost be like going home.

Once everything had been confirmed, Dr. Starrs broke the news to Jackson at his bedside. "The worst is over, Alex," he said. "Now you've got to get stronger so we can take you down to Kleinburg."

"Do they still want me?" Jackson replied weakly.[20]

All the arrangements were made; the McMichaels placed ads for two "nurse-companion(s) for an elderly gentleman living in the Kleinburg area," carefully avoiding any mention of Jackson's name.[21] Signe selected two from the applicants — Zita Wilson and Dora McLean. They would each spend half a week, day and night, at Jackson's side, overseeing every aspect of his life.

The move to Kleinburg took place in June 1968. Dressed in pyjamas and a hat, Jackson was helped into Dr. Starrs's car and driven to Kleinburg along with Rita Starrs, Robert McMichael, and Naomi, who repeatedly assured her nervous uncle that his painting supplies had been packed and were going with him.[22] Sure enough, once he was settled in, the first thing Jackson wanted to do was get set up with his sketch box on the grounds — despite the predominantly green summer landscape.

"The days go slowly by," Jackson wrote to the Putnams shortly after his arrival in Kleinburg. "I live in the lap of luxury with plenty of medical guidance. Tried to paint out of doors, but my left arm does not work and my painting is not good yet, and it will be a couple more months before I am myself again."[23]

But despite some signs of improvement here and there, Jackson was never himself again. Brain damage from the stroke had permanently altered him, and his ability to paint was severely affected. He could no longer control his brush properly, and while his mind was clear one moment, he could become utterly confused the next.

"It is interesting to see how the old brain works away," Naomi commented on her uncle's mental state. "I'm sometimes reminded of a mirror that's been shattered and put together again — there is an accurate reflection in segments, but the overall picture is distorted."[24]

The McMichaels saw to it that Jackson's new life in Kleinburg was regulated into a comfortable routine. He met with visitors to the gallery whenever he felt well enough, and took great pleasure in recounting tales of the Group of Seven to children. But as the eternal outdoorsman, he preferred to swim in the pool or, best of all, sit with his sketch box in some remote corner of the property. This caused an unforeseen problem for Naomi and the McMichaels, for the splotchy, half-finished sketches were full of obvious mis-

takes. If these "very late Jacksons" ever found their way onto the market, they would certainly damage the artist's reputation — and be a personal embarrassment to Jackson himself, who was fully aware of their faults. It was firmly agreed that anything Jackson painted was not to leave the premises. Instead, they were all to be destroyed.[25]

This arrangement suited the self-critical Jackson just fine. One night, as he and McMichael sat by the fireplace, tossing the botched panels into the flames, Jackson chuckled and said, "You know, Bob, I guess I've burned about a thousand of my pictures. They used to be a lot cheaper than firewood."[26]

A.Y.'s Canada

The continued success of *A Painter's Country* over the past decade had spawned several subsequent editions, including paperback in 1964 and an updated version for which Jackson added another chapter in 1967. Throughout the early 1960s another book was in the works, to be handled by the same publisher. This one would feature a selection of the least-known aspect of Jackson's work — the pencil drawings from his travels back and forth across the country.

A.Y.'s Canada was originally conceived as a joint venture by the artist and his niece, but after Jackson's stroke the project was completed by Naomi, who sorted through hundreds of her uncle's drawings — complete with his notations on colour, shade, and effects. She wrote extensive texts for each one, and once they were collected by region, they provided readers with a grand tour of the country, from Newfoundland to Skeena and north to Ellesmere Island.

Published in the autumn of 1968, *A.Y.'s Canada* was praised not only for the rare glimpse into Jackson's working methods but also for the keen sense of place conveyed by the images and their accompanying texts:

> What we have here is a tremendous zest for, and appreciation of, things Canadian whether expressed in the isolation and loneliness of the tundra or the enclosed parochialism of French Canada, in the Twenties and Thirties. There is nothing, for example, more affecting than the view of "Cacouna Village with melting snow" of 1921, a drawing which Dr. Groves compares not unjustifiably to Corot and in which J.E.H. MacDonald saw "the dark earth lifting through the sinking snow" ... There are regrets in everyone's life, but after looking through "A.Y.'s Canada" one of the things I know I will regret is never knowing Mr. Jackson and, more importantly, never having had the chance to roam through at least a small part of Canada with him.[27]

Farewell to Old Comrades

Bad news reached Kleinburg in March 1969, when it was announced that Jackson's old friend Arthur Lismer had died. Always quick-witted and nimble, Lismer was a beloved institution in Montreal, where he had been living since late 1940.[28] His first love had

always been teaching, and for twenty-seven years he supervised the education program at the Art Association of Montreal — finally retiring from the position of principal of the School of Arts and Design, Montreal Museum of Fine Arts, at the age of eighty-two. He also taught at McGill University from 1941 to 1955, and served two consecutive two-year terms as president of the Canadian Group of Painters. These activities took up so much of his time that he barely had a chance to paint — but no matter how busy he was throughout the school year, he did manage to get away each summer for some leisurely sketching, making regular visits with Esther to Georgian Bay and Long Beach on Vancouver Island.

There is no question that one of Lismer's proudest accomplishments was the Children's Art Centre, which he ran from his top-floor office in an old house annexed by the Museum of Fine Arts. Always scrambling to find funding, he oversaw the centre's development from original concept to a vibrant element of Montreal's art education system. For years, Lismer was a familiar sight in the neighbourhood — the tall, thin figure with white hair and a pipe clenched in his teeth, rushing up the hill from his home at 1485 Fort Street to the Art Centre behind the main museum building on nearby Sherbrooke Street. Once in the classroom, he would move from student to student, uttering words of encouragement in his soft Yorkshire accent as he patiently showed them how to draw figures, trees, and animals. He often pulled out his ever ready pen and drew on a child's paper — creating an instant keepsake for those whose parents thought to hold onto this "original Lismer."

Lismer and Jackson saw each other for the last time in the summer of 1967, when Jackson visited Montreal. But even after retirement, the energetic Lismer could not keep still. He and Esther made two more cross-country trips out to Vancouver Island, but by 1968 his memory was failing and he was suffering from hardening of the arteries. His condition worsened in early 1969, but always the maverick, he refused to be hospitalized.[29] He died on March 23, at the age of eighty-three. Thanks to Jackson's earlier initiative, Lismer's ashes were brought to Kleinburg, where he became the first Group of Seven member to be buried on the McMichael grounds.[30]

"His influence as a teacher has extended all over Canada,"[31] Jackson once wrote of his friend's devotion to art education. "He carried the Gospel of Art for Canadians to every corner of the country."[32]

Just five months later, on September 8, there came word that Lismer's fellow Sheffield native Fred Varley had died of circulatory obstruction in a Scarborough hospital at the age of eighty-eight.[33] Always the bohemian, Varley's career was marred by bouts of alcoholism, chronic debt, and frequent quarrels with friends and relatives. After leaving his family in the 1930s, he moved frequently, from Vancouver to Ottawa to Montreal, and later to Toronto, living in rooming houses and other cheap accommodations. His womanizing and drinking binges were well known in art circles across the country. By 1960, the notorious Varley was settled in Unionville, just outside Toronto, with Kathleen McKay, who looked after him for the rest of his life.

"He was such an intense and restless person," Jackson said of Varley. "Some of my women painter friends in Toronto used to say they wouldn't trust Varley around the corner. His heavy drinking did not help his painting either."[34] Still, Jackson maintained the utmost respect for Varley the painter, whose portraits were well beyond Jackson's own

abilities in that area, and whose War Memorials canvases conveyed horrors that no other Canadian artist came close to expressing.

Following the tradition begun by Lismer, Varley's ashes were brought to Kleinburg and buried during a solemn ceremony attended by family members and several old friends — Barker Fairley, A.J. Casson, Isabel McLaughlin, Yvonne McKague Housser, and, of course, A.Y. Jackson.[35] As Varley's second son, James, affectionately remembered his father shortly afterward, "We all know he was an old bugger."[36]

The next loss came early in the new year — and new decade — when Canada learned of the death of Lawren Harris, a prime instigator and driving force behind the ground-breaking movement, as well as Jackson's most frequent sketching companion among the original Group of Seven.

After settling in Vancouver during the Second World War, Harris had remained a key figure in Canadian art, serving on the boards of several art institutions, including an eleven-year stint as the first artist to sit on the National Gallery's board of trustees.[37] He and Bess travelled widely throughout the 1940s and '50s, making many visits to Toronto and Ottawa, as well as trips to the United States and Europe. Through it all, he continued to produce dozens of colourful abstract paintings, all inspired by his unwavering spiritualism. In 1948, much the way Jackson would be venerated five years later, Harris was honoured with a major retrospective exhibition of his work at the Art Gallery of Toronto and subsequent nationwide tour. The opening of *Lawren Harris: Paintings 1910–1948* was a gala affair that attracted many close friends, including four other Group of Seven members — Jackson, Lismer, Varley, and Casson. They posed with Harris for a now-famous photo that showed not a band of controversial radicals but five elder statesmen of Canadian culture.

Harris was plagued by ill health during much of the 1960s, and made his final trip east in 1967, to attend the big *Three Hundred Years of Canadian Art* exhibition at the National Gallery. Although he still enjoyed hiking through the mountains of British Columbia, his health continued to fail; now it was Bess who served as main correspondent, writing letters to Jackson and their other friends on her husband's behalf. The couple knew about the Group of Seven gravesite at Kleinburg, but Bess was particularly opposed to their being buried there, for it clashed with her devout theosophist beliefs.[38] Her wishes were apparently not followed, for she predeceased her husband by four months and, several weeks after Harris died of heart disease at age eighty-four on January 29, 1970, her ashes were buried along with his at the McMichael site.[39]

Jackson and Harris shared a deep friendship over nearly sixty years; despite their very different personalities, they maintained a mutual respect for each other. The straightforward, down-to-earth Jackson never shared Harris's deep interest in spiritual matters or abstract art.[40] He did, however, have great admiration for Harris as a painter, as well as for his lifelong devotion to the vision that led to the formation of the Group of Seven. "In shaping the course of Canadian art by his goodwill and enthusiasm he has encouraged and given practical assistance to many other artists," Jackson wrote of his friend in the catalogue of the 1948 Harris retrospective. "He does not believe that artists should lead obscure and humble lives, but rather that it is a reproach to a country to show no concern for its artists. With Dr. Banting, he believed 'That no country can afford to neglect its creative minds.'"[41]

The Guest of Honour

With Harris's death came a new distinction for Jackson — he was now the only surviving member of the original Group of Seven. Casson and Holgate were still very much alive and producing new work, but they had joined the Group in 1926 and 1931, respectively. Jackson's new status meant more demands for interviews and personal appearances, even though he was rarely up to the task, neither physically nor mentally. Instead, he preferred to sketch on the McMichael grounds, often in the company of Casson, one of his most regular visitors. Casson was painfully aware of his older friend's inability to produce a passable sketch, but he faithfully took him out and sat patiently at his side, offering words of encouragement whenever necessary.

On June 19, 1970, the "Grand Old Man" made his last public appearance when Robert and Signe McMichael drove him and nurse Zita Wilson to Ottawa, where Jackson would be guest of honour at the opening of the National Gallery's major Group of Seven exhibition, mounted by curator Dennis Reid to commemorate the fiftieth anniversary of the first Group show in 1920.

While en route to Ottawa in the McMichaels' station wagon, the party was informed that Prime Minister Pierre Trudeau had requested a private meeting with Jackson, so instead of stopping at the Chateau Laurier Hotel to check in and dress for the opening reception, they drove directly to Parliament Hill. The Prime Minister greeted them warmly, but the McMichaels apologized for not having had time to dress up for the unscheduled meeting. Trudeau immediately pulled off his tie and opened his shirt collar. "There," he said with a chuckle. "Does that make you feel more comfortable?"[42]

As the conversation turned to art and the Group of Seven, Jackson and Trudeau chatted like old friends, drifting back and forth between English and French with equal ease. Jackson's French was a bit rusty, but the words came back to him as he spoke. Then, the old painter paid the young Prime Minister a high compliment — many years ago, he said, he had seen Sir Wilfrid Laurier give a speech, and Trudeau reminded him of his illustrious predecessor. "He says that I remind him of Laurier!" Trudeau exclaimed proudly.[43]

That night, over at the National Gallery, Jackson was once again the centre of attention. Maude Brown, widow of former Gallery director Eric Brown, gave the keynote speech in which she recalled how her husband had taken great risks and endured much criticism in championing the Group of Seven during those turbulent years leading up to the notorious Wembley controversy.[44] She then introduced Jackson by his beloved old Québécois nickname, Père Raquette.[45]

Tired from the long day of travel and meeting the Prime Minister, the old man made his way slowly to the podium, accompanied by Nurse Wilson to keep him steady. He looked around with a bewildered expression as current gallery director Jean Sutherland Boggs spoke about his life and work. He was the centre of attention, but did not seem to know why. Just as he had been seventeen years earlier at his own retrospective exhibition in Toronto, Jackson was surrounded by well-wishers. But this time he could not appreciate all the attention. Instead, he seemed confused by it. His frail appearance as he stood between Wilson and Signe McMichael was particularly disturbing to his friend Jack Firestone, who remembered the hale and hearty Jackson of just a few years earlier: "I won-

dered whether Alec recognized what he saw. The twinkle in his eye was gone," he wrote.
"He shook my hand weakly, nodded, and closed his eyes for a moment. Then, without a
word, he moved on. I doubt very much that he understood the speeches or what people
said to him as he was led firmly through the crowd by the two women. He may well have
wondered what all the commotion was about."[46]

The exhibition itself was a tremendous tribute to the Group of Seven and Tom Thom-
son, and it brought them once again to the forefront of national attention. It remained at
the National Gallery through the summer of 1970, then moved to the Montreal Museum
of Fine Arts in the fall. But while many of Canada's best-loved paintings hung quietly on
the walls of the Montreal gallery — in the same space where Jackson and Randolph Hew-
ton had held their sparsely attended show of recent European canvases back in 1913 —
art was far from most people's minds. Military tanks were rolling through the streets as
police rounded up suspected terrorists by the dozen. Jackson's new friend, Prime Minister
Trudeau, had recently invoked the War Measures Act in an attempt to quell the October
Crisis — the period of unprecedented social unrest touched off by the kidnapping of
British Trade Commissioner James Cross, as well as the kidnapping and subsequent
murder of Quebec Labour Minister Pierre Laporte, by the militant separatist group
Front de libération du Québec.

Jackson's earlier observations about his native province's militant turn had proven to
be especially prescient.

The Final Days

Back in quiet Kleinburg, Jackson continued his comfortable albeit uneventful life. He
could get cranky at times, especially on busy days when the McMichael galleries were
crowded with visitors and he was required to answer questions and repeat old stories for
audiences who often seemed only half interested. This sapped his energy and patience, so
he took every opportunity to get away for an hour's sketching, even if he knew the result
of his efforts would end up in the McMichaels' fireplace.

One work from this period did survive, however — a canvas of Jackson's last sketch at
Notre-Dame-de-la-Salette, which he had promised to Betty Kirk on that last sketching trip
with her. Despite his disability, he struggled to complete the canvas on several occasions
over the course of about a year, but he could never get it right. "As much as he tried, Alec
could not paint that canvas," Firestone recalled. "He became very upset about it, and all
those who watched him struggle to move the stiff fingers that would not respond to his
creative mind were in tears."[47]

Robert McMichael would never forget the tragic figure Jackson presented when he real-
ized he could no longer paint:

Alex kept his head turned away, but I could see that his cheeks were wet with tears
as he looked dejectedly back and forth from the small panel to the roughed-in can-
vas before him. I saw at once that his distress was mental, not physical. Following
his gaze from sketch to canvas I saw that the outline of an old barn on the canvas

was grotesquely out of scale and perspective. Alex looked at me with a mixture of futility, terror and the extreme anguish which had come with the sudden realization that he had lost his skill, perhaps forever.[48]

Determined to honour his promise, Jackson insisted that the unfinished canvas be sent to Kirk; he would later visit her and complete it there. He did eventually make it to Buckingham, accompanied by his nurse, and he again attempted to finish the canvas — but it was no use. Kirk was left with the only known painting from Jackson's post-stroke period.

Perhaps the saddest news of all for Jackson came in late March 1971 when Anne Savage, his special friend for more than half a century and the woman with whom he came closest to sharing his life, died in a nursing home in the Montreal suburb of Pierrefonds.[49] She had devoted herself to painting following her retirement from the Protestant School Board of Greater Montreal in 1953, and spent much of her time working in her studio at her family property at Lake Wonish, near Morin Heights in the Laurentians. She had been in declining health since 1965, when she underwent a mastectomy, and spent the remainder of her life walking with a cane. In 1969 she was given a retrospective exhibition at Sir George Williams University — now Concordia — where two of her former students, Alfred Pinsky and Leah Sherman, were teaching.[50] Jackson did not attend the show, but he remained a faithful correspondent, even though his stroke had affected his handwriting as well as his painting, which meant his letters from Kleinburg were mostly illegible.

The fifty-year Jackson-Savage correspondence remained an essentially private matter until the discovery of a cache of Jackson's letters at Savage's Highland Avenue home shortly after her death. A few years later, Savage's niece, Anne McDougall, got together with Naomi, who had many of Savage's letters among her uncle's papers, to publish excerpts of both. The result formed the basis for McDougall's 1977 biography of her aunt, *Anne Savage: The Story of a Canadian Painter.* Here Jackson's very discreet relationship with Savage was made public for the first time, although the published excerpts of letters only hinted at the full extent of their long affair.

Jackson's reaction to Savage's death was never recorded. Given his reduced physical and mental health by this time, it is possible that he never fully understood the news.

"A.Y. once told us that he would like to die by just rolling over as he was working on a good sketch," one of Jackson's close friends wrote. "This was not to be."[51]

Despite any hopes that the rugged painter would end his days out in his beloved wild country, surrounded by nature, his physical condition continued to deteriorate after his ninetieth birthday in 1972. He was often confined to a wheelchair, his mind drifting back and forth between clarity and confusion. Finally, in early 1973, it was decided that he could no longer stay with the McMichaels. He was transferred to the Pine Grove Nursing Home in nearby Woodbridge, where he could be kept under closer observation.[52] Here he still received a regular flow of visitors, and on his better days he was able to return to the gallery for a few hours. In typical Jackson style, he continued to put on a tough front for his friends whenever he was lucid.

For years, Naomi had affectionately referred to her seemingly indestructible uncle as a force of nature. Now, in early 1974, nature was taking its course and it was obvious that he could not hold out much longer.

Hazel Devereaux, a friend from Jackson's Ottawa period who had frequently provided him with room and board on sketching trips to the Combermere, Ontario, area, dropped by the nursing home one day in March 1974 and found a frail old man instead of the robust outdoorsman she knew. He was alarmingly thin and weak, but worst of all, the glint in his eye was gone. The change was so dramatic that she could not hide her grave concern.

"Don't worry about me," Jackson rasped, summoning his strength. "I'm going to live to be a hundred."[53]

It was one promise he would not be able to keep. Within a month, he was gone.

The Landscape Painter Remembered

As March turned to April and the snow began to melt — Jackson's favourite sketching period — the painter's ninety-one-year-old body could take no more. He died quietly at the nursing home in Woodbridge on Friday, April 5, 1974.

"A.Y. had been in the gallery here just three weeks ago, wheeling around in his wheelchair, talking to the children," a sombre Robert McMichael said the day his friend passed away. "He was conscious all day Thursday, but his great old heart just gave up."[54]

The news immediately spread across the country — the "Grand Old Man" of Canadian art was gone. That day in the House of Commons, York-Simcoe MP Sinclair Stevens stood up and, after a few words of praise for Jackson's work, introduced a motion for the House to offer its condolences to the artist's family — a motion that passed unanimously.[55]

Funeral arrangements were announced the next day: Jackson's body would be returned to Kleinburg to lie in state over the weekend, surrounded by his paintings and those of his old friends. The service would be conducted on Monday afternoon by the Very Rev. T.E. Downey of Christ Church Cathedral, Ottawa. Among the honorary pallbearers were two of Jackson's oldest friends — surviving Group of Seven members A.J. Casson and Edwin Holgate.[56] As per his wishes, Jackson's remains would then join Lismer, Varley, Harris, and Johnston (whose remains had been reinterred in 1969) in the small cemetery on the McMichael grounds — a quiet clearing off the parking lot, marked by large Algoma boulders.[57]

Public assessments of Jackson's life and work came quickly upon the news of his passing. Beneath a large caricature of the artist seated on a rock with his ever present sketch box and the simple caption "Thanks," the *Globe and Mail*'s editorial writers took full advantage of the opportunity to reiterate the Group of Seven's fifty-four-year-old message:

> The death of A.Y. Jackson, an artist of historical importance and a human being of memorable warmth and simplicity, might signal an appropriate time for contemporary Canadian artists to reflect on their own work in the light of what the Group of Seven achieved in its own time, to ask if they have done as much as they could to preserve, within the very different approaches of today, a directness of Canadian identity as clear as the one left by these pioneers.[58]

In Jackson's home town, a *Montreal Gazette* editorial also focused on the nationalistic aspect of his legacy, stating that he "did as much as one man could to give Canadians a sense of cultural identity. By wrenching Canadian eyes from their fixation on Europe, he forced them to recognize through art something of the majesty, grandeur, and inspiration of their own land."[59] The tribute also provided readers with a brief glimpse of Jackson himself, describing him as "a cheerful man who in later years developed in profile a pronounced resemblance to Alfred Hitchcock [*sic*]," and a serious artist who hated to be disturbed while he sketched:

"Where's the telephone pole?" he was once asked.
 "Left it out."
 "Why?"
 "Because it looks like hell, that's why."[60]

Of all the obituaries and tributes that emerged in the Canadian media over the next few days, none captured the essence of A.Y. Jackson more than the words written two decades earlier by Arthur Lismer for the catalogue of the big Jackson retrospective exhibition that opened on that cold, rainy night in October 1953 at the Art Gallery of Toronto. "His trails cross and recross like the pattern of ski tracks on the fresh snow of a winter hillside," Lismer wrote. "In all of these widely separated places where A.Y. has painted he has revealed their unique identity. In his hands and through his eyes they take on a new significance. They become integrated into our national consciousness."[61]

The ever modest Jackson cherished these lines from his old friend and comrade-in-arms for the last two decades of his life, as praise from a fellow member of the Group of Seven meant much more to him than any rave review from an art critic. One sentence in Lismer's essay was especially touching and flattering, summing up a life's work in so few words: "Jackson has done more than any other writer or artist to bind us to our own environment, to make us vitally aware of the significance, beauty and character of the land."[62]

"He shouldn't have done it," was Jackson's modest response, "but I love every word of it."[63]

The quintessential image of A.Y. Jackson — and the way he would have wanted to be remembered — sketching in the Teshierpi Mountains, Northwest Territories, in 1950.

Appendix I

THE LANDSCAPE PAINTER AT WORK

"WHEN I AM MAKING A SKETCH, I TRY TO emphasize the things I want and ignore the things I don't want. I like to think of a sketch not as a little picture but rather as an idea for a big one. A close resemblance to the subject is only a minor virtue. You may try to get an effect of light or an arrangement of colour, or a certain relationship of form and line — but what you always strive for is an intensification of nature. So often the northern landscape is a crowded confusion of shapes and colours, and you have to reduce it to some kind of order."[1]

When A.Y. Jackson faced a motion picture camera and spoke these words in the National Film Board's 1941 documentary *Canadian Landscape*, he summed up in one paragraph the entire philosophy behind his working methods. He had been asked the same questions over and over — by everyone from fascinated art students and collectors to merely curious onlookers — and was likely grateful for the opportunity to publicly explain his use of the sketch and his ideas of landscape painting in general.

The sketch, usually painted outdoors in oil on a small wooden panel held firmly in his sketch box, was Jackson's primary study for a larger painting on canvas. Obviously, he could not bring an easel and canvases with him when he travelled through the northern wilderness by canoe, nor could he have dragged such large items along when he went camping in the mountains. Instead, working with the compact, lightweight sketch box was the ideal solution. It served as a durable combination storage box, palette, and easel, and was much easier to carry over long portages and on snowshoe hikes.

The oil sketch was certainly not Jackson's invention. It was standard practice among the previous generation of Montreal artists such as Morrice, who was known to sit for hours at sidewalk cafés, painting colourful sketches of Parisian street life on 12 x 17-centimetre panels, about the size of a cigar box lid. Like Jackson's outdoor sketches, Morrice's studies served as guides for later canvases, reminding him of colour and effects of light. But unlike Jackson, the smaller format allowed Morrice to carry his sketch box with him wherever he went, as it fit conveniently into the oversized breast pocket he had custom tailored into each of his suit jackets.[2] Jackson's sketch boxes were much larger, holding 21.5 x 26.5-centimetre birch panels. In the 1930s, when he switched to the larger format of 26 x 34-centimetre panels, he designed his own box — but it was still compact enough to fit snugly in his knapsack along with his ever present drawing pad.

Travelling Light

Over many years of working outdoors, Jackson perfected his own efficient methods. Travelling through the rough north country — be it Algoma, Algonquin Park, or the Barren Lands of the Northwest Territories — always meant travelling light. Before he set off from his camp for a day's sketching, he had to prepare his sketch box. He had long since realized that carrying a dozen paint tubes meant a lot of unnecessary weight, so when loading his sketch box with blank panels he also squeezed a bit of each colour he would need onto the bottom of the box, which served as his palette. First, he placed a large dollop of flake white in the upper left-hand corner. Then, along the top edge he squeezed out smaller portions of cadmium yellow, orange, two reds, and burnt sienna. Placed vertically along the left-hand edge were cerulean blue, French ultramarine, viridian green, and yellow ochre. This combination of colours, Jackson felt, worked best to give him the wide range of shades he would need.[3] After that it was a simple matter of adding a rag, a palette knife, a few brushes, and, to clean them, a small container of paint thinner (which, in a pinch, could be substituted with gasoline).[4]

Once he came across a promising subject, Jackson would immediately decide upon a composition and the colours best suited to capture the scene in front of him. After quickly mixing these colours on the bottom of his box, he would use his smallest brush to draw the basic outline on the panel, little more than a simple line drawing in dark paint, to serve as a guide. Then, usually working from dark to light, he would paint in the shapes, gradually adding more and more detail as he went along.

The landscape itself had much to do with how Jackson worked. If, for example, he was in a snow-covered field wearing snowshoes, or on a swampy marsh, he would sketch standing up, painting with his right hand while holding the open sketch box in his left. Other times he sat down while he worked — on a rock or a log, or sometimes even in the middle of a deserted road — with his sketch box resting on his lap. As he grew older, Jackson almost always sat down to sketch, and a small folding campstool became part of his basic equipment. In the studio, however, he always stood to paint at his large easel. With a palette hooked onto the thumb of his left hand, in which he also clutched the brushes he wasn't using, his right hand held the brush or knife in an overhand grip, opposite to the way one would normally hold a pen or pencil.

While sketching, Jackson's concentration was complete. He would work on a panel for about an hour or ninety minutes, during which he would often lose all sense of time or of where he was. One spring, while sketching in the company of a friend in Grenville, Quebec, Jackson was happily setting to work with his sketch box and panel when his friend tripped and fell backwards into a large puddle of melted snow. He made his way back to his car, drove home, and changed clothes, then returned to the spot where he had left Jackson. Finding the artist still hard at work, he apologized for his absence — much to Jackson's surprise, for he was not even aware that his friend had been gone.[5]

Arranging the Composition

When working from nature, Jackson usually had to rearrange, modify, or even eliminate some objects for his sketch. He had not been taught to do this in any of his art classes in Montreal, Chicago, or at the Académie Julian. This is hardly surprising, because the instruction in those institutions consisted mainly of painting and drawing the figure and still life — disciplines in which the subjects are posed and all elements of lighting and composition are arranged to the artist's exact specifications. Landscape painting was another matter altogether.

Jackson claimed that he learned to take artistic liberties with the composition from Albert Robinson while the two were sketching together in Brittany. "I used to waste a good deal of time in hunting about for ready-made compositions," he wrote about their trip to Saint-Malo and Carhaix in 1911. "Robinson would sit and wait for effects of light, and then he would push fishing schooners and market carts and such things about on his canvas to arrange a composition."[6] This came as a great revelation to Jackson, who realized that for years he "had been constrained by a too close adherence to nature," and he immediately adopted Robinson's method to suit his own purposes.[7] If, for example, there were too many trees on the right side of a field and too few on the left, he might move some over to the left side in order to balance the composition. He might also enlarge some of the trees on the left to achieve the same sense of balance. Likewise, he might alter the curve of a fence or a road so that it led the viewer's eye into the middle of the composition. In some cases this even helped in adding social commentary to Jackson's work. If the white steeple of a village church in rural Quebec did not contrast well against the snow-covered mountains along the horizon, he could have simply made it taller so that it stood out well against the deep blue sky — and also commented on the dominance of the Catholic Church in the region.

One might suggest that a camera would have solved many problems of sketching in the wilds, both in its portability and its ability to record a scene exactly. But that was never an option for Jackson and his contemporaries because they were most active in the days when photography was still an expensive, delicate undertaking. And colour photography, which would have been crucial to the process, was the exclusive domain of a few professionals. Tom Thomson was an avid photographer, recording outdoor life in Algonquin Park, and a camera was definitely taken along on the second boxcar trip to Algoma, but it served only to document the trip itself, not the landscape.

Jackson and his fellow painters were obviously aware that photography might save them time in the field, but they were artists — dedicated to recording their impressions in line, colour, and form. Striving for these all-important elements, they were always keenly aware of composition while they sketched. A photographic image would have provided an exact reproduction of the scene before them, but would not have given them what they needed, for very few things in nature are arranged artistically. Much like the Impressionists, who were working at a time when photography was in its infancy and therefore

all the rage in France, they knew that a black-and-white photograph of the Canadian landscape was completely useless to them. On the other hand, a colour sketch gave Jackson all the visual information he needed to produce a later canvas.

The Banting Method

Depending on the weather and, of course, the availability of interesting subjects, Jackson normally produced two sketches per day while on his sketching trips — three if he was particularly lucky. After a day's work, he would place his wet sketches in a safe, sheltered spot, perhaps under a log or in his tent, where they could begin the drying process without anything touching the wet paint.

Still, oil paint can take more than a week to dry, so carrying wet panels around in the bush was always difficult. Sketch boxes could safely store a few panels, but Jackson would regularly accumulate as many as thirty-five or forty fresh sketches on a three-week excursion. His most common method of transporting wet panels was invented by one of his favourite sketching companions, the illustrious Dr. Frederick Banting. Unlike Thomson, who had little regard for his own work and was known to rather carelessly stack his wet sketches — several of which were permanently marred by areas of flattened paint — most other artists took great care of their sketches, and Banting was no exception. The same man who won a Nobel Prize for his advanced medical research also came up with the simple but most effective method of breaking up a wooden match-stick or a twig into five equal pieces and placing one near each of the four corners and in the very middle of a wet panel. The panels were then stacked on top of each other, the matchsticks separating them and protecting each one from the panel above. The top panel would be placed face to face with the one below. As a final step, the stack of panels was tied tightly together, preventing the movement of any panel. Once the artist got the panels back into the studio, it was a simple matter of removing the matchstick pieces and touching up any holes or marks they had left in the wet paint.

On one of their many sketching trips together, Dr. Banting observed with admiration how Jackson was able to create a sketch even when extreme cold prevented him from actually painting:

> Alex has been painting from notes all day and has done three or four fine sketches. It is a fine method for one who knows how. It requires detailed observation and a memory for colour and tone. He makes a careful drawing and then makes short-hand colour notes and it is remarkable how true he can hit the scene. It has the advantage that he can work indoors with warm plastic paint without being rushed instead of standing in the cold wind trying to place hard gummy paint. Colour and tone are important but design is the big thing in painting.[8]

To Jackson, sketches were simply tools that might help him when he painted his large canvases, and they were entirely expendable. Each night in camp, it was his habit to look

closely at the day's sketches as he sat by his campfire. If he suddenly decided that a sketch was in any way inferior or if he deemed the overall design unworthy of a large canvas, he would either scrape off the paint and reuse the panel the following day or simply toss the panel into the fire. If he decided to keep the sketch, he usually signed it.[9]

From Panel to Canvas

The creative process from preliminary sketch to finished canvas was sometimes a long one. Jackson normally painted the sketch on the spot and later worked it up onto canvas in his studio. But he was also prolific with his pencil, producing hundreds of drawings on paper. In fact, contrary to the most likely sequence — drawing to oil sketch to canvas — he often made one or two drawings of a certain scene *after* he had completed the oil sketch. This was done to add detail and, most importantly, to jot down notes on shades and to elaborate on the colours. His shorthand numbering method, which he began using in Europe as a student and developed fully while hurriedly drawing on the battlefields of France and Belgium during the First World War, gave him all the visual information he would need later in his studio.

Once he had decided on a sketch and was ready to reproduce it onto a stretched canvas, he often prepared it for enlargement by taping four lengths of thread across the sketch's surface, two running horizontally and two vertically. These would divide the sketch into nine squares of about equal size. Then he would draw the same grid on his blank canvas, dividing it into nine larger squares. From there it was a relatively simple matter of copying the contents of each square on the sketch into the corresponding square on the canvas, creating a scale reproduction.[10] Later, he would simply remove the thread from the sketch, which he would then sell, give away to a friend, or include in an exhibition. While many artists would prefer not to show their preliminary studies, Jackson had no qualms about giving away or selling his sketches and drawings, even if the latter were littered with numbers and colour notes scrawled in his barely legible handwriting. They were fundamentally meant as ideas for the larger canvases and were of little use to Jackson once the canvas was completed. If someone showed an interest in an original study, he was usually glad to give it away or sell it for a nominal price. To him they were virtually worthless — cheaper than firewood — but today are worth thousands of dollars each.

Jackson's lifelong quest to achieve that "intensification of nature" on canvas led him across Canada so many times that even he probably lost count. Carrying his camping gear and sketching material on his back, he travelled by train, bus, boat, car, and later plane to some of the furthest corners of the nation. He then continued on foot, snowshoe, or canoe to even more remote areas, where he might spot an interesting feature in the tangled landscape and, with great anticipation, set down his gear, open his trusty old sketch box, and start the creative process that often ended, several weeks or even years later, with a finished canvas back home in Toronto.

Appendix II

CHRONOLOGY OF A.Y. JACKSON

IT IS DOUBTFUL THAT ANY CANADIAN ARTIST has travelled further or more frequently than A.Y. Jackson. His itinerant lifestyle and prolific output over eight decades are remarkable in themselves, but due to the sheer scope of these activities, any attempt to establish an absolutely complete record of his travels, paintings, and writings would be doomed from the outset.

We can be certain that many sketching trips went entirely undocumented, not to mention his frequent trips between Montreal and Toronto. Also, there is no question that countless canvases and sketches were sold, given away, or even destroyed by the artist himself without ever being documented. As a result, only his most significant paintings, drawings, and articles are mentioned here. The following may be taken as an accurate — but by no means complete — outline of Jackson's life and work.

Jackson's own memory for dates and the chronological sequence of some events was often hazy by the time he came to write them down himself, so in cases of conflicting information a third source has been consulted. The dates of all paintings, sketches, and drawings are consistent with official gallery documentation.

Main sources for this chronology include Naomi Jackson Groves's *A.Y.'s Canada* (1968), as well as the chronology she prepared for Dennis Reid's *Alberta Rhythm: The Later Work of A.Y. Jackson* (1982). Also extremely helpful were Reid's *The Group of Seven* (1970), and the exhibition catalogue *A.Y. Jackson: Paintings 1902–1953*. Anna Brennan, literary trustee for the estate of the late Naomi Jackson Groves, has also made a significant contribution, having provided information from Jackson family documents.

1820

Paternal grandfather, Henry Fletcher Joseph Jackson, is born in London, England.

1821

Maternal grandfather, Alexander Young, is born in Kelso, Scotland.

1829

Maternal grandmother, Anne Keachie, is born near Paris, Upper Canada.

1834

Alexander Young emigrates from Scotland. He settles in Dumphries Township, Upper Canada, where he eventually supports himself as a schoolmaster.

1846

H.F.J. Jackson arrives in Lower Canada from England. He settles at Longueuil, across the river from Montreal, and finds work as a general agent for the St. Lawrence and Atlantic Railroad. He meets the artist Cornelius Krieghoff and acquires a few of his paintings.

1849

H.F.J. Jackson marries Isabella Murphy, daughter of a prominent Montreal dry goods and linen merchant.

1850

Father, Henry Allen Jackson, is born in Montreal.

1851

Mother, Eliza Georgina Young, is born in Galt, Upper Canada.

1854

H.F.J. Jackson moves his family to Berlin, Upper Canada (now Kitchener), where he supervises the construction of the Grand Trunk Railway through Waterloo County.

1871

Henry Allen Jackson of Berlin, Ontario, marries Georgina Young of Galt, Ontario.

1875

The Jackson family moves back to Montreal. Henry and Georgina settle at 51 City Councillors Street.

1877

Henry and Georgina's first child, brother Henry Alexander Carmichael Jackson (Harry), is born in Montreal.

1880

Brother Ernest Samuel Jackson is born in Montreal.

1882

The Jacksons move into a large townhouse at 43 Mackay Street.

October 3: Alexander Young Jackson is born in Montreal.

1885

October: Sister Isobel Jackson (Belle) is born in Montreal.

1887

Plagued by business failures, Henry Jackson moves his family to a smaller house at 75 Fort Street.

1888

January: Brother William Hespeler Jackson (Bill) is born in Montreal.

1890

February: Sister Catherine Jackson (Kay) is born in Montreal.

1891

Henry Jackson abandons his family and moves to Chicago. Georgina moves her six children to a small flat at 76 Park Avenue in nearby Saint-Henri. Alex Jackson attends Prince Albert Public School on nearby Rose de Lima Street. Eldest brother Harry quits school and takes a job to support the family.

1895

Alex quits school and is hired as an office boy at the Bishop Engraving Company. He begins spending weekends hiking and sketching in the fields beyond Saint-Henri with brother Harry.

Circa 1898

Attends evening art classes at Montreal's Monument National, under instructor Edmond Dyonnet, RCA. Later enrolls in

art classes conducted by William Brymner, RCA, at the Art Association of Montreal on Phillips Square.

1902

Summer: Takes an extended bicycle trip through Cape Breton, Nova Scotia, with fellow art student Billy Ives.

Autumn: Paints the watercolours *River St. Pierre* and *November*.

1903

Sketches at Danville and Nicolet, Quebec.

Summer: Paints the watercolour *Landscape with Willows*.

1904

The Jackson family moves a few blocks north to 69 Hallowell Avenue in affluent Westmount. Exhibits for the first time with the Royal Canadian Academy of Arts.

October: Sketches at Shawbridge, Quebec.

1905

April: Hikes to Hemmingford, Quebec. Paints the watercolour *Early Spring, Hemmingford*.

June: Sails for Europe with brother Harry aboard the cattle ship *Devona*. Visits London, Paris, Liege, and Rotterdam.

Autumn: Begins painting primarily in oil.

1906

Spring: Sketches at Danville and Nicolet, Quebec.

September: Moves to Chicago and works as a designer with the Lammers-Schilling Company. Attends night classes at the Art Institute of Chicago.

1907

Summer: Returns to Montreal with savings.

September: Sails for France aboard the *Sardinian* and enrolls in the Académie Julian in Paris. Shares an apartment with fellow students at 13 rue l'Abbe Grégoire.

1908

April: Takes a trip to Italy with fellow students. Visits Rome, Florence, and Venice.

May: Arrives in Étaples, France, to spend the summer.

Late summer: Sketches at Lefaux.

September: Takes a six-week trip to Bruges.

October: Returns to Étaples, then moves back to Paris by the end of the year.

1909

April: Visits Moret-Sur-Loing with Frederick Porter. Meets Randolph Hewton of Montreal. Moves on to Episy, near the Fontainebleau Forest.

Paints *Canal du Loing near Episy*.

Paysage Embrume is exhibited in the Paris Salon.

June: Returns to Paris to meet an aunt, who is travelling through Europe.

July: Visits Holland. Sketches *Seashore, Katwijk, Holland* and *Veere, Holland*.

September: Returns to Episy. Paints *Autumn Morning, Episy*.

November: Sails for Montreal, arriving home in time for Christmas.

1910

Winter: Sketches *Saint Henry from Hallowell Avenue* from the Jackson family home.

March: Stays at Sweetsburg, Quebec. Paints *The Edge of the Maple Wood* and *Sweetsburg, Quebec*.

May: Arrives in Berlin, Ontario, to visit aunts. Sketches *Grand River, Ontario*.

May 24: *The Edge of the Maple Wood* exhibited by the Royal Canadian Academy in London, England.

Summer: Makes his first trip to Georgian Bay to visit cousins.

Autumn: Works as a commercial artist for Smeaton Brothers in Montreal.

November: *The Edge of the Maple Wood* is exhibited by the Royal Canadian Academy in Montreal.

1911

January: Augments Smeaton Brothers job with an evening job designing cigar labels for a company owned by Adam Beck.

March-April: *The Edge of the Maple Wood* is exhibited in Toronto, attracting the attention of artists J.E.H. MacDonald, Lawren Harris, and Arthur Lismer.

August: Spends ten days at Georgian Bay.

September: Leaves on a third trip to Europe, this time with Albert Robinson.

October 5: Arrives at Saint-Malo, France. Sketches *Saint Malo* and *Saint Malo From the Basin*.

November: Moves to Carhaix, France, where he remains through Christmas.

1912

January: Spends ten days at the seashore at Concarneau, France.

February: Moves back to Saint-Malo, then goes to Paris, where he stays at Randolph Hewton's studio.

March: Visits Picquigny, France, with Australian painter Arthur Baker-Clack.

June: Moves to Trepied, near Étaples. Paints *Sand Dunes at Cucq* and *Studio at Étaples*.

Summer: Visits cousins in Leeds, England. Paints *Factory at Leeds*.

September: Returns to Étaples. Paints *Autumn in Picardy*.

October: Travels to Assisi, Italy, with English cousins and friends. Paints *Hills of Assisi*, *Assisi from the Plain*, and *The Fountain, Assisi*.

December: Spends a few weeks in Venice.

1913

January: Travels to Hungary and boards a boat bound for Canada from Fiume. Sketches *Village Near Fiume*.

February: Arrives in Montreal with many European paintings; holds a joint exhibition with Randolph Hewton at the new Art Association of Montreal gallery.

March: Exhibits European paintings in the AAM's Spring Exhibition. *Sand Dunes at Cucq* is purchased by the National Gallery of Canada.

March-April: Sketches at Émileville, Quebec. Paints *Cedar Swamp, Émileville* and *Morning After Sleet*. Receives a letter from J.E.H. MacDonald announcing Lawren Harris's offer to buy *The Edge of the Maple Wood*.

May: Travels to Toronto to meet J.E.H. MacDonald, Arthur Lismer, Albert Robson, and others at the Arts and Letters Club.

Meets Lawren Harris a week later in Berlin, Ontario.

Summer: Stays with cousins on Georgian Bay. Paints the still life *Blue Gentians*.

Early Autumn: Moves into a shack at Portage Island. Visited by Dr. James MacCallum, who invites him to stay at his cottage on Go Home Bay. Accepts MacCallum's offer of a year's financial support if he takes a studio in the Studio Building in Toronto. Paints *Autumn Snowfall, Huckleberry Country*, and *Night, Georgian Bay*.

November: Arrives in Toronto and moves into Harris's studio at Yonge and Bloor streets. Paints *Terre Sauvage*. Meets more Toronto artists, including Tom Thomson.

December: Exhibition of Jackson sketches at the Arts and Letters Club draws hostile criticism in the press, touching off the "Hot Mush School" controversy.

1914

January: Moves into the Studio Building, 25 Severn Street, Toronto, with Tom Thomson.

February-March: Takes first sketching trip to Algonquin Park. Sketches *Frozen Lake, Early Spring, Algonquin Park* and *Near Canoe Lake*.

June-August: Joins J.W. Beatty on a trip to the Rockies to sketch among the construction camps of the Canadian Northern Railway.

Mid-August: Hears about the outbreak of war in Europe.

September-October: Joins Thomson in Algonquin Park for a six-week sketching trip. They are later joined by the Varley and Lismer families. Paints the sketch for *The Red Maple*.

November: In Toronto, paints *Mount Robson by Moonlight* and *The Red Maple*.

Elected an Associate of the Royal Canadian Academy.

December: Returns to Montreal, planning to enlist in the army.

1915

January: Substitute teaches a life class for ailing artist W.H. Clapp.

Early Spring: Takes a prolonged sketching trip to Émileville, Quebec. Paints *Spring, Lower Canada*.

June 14: Enlists as a private in the 60th Infantry Battalion.

Summer: Undergoes basic training in Valcartier, Quebec.

November: Sails for England on the troop ship SS *Scandinavian*.

1916

February: Completes supplementary training at Bramshott Camp, Hampshire, and arrives in Le Havre, France, with the Third Canadian Division.

Spring: Assigned to the signal corps and put in charge of a telephone station. Eventually, moves up to the front lines.

June 16: Receives serious wounds in the front-line trenches at Maple Copse, Sanctuary Wood. Evacuated to Étaples, France, before being sent back to England.

Autumn and Winter: Recovers from wounds to shoulder and hip. Assigned to light duty in army post office.

1917

Spring: Assigned to retraining at a reserve unit at Shoreham, England.

July: Receives news of Tom Thomson's death in Algonquin Park.

August: Summoned to London for an interview with Lord Beaverbrook. Receives an honorary promotion to lieutenant and is appointed to the Canadian War Memorials staff.

Autumn: Returns to northern France and Belgium as a war artist. Accompanies Canadian troops in the Vimy-Lens sector.

November: Sketches *Houses of Ypres* and *Springtime in Picardy*. Paints *Camouflaged Huts, Villers-au-Bois*.

1918

Winter: Works in a London studio; paints *Houses of Ypres*.

March: Returns to northern France. Paints *Gas Attack, Liévin, Liévin Church, Moonlight*, and *A Copse, Evening*.

Spring: Ordered back to London due to heavy fighting and is joined by Canadian war artists Charles Simpson, J.W. Beatty, Frederick Varley, and Maurice Cullen.

September: Returns to Canada to prepare for a military excursion to Siberia.

Early Autumn: Visits Toronto; helps organize the Tom Thomson Memorial Exhibition and writes the foreword for its catalogue.

November: Returns to Montreal just before the Armistice is announced. Applies to remain on the Canadian War Memorials staff after the war.

Agrees to write a series of short articles for *The Rebel* magazine under the pseudonym Ajax.

1919

January: Article "Figure Versus Landscape" appears in *The Rebel*.

January-April: Resumes work for the Canadian War Memorials in Halifax with Arthur Lismer. Paints *Entrance to Halifax Harbour, Springtime in Picardy, Old Gun, Halifax, The Olympic in Halifax Harbour*, and *Herring Cove, Nova Scotia*.

February: Article "Art and Craft" appears in *The Rebel*.

April: Arrives in Montreal for final discharge from the army. Article "A Volunteer" appears in *The Rebel*.

May: Returns to Toronto and moves into Studio Six on the third floor of the Studio Building.

August: Article "The Vital Necessity of the Fine Arts" appears in *Canadian Courrier*.

Autumn: Accompanies Harris, MacDonald, and Frank Johnston on their second boxcar trip to Algoma, Ontario. Makes sketches for *First Snow, Algoma*.

October: Article "An Aesthetic Standard" appears in *The Rebel*.

November: Article "Dutch Art in Canada: The Last Chapter" appears in *The Rebel*.

December: Elected a full member of the Royal Canadian Academy.

Article "The War Memorials: A Challenge" appears in *The Lamps*.

1920

January: Paints *First Snow, Algoma*. Article "Things Are Looking Up" appears in *The Rebel*.

February: Begins a two-month sketching trip to Penatangueshene and Franceville on Georgian Bay.

March: Included as a founding member of the Group of Seven, in absentia.

Late April: Arrives in Toronto and paints *The Freddy Channel, March Storm, Georgian Bay,* and *Early Spring, Georgian Bay* for first Group exhibition.

May 7: First Group of Seven exhibition opens at the Art Gallery of Toronto.

Mid-May: Sketches at Mongoose Lake, Algoma, with Harris, MacDonald, Lismer, and Dr. MacCallum.

Elected president of Montreal's Beaver Hall Group, in absentia.

Summer: Meets artist Anne Savage in Montreal.

Autumn: Sketches at Mongoose Lake, Algoma. Paints *Maple Woods, Algoma* and *October Morning, Algoma.*

1921

January: First annual exhibition of the Beaver Hall Group in Montreal.

Winter: Wins Arts and Letters Club self-portrait contest with whimsical caricature, *Père Raquette.*

Spring: Sketches at Cacouna, Quebec, and is later joined by Albert Robinson. Paints *A Quebec Village, Winter Road, Quebec,* and *A Village on the Gulf.*

March: Article "Sketching in Algoma" appears in *Canadian Forum.*

May: Second Group of Seven exhibition is held at the Art Gallery of Toronto. The National Gallery purchases *A Quebec Village* and *Early Spring, Georgian Bay.*

Mid-May: Sketches in Algoma with Harris.

May 21: Mother, Georgina Jackson, dies in Montreal at age seventy.

Paints *Georgian Bay, November.*

Autumn: Sketches in Algoma with Lismer and Harris, then accompanies Harris to Rossport on Lake Superior.

1922

Early Spring: Sketches at Bienville and Quebec City, Quebec, with Albert Robinson.

May: The third Group of Seven exhibition opens at the Art Gallery of Toronto.

June: Article "A Policy for Art Galleries" appears in *Canadian Forum.*

Early Summer: Sketches at Brockville, Ontario, with Prudence Heward and friends. *Georgian Bay, November* is purchased for Hart House, University of Toronto.

Autumn: Sketches at Coldwell, Ontario, on Lake Superior, with Harris.

November: Sketches at Georgian Bay. Paints *November.*

1923

February: Article "The Problems of the Canadian Painter" appears in *Canadian Bookman.*

Spring: Sketches at Baie Saint Paul, Quebec, with Edwin Holgate. Paints *Early Spring, Quebec.*

Early Summer: Sketches at Brockville, Ontario, with Prudence Heward and friends.

Autumn: Returns to Lake Superior with Harris. Paints *Autumn, Lake Superior* and *A Northern Lake.*

1924

January: Sketches at Baie St. Paul, Quebec. Paints *Le Boulanger, Baie St. Paul.*

Late Winter: Works on illustrations for *Chez Nous,* a book on old Quebec by Adjuter Rivard.

Spring: Sketches at Mongoose Lake, Algoma, with Harris and Dr. MacCallum.

Summer: Takes an extended trip through the Rocky Mountains in and near Jasper National Park, Alberta, with Harris.

October: Sketches at Jackfish, Ontario, on Lake Superior with Harris. Paints *Above Lake Superior, Lake Superior Country,* and *Night, Pine Island.*

Summer: *Entrance to Halifax Harbour* is sent to the controversial British Empire Exhibition at Wembley and is subsequently bought by the Tate Gallery. Publication of *Chez Nous* by Adjuter Rivard.

Autumn: Accepts a part-time teaching post at the Ontario College of Art.

1925

January: Article "Artists in the Mountains" appears in *Canadian Forum*.

January–Early February: The fourth Group of Seven exhibition is held at the Art Gallery of Toronto.

February: Debates Sir Wyly Grier on Canadian art at the Empire Club of Canada, Toronto.

Spring: Resigns from the Ontario College of Art.

June: Article "In the Realm of Art" appears in *Canadian Bookman*.

Early Summer: Sketches at Georgian Bay.

Summer: Visits Île d'Orléans and Sainte-Anne-de-Beaupré, Quebec, with Arthur Lismer and Marius Barbeau. Sketches *Saint Jean, Île d'Orléans*.

September: Sketches at Saint-Hilarion, Quebec.

Autumn: Returns to the north shore of Lake Superior with Harris, Frank Carmichael, and A.J. Casson.

November: Article "Early Quebec Wood Carving Now in Toronto" appears in *Canadian Bookman*.

1926

March: Article "Art in Toronto" appears in *Canadian Forum*.

Spring: Sketches at Saint-Fidel and La Malbaie, Quebec. Paints *Barns* and *Île aux Coudres*.

May: The fifth Group of Seven exhibition opens at the Art Gallery of Toronto.

Summer-Autumn: Takes an extended trip to the Skeena River region of northwest British Columbia with Marius Barbeau and Edwin Holgate. Paints *Indian Home, Skeena Crossing*, and *Kispayaks Village*.

November: Article "War Pictures Again" appears in *Canadian Bookman*. Paints *North Shore, Lake Superior*.

1927

Spring: Sketches at Trois Pistoles, Saint-Simon, Bic, and Saint-Jean-Port-Joli, Quebec, with Dr. Frederick Banting. Paints *Early Spring, Quebec*.

July-September: Travels to the High Arctic with Dr. Banting aboard the government supply ship *Beothic*.

September: Published comments on "bigoted" Montreal draw bitter rebuttals in the press.

Autumn: Solo exhibition of Arctic sketches and drawings at the Art Gallery of Toronto. Paints *The Beothic at Bache Post, Ellesmere Island* for the Department of the Interior.

October: Solo exhibition at Hart House, University of Toronto.

November: British Columbia artist Emily Carr visits the Studio Building.

November-December: Exhibits Skeena canvases in the Exhibition of Canadian West Coast Art at the National Gallery in Ottawa.

December: Article "Rescuing Our Tottering Totems" appears in *Maclean's*. "Up North" appears in *Canadian Forum*.

1928

February: The sixth Group of Seven exhibition opens at the Art Gallery of Toronto.

July: Sketches at Great Slave Lake, Northwest Territories, with Dr. Banting and MacIntosh Bell.

First book, *The Far North*, a small volume of Arctic drawings, is published by Rous and Mann Ltd.

Paints *Indian Homes, Fort Resolution*.

1929

March: Sketches at Les Eboulements, Quebec. Paints *Les Eboulements*.

September: Sketches at Brockville, Ontario, with Prudence Heward and friends.

Autumn: Takes a car trip to Quebec's Gaspé Peninsula with Harris.

1930

Early Spring: Sketches at Les Eboulements, Saint-Fidèle, and Saint-Urbain, Quebec, with Dr. Banting. Paints *Saint-Tite-des-Caps, Saint Fidèle, A Quebec Farm*, and *Red Barn, Petite Rivière*.

April: The seventh Group of Seven exhibition opens at the Art Gallery of Toronto.

May: A Group of Seven exhibition opens at the Art Association of Montreal.

Late Spring: Visits Vincent and Alice Massey at their home in Port Hope, Ontario.

July-September: Returns to the Arctic aboard the *Beothic*, accompanied by Harris. Paints *Labrador Coast, Mission at Lake Harbour, Morning, Baffin Island*, and *Summer, Pangnirtung*.

November-December: A joint exhibition with Harris of Arctic sketches opens at the National Gallery of Canada and Hart House, University of Toronto.

1931

March: Sketches at Sainte-Ireneé, Quebec, with Dr. Banting and Randolph Hewton. Paints *Country Road, Quebec* and *Grey Day, Laurentians*.

Early Summer: Takes a canoe trip to Nellie Lake, Ontario, with Professor Barker Fairley.

August: Sketches at Go Home Bay, Georgian Bay.

September: Sketches at Brockville, Ontario, with Prudence Heward and friends.

Autumn: Initiates the production of Christmas cards bearing designs by Canadian artists.

December 4: The eighth Group of Seven exhibition opens at the Art Gallery of Toronto.

1932

Spring: Sketches at Saint-Joachim, Les Eboulements, and Saint-Urbain, Quebec, with Randolph Hewton. Paints *Winter, Charlevoix County* and *French River*.

April: Sister Isobel Jackson dies in Montreal.

June: Father, Henry Allen Jackson, dies in Lethbridge.

September–October: Sketches in Frankville and Cobalt, Ontario, with Dr. Banting.

November: J.E.H. MacDonald dies in Toronto.

December: Resigns from the Royal Canadian Academy, citing the RCA's opposition to the modern art being produced by younger painters.

October Morning, Algoma is purchased for Hart House, University of Toronto.

Article "Modern Art No Menace" appears in *Saturday Night*.

1933

January: Article "J.E.H. MacDonald" appears in *Canadian Forum*.

February: Elected vice-president of the newly formed Canadian Group of Painters.

Spring: Sketches at Saint-Hilarion and Saint-Urbain, Quebec. Paints *Valley of the Gouffre River* and *March Day, Laurentians*.

May: Undergoes a tonsillectomy in Toronto.

Summer: Sketches at Georgian Bay with Anne Savage and others.

Autumn: Camps in La Cloche Hills, Algoma, with Keith MacIver. Proposes marriage to Anne Savage by letter, but she turns him down.

1934

Early Spring: Sketches at Quebec City, Saint-Joachim, and Saint-Tite-des-Caps, Quebec. Paints *Road to St. Hilarion*.

Early Summer: Travels to Cape Breton Island, Nova Scotia, with Peter and Bobs Haworth.

Summer: Camps at Pine Island, Georgian Bay, with niece Naomi Jackson and her friend Betty Maw.

September: Sketches near Brockville, Ontario, with Prudence Heward and friends.

Autumn: Sketches at La Cloche Hills, Algoma. Paints *Algoma, November*.

1935

Early Spring: Sketches at Rimouski, Cacouna, and Les Eboulements, Quebec.

Paints *La Malbaie, Quebec* and *Late Winter, Laurentians*.

June: Sketches at Georgian Bay.

Summer: Visits Tadoussac, Quebec. Sketches *Summer, near Tadoussac*.

Early September: Sketches near Brockville, Ontario, with Prudence Heward and friends.

Late September: Returns to Georgian Bay.

October: Works at Cobalt, Ontario. Sketches *Street in Cobalt*.

November: Solo exhibition at Scott Gallery, Montreal.

1936

February: *Retrospective Exhibition of Paintings by Members of the Group of Seven 1919–1933* opens at National Gallery in Ottawa; it later travels to Montreal and Toronto.

Spring: Sketches at Fox River, Gaspé, Quebec.

Early Summer: Sails for Europe for a six-week vacation with niece Naomi. Travels through France, Belgium, Germany, and England.

October: Sketches at Go Home Bay, Georgian Bay.

November: Spends American Thanksgiving in New York City.

1937

Spring: Sketches at Saint-Tite-des-Caps, Quebec, with Dr. Banting. Paints *Farm, Saint-Tite-des-Caps* and *Hillside, Saint-Tite-des-Caps*.

Summer: Sketches at Pine Island, Georgian Bay.

Early September: Sketches near Brockville, Ontario, with Prudence Heward and friends.

Autumn: Takes his first trip to southern Alberta, to visit brother Ernest in Lethbridge. Sketches in Pincher Creek, Lundbreck, and Cowley, Alberta, and Shelby, Montana, with Frederick Cross. Sketches *Porcupine Hills, Alberta, Drought Area, Alberta*, and *Blood Indian Reserve, Alberta*.

1938

Early Spring: Sketches at Georgian Bay.

April: Visits Washington, D.C.

May: Returns to the La Cloche Hills, Algoma. Sketches *Algoma in May*.

Paints *Pre-Cambrian Hills*.

July: Sketches at Georgian Bay.

August-September: Sketches at Port Radium on Great Bear Lake, Northwest Territories. Paints *Radium Mine* and *Northern Landscape, Great Bear Lake*.

Autumn: Sketches at Lethbridge and around southern Alberta.

December: The book *A.Y. Jackson* by Albert H. Robson is published by Ryerson Press.

1939

January-February: Helps Anne Savage prepare a series of CBC Radio broadcasts on the arts. Paints *South from Great Bear Lake*.

Spring: Sketches at Bic, Saint-Simon, Saint-Léonard, Saint-Hyacinthe, and Hull, Quebec. Sketches *The Yamaska River at Saint Hyacinthe* and *Morning, Saint Simon de Rimouski*.

Early Summer: Returns to the La Cloche Hills, Algoma.

July: Sketches at Georgian Bay.

August: Travels to New York City to supervise the hanging of the Canadian Group of Painters exhibition at the world's fair.

Early Autumn: Sketches in the La Cloche Hills, Algoma.

1940

Spring: Sketches at Sainte-Louise, Quebec. Paints *Road to Saint Simon* and *Winter: L'Islet, Quebec*.

Summer: Sketches at Georgian Bay.

October: Camps at Gem Lake in the La Cloche Hills with Keith MacIver, where he is filmed for *Canadian Landscape*, a colour documentary produced by the National Film Board of Canada.

Paints *Algoma Lake*.

December: Receives news of Sir Frederick Banting's death in a plane crash in Newfoundland.

1941

Winter: Solo exhibition opens at Hart House, University of Toronto.

Early Spring: Sketches at Saint-Tite-des-Caps and La Malbaie, Quebec, with Randolph Hewton, where he is filmed for the Quebec segment of the NFB documentary *Canadian Landscape*. Paints *April, Saint-Tite-des-Caps*.

May: Visits Smoke Lake in Algonquin Park to appear in *West Wind*, a National Film Board documentary on Tom Thomson.

June: Participates in the Canadian Conference on the Arts in Kingston, Ontario, with André Bélier, Prudence Heward, Isabel McLaughlin, and many

other Canadian artists. Becomes a founding member of the Canadian Federation of Artists.

July: Sketches at Georgian Bay.

Late Summer: Sketches along the waterfronts of Montreal and Quebec City for illustrations for the book *The Saint Lawrence* by Henry Beston.

October: Returns to Kingston to receive an honorary Doctor of Laws degree from Queen's University.

Paints *North Country, Algoma*.

1942

January 30: *Canadian Landscape* premieres at a gala reception at the Art Gallery of Toronto. Arthur Lismer delivers the keynote speech.

Early Spring: Sketches at Saint-Pierre-de-Montmagny, Quebec, with Randolph Hewton.

October: Begins writing a regular column on art for the *Toronto News*.

Autumn: Stays with brother Harry at his country home in Saint-Aubert, Quebec.

Labrador Coast is purchased for Hart House, University of Toronto.

Organizes a memorial exhibition of Sir Frederick Banting's paintings for Hart House and later the Art Gallery of Toronto.

1943

January: Exhibits with brother Harry and niece Naomi at the Art Association of Montreal.

May: Stays with brother Harry at his country home in Saint-Aubert, Quebec.

Early Summer: Sketches at Georgian Bay.

Summer: Accepts a teaching position at the Banff School of Fine Arts. He will return almost every summer for the next six years.

September: Sketches in the Rocky Mountains and southwestern Alberta, including Canmore, Rocky Mountain House, and Waterton Park.

Autumn: Sketches along the new Alaska Highway with Calgary artist H.G. Glyde. Works on several poster designs for the U.S. Army. Paints *Dawn in the Yukon* and *Mountains on the Alaska Highway*.

November: Visits brother Ernest and works briefly in Lethbridge.

December: Spearheads the Canadian art silkscreen reproduction project with the help of A.J. Casson, Charles Comfort, and others. Thousands of reproductions will eventually be sent overseas to decorate military facilities. Article "Dr. MacCallum, Loyal Friend of Art" appears in *Saturday Night*.

1944

Spring: Stays with brother Harry at his country home in Saint-Aubert, Quebec.

Article "Sketching on the Alaska Highway" appears in *Canadian Art*.

Summer: Teaches painting at Banff School of Fine Arts.

Late Summer: Visits Canmore, Alberta, and Vancouver and Kamloops, British Columbia.

Autumn: Sketches at Lethbridge, Waterton Park, and Rosebud, Alberta.

October 31: Addresses the Woman's Canadian Club in Regina. Officially opens the Canadian Federation of Artists exhibition the next day.

November 2: Addresses the Canadian Federation of Artists in Winnipeg.

1945

April: Article "Art Goes to the Armed Forces" appears in *The Studio*.

Spring: Stays with brother Harry at his country home in Saint-Aubert, Quebec.

Summer: Teaches painting at Banff School of Fine Arts.

Autumn: Spends six weeks sketching in Kamloops, Ashcroft, and Barkerville, British Columbia.

Early November: Visits brother Ernest in Lethbridge; sketches at Pincher Creek and Millarville, Alberta.

Paints *Wild Woods* and *Echo Bay, Great Bear Lake*.

1946

March: Sketches at Saint-Tite-des-Caps, Quebec.

Article "A Record of Total War" appears in *Canadian Art*.

May: Retrospective exhibition *A.Y. Jackson: Thirty Years of Painting* opens at the Dominion Gallery in Montreal.

Summer: Teaches painting at Banff School of Fine Arts.

Autumn: Sketches in southern Alberta and the Cariboo Mountains in British Columbia.

December: Takes a brief trip to Ottawa to be invested as a Companion of the Order of Saint Michael and Saint George.

Elected president of the Canadian Group of Painters for 1947–48.

1947

Spring: Makes his last annual sketching trip to the lower Saint Lawrence region, sketching at La Malbaie and Port-au-Persil, Quebec.

Late May: Sketches at Haliburton, Ontario.

Summer: Teaches painting at Banff School of Fine Arts.

September: Sketches at Canmore, Alberta, and the Cariboo Mountains in British Columbia.

October: Sketches at Pincher Creek, Cowley, and Waterton Park, Alberta. Paints *Elevators at Night, Pincher Creek* and *Late Harvest, Pincher, Alberta*.

Sketches at Lake of the Woods, Manitoba.

Late Autumn: Supervises the hanging of and writes the catalogue foreword for the Canadian Group of Painters exhibition at the Art Gallery of Toronto and the Art Association of Montreal.

1948

Paints *Waterton Lake*.

Writes "Lawren Harris: A Biographical Sketch" for the exhibition catalogue of *Lawren Harris Paintings 1910–1948*.

Spring: Sketches in Gatineau River region.

May: Sketches in Sudbury, Ontario, and the surrounding area.

Summer: Stays with brother Harry at his country home in Saint-Aubert, Quebec.

October: Sketches in the Gatineau region.

Paints *Alberta Rhythm*.

Harris sells the Studio Building to Gordon MacNamara and Charles Redfern.

1949

Early Spring: Sketches along the Gatineau River. Paints *Gatineau Road*.

Article "Sarah Robertson: 1891–1948" appears in *Canadian Art*.

May: Sketches at Barkerville, British Columbia, and surrounding area.

June: Sketches at Pincher Creek, Alberta.

Summer: Teaches his last session at the Banff School of Fine Arts.

Autumn: Sketches at Port Radium, Eldorado, and Yellowknife, Northwest Territories, with Maurice Haycock. Later stays in Lethbridge with brother Ernest.

1950

Spring: Sketches in the Gatineau area.

Article "Arthur Lismer: His Contribution to Canadian Art" appears in *Canadian Art*.

June 7: Broadcasts "Talk on Canadian Art" on CBC Radio.

Early Summer: Sketches at Hemmingford, Quebec.

August: Returns to Port Radium on Great Bear Lake, Northwest Territories. Spends five days camping in Teshierpi Mountains and later visits Yellowknife. Sketches *Camp in Coppermine Country* and *Cobalt Island*.

October: Stops in Calgary, Lethbridge, and Twin Butte, Alberta.

November: Sketches at Georgian Bay.

Paints *Yellowknife Bay* and *Superstition Island, Great Bear Lake*.

1951

March: Sketches at Chenier, Quebec.

Spring: Sketches in the Gatineau River region.

June 21: Travels to Edmonton to receive a National Award for Art from the University of Alberta.

July: Sketches at Georgian Bay.

Summer-Autumn: Returns to Great Bear Lake, Northwest Territories. Sketches in the Barren Lands, Hunter Bay, and Yellowknife with John Rennie. Paints *Hills at Hunter Bay, Great Bear Lake*.

Early October: Sketches in southern Alberta and La Rivière, Manitoba. Paints *October, Twin Butte, Alberta*.

Late October: Visits Kirkland Lake, Ontario.

1952

February: Visits Mount Allison University in Sackville, New Brunswick.

Spring: Sketches the gold mines on Red Lake near Kenora, Ontario.

July: Spends eighteen days in St. John's, Newfoundland, working on a commission for the Seagram's Cities of Canada project.

August: Sketches at Go Home Bay, Georgian Bay.

Late September: Sketches at Barry's Bay, Ontario.

October: Travels through the Peace River region of Alberta and British Columbia with sculptor Frances Loring on a lecture tour sponsored by the National Gallery of Canada.

1953

January: Exhibits a series of sketches from the Northwest Territories at Hart House.

Winter: Paints *Hills at Great Bear Lake*, *Arctic Summer*, and *Faulkenham Lake, Red Lake District*.

Article "Recollections on My Seventieth Birthday" appears in *Canadian Art*.

Spring: Sketches at Sainte-Anne-des-Monts and Mont Joli, Quebec, with Maurice Haycock.

Paints *April Day, Sainte Marthe, Gaspé*.

Late Spring: Sketches at Thetford Mines, Quebec.

Summer: Stays at Go Home Bay, Georgian Bay, to paint decorative panels *Autumn I* and *Autumn II* in the former MacCallum cottage for new owners Henry and Mary Jackman. Sketches *Monument Channel, Georgian Bay* and *On West Wind Island*.

Late Summer: Sketches at Saint-Aubert, Saint-Onésime, Saint-Gabriel, and Saint-Damase, Quebec.

October 16: Receives an honorary Doctor of Laws degree from McMaster University in Hamilton, Ontario.

October 22: The major retrospective exhibition *A.Y. Jackson: Paintings 1902–1953* opens at the Art Gallery of Toronto. Governor General Vincent Massey delivers the keynote speech. The exhibition will later travel to Montreal, Ottawa, and Winnipeg.

Article "Reminiscences of Army Life" appears in *Canadian Art*.

1954

April: Delivers the talk "The Group of Seven" for CBC Radio.

Early Spring: Works in Victoria, British Columbia, and southern Alberta.

Spring: Article "From Rebel Dauber to Renowned Painter: A Self-Portrait of A.Y. Jackson" appears in *Mayfair*.

Article "William J. Wood 1877–1954" appears in *Canadian Art*.

Spring: After frequent disagreements with the new landlord, decides to leave the Studio Building.

Summer: Sketches at Georgian Bay and near Sault Ste. Marie, Ontario.

August: Buys a piece of land next to niece Constance's home on Highcroft Drive in Manotick, Ontario.

Writes essay "The War Records" for exhibition catalogue of "F.H. Varley Paintings 1915–1954."

1955

March: Moves from the Studio Building to a new studio/home in Manotick, Ontario.

April: Takes a ten-day sketching trip to Gracefield, Quebec.

July 10: "A.Y. Jackson: Still Painting at 73," a twelve-minute television profile, airs on CBC's *Newsmagazine*.

Summer: Sketches at Georgian Bay. Paints *Georgian Bay Islands*.

August: Buys property at Twidale Bay on Lake Superior, near Wawa, Ontario.

Early Autumn: Sketches in Algoma.

November: Works in Ottawa Valley region with Ralph Burton.

1956

Winter: Takes a two-month vacation in Trinidad and Tobago.

April: Sketches along the Ottawa River with Ralph Burton.

Summer: Stays at Go Home Bay on Georgian Bay.

Autumn: Sketches in Algoma and Wawa, Ontario.

October: Albert Robinson dies in Montreal.

November: After a twenty-four-year absence, accepts an honorary membership in the Royal Canadian Academy.

1957
March: Visits Hamilton, Ontario.
Spring: Sketches at Sainte-Adele, Quebec.
Early May: Spends a week in Sudbury, Ontario.
May 17: Receives an honorary Doctor of Laws degree from Carleton University, Ottawa.
Article "Box-Car Days in Algoma 1919–20" appears in *Canadian Art*.
Summer: Sketches at Georgian Bay.
Autumn: Spends six weeks camping near Yellowknife on Great Bear Lake, Northwest Territories, and in Uranium City, Saskatchewan, with Maurice Haycock.
Works on memoirs with niece Naomi.

1958
Late Winter: Sketches in the region of Lake Clear, Ontario.
April: Sketches at Morin Heights, Quebec, with Edwin Holgate.
Spring: Visits Guelph, Ontario, to begin work on a mural for the Ontario College of Agriculture.
May: Works at his cabin on Lake Superior near Wawa, Ontario.
Early October: Sketches in Quebec's Eastern Townships.
November: Autobiography, *A Painter's Country*, is published by Clarke, Irwin & Co.
Writes a foreword to the book *Frederick Simpson Coburn* by Gerald Stevens.

1959
March: Accepts a Freedom of the City award from the City of Toronto.
April: Sketches in Sainte-Adele, Quebec, and the Ottawa Valley.
June: Spends a week in Guelph, Ontario, for the unveiling of the Ontario College of Agriculture mural.
July: Works at his cabin on Lake Superior near Wawa, Ontario.
Early August: Sketches at Georgian Bay.
Late Summer: Travels north to Lake Athabaska with Maurice Haycock; sketches at Beaverlodge and Uranium City, Saskatchewan, then goes to Port Radium on Great Bear Lake.
September: Camps at Lake Rouvière and Bathurst Inlet, Northwest Territories.
Late September: Stays at Lethbridge with brother Ernest.
Mid-October: Sketches at Georgian Bay.

1960
March: *A.Y. Jackson: A Retrospective Exhibition* opens at the Art Gallery of Hamilton; it later travels to London, Ontario.
Randolph Hewton dies in Trenton, Ontario.
Spring: Sketches in the Ottawa Valley and Gatineau regions.
July: Works at his cabin on Lake Superior near Wawa, Ontario.
August: Visits Georgian Bay.
October: Sketches at Combermere, Ontario.

1961
Bother Harry dies in Manotick, Ontario.
Visits Toronto, Kleinburg, and Guelph, Ontario.
Paints *Lake Rouvière* and *End of Winter, Labrador*.
Spring: Sketches in the Ottawa Valley region.
Late Spring: Visits Labrador and Schefferville, Quebec, with Maurice Haycock.
Summer: Sketches at Georgian Bay and Rock Island, Quebec.
September: Works at his cabin on Lake Superior near Wawa, Ontario.
Autumn: Sketches near Ottawa.
November: Addresses the Woman's Art Associations in Toronto and Sarnia, Ontario.
Early December: Sketches at Cowansville, Quebec.

1962
February: Receives the 1961 Canada Council Medal in Ottawa.
Late Spring: Moves to a ground-floor apartment at 192 MacLaren Street in Ottawa.
Diagnosed with diabetes.
June: Returns to Labrador and Schefferville, Quebec.

July: Works at his cabin on Lake Superior
near Wawa, Ontario.

Late Summer: Sketches at Georgian Bay and
Muskoka, Ontario.

November: Receives an honorary Doctor of
Laws degree from the University of
Saskatchewan.

1963

Spring: Sketches at Notre-Dame-de-la-Salette,
Quebec, and Brantford, Ontario.

June: Spends a week at Saint-Césaire,
Quebec.

August: Sketches at Georgian Bay.

Autumn: Sketches at Combermere, Ontario.

1964

Winter: Sketches at Morin Heights, Quebec,
with Edwin Holgate and at Sainte-Agathe,
Quebec, with Sam Borenstein.

Late March: Sketches at Lake Clear, Ontario,
with Ralph Burton.

Spring: Writes to Prime Minister Lester B.
Pearson and submits a maple leaf design
proposal for a new Canadian flag.

July: Visits Canoe Lake in Algonquin Park.

August: Sketches at Georgian Bay.

Autumn: Takes a seven-week camping trip to
Alaska and the Yukon with Ralph Burton
and Maurice Haycock.

Mid-November: Sketches at Port Arthur,
Ontario.

1965

Brother Ernest dies in Lethbridge.

Early Spring: Spends three weeks sketching in
and around Grenville, Quebec.

Early Summer: Sketches at Rivière Ouelle and
Saint-Onésine, Quebec, with Sam Boren-
stein.

July: Spends a month camping on Baffin
Island with niece Geneva and the Alpine
Club of Canada. Returns with many new
sketches of the Arctic.

August: Works at his cabin on Lake Superior
near Wawa, Ontario.

September: Sketches at Buckingham,
Quebec.

October: Sketches at Lake Clear, Ontario.

Late Autumn: Diagnosed with Ménières
syndrome and spends ten days in hospital.

1966

Early Spring: Sketches in the Gatineau region.

May: Sketches at Lake Clear, Ontario.

June: Travels to Vancouver to receive an
honorary Doctor of Laws degree from the
University of British Columbia.

July: Works at his cabin on Lake Superior
near Wawa, Ontario.

August: Sketches at the Jackman cottage on
Go Home Bay, Georgian Bay.

Autumn: Sketches in the Gatineau region.

December: Visits Toronto and Kleinburg,
Ontario.

Writes a brief foreword for Dudley Copland's
self-published biography of Arctic explorer
Dr. Leslie Livingstone.

1967

Early Spring: Sketches in the Gatineau region
and Ripon, Quebec.

June: Makes his last trip to Montreal.
Receives an honorary Doctor of Letters
degree from McGill University and visits
Expo 67.

Summer: Stays at Go Home Bay, Georgian
Bay.

Article "A Portfolio of Arctic Sketches"
appears in *The Beaver*.

North of Summer, a collection of poems from
Baffin Island by Al Purdy, is published by
McClelland & Stewart. It features several of
Jackson's recent Baffin Island sketches.

Early Autumn: Sketches with Ralph Burton
along the lower St. Lawrence and in
Campbellton, New Brunswick.

October: Sketches at Lake Clear, Ontario, and
makes his last visit to Algonquin Park.

November: Sketches at Notre-Dame-de-la-
Salette, Quebec, with Betty Kirk.

1968

Winter: Writes to Robert and Signe
McMichael regarding a possible cemetery
for the Group of Seven on the couple's
Kleinburg property.

February: Sketches at Notre-Dame-de-la-
Salette, Quebec, where he produces his last
satisfactory sketch.

March: Visits Ripon and Grenville, Quebec,
but can't complete any sketches.

April: Suffers a stroke at home in Ottawa. Undergoes surgery to remove a clot from his brain, but never fully recovers.

April 26: Niece Naomi Jackson Groves accepts the Companion of the Order of Canada on behalf of her uncle.

June: Accepts Robert and Signe McMichael's invitation to move into an apartment above their art gallery in Kleinburg, Ontario.

Autumn: Naomi's book featuring her uncle's pencil drawings, *A.Y.'s Canada*, is published.

1969

Lives as artist-in-residence at the McMichael Canadian Collection in Kleinburg, Ontario. He greets visitors and often goes out sketching on the grounds.

March: Arthur Lismer dies in Montreal. He is the first Group of Seven member to be buried on the McMichael grounds at Kleinburg.

September: Frederick Varley dies in Unionville, Ontario. He is also buried at Kleinburg.

Franz Johnston's remains are reinterred at Kleinburg.

1970

January: Lawren Harris dies in Vancouver. He and wife Bess are buried at Kleinburg.

May: A reconstruction of the 1920 Group of Seven exhibition opens at the Art Gallery of Ontario.

June: Driven to Ottawa to be guest of honour at the National Gallery opening of a major Group of Seven exhibition to commemorate the fiftieth anniversary of the Group's first show. Meets with Prime Minister Pierre Trudeau in his office.

September: Visits Toronto for the opening of A.Y. Jackson Secondary School in North York.

1971

Sketches frequently on the McMichael grounds, but finds he can no longer control his brush.

Anne Savage dies in Montreal.

1972

October: *A.Y. Jackson 90th Birthday Exhibition* held at the National Gallery of Canada, curated by Dennis Reid.

1973

Health deteriorates to the point where he must be moved to the Pinegrove Nursing Home in Woodbridge, Ontario

1974

March: Visits the McMichael Gallery for the last time.

April 5: Dies at the age of ninety-one in Woodbridge, Ontario.

April 8: Funeral service at Kleinburg. Buried on the grounds of the McMichael Canadian Collection, near the graves of Harris, Johnston, Lismer, and Varley.

1976

October 21: A. Y. Jackson Secondary School opens in Kanata, Ontario.

1977

Edwin Holgate dies in Montreal.

1982

May 15: *Alberta Rhythm: The Later Work of A.Y. Jackson*, an exhibition curated by Dennis Reid, opens at the Art Gallery of Ontario. It will later travel to the Glenbow Museum in Calgary, Alberta.

1992

A.J. Casson, the last surviving member of the Group of Seven, dies in Toronto. He is also buried in the small Group of Seven cemetery at Kleinburg.

1995

The seventy-fifth anniversary of the Group of Seven's first exhibition is marked by the major exhibition *The Group of Seven: Art for a Nation*, curated by Charles Hill, which opens at the National Gallery of Canada. It will later travel to Toronto, Vancouver, and Montreal.

NOTES

Chapter 1: The Breath of Canada

1. A.Y. Jackson and Leslie F. Hannon, "From Rebel Dauber to Renowned Painter: A Self-Portrait of A.Y. Jackson," *Mayfair*, Vol. XXVIII, no. 9 (Spring 1954): 27.
2. "A.Y. Jackson: A Retrospective Exhibition," *Canadian Art*, vol. XI, no. 1 (Autumn 1953): 4.
3. Peter Mellen, *The Group of Seven* (Toronto: McClelland & Stewart, 1970), 36.
4. "A.Y. Jackson: A Retrospective Exhibition," 4.
5. A.Y. Jackson, *A Painter's Country* (Toronto: Clarke, Irwin & Co., 1958), 128.
6. *Ibid.*, xi.
7. *Ibid.*
8. Arthur Lismer, "A.Y. Jackson," in *A.Y. Jackson: Paintings 1902–1953* (Toronto: Art Gallery of Ontario, 1953), 5.
9. Jackson, *Painter's Country*, 13.
10. *Ibid.*
11. *Ibid.*, 155.

Chapter 2: Roots in Upper and Lower Canada

1. Dennis Reid, *Krieghoff: Images of Canada* (Vancouver: Douglas & McIntyre, 1999), 50.
2. *Ibid.*, 15.
3. Jackson, *Painter's Country*, 1.
4. *Ibid.* See also Albert H. Robson, *A.Y. Jackson* (Toronto: Ryerson Press, 1938), 5.
5. Montreal Directory, 1851, 199.
6. Naomi Jackson Groves, *A.Y.'s Canada* (Toronto: Clarke, Irwin & Co., 1968), 92.
7. Jackson, *Painter's Country*, 1.
8. From family records kept by Naomi Jackson Groves; provided by Anna Brennan.
9. Galt, Waterloo County, Ontario, 1851 Census.
10. Jackson, *Painter's Country*, 2.
11. Robson, 5.
12. Jackson, *Painter's Country*, 2.
13. *Ibid.*
14. Galt, Waterloo County, Ontario, 1851 Census.
15. Janet M. Brooke, *Discerning Tastes: Montreal Collectors 1880–1920* (Montreal: Montreal Museum of Fine Arts, 1989), 20.
16. *Ibid.*, 21.
17. Naomi Jackson Groves, *Young A.Y. Jackson: Lindsay A. Evans' Memories 1902–1906* (Ottawa: Edahl Productions Ltd., 1982), 23.
18. Lismer, 1953, 5.
19. *Lovell's Montreal Directory* (1882), 95.
20. *Lovell's Montreal Directory* (1890–91), 539.
21. Jackson, *Painter's Country*, 2.
22. From family records kept by Naomi Jackson Groves, provided by Anna Brennan.
23. Naomi Jackson Groves, "A Profile of A.Y. Jackson," *The Beaver* (Spring 1967): 15.
24. Jackson, *Painter's Country*, 3.
25. City of Westmount, Quebec, 1911 Census.
26. From family records kept by Naomi Jackson Groves, provided by Anna Brennan.
27. Jackson, *Painter's Country*, 2.
28. *Ibid.*
29. From family records kept by Naomi Jackson Groves, provided by Anna Brennan.
30. *Ibid.*
31. Jackson and Hannon, 58.
32. *Ibid.*, 48.
33. Jackson, *Painter's Country*, 3.
34. O.J. Firestone, *The Other A.Y. Jackson* (Toronto: McClelland & Stewart, 1979), 228.
35. Groves, *A.Y. Jackson*, 23.
36. Jackson, *Painter's Country*, 2.
37. *Lovell's Montreal Directory* (1896–97), 284.
38. *Ibid.*
39. Jackson, *Painter's Country*, 3.
40. *Ibid.*
41. F.B. Housser, *A Canadian Art Movement* (Toronto: Macmillan, 1926), 51.
42. Jackson, *Painter's Country*, 3.
43. Groves, "A Profile": 15.
44. Robson, 6.

Chapter 3: An Apprenticeship in the Arts

1. Jackson, *Painter's Country*, 3.
2. Firestone, 20.
3. *Ibid.*
4. *Ibid.*, 219.
5. Jackson, *Painter's Country*, 3
6. Firestone, 219.
7. Jackson, *Painter's Country*, 4.
8. *Ibid.*
9. Firestone, 219.
10. Housser, 52.
11. Groves, *A.Y. Jackson*, 8.
12. Jackson, *Painter's Country*, 148.
13. Jackson and Hannon, 58.
14. Housser, 52.
15. Mellen, 205.
16. Jackson, 4.
17. Housser, 69.
18. *Ibid.*, 82.
19. Kathleen Daly Pepper, *James Wilson Morrice* (Toronto: Clarke, Irwin & Co., 1966), x.
20. Paul Duval, *Canadian Impressionism* (Toronto: McClelland & Stewart, 1990), 34.
21. Jackson, *Painter's Country*, 16.
22. Groves, *A.Y.'s Canada*, 30.
23. *Ibid.*
24. Groves, *A.Y.'s Canada*, 8.

0# Header

25. *Ibid.*, 15–16.
26. *Ibid.*, 16.
27. *Ibid.*, 17.
28. *Ibid.*, 43.
29. Jackson, *Painter's Country*, 5.
30. Firestone, 20.
31. Jackson and Hannon, 61.
32. Firestone, 20.
33. Jackson and Hannon, 61.
34. Carol Lowrey, "Impressionist Tradition," in *Visions of Light and Air: Canadian Impressionism, 1885–1920* (New York: Americas Society Art Gallery, 1995), 22.
35. Groves, *A.Y. Jackson*, 8.
36. Jackson, *Painter's Country*, 5.
37. *Ibid.*, 6.
38. Dennis Reid, *The Group of Seven* (Ottawa: National Gallery of Canada, 1970), 22.
39. Jackson and Hannon, 61.
40. Firestone, 21.
41. Jackson, *Painter's Country*, 6.

Chapter 4: Roaming the Continent
1. Jackson, *Painter's Country*, 7.
2. Reid, Group of Seven, 22.
3. Bernard Denvir, *Encyclopaedia of Impressionism* (London: Thames and Hudson, 1990), 14.
4. Pepper, 19.
5. Denvir, 14.
6. Pepper, 20.
7. Donald W. Buchanan, *James Wilson Morrice: A Biography* (Toronto: Ryerson Press, 1936), 10.
8. Jackson, *Painter's Country*, 7.
9. *Ibid.*
10. *Ibid.*
11. Firestone, 220.
12. Duval, *Canadian Impressionism*, 122.
13. Jackson, *Painter's Country*, 7.
14. *Ibid.* 8.
15. Firestone, 220.
16. Reid, Group of Seven, 22.
17. Jackson, *Painter's Country*, 9.
18. Reid, *Group of Seven*, 22.
19. Jackson, *Painter's Country*, 9.
20. *Ibid.*

21. Victoria Baker, *Modern Colours: The Art of Randolph Stanley Hewton 1888–1960* (Hamilton: Art Gallery of Hamilton, 2001), 11.
22. Jackson, *Painter's Country*, 11.
23. Rosemarie L. Tovell, "A. Y. Jackson in France, Belgium and Holland: A 1909 Sketch Book," in *National Galley of Canada Annual Bulletin*, no. 2 (1978–1979).
24. *Ibid.*
25. *Ibid.*
26. Reid, *Group of Seven*, 24.
27. "If Cow Can Stay in Parlour, Then Why Can't Bull Moose?" *Toronto Star*, February 27, 1925.
28. Firestone, 21.
29. Reid, *Group of Seven*, 24.
30. Jackson, *Painter's Country*, 13.
31. *Ibid.*
32. Reid, *Group of Seven*, 38.
33. *Ibid.*, 41.
34. *Ibid.*
35. Jackson, *Painter's Country*, 13.
36. *Ibid.*
37. *Ibid.*, 14.
38. Reid, *Group of Seven*, 34.
39. Housser, 54.
40. Reid, *Group of Seven*, 34.
41. Housser, 55.
42. Jackson, *Painter's Country*, 4.
43. Housser, 56.
44. Reid, *Group of Seven*, 36.
45. Jackson, *Painter's Country*, 17.
46. *Ibid.*, 57.
47. Reid, *Group of Seven*, 42.
48. Jackson, *Painter's Country*, 17.
49. Reid, *Group of Seven*, 42.
50. Jackson, *Painter's Country*, 18.
51. *Ibid.*
52. Reid, *Group of Seven*, 44.
53. Jackson, *Painter's Country*, 19.
54. Reid, *Group of Seven*, 42.
55. *Ibid.*
56. Jackson, *Painter's Country*, 19.
57. Reid, *Group of Seven*, 42.
58. Jackson, *Painter's Country*, 18.

Chapter 5: New Friends in Toronto
1. Reid, *Group of Seven*, 36.
2. *Ibid.*, 37.
3. Jackson, *Painter's Country*, 21.
4. Blodwen Davies, *Tom Thomson* (Vancouver: Mitchell Press Ltd. 1967), 5.
5. Baker, 45.
6. Jackson, *Painter's Country*, 20.
7. Housser, 69.
8. "Montreal Boys Achieve Success with Paintings," *Montreal Daily Star*, February 20, 1913, 9.
9. *Ibid.*
10. Jackson, *Painter's Country*, 20.
11. Charles C. Hill, *The Group of Seven: Art for a Nation* (Ottawa: National Gallery of Canada, 1995), 55.
12. *Ibid.*
13. Housser, 71.
14. Jackson, *Painter's Country*, 19.
15. S. Morgan-Powell, "Art and Post-Impressionists," *Montreal Daily Star*, March 29, 1913, 22.
16. Davies, 53.
17. Reid, *Group of Seven*, 45.
18. Robson, 7.
19. *Ibid.*
20. Jackson, *Painter's Country*, 20.
21. *Ibid.*
22. *Ibid.*, 21.
23. Robson, 8.
24. Lawren S. Harris, *The Story of the Group of Seven* (Toronto: Rous & Mann Ltd., 1964), 15.
25. Housser, 79.
26. Mellen, 18.
27. *Ibid.*
28. Paul Duval, *The Tangled Garden* (Toronto: Cerebrus/Prentice-Hall, 1978), 13.
29. *Ibid.*, 15.
30. *Ibid.*, 17.
31. Peter Larissey, *Light for a Cold Land* (Toronto: Dundurn Press, 1993), 3.
32. Reid, *Group of Seven*, 25–26.
33. Housser, 64.
34. *Ibid.*
35. Harris, n/p.
36. *Ibid.*, 18.

37. Housser, 66.
38. *Ibid.*
39. Mellen, 18.
40. Augustus Bridle, *The Story of the Club* (Toronto: Ryerson Press, 1945), 3.
41. *Ibid.*
42. Mellen, 18.
43. Bridle, 43.
44. Jackson, *Painter's Country*, 22.
45. *Ibid.*, 23.
46. Reid, *Group of Seven*, 36.
47. *Ibid.*
48. Dennis Reid, *The MacCallum Bequest* (Ottawa: National Gallery of Canada, 1969), 67.
49. Jackson, *Painter's Country*, 50.
50. *Ibid.*, 24.
51. *Ibid.*
52. Davies, 51.
53. Jackson and Hannon, 62.
54. Housser, 85–86.
55. Jackson, *Painter's Country*, 24.
56. *Ibid.*
57. *Ibid.*
58. Firestone, 221.
59. Lawrence Sabbath, "A.Y. Jackson," *Canadian Art 69*, vol. XVII, no. 4 (July 1960): 243.
60. Firestone, 221.
61. Jackson, *Painter's Country*, 24.
62. *Ibid.*, 25.

Chapter 6: Radical Images
1. Douglas Ord, *The National Gallery of Canada: Ideas Art Architecture* (Montreal and Kingston: McGill-Queen's University Press, 2003), 77.
2. Hill, 294.
3. Mellen, 101.
4. Jackson, *Painter's Country*, 25.
5. Joan Murray, "Chronology of Tom Thomson," in Dennis Reid and Charles C. Hill, *Tom Thomson* (Toronto: Art Gallery of Ontario/National Gallery of Canada/Douglas & McIntyre, 2002), 310–11.
6. Davies, 33.
7. Sabbath, 243.
8. Housser, 62.
9. Davies, 3.
10. Mellen, 20.
11. *Ibid.*, 24.
12. H.F. Gadsby, "The Hot Mush School," *Toronto Star*, December 12, 1913.
13. *Ibid.*
14. J.E.H. MacDonald, "The Hot Mush School, a Rebuttal," *Toronto Star*, December 20, 1913.
15. *Ibid.*
16. "The Little Picture Show," *Saturday Night*, vol. XXVII, no. 18 (February 14, 1914): 21.
17. Reid, *Group of Seven*, 66.
18. Duval, *Tangled Garden*, 52.
19. Davies, 56.
20. Jackson, *Painter's Country*, 26.
21. Davies, 56.
22. Jackson, *Painter's Country*, 27.
23. Joan Murray, *The Best of the Group of Seven* (Edmonton: Hurtig Publishers Ltd., 1984), 59.
24. Davies, 56.
25. Reid and Hill, 94.
26. Jackson, *Painter's Country*, 28; see also Groves, *A.Y.'s Canada*, 105.
27. Reid and Hill, 118.
28. Jackson, *Painter's Country*, 28.
29. A.Y. Jackson, Mowat, Ontario, to J.E.H. MacDonald, Toronto, February 14, 1914; quoted in Hill, 294.
30. Duval, *Tangled Garden*, 53.
31. Jackson, *Painter's Country*, 29.
32. Groves, *A.Y.'s Canada*, 148.
33. Bridle, 43.
34. Groves, *A.Y.'s Canada*, 148.
35. Reid, *Group of Seven*, 73.
36. Postcard from A.Y. Jackson, Lucerne, British Columbia, to Dr. J. MacCallum, Toronto, August 27, 1914; quoted in Groves, *A.Y.'s Canada*, 148.
37. Jackson, *Painter's Country*, 30.
38. *Ibid.*
39. *Ibid.*
40. *Ibid.*
41. Groves, *A.Y.'s Canada*, 148.
42. Maria Tippett, *Stormy Weather: F.H. Varley, A Biography* (Toronto: McClelland & Stewart, 1998), 71.
43. Jackson, *Painter's Country*, 30.
44. Davies, 62.
45. Jackson, *Painter's Country*, 31.
46. A.Y. Jackson, "Arthur Lismer," *Canadian Art*, vol. VII, no. 3 (Spring 1950): 89.
47. *Ibid.*
48. Tippett, *Stormy Weather*, 72.
49. Davies, 63.

Chapter 7: Called to the Trenches
1. Housser, 96.
2. Tippett, *Stormy Weather*, 85.
3. Jackson, *Painter's Country*, 30.
4. *Ibid.*, 120.
5. Aline Gubbay, *A View of Their Own* (Montreal: Price-Patterson, 1998), 81.
6. Jackson, *Painter's Country*, 33.
7. *Ibid.*
8. *Ibid.*
9. *Ibid.*
10. Housser, 103.
11. Reid, *Group of Seven*, 84.
12. Baker, 18.
13. Thomas R. Lee, *Albert Robinson: The Painter's Painter* (Montreal: Private printing, 1956), n/p.
14. Jackson, *Painter's Country*, 33.
15. A.Y. Jackson enlistment papers, June 1915. National Library of Canada, CEF Archives.
16. *Ibid.*
17. "Third Montreal Artist for Front," *Montreal Gazette*, June 29, 1915, 5.
18. *Ibid.*
19. Jackson, *Painter's Country*, 34.
20. *Ibid.*
21. Reid, *Group of Seven*, 113.
22. Jackson, *Painter's Country*, 34
23. *Ibid.*
24. Reid, *Group of Seven*, 113.
25. A.Y. Jackson, "Reminiscences of Army Life, 1914–1918," *Canadian Art*, Vol. XI, no. 1 (Autumn 1953): 6.
26. A.Y. Jackson, Toronto, to Anne Savage, Montreal, June 3, 1932; quoted in Anne McDougall, *Anne Savage: The Story of a Canadian Painter* (Montreal: Harvest House, 1977), 35.

27. Jackson, *Painter's Country*, 35.
28. *Ibid.*
29. *Ibid.*
30. Hector Charlesworth, "Pictures That Can Be Heard: A Survey of the Ontario Society of Artists' Exhibition," *Saturday Night* XXIX:23 (18 March 1916): 11.
31. J.E.H. MacDonald, "Bouquets from a Tangled Garden," Toronto *Globe*, March 27, 1916, 4.
32. Housser, 126.
33. Jackson, *Painter's Country*, 36.
34. Housser, 127.
35. Jackson, *Painter's Country*, 36.
36. A.Y. Jackson, Shoreham, England, to J.E.H. MacDonald, Toronto, August 4, 1917; quoted in Hill, 63.
37. Davies, 98.
38. Housser, 127.
39. Jackson, *Painter's Country*, 36.

Chapter 8: Art on the Battlefield
1. Jackson, *Painter's Country*, 36.
2. Maria Tippet, *Art at the Service of War* (Toronto: University of Toronto Press, 1984), 30.
3. Jackson, *Painter's Country*, 37.
4. Tippett, *Art at the Service*, 23.
5. *Ibid.*, 29.
6. Jackson, *Painter's Country*, 36.
7. *Ibid.*
8. *Ibid.*
9. *Ibid.*
10. Susan Butlin, "Landscape as Memorial: A.Y. Jackson and the Landscape of the Western Front, 1917–1918," *Canadian Military History*, vol. 5, no. 2 (Autumn 1996): 62.
11. Tippett, *Art at the Service*, 33.
12. Groves, *A.Y. Jackson*, 26.
13. J. Russell Harper, *Painting in Canada* (Toronto: University of Toronto Press, 1977), 277.
14. Firestone, 22.
15. Housser, 128.
16. Dean F. Oliver and Laura Brandon, *Canvas of War* (Vancouver: Douglas & McIntyre, 2000), 29.

17. Jackson, *Painter's Country*, 39.
18. A.Y. Jackson, speech at Royal York Hotel, Toronto, April 20, 1965.
19. Jackson, *Painter's Country*, 38.
20. A.Y. Jackson, "A Record of Total War," *Canadian Art*, vol. III, no. 4 (July 1946): 151.
21. Butlin, 70.
22. *Ibid.*
23. Groves, *A.Y.'s Canada*, i.
24. *Ibid.*
25. Jackson, *Painter's Country*, 7.
26. *Ibid.*, 39.
27. *Ibid.*, 40.
28. Butlin, 66.
29. Hill, 65.
30. Reid, *Group of Seven*, 115.
31. Tippett, *Stormy Weather*, 102.
32. Letter from Frederick Varley to Arthur Lismer, 1918; quoted in Mellen, 72.
33. Tippett, *Stormy Weather*, 92.
34. A.Y. Jackson, speech at Royal York Hotel, Toronto, April 20, 1965.
35. Jackson, *Painter's Country*, 40.
36. Lois Darroch, *Bright Land* (Toronto/Vancouver: Merritt Publishing Co., 1981), 41–42.
37. Hill, 313.
38. Tippet, *Art at the Service*, 3–4.
39. Hill, 67.
40. Jackson, *Painter's Country*, 41.

Chapter 9: *Ars Longa, Vita Brevis*
1. Jackson, *Painter's Country*, 49.
2. Reid, *Group of Seven*, 152.
3. Jackson, *Painter's Country*, 49.
4. *Ibid.*
5. *Ibid.*
6. Reid, *Group of Seven*, 136.
7. Reid and Hill, 372.
8. Jackson, *Painter's Country*, 42.
9. Hill, 85.
10. *Ibid.*
11. *Ibid.*
12. Jackson, *Painter's Country*, 132.
13. *Ibid.*
14. Hill, 339.
15. Mellen, 82.

16. Hill, 80.
17. Reid, *Group of Seven*, 126.
18. Housser, 137.
19. Reid, *Group of Seven*, 126.
20. Harris, 19.
21. Mellen, 100.
22. Hill, 80.
23. J.E.H. MacDonald, Agawa, Ontario, to J. MacDonald, Toronto, September 11, 1918; quoted in Hill, 80.
24. Mellen, 80.
25. Reid, *Group of Seven*, 128.
26. *Ibid.*, 138.
27. A.Y. Jackson, "Sketching in Algoma," *Canadian Forum* (March 1921): 175.
28. Murray, 1984, 59.
29. Jackson, *Painter's Country*, 46.
30. *Ibid.*
31. Reid, *Group of Seven*, 132.
32. Reid and Hill, 372.
33. David P. Silcox, *The Group of Seven and Tom Thomson* (Toronto: Firefly, 2003), 17.
34. Mellen, 98.
35. Hill, 88.
36. Jackson, *Painter's Country*, 51.
37. A. Lismer, Toronto, to E. Brown, Ottawa, March 21, 1920; quoted in Reid, *Group of Seven*, 132.
38. E. Brown, Ottawa, to A. Lismer, Toronto, March 24, 1920; quoted in Hunkin, 84.
39. Reid, *Group of Seven*, 152.
40. Jackson, *Painter's Country*, 24.
41. *Ibid.*, 50.
42. *Ibid.*, 49.
43. Silcox, *Group of Seven and Thomson*, 290.
44. Jackson, *Painter's Country*, 50.
45. Hill, 88.
46. Jackson, *Painter's Country*, 50.
47. Reid, *Group of Seven*, 152.
48. Jackson, *Painter's Country*, 51.
49. *Ibid.*, 51.
50. Mellen, 216.

Chapter 10: A Continuous Blaze of Enthusiasm
1. Augustus Bridle, "Are These New-Canadian Painters Crazy?" *Canadian Courier*, May 22, 1920.

2. "Seven Painters Show Some Excellent Work," *Toronto Star*, May 7, 1920.
3. Jackson, *Painter's Country*, 52.
4. Hunkin, 86.
5. Jackson, *Painter's Country*, 52.
6. Mellen, 100.
7. *Ibid.*
8. Hill, 95.
9. *Ibid.*
10. Hunkin, 91.
11. Jackson, *Painter's Country*, 46.
12. Barbara Meadowcroft, *Painting Friends: The Beaver Hall Women Painters* (Montreal: Véhicule Press, 1999), 60.
13. McDougall, 41.
14. Lovell's Montreal Street Directory, 1884, 139.
15. Meadowcroft, 62.
16. *Ibid.*, 23.
17. C.R. Greenaway, "Jackson Says Montreal Most Bigoted City," *Toronto Star*, September 10, 1927.
18. Hill, 96.
19. Meadowcroft, 62.
20. Jackson, *Painter's Country*, 52.
21. Mellen, 130.
22. Larisey, 20.
23. In his autobiography, Jackson mistakenly put the year of his mother's death as 1920, but letters indicate that she, in fact, died a year later on her seventieth birthday. See Reid, *Group of Seven*, 181, note 2.
24. Jackson, *Painter's Country*, 48.
25. Reid, *Group of Seven*, 180.
26. Mellen, 138.
27. Hunkin, 123.
28. Frank Johnston, *Toronto Star Weekly*, October 11, 1924.
29. Mellen, 138.
30. Hunkin, 101.

Chapter 11: Spring in Quebec with Père Raquette
1. Janice Tyrwhitt, "A.Y. Jackson: All Canada for His Canvas," *Reader's Digest* (Canada) (April 1978): 45.
2. Firestone, 121.

3. *Ibid.*
4. *Ibid.*
5. Groves, *A.Y.'s Canada*, 40.
6. Jackson, *Painter's Country*, 56.
7. Groves, *A.Y.'s Canada*, 40.
8. Jackson, *Painter's Country*, 56.
9. Groves, *A.Y.'s Canada*, 78.
10. Jackson, *Painter's Country*, 57.
11. *Ibid.*, 46.
12. A.Y. Jackson, "Lawren Harris: A Biographical Sketch" in *Lawren Harris: Paintings 1910–1948* (Toronto: Art Gallery of Toronto, 1948), 10.
13. Jackson, *Painter's Country*, 47.
14. Jackson, "Lawren Harris," 10.
15. *Ibid.*
16. Jackson, *Painter's Country*, 48.
17. Mellen, 104.
18. Hill, 143.
19. *Ibid.*
20. Jackson, *Painter's Country*, 79.
21. *Ibid.*, 78.
22. Hunkin, 115.
23. Hector Charlesworth, "Canadian Pictures at Wembley," *Saturday Night* (May 17, 1924).
24. A.Y. Jackson, Toronto, to Clarence A. Gagnon, Paris, November 11, 1926. McCord Museum of Canadian History, P116 Clarence Gagnon fonds.
25. Firestone, 22.
26. Jackson, *Painter's Country*, 76.
27. *Ibid.*
28. Silcox, *Group of Seven and Thomson*, 77.
29. Jackson, *Painter's Country*, 24.
30. *Ibid.*, 77.
31. *Empire Club of Canada: Addresses Delivered to the Members During the Year 1925* (Toronto: Macoomb Press, 1925), vii.
32. *Ibid.*, 97.
33. *Ibid.*, 98.
34. *Ibid.*, 105.
35. *Ibid.*, 104.
36. *Ibid.*, 105.
37. *Ibid.*, 108.
38. *Ibid.*
39. *Ibid.*, 113.

40. Jackson, *Painter's Country*, 76.
41. Naomi Jackson Groves, *One Summer in Quebec: A.Y. Jackson in 1925* (Kapuskasing, ON: Penumbra Press, 1988), 10.

Chapter 12: All the Way Out to the Pacific
1. Jackson, *Painter's Country*, 86.
2. Larisey, 100.
3. Housser, 193.
4. *Ibid.*, 104.
5. Jackson, *Painter's Country*, 87.
6. Mellen, 159.
7. *Lawren Harris: Paintings 1910–1948*, 11.
8. Jackson, *Painter's Country*, 87.
9. *Ibid.*, 88.
10. Groves, *A.Y.'s Canada*, 150.
11. Jackson, *Painter's Country*, 87.
12. Reid, *Group of Seven*, 192.
13. Mellen, 213.
14. Groves, *One Summer*, 10.
15. Hill, 178.
16. *Ibid.*
17. Groves, *One Summer*, 12.
18. Jackson, *Painter's Country*, 65.
19. *Ibid.*
20. *Ibid.*, 66.
21. Groves, *One Summer*, 26.
22. Jackson, *Painter's Country*, 66.
23. *Ibid.*
24. *Ibid.*
25. A.Y. Jackson, Toronto, to Clarence A. Gagnon, Paris, December 27, 1925. McCord Museum of Canadian History, P116 Clarence Gagnon fonds.
26. A.J. Casson, *My Favourite Watercolours 1919 to 1957* (Toronto: Cerebrus/Prentice-Hall, 1982), 46.
27. Mellen, 158.
28. Firestone, 153.
29. Hill, 169.
30. *Ibid.*, 170.
31. Groves, *A.Y.'s Canada*, 154.
32. *Ibid.*, 152.
33. A.Y. Jackson, Toronto, to Clarence A. Gagnon, Paris, November 11, 1926. McCord Museum of Canadian History, P116 Clarence Gagnon fonds.
34. Jackson, *Painter's Country*, 89.

35. *Ibid.*
36. Groves, *A.Y.'s Canada*, 152.
37. Jackson, *Painter's Country*, 90.
38. *Ibid.*
39. Groves, *A.Y.'s Canada*, 154.
40. *Ibid.*, 155.
41. Maria Tippett, *Emily Carr: A Biography* (Toronto: Penguin Books, 1985), 126.
42. Jackson, *Painter's Country*, 91.
43. Tippett, *Emily Carr*, 143.
44. Emily Carr, *Hundreds and Thousands: The Journals of Emily Carr* (Toronto: Clarke, Irwin & Co., 1966), 5.
45. Tippett, *Emily Carr*, 145.
46. Carr, 5.
47. *Ibid.*, 6.
48. *Ibid.*
49. *Ibid.*

Chapter 13: Exploring the Northern Frontiers
1. Jackson, *Painter's Country*, 61.
2. A.Y. Jackson, *Banting as an Artist* (Toronto: Ryerson Press, 1943), 11.
3. Jackson, *Painter's Country*, 63.
4. *Ibid.*, 93,
5. Bridle, 6.
6. Jackson, *Painter's Country*, 93.
7. Reid, *Group of Seven*, 231.
8. Tyrwhitt, 44.
9. Mellen, 221.
10. "Canadian Artists Exhibit Widely," *Sault Ste. Marie Star*, June 2, 1927.
11. "Toronto Artist After Distinct Values in Art," *Regina Leader-Post*, July 30, 1927.
12. Firestone, 87.
13. Jackson, *Painter's Country*, 94.
14. Naomi Jackson Groves, *A.Y. Jackson: The Arctic, 1927* (Moonbeam, ON: Penumbra Press, 1982), n/p.
15. Jackson, *Painter's Country*, 94.
16. Groves, *A.Y.'s Canada*, 2.
17. Jackson, *Painter's Country*, 97.
18. Groves, *A.Y. Jackson*, n/p.
19. Jackson, *Painter's Country*, 94.
20. *Ibid.*
21. Groves, *A.Y. Jackson*, n/p.
22. *Ibid.*, n/p.

23. *Ibid.*, n/p.
24. *Ibid.*, n/p.
25. *Ibid.*, n/p.
26. Jackson, *Painter's Country*, 95.
27. Groves, *A.Y. Jackson*, n/p.
28. *Ibid.*, n/p.
29. Jackson, *Painter's Country*, 96.
30. Groves, *A.Y. Jackson*, n/p.
31. *Ibid.*, n/p.
32. Dr. F.G. Banting, quoted in Groves, *A.Y. Jackson*, n/p.
33. Jackson, *Painter's Country*, 96.
34. Groves, *A.Y. Jackson*, n/p.
35. *Ibid.*, n/p.
36. Jackson, *Painter's Country*, 96.
37. Groves, *A.Y. Jackson*, n/p.
38. Groves, *A.Y.'s Canada*, 2.
39. Groves, *A.Y. Jackson*, n/p.
40. Jackson, *Painter's Country*, 100.
41. *Ibid.*
42. Hill, 332.
43. Reid, Group of Seven, 232.
44. Groves, *A.Y. Jackson*, n/p.
45. A.Y. Jackson, Toronto, to Clarence Gagnon, Paris, June 8, 1932. Clarence Gagnon fonds, McCord Museum of Canadian History.

Chapter 14: Blackflies, Ice, and Fog
1. "Montreal Dubbed Most Bigoted City by Toronto Artist," *Montreal Star*, September 23, 1927, 6.
2. C.R. Greenaway, "Jackson Says Montreal Most Bigoted City," *Toronto Star*, September 10, 1927.
3. "Who Bit Mr. Jackson?" *Montreal Standard*, September 24, 1927.
4. Groves, *A.Y.'s Canada*, 194.
5. Jackson, *Painter's Country*, 100.
6. *Ibid.*
7. Groves, *A.Y.'s Canada*, 194.
8. *Ibid.*, 195.
9. Tyrwhitt, 44.
10. Jackson, *Painter's Country*, 101.
11. *Ibid.*
12. Groves, *A.Y.'s Canada*, 201.
13. *Ibid.*, 206.
14. *Ibid.*, 202.

15. Reid, *Group of Seven*, 236.
16. Groves, *A.Y.'s Canada*, 204.
17. A.Y. Jackson, Toronto, to Clarence Gagnon, Paris, June 8, 1932. Clarence Gagnon fonds, McCord Museum of Canadian History.
18. Hill, 331.
19. Groves, *A.Y.'s Canada*, 64.
20. Hill, 331.
21. Groves, *A.Y.'s Canada*, 2.
22. Jackson, *Painter's Country*, 103.
23. *Ibid.*
24. *Ibid.*, 104.
25. Groves, *A.Y.'s Canada*, 2.
26. *Ibid.*, 3.
27. *Ibid.*, 2.
28. Jackson, 107.
29. P.D. Baird, "Baffin Island," *The Beaver* (Spring 1967): 31.
30. Jackson, *Painter's Country*, 108.
31. *Ibid.*, 109.
32. *Ibid.*
33. *Ibid.*, 110.
34. Harris, 24.

Chapter 15: Heartbreak and Depression
1. McDougall, 95–96.
2. *Ibid.*, 117.
3. Naomi Jackson Groves, *Works by A.Y. Jackson from the 1930s* (Ottawa: Carleton University Press, 1990), 12.
4. Firestone, 26.
5. Hill, 242–43.
6. McDougall, 89.
7. *Ibid.*
8. *Ibid.*, 85.
9. Meadowcroft, 114.
10. McDougall, 85.
11. Joyce Ziemans, "Establishing the Canon: Nationhood, Identity and the National Gallery's First Reproduction Programme of Canadian Art," *The Journal of Canadian Art History*, Vol. XVI/2 (1995): 10.
12. Robert McMichael, *One Man's Obsession* (Scarborough, ON: Prentice-Hall Canada, 1986), 231–32.
13. Dennis Reid, *Alberta Rhythm: The Later Work of A.Y. Jackson* (Toronto: Art Gallery of Ontario, 1982), 11.

14. *Lovell's Montreal Street Directory*, 1922–23.
15. From family records kept by Naomi Jackson Groves, provided by Anna Brennan.
16. Jackson and Hannon, 58.
17. Jackson, *Painter's Country*, 6.
18. Jackson and Hannon, 58.
19. Jackson, *Painter's Country*, 112.
20. Duval, *Tangled Garden*, 148–49.
21. *Ibid.*, 151.
22. *Ibid.*, 152.
23. McDougall, 86.
24. Hill, 268.
25. Reid, *Group of Seven*, 203.
26. Paul Duval, *Four Decades: The Canadian Group of Painters and Their Contemporaries 1930–1970* (Toronto: Clarke, Irwin & Co., 1972), 12.
27. Mellen, 183.
28. Hill, 334.
29. Duval, *Four Decades*, 12.
30. Dennis Reid, *Atma Buddhi Manas: The Later Work of Lawren Harris* (Toronto: Art Gallery of Ontario, 1985), 44.
31. *Ibid.*, 13.
32. Reid, *Alberta Rhythm*, 97.
33. A.Y. Jackson, Montreal, to Clarence A. Gagnon, Paris, April 20, 1926. McCord Museum of Canadian History, P116 Clarence Gagnon fonds.
34. Jackson, *Painter's Country*, 116–17.
35. McDougall, 113.
36. *Ibid.*
37. Firestone, 85.
38. *Ibid.*, 99.
39. McDougall, 69.
40. *Ibid.*, 134.
41. Anne Savage interview with Arthur Calvin, 1968; tape transcript, page 16. Anne Savage fonds, Concordia University archives.
42. Larisey, 118.
43. *Ibid.*, 119.
44. Groves, "A Profile": 18.
45. *Ibid.*

Chapter 16: The Public Personality

1. Megan Bice, *Light & Shadow: The Work of Franklin Carmichael* (Kleinburg, ON: McMichael Canadian Art Collection, 1990), 106.
2. Jackson, *Painter's Country*, 116.
3. Dennis Reid, *Canadian Jungle: The Later Work of Arthur Lismer* (Toronto: Art Gallery of Ontario, 1985), 24.
4. Naomi Jackson Groves and A.Y. Jackson, *Two Jacksons Abroad 1936* (Manotick, ON: Penumbra Press, 2000), 38.
5. Interview with Heward Grafftey, May 11, 2006.
6. Groves and Jackson, 135.
7. *Ibid.*, 123.
8. *Ibid.*, 42.
9. *Ibid.*, 123.
10. Jackson, *Painter's Country*, 119.
11. Groves and Jackson, 124.
12. Interview with Heward Grafftey, May 11, 2006.
13. Jackson, *Painter's Country*, 119.
14. *Ibid.*
15. *Ibid.*, 34.
16. Postcard from A.Y. Jackson, London, to Anne Savage, Montreal, July 10, 1936. Anne Savage fonds, Concordia University.
17. Groves and Jackson, 128.
18. *Ibid.*, 140.
19. Jackson, 119.
20. Groves and Jackson, 129.
21. Reid, *Alberta Rhythm*, 15.
22. *Ibid.*, 43.
23. Groves, *A.Y.'s Canada*, 128.
24. Jackson, *Painter's Country*, 121.
25. Groves, *A.Y.'s Canada*, 208.
26. Jackson, *Painter's Country*, 123.
27. Groves, *A.Y.'s Canada*, 208.
28. Jackson, *Painter's Country*, 122.
29. Groves, *A.Y.'s Canada*, 208.
30. Jackson, *Painter's Country*, 123.
31. Groves, *A.Y.'s Canada*, 208.
32. *Ibid.*
33. McDougall, 152.
34. *Ibid.*, 154.
35. Anne Savage, typescript for CBC broadcast, February 1939. Anne Savage fonds, Concordia University.
36. Jackson, *Painter's Country*, 154.
37. Groves, *Works by A.Y.*, 45.
38. Jackson, *Painter's Country*, 154.
39. *Ibid.*, 155.

Chapter 17: Mass Reproduction for Mass Recognition

1. Jackson, *Painter's Country*, 133.
2. Groves, *A.Y.'s Canada*, 188.
3. Jackson, *Painter's Country*, 141.
4. Reid, *Alberta Rhythm*, 94.
5. Jackson, *Painter's Country*, 138.
6. *Ibid.*
7. Henry Beston, *The St. Lawrence* (New York: Farrar & Rinehart, 1942), 53.
8. McMichael, 321.
9. Firestone, 321.
10. *Ibid.*
11. Federation of Canadian Artists website, *www.artists.ca*.
12. Groves, *A.Y.'s Canada*, 170.
13. A.Y. Jackson, "Banff School of Fine Arts," *Canadian Art*, vol. III, no. 4 (July 1946).
14. Jackson, *Painter's Country*, 141.
15. Jackson, 1946.
16. *Ibid.*
17. Jackson, *Painter's Country*, 141.
18. Reid, *Alberta Rhythm*, 21.
19. Jackson, 1946.
20. Jackson, *Painter's Country*, 141.
21. *Ibid.*, 142.
22. Reid, *Alberta Rhythm*, 59.
23. Groves, *A.Y.'s Canada*, 189.
24. Jackson, *Painter's Country*, 144.
25. Groves, *A.Y.'s Canada*, 142.
26. Jackson, *Painter's Country*, 139.
27. Groves, *A.Y.'s Canada*, 188.
28. Jackson, *Painter's Country*, 139.
29. Groves, *A.Y.'s Canada*, 189.
30. Reid, *Alberta Rhythm*, 21.
31. Ziemans, 9.
32. *Ibid.*, 10.
33. Groves, *A.Y.'s Canada*, 78.
34. A.Y. Jackson, Toronto, to Clarence Gagnon, Paris, June 8, 1932. Clarence Gagnon fonds, McCord Museum of Canadian History.
35. *Ibid.*
36. *Ibid.*
37. Reid, Alberta Rhythm, 95.

38. Dennis Reid, *A Concise History of Canadian Painting* (Toronto: Oxford University Press, 1973), 225.
39. *Ibid.*, 228.
40. *Canadian Group of Painters 1947–1948* (Montreal and Toronto: Art Association of Montreal/Art Gallery of Toronto, 1947), n/p.
41. Jackson and Hannon, 28.
42. Sabbath, 243.
43. Firestone, 159.
44. Jackson, *Painter's Country*, 114.
45. Bice, 109.
46. *Ibid.*, 121.
47. Mason, Roger Burford, *A Grand Eye for Glory: A Life of Franz Johnston* (Toronto: Dundurn Press, 1998), 63–64.
48. *Ibid.*
49. Firestone, 158.
50. Jackson, *Painter's Country*, 98.
51. *Ibid.*, 152.
52. *Ibid.*, 153.
53. Jackson and Hannon, 65.
54. Sabbath, 240.

Chapter 18: The *Y* Stands for Young
1. McMichael, 111.
2. Jackson, *Painter's Country*, 156.
3. *CBC Evening News*, July 19, 1999.
4. Jackson, *Painter's Country*, 156.
5. Firestone, 35.
6. Jackson, *Painter's Country*, 156.
7. McMichael, 185.
8. Jock Carroll, "Last of the Seven Says Farewell," *Weekend Magazine* (June 3, 1955): 8.
9. Firestone, 35.
10. David P. Silcox, *Painting Place: The Life and Work of David B. Milne* (Toronto: University of Toronto Press, 1996), 379.
11. A.Y. Jackson, A Painter's Country, rev. ed. (Toronto: Clarke, Irwin & Co., 1967), 160.
12. Firestone, 35.
13. Jackson, *Painter's Country*, 60.
14. Reid, *Alberta Rhythm*, 29.
15. Firestone, 207.
16. Reid, *Alberta Rhythm*, 97–98.

17. Interview with Heward Grafftey, May 11, 2006.
18. *Ibid.*
19. *Ibid.*
20. Firestone, 41.
21. *Ibid.*, 48.
22. *Ibid.*, 49.
23. *Ibid.*, 45.
24. *Ibid.*, 227.
25. Jackson and Hannon, 58.
26. Firestone, 108.
27. *Ibid.*, 109.
28. *Ibid.*, 112.
29. *Ibid.*
30. *Ibid.*, 116.
31. *Ibid.*, 238.
32. *Ibid.*
33. P.D. Baird, "A.Y. Jackson," *The Beaver* (Spring 1967): 6.
34. Firestone, 122.
35. *Ibid.*
36. Jackson, *Painter's Country*, 162.
37. Groves, "A Profile": 19.
38. *Ibid.*
39. Baird, 16.
40. Jackson, *Painter's Country*, 162.
41. Firestone, 122.
42. *Ibid.*, 123.
43. Jackson and Hannon, 58.

Chapter 19: A Force of Nature
1. Firestone, 238.
2. Reid, *Alberta Rhythm*, 33.
3. Firestone, 239.
4. Heather Robertson, "Together Forever," *The Beaver*, vol. 84:2 (April/May 2004), 30.
5. McMichael, 111.
6. Interview with Michael Millman, West End Gallery, November 2008.
7. Firestone, 102.
8. *Ibid.*, 105.
9. Reid, *Alberta Rhythm*, 91.
10. Joyce Putnam, *Seven Years with the Group of Seven* (Kingston: Quarry Press, 1991), 79.
11. Firestone, 240.

12. Reid, *Alberta Rhythm*, 34.
13. Firestone, 242.
14. *Ibid.*
15. *Ibid.*, 243.
16. *Ibid.*, 244.
17. Tyrwhitt, 48.
18. Firestone, 245.
19. Putnum, 94.
20. McMichael, 226.
21. *Ibid.*
22. Firestone, 249.
23. Putnam, 95.
24. *Ibid.*
25. Firestone, 250.
26. Tyrwhitt, 48.
27. Michael Ballantyne, "A Fascinating Record: A.Y. Jackson's Canada," *Montreal Star*, November 23, 1968.
28. Reid, *Atma Buddhi Manas*, 106.
29. *Ibid.*, 140.
30. *Ibid.*, 108.
31. A.Y. Jackson, "Arthur Lismer: His Contribution to Canadian Art," *Canadian Art*, vol. VII, no. 3 (Spring 1950): 89.
32. Firestone, 157.
33. Tippett, *Stormy Weather*, 278.
34. Firestone, 157.
35. Tippett, *Stormy Weather*, 279.
36. *Ibid.*
37. Reid, *Atma Buddhi Manas*, 105.
38. Robertson, 30.
39. Reid, *Atma Buddhi Manas*, 108.
40. Firestone, 156.
41. *Lawren Harris: Paintings 1910–1948*, 12.
42. McMichael, 317.
43. *Ibid.*, 318.
44. Firestone, 253.
45. *Ibid.*, 122.
46. *Ibid.*, 253.
47. *Ibid.*, 105.
48. McMichael, 227.
49. Meadowcroft, 175.
50. *Ibid.*, 174.
51. Putnam, 80.
52. Reid, *Alberta Rhythm*, 99.
53. Firestone, 254.

54. Kay Kritzwiser and Pearl McCarthy, "Last of Group of Seven a Giant in Canadian Art," *Globe and Mail*, April 6, 1974, 29.
55. "Last of Group of Seven A.Y. Jackson Dies at 91," *Vancouver Sun*, April 6, 1974, 17.
56. McMichael, 219.
57. Firestone, 254.
58. "A.Y. Jackson," editorial, *Globe and Mail*, April 6, 1974, 6.
59. "A.Y. Jackson Country," editorial, *Montreal Gazette*, April 6, 1974, 8.
60. *Ibid.*
61. Lismer, 1953, 7.
62. *Ibid.*
63. Jackson and Hannon, 65.

Appendix I: The Landscape Painter at Work

1. *Canadian Landscape*, National Film Board of Canada, 1941.
2. Pepper, 26.
3. Firestone, 120.
4. Jackson, *Painter's Country*, 153.
5. Tyrwhitt, 44.
6. Jackson, *Painter's Country*, 18.
7. Jackson and Hannon, 61.
8. Hill, 335.
9. Tyrwhitt, 48.
10. Firestone, 38.

BIBLIOGRAPHY

Books

A.Y. Jackson: Paintings 1902–1953. Toronto: Art Gallery of Toronto, 1953.

Adamson, Jeremy. *Lawren S. Harris: Urban Scenes and Wilderness Landscapes 1906–1930.* Toronto: Art Gallery of Ontario, 1978.

Baker, Victoria. *Modern Colours: The Art of Randolph Stanley Hewton 1888–1960.* Hamilton: Art Gallery of Hamilton, 2001.

Beston, Henry. *The St. Lawrence.* New York: Farrar & Rinehart, 1942.

Bice, Megan. *Light & Shadow: The Work of Franklin Carmichael.* Kleinburg, ON: McMichael Canadian Art Collection, 1990.

Bridle, Augustus. *The Story of the Club.* Toronto: Ryerson Press, 1945.

Brooke, Janet M. *Discerning Tastes: Montreal Collectors 1880–1920.* Montreal: Montreal Museum of Fine Arts, 1989.

Boulet, Roger. *The Canadian Earth.* Toronto: Cerebrus/Prentice-Hall, 1982.

Buchanan, Donald W. *James Wilson Morrice: A Biography.* Toronto: Ryerson Press, 1936.

Canadian Group of Painters 1947–1948. Montreal, Toronto: Art Association of Montreal/ Art Gallery of Toronto, 1947.

Carr, Emily. *Hundreds and Thousands: The Journals of Emily Carr.* Toronto: Clarke, Irwin & Co., 1966.

Casson, A.J. *My Favourite Watercolours 1919 to 1957.* Toronto: Cerebrus/Prentice-Hall, 1982.

Copland, Dudley. *Livingstone of the Arctic.* Ottawa: Dudley Copland, 1967.

Darroch, Lois. *Bright Land: A Warm Look at Arthur Lismer.* Toronto and Vancouver: Merritt Publishing Co., 1981.

Davies, Blodwen. *Tom Thomson: The Story of a Man Who Looked for Beauty and Truth in the Wilderness.* Vancouver: Mitchell Press Ltd. 1967.

Duval, Paul. *The Tangled Garden: The Art of J.E.H. MacDonald.* Toronto: Cerebrus/Prentice-Hall, 1978.

_____. *Canadian Impressionism.* Toronto, McClelland & Stewart, 1990.

_____. *Four Decades: The Canadian Group of Painters and Their Contemporaries 1930–1970.* Toronto: Clarke, Irwin & Co., 1972.

Empire Club of Canada: Addresses Delivered to the Members During the Year 1925. Toronto: Macoomb Press, 1925.

Firestone, O.J. *The Other A.Y. Jackson.* Toronto: McClelland & Stewart, 1979.

Groves, Naomi Jackson. *A.Y.'s Canada.* Toronto: Clarke, Irwin & Co., 1968.

_____. *A.Y. Jackson: The Arctic, 1927.* Moonbeam, ON: Penumbra Press, 1982.

_____. *One Summer in Quebec: A.Y. Jackson in 1925.* Kapuskasing, ON: Penumbra Press, 1988.

_____. *Works by A.Y. Jackson from the 1930s.* Ottawa: Carleton University Press, 1990.

_____. *Young A.Y. Jackson: Lindsay A. Evans' Memories 1902–1906.* Ottawa: Edahl Productions Ltd. 1982.

_____., with A.Y. Jackson. *Two Jacksons Abroad 1936.* Manotick, ON: Penumbra Press, 2000.

Gubbay, Aline. *A View of Their Own: The Story of Westmount.* Montreal: Price-Patterson Ltd., 1998.

Harper, J. Russell. *Painting in Canada: A History.* Second edition. Toronto: University of Toronto Press, 1977.

Harris, Lawren S. *The Story of the Group of Seven.* Toronto: Rous & Mann Press Ltd., 1964.

Hill, Charles C. *Canadian Painting in the Thirties.* Ottawa: National Gallery of Canada, 1975.

_____. *The Group of Seven: Art for a Nation.* Ottawa: National Gallery of Canada, 1995.

Housser, F.B. *A Canadian Art Movement: The Story of the Group of Seven.* Toronto: Macmillan, 1926.

Hunkin, Harry. *The Group of Seven: Canada's Great Landscape Painters.* Edinburgh: Paul Harris Publishing, 1979.

Jackson, A.Y. *A Painter's Country.* Toronto: Clarke, Irwin & Co., 1958.

_____. *A Painter's Country,* rev. ed. Toronto: Clarke, Irwin & Co., 1967.

_____. *Banting as an Artist.* Toronto: Ryerson Press, 1943.

_____. *The Far North.* Toronto: Rous and Mann, 1928.

Laing, G. Blair. *Memoirs of an Art Dealer 2.* Toronto: McClelland & Stewart, 1982.

_____. *Morrice.* Toronto: McClelland & Stewart, 1984.

Larisey, Peter. *Light for a Cold Land.* Toronto: Dundurn Press, 1993.

Larsen, Wayne. *A.Y. Jackson: A Love for the Land.* Montreal: XYZ Publishing, 2003.

_____. *James Wilson Morrice: Painter of Light and Shadow.* Toronto: Dundurn Press, 2008.

Lawren Harris: Paintings 1910–1948. Toronto: Art Gallery of Toronto, 1948.

Lee, Thomas R. *Albert H. Robinson: The Painter's Painter.* Montreal: Private printing, 1956.

Lovell's Street Directory, Montreal, 1882–1922.

MacDonald, Thoreau. *The Group of Seven.* Toronto: Ryerson Press, 1944.

McDougall, Anne. *Anne Savage: The Story of a Canadian Painter.* Montreal: Harvest House, 1977.

McMichael, Robert. *One Man's Obsession.* Scarborough, ON: Prentice-Hall Canada, 1986.

Mason, Roger Burford. *A Grand Eye for Glory: A Life of Franz Johnston.* Toronto: Dundurn Press, 1998.

Mastin, Catharine M., ed. *The Group of Seven in Western Canada*. Toronto: Key Porter Books and the Glenbow Museum, Calgary, 2002.

Meadowcroft, Barbara. *Painting Friends: The Beaver Hall Women Painters*. Montreal: Véhicule Press, 1999.

Mellen, Peter. *The Group of Seven*. Toronto: McClelland & Stewart, 1970.

Murray, Joan. *The Best of the Group of Seven*. Edmonton: Hurtig Publishers Ltd., 1984.

_____. *Confessions of a Curator: Adventures in Canadian Art*. Toronto: Dundurn Press, 1996.

_____. *Flowers: J.E.H. MacDonald, Tom Thomson and the Group of Seven*. Toronto: McArthur & Company, 2002.

_____. *Masterpieces: Tom Thomson and the Group of Seven*. Toronto: Prospero Books, 1994.

_____. *Tom Thomson: Design for a Canadian Hero*. Toronto: Dundurn Press, 1998.

_____. *Tom Thomson: The Last Spring*. Toronto: Dundurn Press, 1994.

Oliver, Dean F., and Laura Brandon, *Canvas of War*. Vancouver: Douglas & McIntyre, 2000.

Ord, Douglas. *The National Gallery of Canada: Ideas Art Architecture*. Montreal and Kingston: McGill-Queen's University Press, 2003.

Pepper, Kathleen Daly. *James Wilson Morrice*. Toronto: Clarke, Irwin & Co., 1966.

Purdy, Al. *Beyond Remembering: The Collected Poems of Al Purdy*. Madeira Park, BC: Harbour Publishing, 2000.

Putnam, Joyce. *Seven Years with the Group of Seven*. Kingston: Quarry Press, 1991.

Reid, Dennis. *Alberta Rhythm: The Later Work of A.Y. Jackson*. Toronto: Art Gallery of Ontario, 1982.

_____. *Atma Buddhi Manas: The Later Work of Lawren Harris*. Toronto: Art Gallery of Ontario, 1985.

_____. *Canadian Jungle: The Later Work of Arthur Lismer*. Toronto: Art Gallery of Ontario, 1985.

_____. *A Concise History of Canadian Painting*. Toronto: Oxford University Press, 1973.

_____. *The Group of Seven*. Ottawa: National Gallery of Canada, 1970.

_____. *Krieghoff: Images of Canada*. Vancouver: Douglas & McIntyre, 1999.

_____. *The MacCallum Bequest*. Ottawa: National Gallery of Canada, 1969.

_____., and Charles C. Hill. *Tom Thomson*. Toronto: Art Gallery of Ontario/National Gallery of Canada/Douglas & McIntyre, 2002.

_____. *Tom Thomson: The Jack Pine*. Ottawa: National Gallery of Canada, 1975.

Rivard, Adjutor. *Chez Nous*. Toronto: McClelland & Stewart, 1924.

Robertson, Heather. *A Terrible Beauty: The Art of Canada at War*. Toronto: James Lorimer & Co., 1977.

Robson, Albert H. *Canadian Landscape Painters*. Toronto: Ryerson Press, 1932.

_____. *A.Y. Jackson*. Toronto: Ryerson Press, 1938.

Siddall, Catherine D. *The Prevailing Influence: Hart House and the Group of Seven, 1919–1953*. Oakville, ON: Oakville Galleries, 1989.

Silcox, David P. *Painting Place: The Life and Work of David B. Milne*. Toronto: University of Toronto Press, 1996.

_____. *The Group of Seven and Tom Thomson*. Toronto: Firefly Books, 2003.

Stevens, Gerald. *Frederick Simpson Coburn*. Toronto: Ryerson Press, 1958.

Tippett, Maria. *Art at the Service of War: Canada, Art and the Great War*. Toronto: University of Toronto Press, 1984.

_____. *Emily Carr: A Biography*. Toronto: Penguin Books, 1985.

_____. *Stormy Weather: F.H. Varley, a Biography*. Toronto: McClelland & Stewart, 1998.

Town, Harold, and David P. Silcox. *Tom Thomson: The Silence and the Storm*. Toronto: McClelland & Stewart, 1977.

Varley, Peter. *Frederick H. Varley*. Toronto: Key Porter Books, 1983.

Visions of Light and Air: Canadian Impressionism, 1885–1920. New York: Americas Society Art Gallery, 1995.

Articles

"A.Y. Jackson: A Retrospective Exhibition." *Canadian Art*, vol. XI, no. 1 (Autumn, 1953).

"A.Y. Jackson." Editorial. *Globe and Mail*, April 6, 1974.

"A.Y. Jackson Country." Editorial. *Montreal Gazette*, April 6, 1974.

Baird, P.D. "A.Y. Jackson." *The Beaver* (Spring 1967), 6.

_____. "Baffin Island." *The Beaver* (Spring 1967).

Ballantyne, Michael. "A Fascinating Record: A.Y. Jackson's Canada." *Montreal Star*, November 23, 1968.

Buckman, Eduard. "Canadian Landscape: New Film of an Artist at Work." *Magazine of Art*, vol. 34, no. 8 (October 1941).

Butlin, Susan. "Landscape as Memorial: A.Y. Jackson and the Landscape of the Western Front, 1917–1918." *Canadian Military History*, vol. 5, no. 2 (Autumn 1996).

Carroll, Jock. "Last of the Seven Says Farewell." *Weekend Magazine* (June 3, 1955).

Charlesworth, Hector. "Canadian Pictures at Wembley." *Saturday Night* (May 17, 1924).

_____. "Pictures That Can Be Heard: A Survey of the Ontario Society of Artists Exhibition." *Saturday Night*, XXIX:23 (March 18, 1916).

Fenton, Terry. "High Culture in Prairie Canada." *ARTNews*, vol. 73, no. 7 (September 1974).

Gadsby, H.F. "The Hot Mush School." *Toronto Star*, December 12, 1913.

Groves, Naomi Jackson. "A Profile of A.Y. Jackson." *The Beaver* (Spring 1967).

"If Cow Can Stay in Parlour, Then Why Can't Bull Moose?" *Toronto Star*, February 27, 1925.

Harper, J. Russell. "Three Centuries of Canadian Painting." *Canadian Art 82*, vol. XIX, no. 6 (November/December 1962).

Jackson, A.Y. "Art Goes to the Armed Forces." *The Studio*, vol. CXXIX, no. 625 (April 1945).

_____. "Banff School of Fine Arts." *Canadian Art*, vol. III, no. 4 (July 1946).

_____. "Box-Car Days in Algoma 1919–20." *Canadian Art*, vol. XIV, no. 4 (Summer 1957).

_____. "Arthur Lismer: His Contribution to Canadian Art." *Canadian Art*, vol. VII, no. 3 (Spring 1950).

_____. "A Record of Total War." *Canadian Art*, vol. III, no. 4 (July 1946).

_____. "Reminiscences of Army Life 1914–1918." *Canadian Art*, vol. XI, no. 1 (Autumn 1953).

_____. "Sketching in Algoma." *Canadian Forum* (March 1921).

_____. with Leslie F. Hannon. "From Rebel Dauber to Renowned Painter: A Self-Portrait of A.Y. Jackson." *Mayfair*, vol. XXVIII, no. 9 (Spring 1954).

"Jackson, Last of Group of 7, Dies at 91." *Montreal Star*, April 5, 1974.

Jarvis, Alan. "Faces of Canada Exhibit a Modest Social History." *Canadian Art 93*, vol. XXI, no. 5 (September/October 1964).

Kent, Norman. "Two Canadian Masters of Landscape." *American Artist 233*, vol. 24, no. 3 (March 1960).

Kilbourn, Elizabeth. "The Toronto-Hamilton Scene." *Canadian Art 69*, vol. XVII, no. 4 (July 1960).

Kritzwiser, Kay, and Pearl McCarthy. "Last of Group of Seven a Giant in Canadian Art." *Globe and Mail*, April 6, 1974.

"Last of Group of Seven A.Y. Jackson Dies at 91." *Vancouver Sun*, April 6, 1974.

Lismer, Arthur. "A.Y. Jackson — Retrospective." *Canadian Art*, vol. III, no. 4 (Summer 1946).

MacDonald, J.E.H. "The Hot Mush School in Rebuttal of H.F.G." *Toronto Star*, December 20, 1913.

_____. "Bouquets from a Tangled Garden," Toronto *Globe*, March 27, 1916.

"Montreal Boys Achieve Success with Paintings." *Montreal Daily Star*, February 20, 1913.

"Montreal Dubbed Most Bigoted City by Toronto Artist." *Montreal Daily Star*, September 13, 1927.

Robertson, Heather. "Together Forever." *The Beaver*, vol. 84:2 (April/May 2004).

Sabbath, Lawrence. "The Private Collector: Charles S. Band." *Canadian Art 73*, vol. XVIII, no. 3 (May/June 1961).

_____. "A.Y. Jackson." *Canadian Art 69*, vol. XVII, no. 4 (July 1960).

"Third Montreal Artist for Front." *Montreal Gazette*, June 29, 1915.

Tovell, Rosemarie L. "A. Y. Jackson in France, Belgium and Holland: A 1909 Sketch Book." *National Gallery of Canada Annual Bulletin 2* (1978–1979).

Tyrwhitt, Janice. "A.Y. Jackson: All Canada for His Canvas." *Reader's Digest* (Canada) (April 1978).

"War Pictures May Evoke Criticism," *Montreal Gazette*, July 16, 1919.

"Who Bit Mr. Jackson?" *Montreal Standard*, September 24, 1927.

Ziemans, Joyce. "Establishing the Canon: Nationhood, Identity and the National Gallery's First Reproduction Programme of Canadian Art." *The Journal of Canadian Art History*, vol. XVI/2 (1995).

Films and Broadcasts

A.Y. Jackson: Still Painting at 73. CBC *Newsmagazine*, July 10, 1955.

Canadian Landscape. National Film Board of Canada, 1941.

The West Wind. National Film Board of Canada, 1943.

LIST OF PAINTINGS

Page 114: *Barns*, circa 1926. Oil on canvas, 81.6 x 102.1 cm. Art Gallery of Ontario, Toronto. Gift from the Reuben and Kate Leonard Canadian Fund, 1926. Courtesy of the estate of the late Dr. Naomi Jackson Groves. 846.

Page 117: *Lake Superior Country*, 1924. Oil on canvas, 117.0 x 148.0 cm. McMichael Canadian Art Collection. Gift of Mr. S. Walter Stewart. 1968.8.26.

Page 131: *Totem Poles, Kitwanga*, 1926. Oil on wood panel, 21.0 x 26.7 cm. Private Collection, Fred and Beverly Schaeffer.

Page 132: *Skeena Crossing, B.C. (Gitsegyukla)*, circa 1926. Oil on canvas, 53.5 x 66.1 cm. McMichael Canadian Art Collection. Gift of Mr. S. Walter Stewart. 1968.8.27.

Page 141: *The "Beothic" at Bache Post, Ellesmere Island*, 1929. Oil on canvas, 81.6 x 102.1 cm. Copyright © National Gallery of Canada, Ottawa. Gift of the Honourable Charles Stewart, minister of the interior, 1930, to commemorate the establishment on August 6, 1926, of Bache Peninsula post. Courtesy of the estate of the late Dr. Naomi Jackson Groves. 3711.

Page 145: *St. Fidele*, circa 1930. Oil on canvas. Private collection, Christine Guest.

Page 152: *Saint-Tite-des-Caps*, circa 1930. Oil on canvas, 53.9 x 66.5 cm. © National Gallery of Canada, Ottawa. Courtesy of the estate of the late Dr. Naomi Jackson Groves.

Page 163: *Winter, Charlevoix County*, 1932–33. Oil on canvas, 63.5 x 81.3 cm. Art Gallery of Ontario, Toronto. Purchase 1933. Courtesy of the estate of the late Dr. Naomi Jackson Groves. 2156.

Page 166: *March Day, Laurentians*, circa 1933. Oil on canvas, 54.0 x 66.9 cm. McMichael Canadian Art Collection. Gift of Mrs. H.P. de Pencier. 1966.2.6.

Page 169: *Algoma, November*, 1934. Oil on canvas, 81.3 x 102.1 cm. Copyright © National Gallery of Canada, Ottawa. Gift of H.S. Southam, Ottawa, 1945. Courtesy of the estate of the late Dr. Naomi Jackson Groves. 4611.

Page 172: *Early Snow, Alberta*, 1937. Oil on canvas, 82.5 x 116.8 cm. Courtesy Sotheby's Canada.

Page 175: *Blood Indian Reserve, Alberta*, 1937. Oil on canvas, 64.0 x 81.6 cm. Art Gallery of Ontario, Toronto. Purchase 1946. Courtesy of the estate of the late Dr. Naomi Jackson Groves. 2828 2956.

Page 176: *South from Great Bear Lake*, circa 1939. Oil on canvas, 81.2 x 101.5 cm. Art Gallery of Ontario, Toronto. Gift from the J.S. McLean Collection, 1969. Donated by the Ontario Heritage Foundation, 1988. Courtesy of the estate of the late Dr. Naomi Jackson Groves. L69.21

Page 183: *Porcupine Hills, Alberta*, 1937. Oil on wood, 26.6 x 34.3 cm. Copyright © National Gallery of Canada, Ottawa. Courtesy of the estate of the late Dr. Naomi Jackson Groves. 4535.

Page 186: *Waterton Lake*, circa 1948. Oil on canvas, 62.2 x 79.7 cm. Buchanan Art Collection, Lethbridge College. Courtesy of the estate of the late Dr. Naomi Jackson Groves. 00009.

Page 199: *Elevators at Night, Pincher Creek*, circa 1947. Oil on canvas, 49.6 x 65.3 cm. Buchanan Art Collection, Lethbridge College. Courtesy of the estate of the late Dr. Naomi Jackson Groves. 00001.

Page 206: *October, Twin Butte, Alberta*, 1951. Oil on canvas, 64.2 x 81.5 cm. Copyright © National Gallery of Canada, Ottawa. Courtesy of the estate of the late Dr. Naomi Jackson Groves. 6456.

INDEX

Also by Wayne Larsen

JAMES WILSON MORRICE
Painter of Light and Shadow

978-1-55002-818-8 • $17.95

James Wilson Morrice was a Canadian painter of extraordinary passion and simplicity whose canvases and oil sketches are valued throughout the world and cherished in Canada as our first real examples of modern art. Although cut short by chronic alcohol abuse, Morrice's restless bohemian life was spent in constant motion. In *James Wilson Morrice*, Wayne Larsen chronicles the creative but often troubled life of this early cultural icon as he travels in search of the colours, compositions, and subtle effects of light that would inspire a revolution in Canadian art.

Of Related Interest

F.H. VARLEY
Portraits into the Light/Mise en lumière des portraits
by Katerina Atanassova
978-1-55002-675-7 • $60.00

Frederick Horsman Varley was unique among the members of the Group of Seven. One of the greatest Canadian portraitists of the twentieth century, he is an intriguing example of an artist who, despite his fame as a portrait painter, remains better known for his landscapes. Even though many public collections across the country display some of Varley's best-known portraits, these works don't easily fit into the conventional mould of the Group of Seven. This is due mainly to the Group's deliberate attempt to raise awareness of our national identity by depicting the Canadian landscape.

THE WOMEN OF BEAVER HALL
Canadian Modernist Painters
by Evelyn Walters, Ph.D.
978-1-55002-588-0 • $60.00

Ten women artists, counterparts of the Group of Seven, are finally being given their due. Long overlooked, they are today among the most sought after Canadian painters. Engaging and beautifully produced, *The Women of Beaver Hall* portrays the lives and works of Nora Collyer, Emily Coonan, Prudence Heward, Mabel Lockerby, Henrietta Mabel May, Kathleen Moir Morris, Lilias Torrance Newton, Sarah Robertson, Anne Savage, and Ethel Seath. With a clear and concise style directed to the aficionado and scholar alike, this book is the ultimate reference on the Beaver Hall women.

Available at your favourite bookseller.

DUNDURN
www.dundurn.com

Tell us your story! What did you think of this book? Join the conversation at
www.definingcanada.ca/tell-your-story by telling us what you think.